BLIZZARD®
ENTERTAINMENT
FORGING WORLDS

STORIES BEHIND

THE ART OF BLIZZARD

ENTERTAINMENT

INTRODUCTION BY **Samwise Didier**

WRITTEN BY **Micky Neilson**

CONTENTS

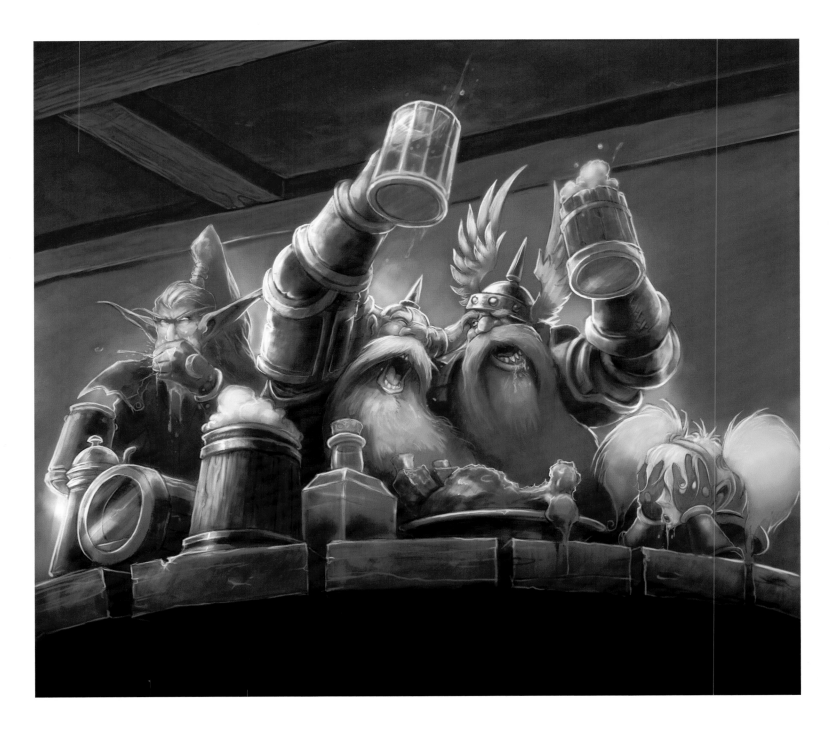

INTRODUCTION

Over the years, Blizzard has created some gorgeous art books showcasing the fantastical artwork our teams have created for our games. Each book is filled with sketches and doodles and renders, and like those previous books, this one delivers some killer artwork.

For those of you who own our previous art books, you have walked with us through the High Heavens and the Burning Hells, searched the stars in terran battle cruisers, ridden across the Barrens atop colossal kodo beasts, and roamed the shadowed streets of King's Row searching for your foes. On those journeys, we have shared with you some of the most beautiful and extravagant art we have ever created. But this book is a bit special, a bit different from the other Blizzard art books you might have tucked away in your inner sanctum. Not only does this book help celebrate thirty years

of Blizzard Entertainment, but it also celebrates the stories behind some of our most beloved characters and tells the legendary tales that brought some of our most iconic and important images to life.

Art books are always difficult to create, with much conversation around selecting images to use, interviewing all the players from development . . . and that's before stringing it together with the editing and layout. The process for picking out art for this book was no easier, as everyone involved had their favorite images that personally spoke to them, but we also had to keep in mind that this is not just an art book but a storybook as well. The creators of this book were constantly reminded to choose the artwork not based on artistic quality alone. It had to tell a great tale.

ALL IMAGES: Samwise Didier

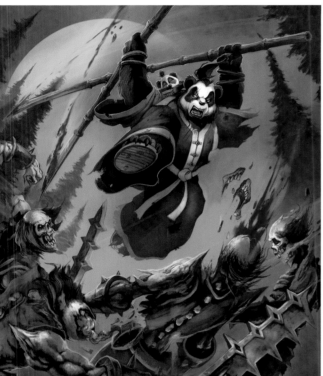

They say every picture tells a story, so we picked images that hold libraries full of prose. We combed through the archives and hit up every art team at Blizzard to hear the journey of the piece and how it fit in with the team's approach to art. We wanted to bring forward something for the old fans who have been with Blizzard since *The Lost Vikings*, as well as for the newer fans who came into our worlds just recently. We wanted every fan to walk away from this book having learned something new.

I have worked at Blizzard for thirty years now, and while reading, I was shocked at how many of these tales were new to me. We have thousands of pieces of artwork—and probably just as many stories behind each one. What I really like to think about, though, what really excites me, are not the old stories we have . . . but wondering what the future stories are going to be. What new artist will join Blizzard and create the

next image that just floors us with its creativity, quality, and, of course, its story? That could be happening right now. That could be you, new artist at Blizzard . . . and maybe that could be you, up-and-coming artist reading these words right now. You want to share your artwork with the world and tell us its story? Well, we are waiting, and we look forward to creating new worlds and stories with you!

I do hope you enjoy this book and the stories its pages hold. Hopefully we won't have to wait another thirty years for something like this to come around again. Well, even if it does take that long, it will be worth the wait.

ABC, Always Be Creating!

Samwise

CHAPTER **ONE**

HUMBLE ORIGINS

OPPOSITE: Chris Metzen

From the very first **Warcraft**, **StarCraft**, and **Diablo**
game manuals, Blizzard artists began setting down
a style that, today, informs every new release, from
Overwatch to **Hearthstone**. But just what is Blizzard's
style, and how has the team come to define it?

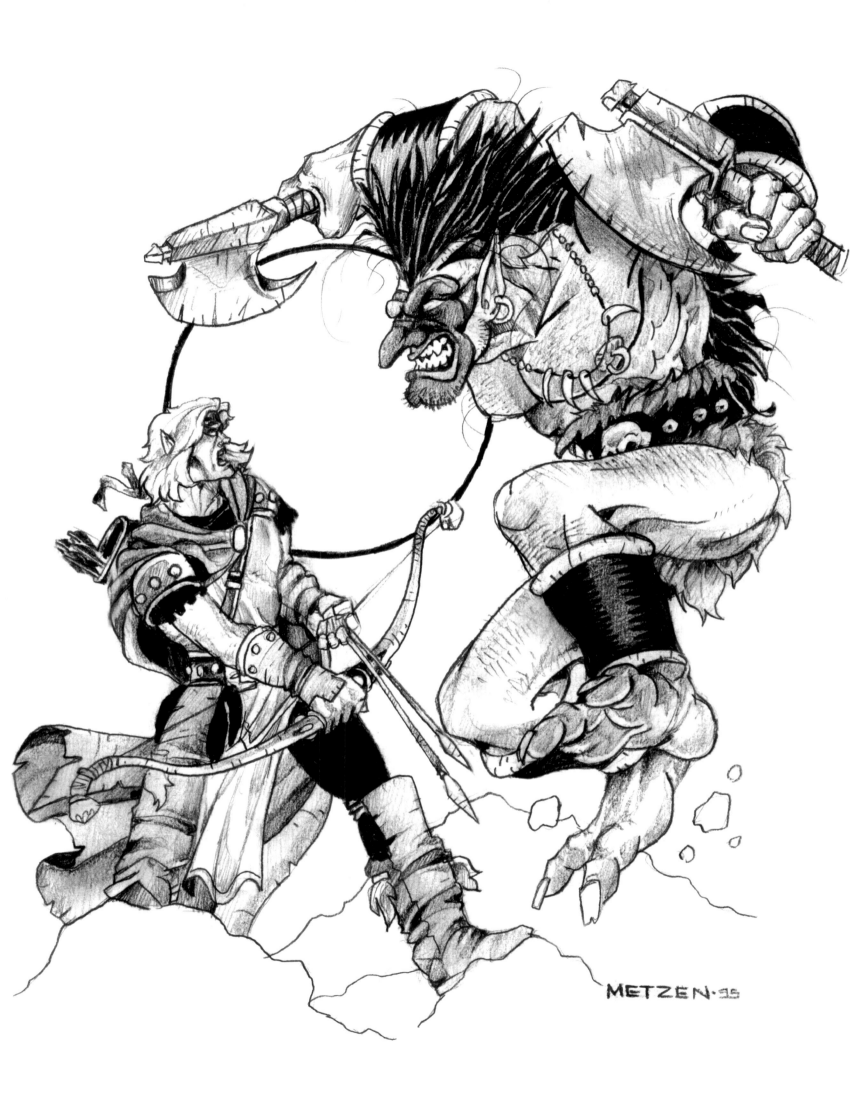

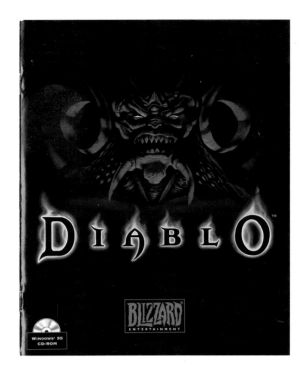

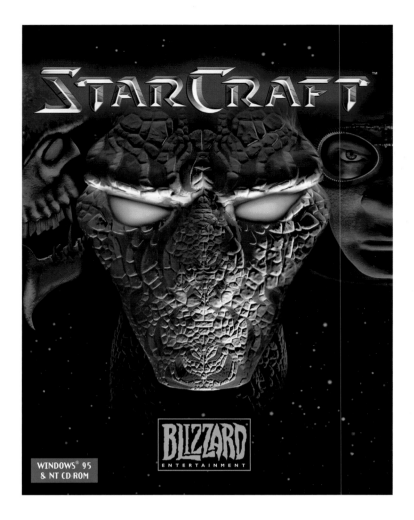

MANUAL LABOR

IF you never purchased a video game in the nineties, you might be wondering, "What the heck is a game manual?"

Back in the day, video games used to ship with manuals that contained technical information such as instructions on how to install the game. "This was before the internet," notes senior art director Samwise Didier. "You couldn't just go online and find cheat codes. This was back when magazines were the big thing, and they'd do a review or release cheat codes in print. We used to release strategy guides on how to conquer the missions. Now, that's a quaint little idea."

Blizzard saw the manuals not just as an opportunity to provide necessary data but also as a showcase for the lore and art behind the games. "I always describe manuals as our first art books because they were loaded with pictures," says Samwise. "They were all black-and-white, but we pushed the limits with what we could do."

This was a time when the company was still fairly small, and every employee performed multiple tasks.

"Ideas came from everybody," Samwise recalls. "We had game designers, but they were starting out in the industry just like we were starting out on the art. We had artists contributing to the design of the game. People had their specialties, but everyone worked on everything, and more importantly, people weren't excluded from working on other things. A lot of ideas came from when we were playing trading card games or console fighter games at lunch or driving to get food. We were always hanging out, always talking about games."

For the first manuals, as with the early games themselves, there was relatively little art direction. Often, the artists just used sketches that they had already created, whatever was sitting on their desks.

"Half the time, the art was just drawn, not illustrated," principal artist Justin Thavirat remembers. "They weren't made as a piece of marketing material—it was just creative stuff coming out. We were just making images that spawned and sparked ideas, took the ones we loved the most, and put them in."

There was also some confusion as to what the limitations were.

"I did some for the *Warcraft II* manual," says art director Trevor Jacobs, "and I remember sitting down, thinking, 'It has to be only black-and-white,' like ballpoint pen or ink brush, no pencils. 'I'll do my best.' And then freaking Thavirat blew my mind. I thought, 'Wait a second, we can do gray?' All our drawings are etched in, and Thavirat has this beautiful, full-on watercolor ogre!"

The unpolished state of the manual art is something former senior vice president, story and franchise development Chris Metzen reflects on philosophically. "I've thought a lot about my drawing style back then," Metzen says. "If I put pencil to paper today, my style is still essentially what it was in the nineties. I didn't progress like Sammy and these others who became digital monsters. But I think my style back then, because it wasn't crisp, because it was raw and done by a kid who didn't know what he was doing, there was something gloriously accessible about that. It's like looking at pictures that you or one of your buddies could have done."

Metzen also compares the rough art style to the relatively preliminary nature of the games themselves: "The art made you feel like you were part of a world that was just beginning, that was beginning to grow."

RIGHT: StarCraft Team
LEFT: Hamagami/Carroll, *Diablo* Team

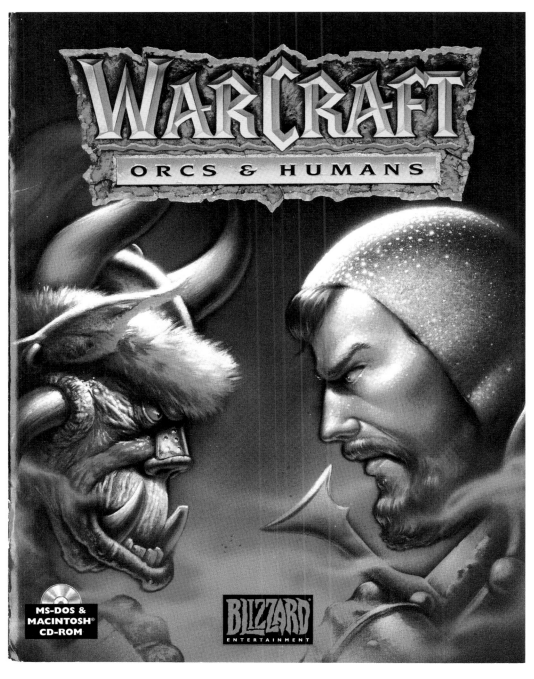

TOP LEFT: Justin Carroll
TOP RIGHT: Samwise Didier
TOP UPPER MIDDLE: Brian Sousa
TOP LOWER MIDDLE: Nick Carpenter

BOTTOM LEFT & CENTER:
Roman Kenney
BOTTOM RIGHT: Justin Thavirat

9

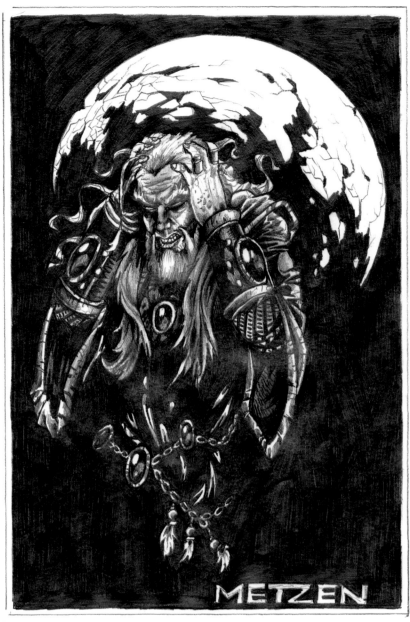

MADNESS AND COFFEE MUGS

MANY of the old manual drawings have since become fondly remembered classics, including a piece done by Chris Metzen for the *Diablo* manual, titled *The Madness of King Leoric*.

Because the character in the game—the Skeleton King—was essentially just a skeleton with a broadsword, Metzen wanted to build out some history.

"Pardon the pun, but there wasn't a lot of *meat on the bone* relative to his backstory," Metzen laughs. "So I tried to conjure this sense of family tragedy: the eldest son is lost, the youngest son has been dragged down into the mines, and this once-noble guy is just losing his marbles. I wanted there to be a relatable core to the fiction, to create a big, classical, mythical backdrop behind what was a relatively simple gameplay experience in terms of lore."

Whereas artists today use a tablet and digital software to render their pieces, Metzen accomplished his image with a pencil and a coffee mug: "I would go through five pencils' worth of graphite to blacken the page. These days you just autofill it. Back then I had to literally draw the whole image black to give it that macabre, gothic feel."

Metzen also included a graphic element that he had begun using on early *Warcraft* pencil sketches: "I couldn't draw backgrounds very well, so I would pick up the coffee cup on my desk, plant it on the drawing, and draw a circle, almost this negative sun space, and that wound up being a motif, all the way through many of my *Warcraft II* drawings. There's always this funky circle. It's not the sun—it's just shorthand so I didn't

have to draw a background and to have some visual, stylistic thread through the art."

For the King Leoric piece, Metzen used the circle element again, but with a twist.

"I drew my circle and then filled it all around, just so there was this graphical, visual kick to the image of this guy in internal agony, but then I began to shatter that shape, as if the sun shape behind him is his soul, his sanity, or the core of him, beginning to disintegrate as he's consumed by his internal demons. It had a dramatic effect, which surprised me. I was not remotely that clever—it was just a risk I took on the image that paid off."

THE PLOT THICKENS

BLIZZARD game manuals were often used to explore the stories of the games in greater richness, depth, and detail than was possible in the games themselves.

"I wanted the story to live beyond what you actually played," Metzen says. "I wanted it to resonate and potentially be able to launch—dare to dream—books and things like that one day. To me, the manuals were this golden opportunity to do some worldbuilding."

In the process of creating content, Metzen called on his love of tabletop role-playing games. "Growing up as an RPG [role-playing game] kid and falling into those old source books with their illustrations and lore and monsters, I lived in those books. My gut was, you offer me twelve pages to fill, I want it to feel as RPG as possible. I want you to come away feeling there's this rich idea that can keep feeding you, even after you turn the game off."

Metzen carried this mindset over to his art: "I had all these ideas that I wanted to convey, complex story worlds, and I wasn't much of a writer, but I could draw, and I could set a scene. I loved how the right drawing could communicate a theme or a complex idea or a moment in time. You could see the world. With the right drawing, you were just right there."

The RPG influence was shared by many early Blizzard artists, including Samwise. "We were really just drawing extensions of our RPG groups," Samwise says. "Metzen had his style, I had my own style, and we all would create what we thought was representative of these characters or these monsters, but as we started moving toward *World of Warcraft*, we started moving away from our own styles and really defining what the *Warcraft* style was."

PROOF OF CONCEPT

IN the same way that manuals allowed Metzen to add depth to story, one benefit of manual art was that it allowed artists to get up close and personal and provide visual fidelity to characters that were tiny on-screen.

At the time, game graphics were not the most detailed. The team painted over everything in sprite sheets, which often made things unrecognizable from the artists' vision. Manual art gave the artists an outlet to express what they couldn't in the game.

Manual artwork, however, was not a collection of concept art. Concept art—the process of using 2D illustrations to visualize environments, props, or characters before constructing models in a game environment—is done early in a game's development cycle.

"Manual art was mostly created after the game was worked on," Samwise says. "Back in the day, there wasn't a lot of concepting going on."

Over time, however, concept work at the company increased. What's more, it can be said that the process of translating concepts to later *Warcraft* game art helped establish Blizzard style.

"*Warcraft* was largely a hyperfantasy sort of game," Samwise says. "Every character was big and over-the-top in proportion and color and silhouette. We used lots of color; bigger, thicker proportions; and the weapons were oversize. We kept pushing the art style to be visually appealing because video games are a visual medium. You want to see something that is larger than life."

The trick was to convey those elements in a top-down isometric perspective.

"You draw a picture of a character straight on, he might look cool," explains Samwise. "While from the top view you might say, 'Oh, he seems a little thin.' We would bulk out the proportions in 3D, and that's a lot of where the Blizzard art style came from. Blizzard's known for these big, thick, beefy characters, and a lot of that was to help make them readable from the top-down view of almost all of our games."

As Blizzard style began to take form, art direction became more important. "We really started pushing the art direction from *Warcraft I* to *Warcraft II*," Samwise explains. "We had a better resolution. We started pushing the colors more. We started pushing the chunkiness and the heroic proportions more."

TOP LEFT: Samwise Didier
TOP CENTER, TOP RIGHT, & BOTTOM: Chris Metzen **13**

CHIMERA

By the time of *Warcraft III*, art direction became a necessity, especially in terms of continuity. "We were coming up with completely new races," Samwise says. "And though I'm guilty of drawing three-fingered tauren, we had to say, 'Tauren have two fingers—they don't have three.' We were going from a bunch of crazy kids to, 'Oh, wow, we're actually a real video game company.'"

Art and story evolved hand in hand, with the iconic *Warcraft* orcs becoming a stylistic focal point.

"There was a constant battle," Samwise says, "between my orcs and Metzen's orcs. His orcs were more human-proportioned, more upright, where mine were hunched over, super heavy, with bony protrusions on their knuckles. The Metzen orcs ended up being more of the leader type, lore-wise, like Thrall, where guys like Grommash and Garrosh were more of the bestial type, the Cro-Magnon, heavy brow, sloping forehead, jutting jaw. Using both was one of the best things we did."

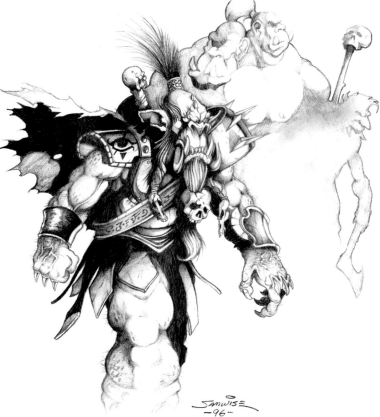

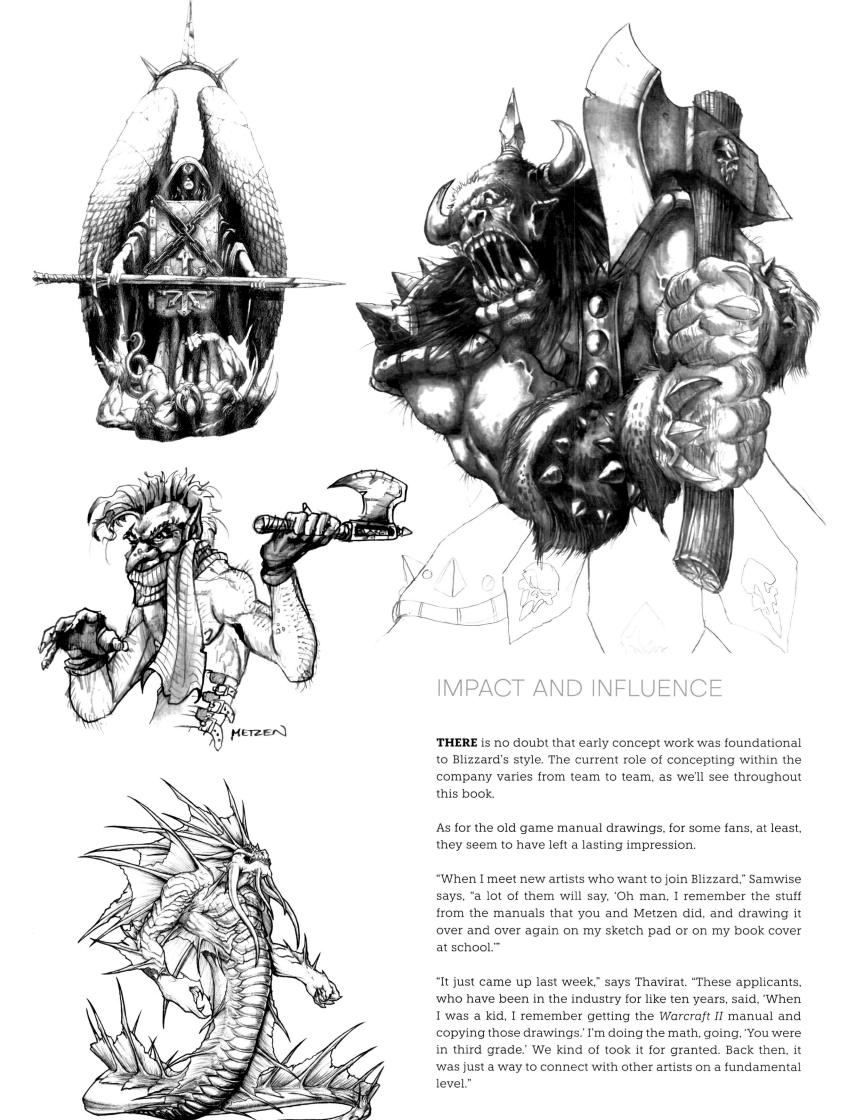

IMPACT AND INFLUENCE

THERE is no doubt that early concept work was foundational to Blizzard's style. The current role of concepting within the company varies from team to team, as we'll see throughout this book.

As for the old game manual drawings, for some fans, at least, they seem to have left a lasting impression.

"When I meet new artists who want to join Blizzard," Samwise says, "a lot of them will say, 'Oh man, I remember the stuff from the manuals that you and Metzen did, and drawing it over and over again on my sketch pad or on my book cover at school.'"

"It just came up last week," says Thavirat. "These applicants, who have been in the industry for like ten years, said, 'When I was a kid, I remember getting the *Warcraft II* manual and copying those drawings.' I'm doing the math, going, 'You were in third grade.' We kind of took it for granted. Back then, it was just a way to connect with other artists on a fundamental level."

TOP LEFT & RIGHT: Samwise Didier
MIDDLE LEFT: Chris Metzen
BOTTOM LEFT: Roman Kenney **15**

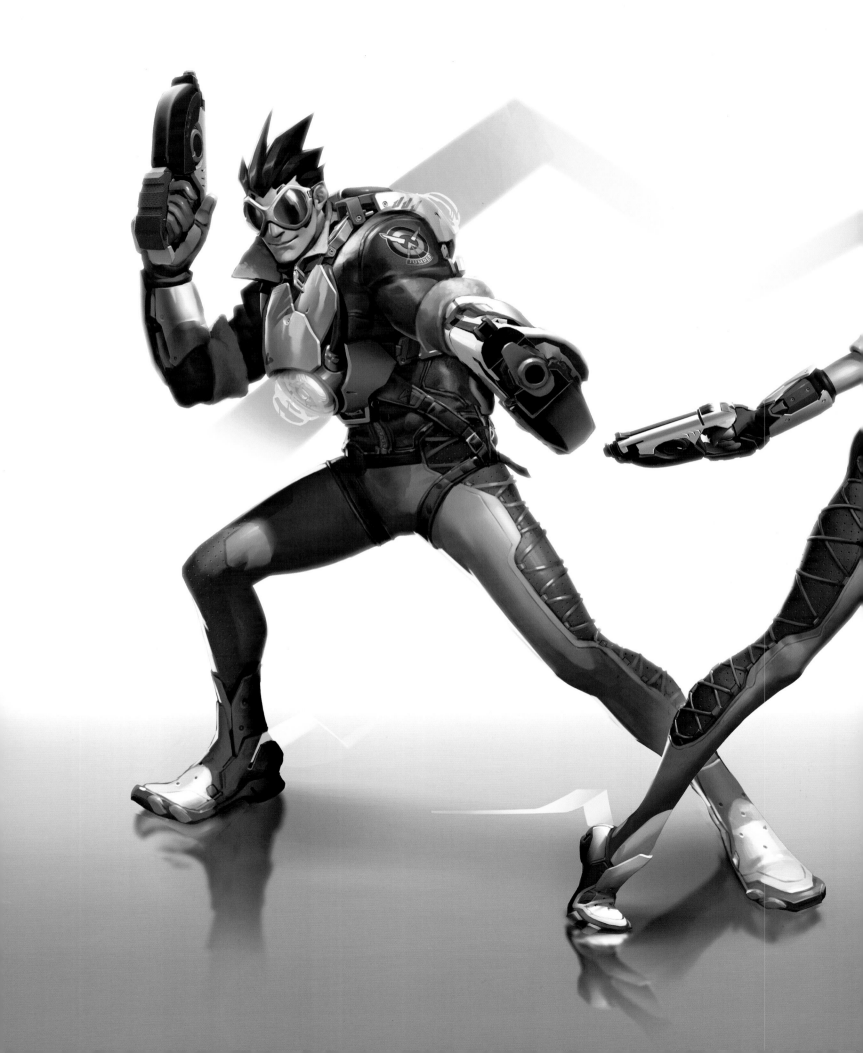

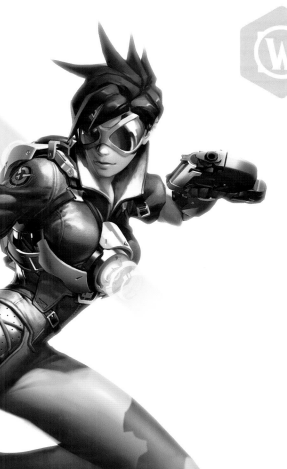

FROM THE ASHES

CANCELED, NOT DEAD

OPPOSITE: Arnold Tsang

The landscape of game development is ever-changing. Projects are undertaken and abandoned for a variety of reasons. While shelving a game is never a simple decision, sometimes the ideas, details, and characters of the game don't end with cancellation. After all, compelling work has a way of sticking with its creators—even when that team's attention has shifted to a new task. And in some fortunate cases, this work can even find a new home in an unexpected place.

In fact, as we're about to discover, some of Blizzard's most beloved and iconic characters made their comebacks from canceled games.

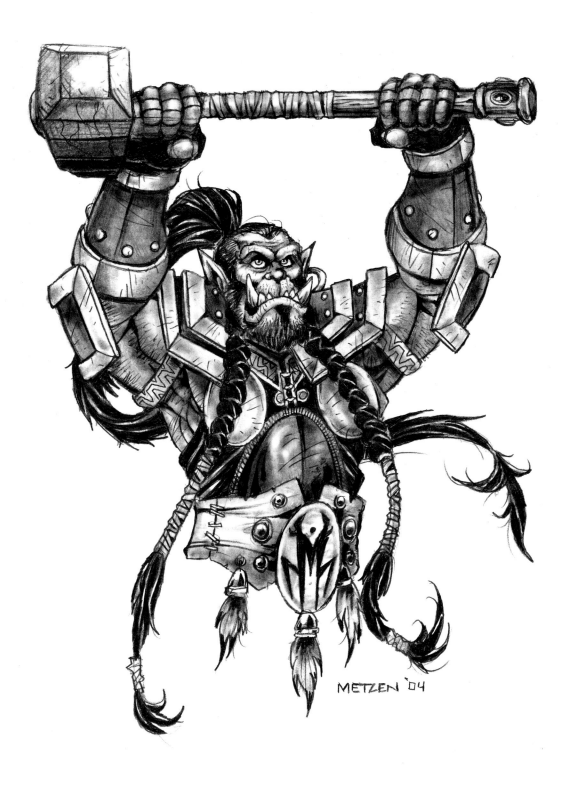

THRALL: THE ADVENTURE CONTINUES

IN 1996, Blizzard planned on throwing its hat into the adventure game ring with the development of *Warcraft Adventures: Lord of the Clans*. A number of factors, including developmental hurdles, led to the game's cancellation in 1998. One inspired character from that title, however, would stand the test of time and go on to become *Warcraft*'s most popular orc.

Thrall was originally brought to life by former senior vice president, story and franchise development Chris Metzen, with an eye toward making the franchise's orc race more accessible to gaming audiences.

"When we started out with the adventure game, I had an instinct that we should turn the tables and make it about an orc character and not a human character," Metzen remembers. "In classic fantasy, orcs are always kind of disposable, mindless killers. I wanted to give them depth, base the game around an orc hero, just thinking that it would be unique in the marketplace and a creative angle to do."

Thrall's early visual development was carefully crafted to build a more relatable orc. Metzen sought to humanize the orc facial features, making this new character stand more upright. Rather than decking out Thrall in the traditional bulky armor, he clad him in a simple vest. "I wanted him to start to break the immediate visual expectation you would have playing an orc character. I wanted our guy to feel as relatable as was possible."

TOP: Chris Metzen
OPPOSITE: Samwise Didier, Hamagami, Chris Metzen

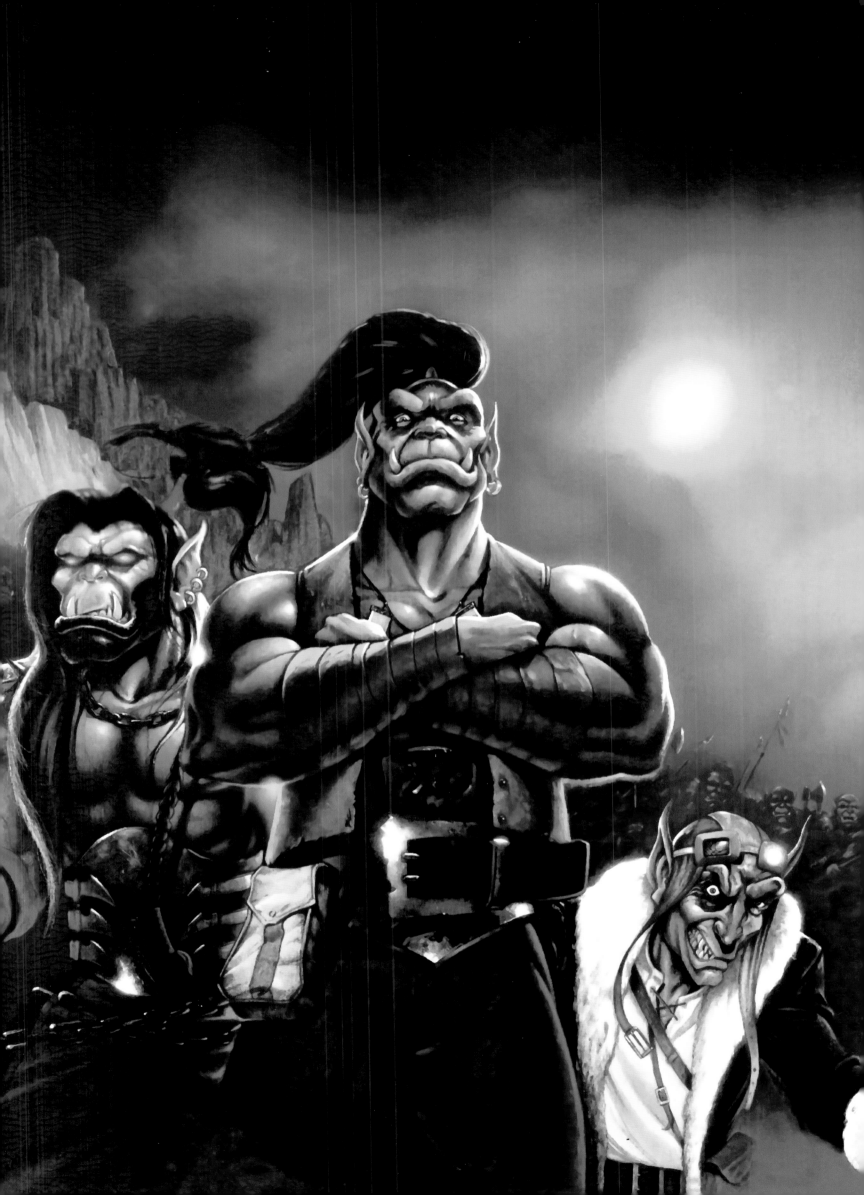

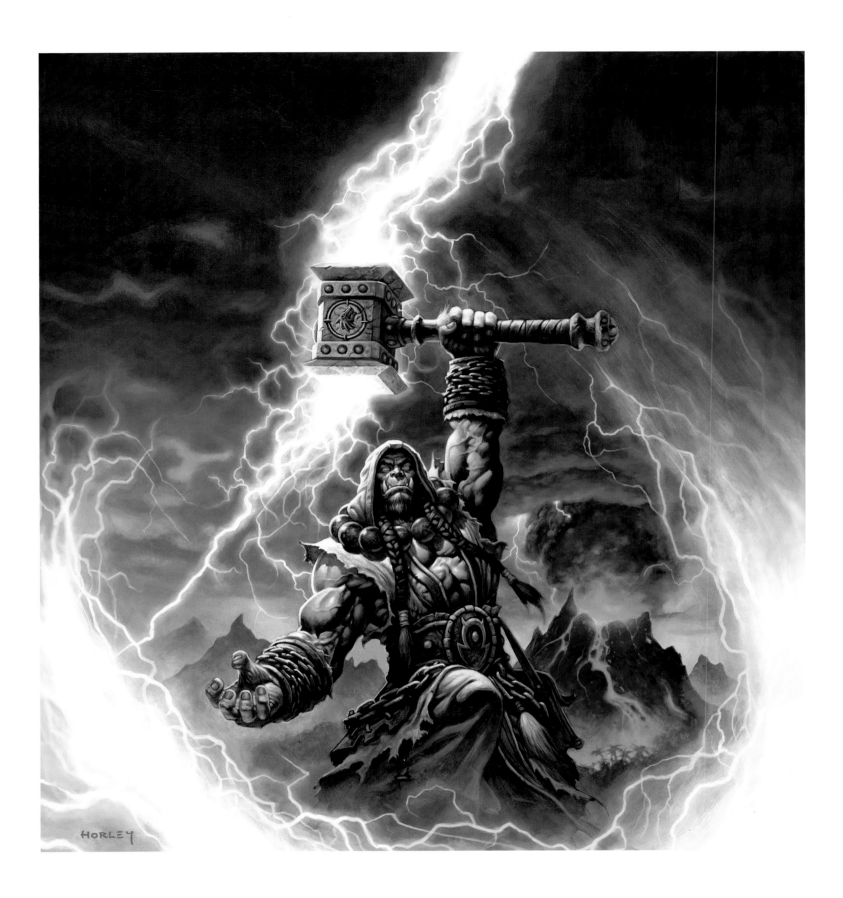

HORLEY

Despite the cancellation of *Warcraft Adventures*, Thrall's entire character kit carried forward in the *Warcraft* franchise, first with the novel *Lord of the Clans* by Christie Golden and then as a main character in the real-time strategy (RTS) game *Warcraft III*. One alteration for Thrall came in overall tone, from slightly cartoonish to the more grounded orc that fans have come to know and love today.

"Adventure games then were inherently zany, and the *Warcraft* adventure game had some quirky humor that I don't think always worked," Metzen notes. "But apart from that element, the core of him, the humanity, the optimism, the 'I will redeem my broken people' theme was very important to me, so all of that ported over into *Warcraft III*. He was a much more serious, dramatic, brooding dude with the world on his shoulders."

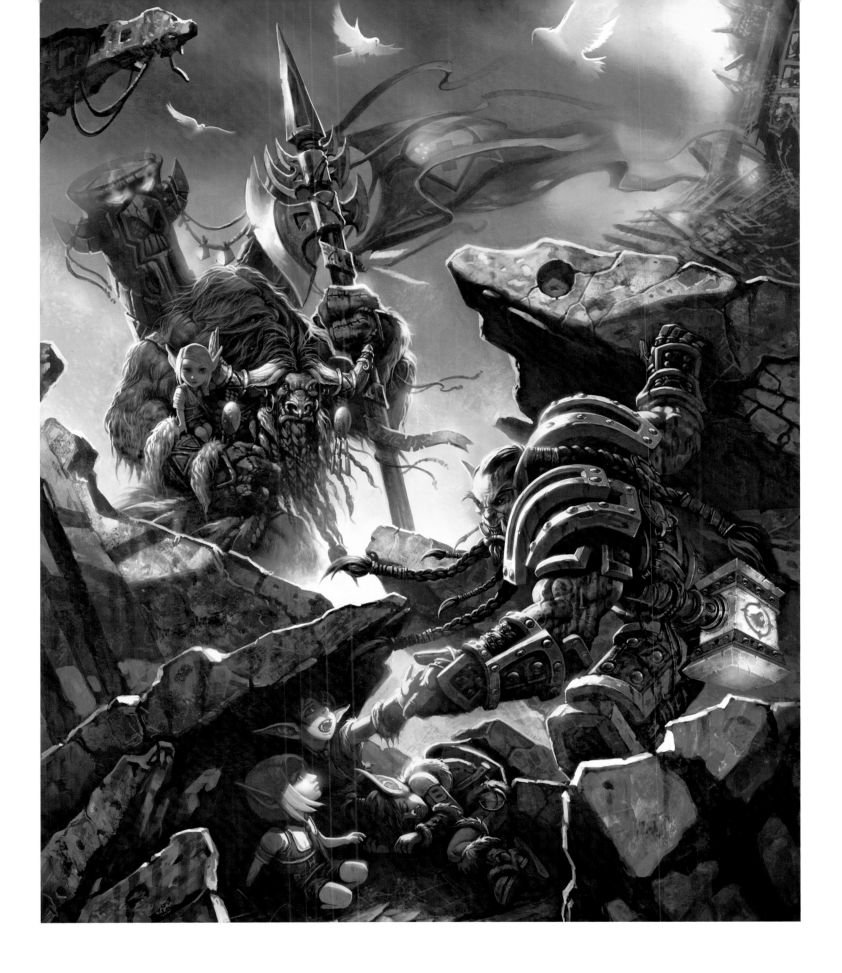

And despite those initial sketches, Thrall carrying the world on his shoulders meant, of course, big, armored shoulder pads. Fortunately, this adjusted character design had also been explored in *Warcraft Adventures*. "This actually happened at the end of the adventure game—in becoming the inheritor for Orgrim Doomhammer, who was the preceding Warchief and a very noble orc, Thrall donned his armor and took up his

hammer. I love that as a way of passing the mantle visually as well as making him look cool."

Once Thrall assumed that mantle of leadership in *Warcraft III*, he began assembling a diverse Horde—outcasts, like himself, with a vast depth of soul—yet another continuation of the character's roots in *Warcraft Adventures*.

"He sees to the heart of things, and that absolutely echoed from the adventure game and his core origins," Metzen reflects. "I love how his life story really is the only way that something like the Horde could have even come together—someone to unite them, who truly sees their common humanity."

Thrall remains an immensely popular and important character to the franchise to this day. So what is it about the orc that continues to resonate? Metzen has a few ideas, particularly in how Thrall's design dovetails with his story.

"We're all mutants and outcasts in our own heads, so I think his inherent loneliness makes him accessible to everybody. In body, he's this intimidating creature, but he's also a very soulful, very sensitive person. It's such an interesting contrast—beauty and the beast."

TOP: Blizzard Animation
BOTTOM: John Polidora

OPPOSITE, TOP: Tooth Wu
OPPOSITE, BOTTOM: Ruan Jia

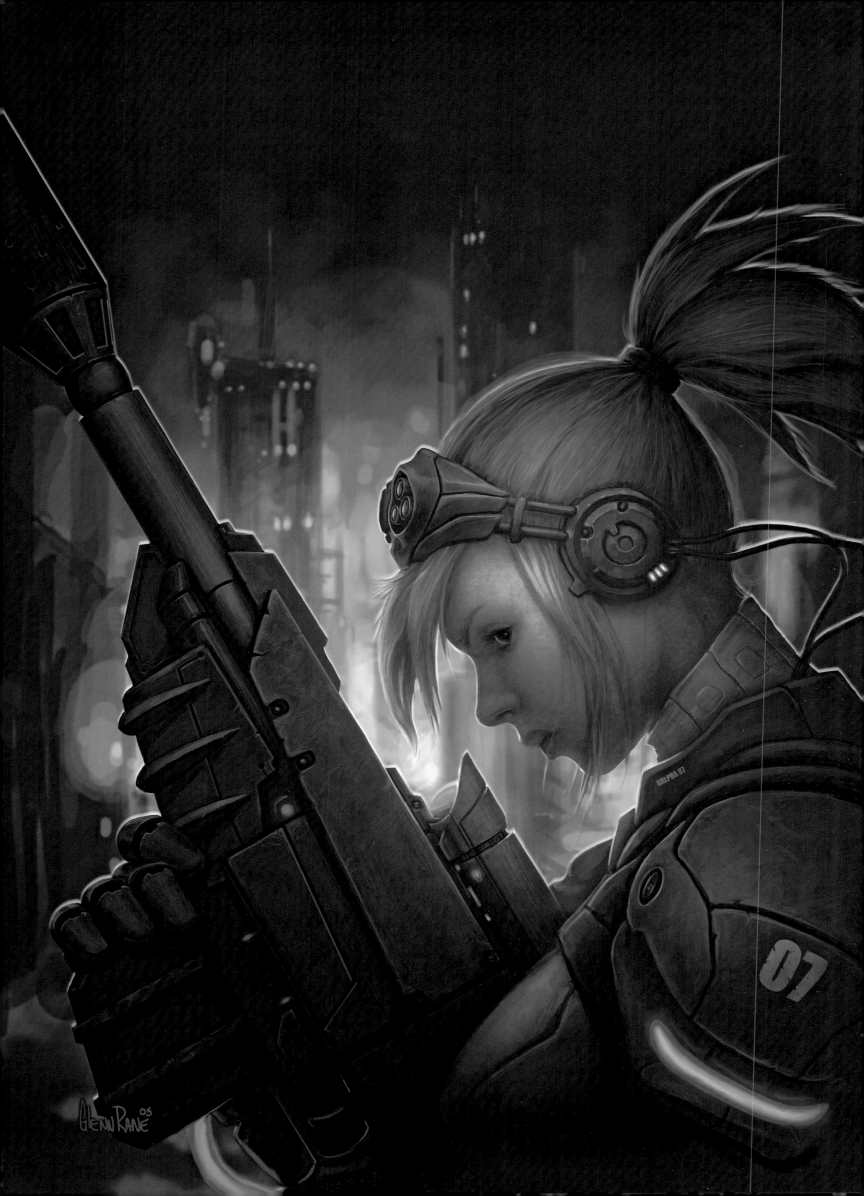

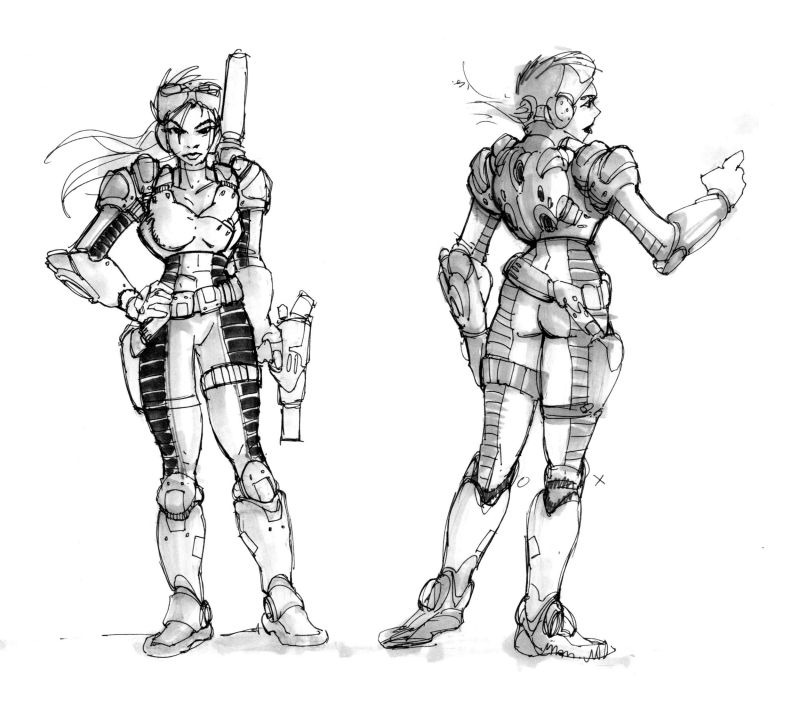

NOVA: GHOST REINCARNATED

WHEN video game developer Nihilistic Software pitched Blizzard a *StarCraft*-based action/stealth game, the idea sparked instant excitement. The demo featured a playable female Ghost, and the game would be intended for new and emerging consoles. It quickly garnered a green light from Blizzard, and in late 2002, development on *StarCraft: Ghost* was announced.

Early on, other playable character types were considered, such as a space marine or the Queen of Blades herself, Sarah Kerrigan—perhaps even a zerg-infested or "zergified" version of her—but ultimately the choice was made to focus on a new Ghost character for the franchise: Nova.

"In *StarCraft*, everyone loves a Ghost," senior art director Samwise Didier notes. "They can cloak, they can drop nukes on people, and they have a badass single-shot heavy sniper rifle."

And while Nova's abilities fit perfectly with the game mechanics, the team also took time fleshing out Nova's character and backstory. "She's a rich girl, sequestered away from the reality that most citizens have to deal with," Metzen explains. "I think that launched us on the whole vector of 'What if there's something about her?' She has psionic powers, but unlike Kerrigan, who was conscripted into the Ghost Academy at a young age, Nova grew up in affluence. What if you take all of that away? What if you dump her in the streets? How does this power actualize for this girl who has never really been challenged before and never had to suffer before?"

As the narrative team came to understand what made Nova tick, the artists and developers were focused on putting players in the same world as her—literally. This was perhaps the most enthralling aspect of *Ghost*: the opportunity to remove players from the zoomed-out isometric perspective of the *StarCraft* RTS

ABOVE: Justin Thavirat
OPPOSITE: Glenn Rane

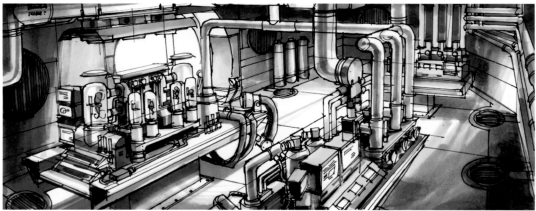

and put them in the heat of the action, in a much closer third-person perspective. The paradigm shift of an all-new platform, a different POV, and an untested (by Blizzard, at the time) game genre brought with it a host of challenges, beginning with visualizing the *StarCraft* aesthetic at a much higher level of detail.

"We had to come up with basically everything," Samwise remembers. "We didn't have a set Ghost outfit. We'd never really made one before to that level of detail, to see 'What does it look like from behind?' I think that's where we came up with that circular design in the back, the moebius reactor that was also a visual clue of how much energy she had."

Nova's weapons arsenal soon became another major focus. In the early story line, she trained under a protoss mentor and carried a psi-blade. The blade was later scrapped, leaving Nova with the iconic *StarCraft* canister rifle as her primary weapon. The team worked on various iterations, including a rifle that could do everything from calldowns to sniping.

With Nova's kit changing, the world around her had to change too. Getting players in at ground level required significant work on props and environments, as lead artist Allen Dilling recalls. "There were unique buildings we needed, sure, but on the other side of that was the 'not new' stuff: inside a command center, inside a barracks. It was super fun, just getting deeper into the old stuff and putting it into perspective."

As *Ghost* forged ahead, codevelopment shifted from Nihilistic to Swingin' Ape Studios in 2004. Production continued to face logistical hurdles, including keeping up with the rapid progression of console technology from one generation to the next. One way in which *StarCraft: Ghost* turned out to be ahead of its time, however, was through its multiplayer mode. Early playtest builds allowed players to choose different classes, including playable hydralisks and zerglings.

Ghost was developed at the dawn of multiplayer shooters, and many of the developers agree that the strongest part of the game was perhaps its multiplayer mode.

Dilling shared the sentiment. "Every Friday we'd play eight on eight, and it was basically 'Battlefield *StarCraft*' with all the different classes. We had a blast."

While continuous setbacks and a shift in company focus led to *StarCraft: Ghost* being put on indefinite hold, Nova lived on, beginning with the novel *StarCraft: Ghost: Nova*, the story line of which had been developed concurrent with the game.

Nova's journey continued to take shape on the page, and in time she appeared on-screen in both playable missions and cinematics in *StarCraft II—Wings of Liberty* as well as *StarCraft II—Heart of the Swarm*. She ultimately headlined her own downloadable mission content pack for *StarCraft II—Nova Covert Ops*.

Throughout the character's journey, Nova has proven one thing above all else: she's a survivor and a Ghost who is likely to haunt the *StarCraft* universe—in the best possible way—for a long time to come.

TOP: Ghost Team
OPPOSITE, TOP: Roman Kenney
OPPOSITE, BOTTOM: Blizzard Animation

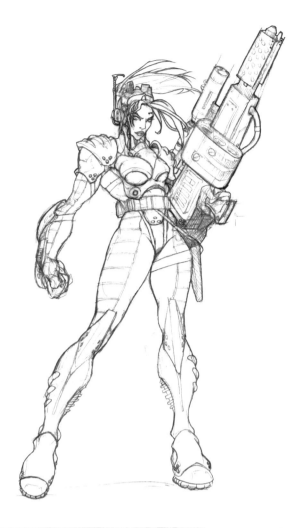
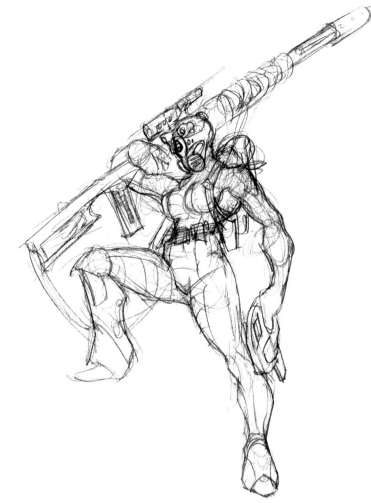

SUITING UP

The **StarCraft: Ghost** game introduced several conundrums about how certain **StarCraft** elements might function in a more realistic world. One thorny question that arose: "How does a marine put on a suit?"

Keep in mind this was well before the "Building a Better Marine" cinematic from **StarCraft II**, which features the character Tychus Findlay being suited up in marine armor. One of the first things artists on **StarCraft: Ghost** realized was that a marine suit "to scale" wouldn't work with real human anatomy without breaking a few bones.

"We had to figure something out," Dilling laughs. "We suggested they hop in from the top down and seal up. Then we asked, 'How do they eat? Do they eat in their suits?' We concepted a lot of those things."

TOP: Jonathan Ryder
BOTTOM LEFT: Justin Thavirat
BOTTOM RIGHT: Joe Madureira
OPPOSITE: Wei Wang

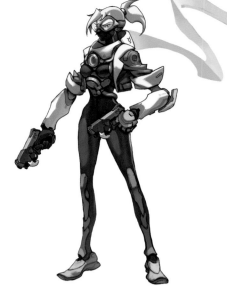

RECALLING TRACER

Titan was a hugely ambitious, MMO-style (massively multiplayer online game) project whose saga is chronicled throughout various chapters of this book. While the title was ultimately shelved, its development spawned some of *Overwatch*'s most memorable characters, including the game's bubbly, fun-loving, and fast-as-lightning icon, Tracer.

The *Titan* MMO featured various classes that were meant for player-versus-player battles. Many of the ideas seeded in *Titan* development stuck with the *Overwatch* team and carried over, as described by *Overwatch* character art director Arnold Tsang: "One of our principal designers had made different abilities and weapons for each of the classes, and the thought was, we can take all those different weapons and abilities that we designed and make a hero out of each one of them. We had made a character class called the ranger, and the ranger had a sniper rifle, an assault rifle, and a rifle that could transform into a turret, so that class became three heroes: Widowmaker the sniper; Soldier: 76 with the assault rifle; and Bastion, who can transform into a turret. So a lot of it was reimagining things that we liked about *Titan*."

Before these other classes were translated to *Overwatch*, however, there was one class in particular that the team was keen to explore: the jumper. Like the ranger, the jumper was a playable class, meaning there were multiple jumpers—men and women who used their tech to travel back in time and help save the world.

"We had some cool sketches of different jumpers," Tsang notes. "There were some that were really influenced by retro pilot jackets and goggles and stuff, so there was a heavy aviator theme to them."

But beyond the visually unique elements of the design, many aspects of the jumper class were a lot of fun to draw. "The speed trail . . . I love playing with dynamic poses and having that trail," Tsang says. "That's why the jumper was one of the first characters that we thought of bringing in. There was so much untapped potential there—the idea that she could blink and hit these crazy poses."

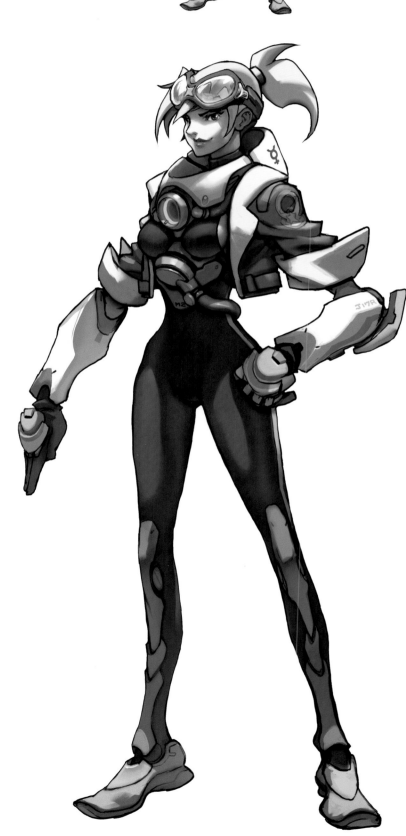

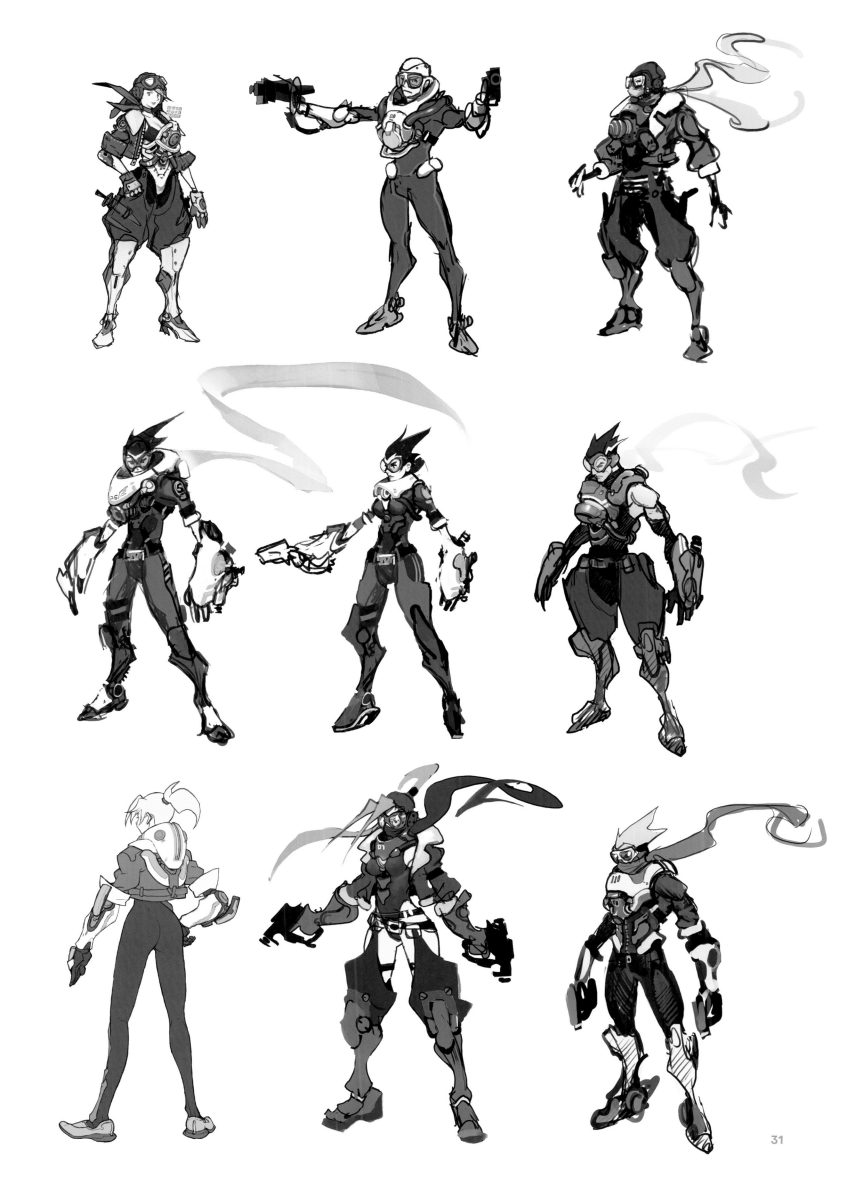

As the team explored Tracer, they also homed in on the unique aesthetic that *Overwatch* would come to be known for—a mix of style and realism. Lead animator Ryan Denniston reflects, "The characters on *Titan* felt a bit like toys. The designs were cool, but they didn't have that weathered feeling that made them grounded. That was one thing we identified we were

going to change with *Overwatch*, and the first example was Tracer. We had this jacket, and you could see all the cool stitching and weathering on the leather."

For a team that had been through a tough development process on *Titan*, iterating on and eventually landing the precise look and feel of Tracer was a much-needed win.

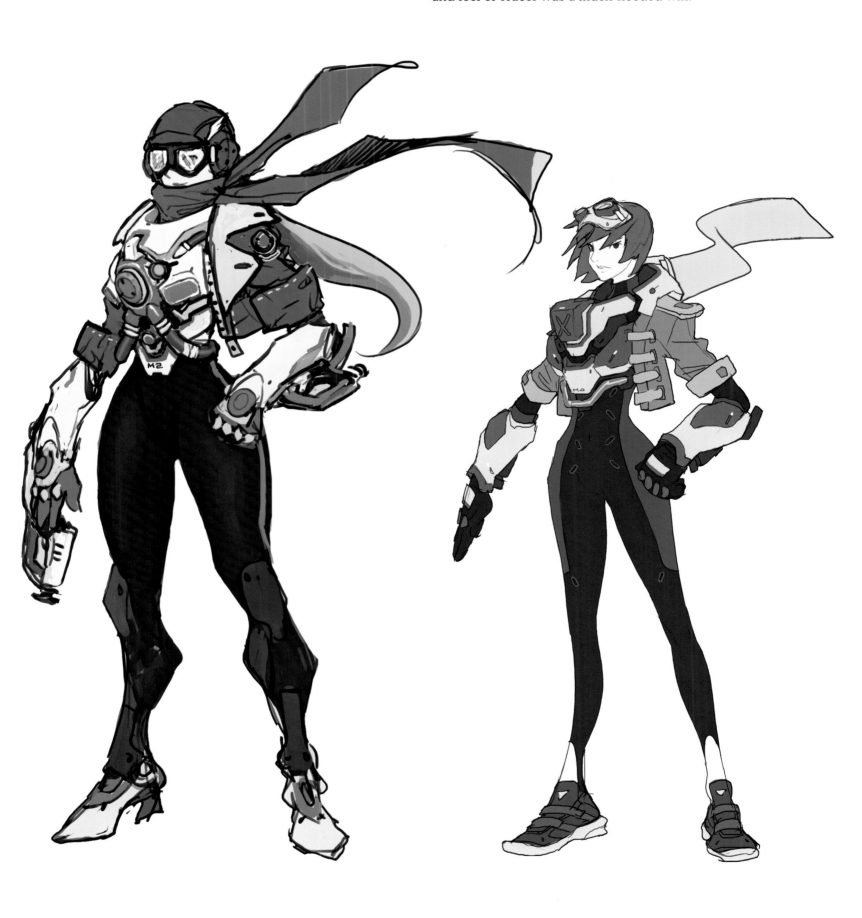

"It was this amazing period after coming off *Titan*, where we had been all over the place: there were so many things that went wrong," Denniston recalls. "And then to find it, to take the best parts of *Titan* and bring them over and apply them to Tracer and the other characters at the very beginning—it was magical."

For fans worldwide, Tracer is the face of *Overwatch*. But was that intentional? Unlike Thrall in *Warcraft*, who was the basis of several important story lines, Tracer's emergence as a marquee character was not necessarily planned.

"The question came up of who's the main character in *Overwatch*?" Arn explains. "And at first I said, 'There is no main character,' but I started to think about it differently. Tracer happened to be the first hero we made, concepted, modeled, and put into the game. But the reason why we chose her to be the first is because she is so cool. She embodies so much about the game—not only in design and aesthetic and color but also in her positive outlook and heroism. It all fit into place."

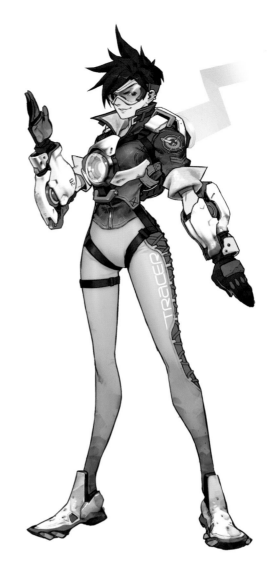

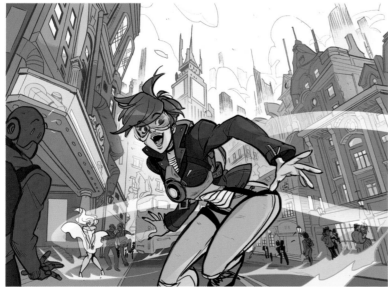

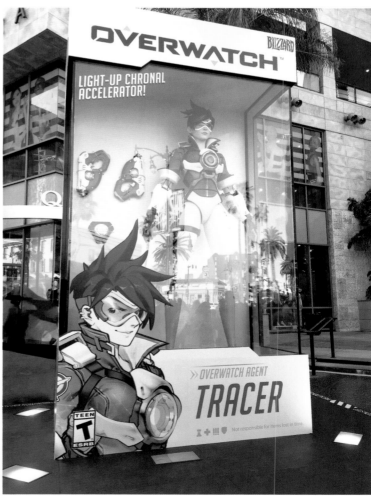

TOP: Arnold Tsang
BOTTOM LEFT: Blizzard Animation
MIDDLE LEFT: Babs Tarr, Rachael Cohen
BOTTOM RIGHT: sculpt by Onyx Forge Studios, photo credit Dion Rogers

OPPOSITE: model by Renaud Galand, render and paintover by Arnold Tsang, background by Stephan Belin

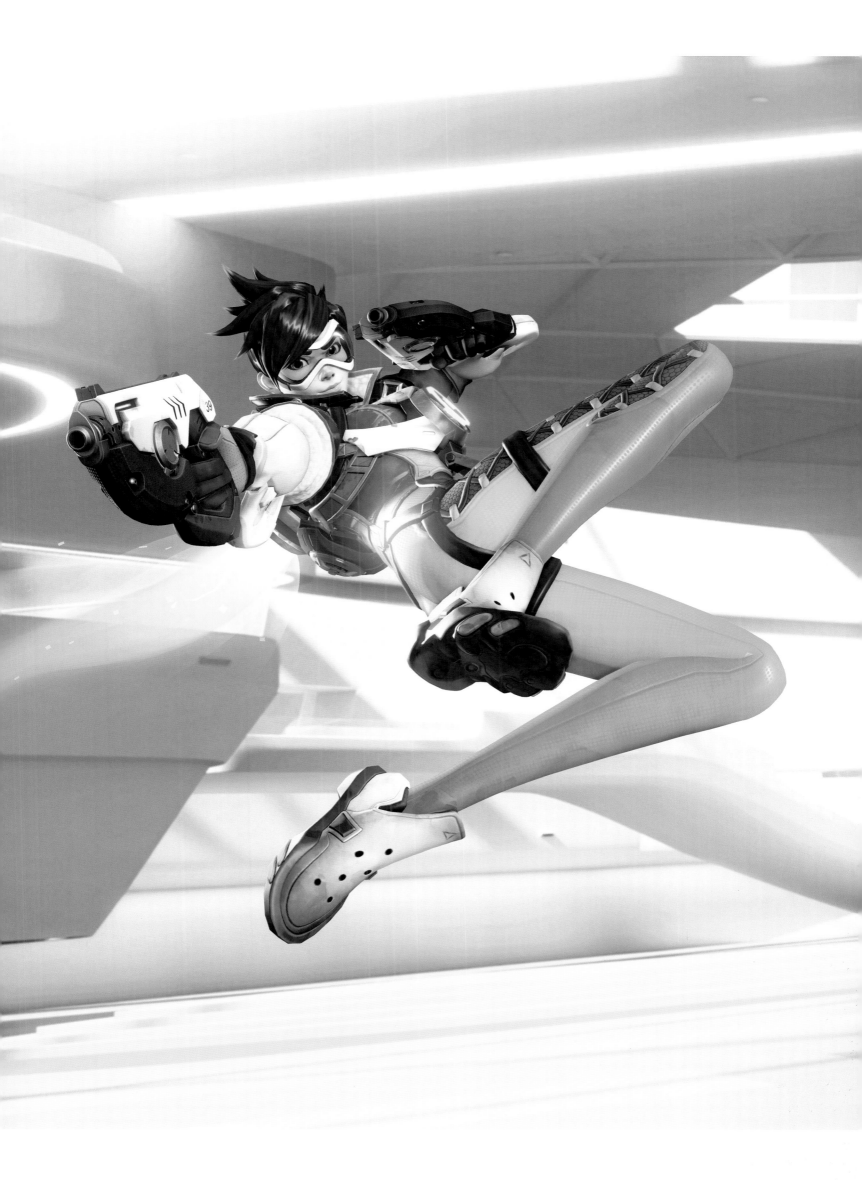

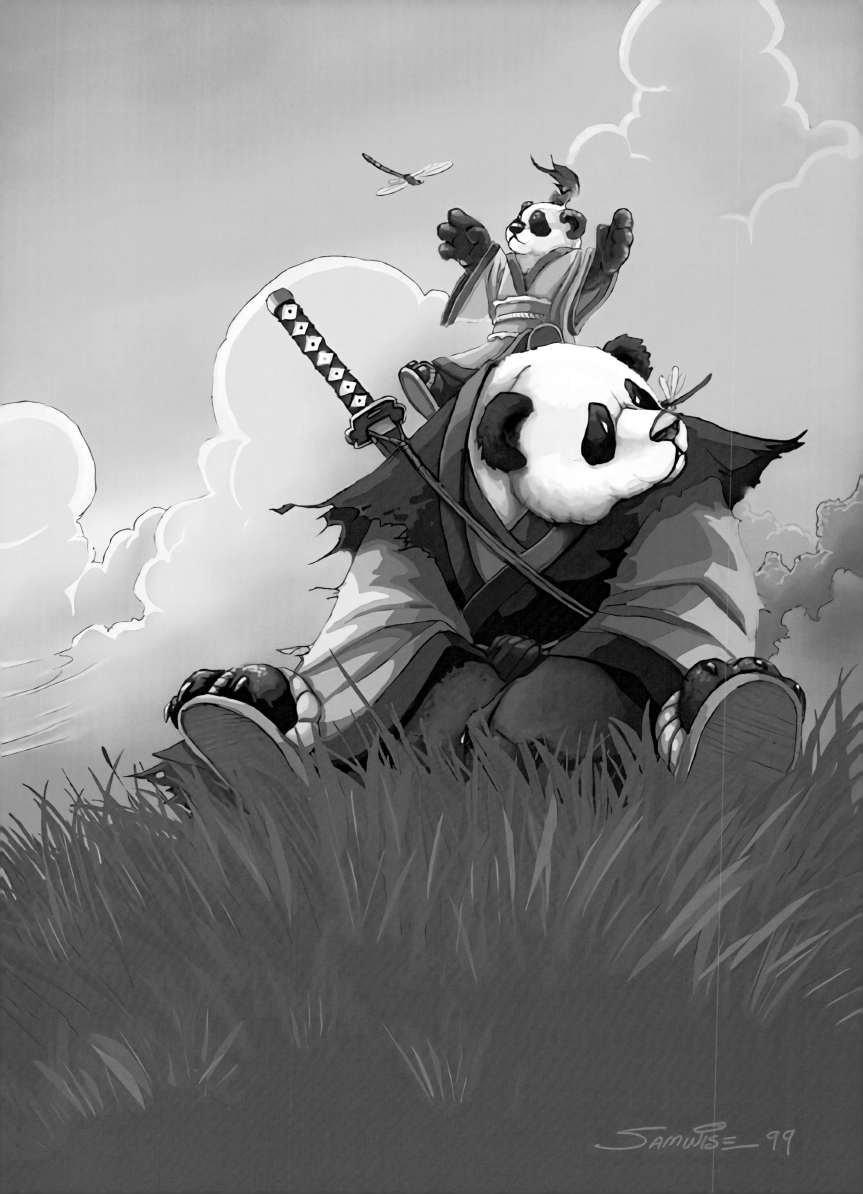

CHAPTER **THREE**

PUTTING YOUR
HEART IN IT

It's no secret that Blizzard artists are passionate about their craft, both inside and outside the studio. At times, the art and ideas that take root in game development can have deeply personal connections to their individual creators. In this chapter, we'll explore how two massive concepts within the *Warcraft* and *Overwatch* universes evolved from passion projects, from a bold and beautiful new *Warcraft* empire to a solitary *Overwatch* soldier on a path to redemption.

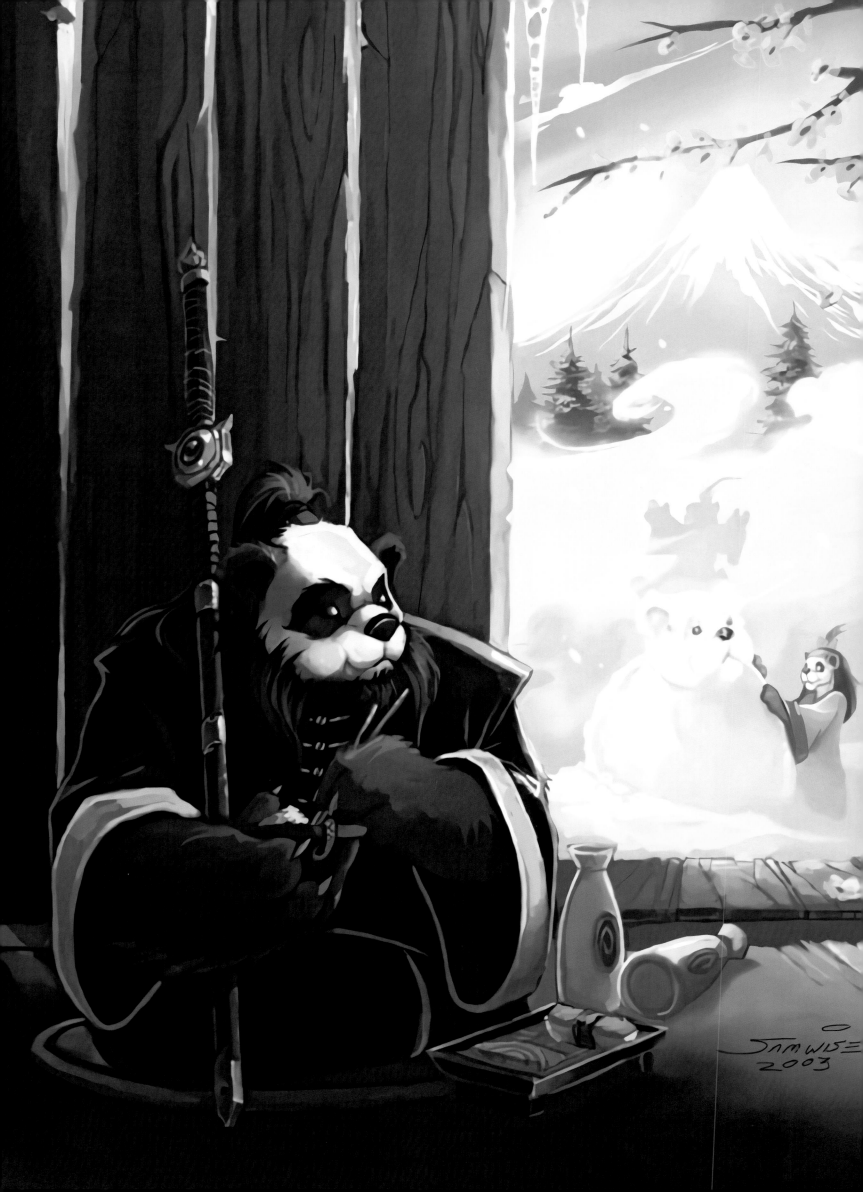

THE PANDA KING

IN late 2012, *World of Warcraft: Mists of Pandaria* introduced an expansion that was a little different. Gone were the cosmos-ending enemies and doomsday revelations. This expansion aimed to realize the endless possibilities of fantasy and worldbuilding, and it all started with a panda.

"The year my kid was born, I drew a Christmas picture," senior art director Samwise Didier recalls. "I've always been into samurai and kung fu movies, so I made this picture of a panda in a kimono sitting on a wavy grassy hill. On his shoulders was a little baby panda trying to catch a dragonfly. And that was just done for fun. I printed it up and gave copies out to my family and friends."

The gifting of the picture set off a chain reaction. In 2002, Blizzard released an April Fools' Day joke around the "Mighty Pandaren Empire," a new race being added to *Warcraft III*. Samwise crafted a few more illustrations, while former senior vice president, story and franchise development Chris Metzen came up with some lore and names to accompany them. While some fans laughed along at the joke, others seemed to embrace the idea.

In response to the excitement, a nonplayable, bearlike creature in *Warcraft III*, called a furbolg, was retextured with a panda skin and dubbed the Panda King, an Easter-egg character that could only be found in a hidden area. In *Warcraft III: The Frozen Throne*, a unique, neutral, playable pandaren character was created—Chen Stormstout. Later in *World of Warcraft*, Chen was honored with the introduction of a quest to find "Chen's Empty Keg."

Samwise was pleasantly surprised by all the attention given to pandaren in the lead-up to *Mists of Pandaria*. "They were always sort of in our world but never really big in our games until *Mists of Pandaria* came out, so it took a while, but they ended up getting a full feature in *Warcraft*, and in my opinion that expansion is still the most beautiful. I've said it dozens of times, but props to the *WoW* team for taking basically three or four concepts for the pandaren and just building an entire world around them. As someone who came up with the original pieces of art, it was impressive to see what they did."

PEARL OF PANDARIA: A HAPPY ACCIDENT

Years before the **Mists of Pandaria** expansion was revealed, work had begun on a graphic novel entitled **Pearl of Pandaria**. The book featured a massive turtle named Shen-zin Su, the mist-enshrouded, island-like being who serves as the floating home of the Pandaren. Shen-zin Su was based on a piece of concept art dreamed up by Samwise. Developed in-house at Blizzard, the book was meant to be a stand-alone story, a way to explore the Pandaren race at a time when it was believed that they would **not** be heavily featured in upcoming game content. The story line was ultimately adapted to align with **Mists of Pandaria** when the expansion was greenlit.

TOP LEFT & OPPOSITE, TOP: Samwise Didier
BOTTOM: Sean "Cheeks" Galloway

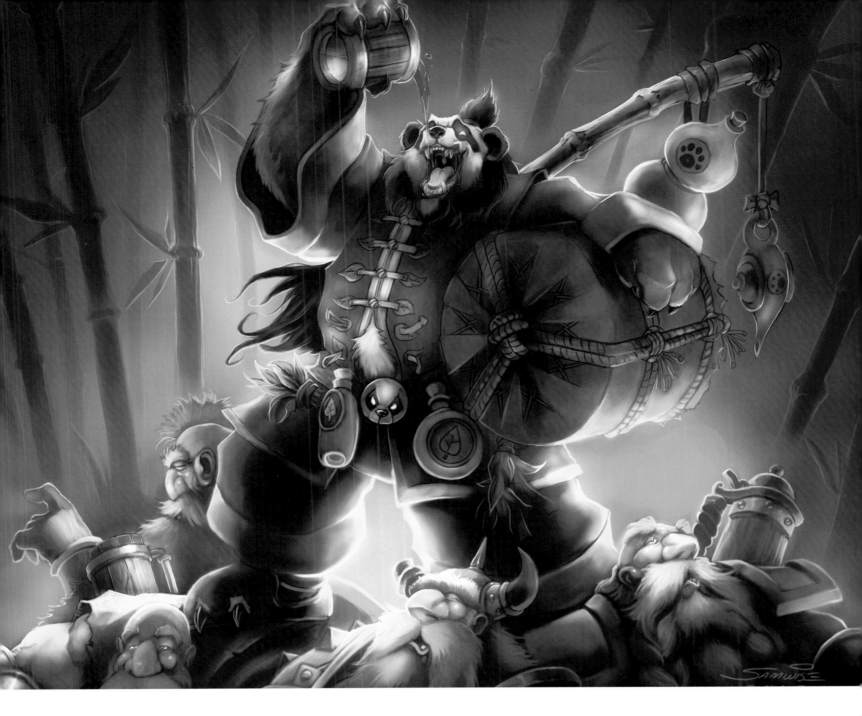
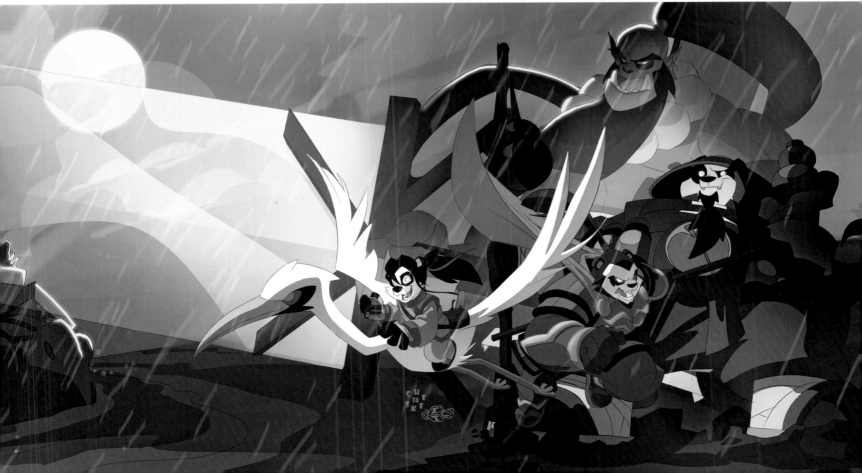

PIERCING THE MISTS

THE pandaren, it turns out, were a constant consideration for the *WoW* team, even before they had plans for a pandaren-based expansion.

"We had Sammy's picture up in the team area," senior art director Chris Robinson elaborates. "I think everyone just kind of gravitated toward it. We were always thinking, 'Should we fit it in somewhere, like a little panda village that you just kind of happen upon?' All the way to 'Could we actually do something where it's a full expansion?'"

While the choice of whether or not to tackle a pandaren expansion wasn't exactly black-and-white—pun intended—it was about darkness and light.

"When we decided to do *Mists of Pandaria*, we had actually thought about doing a demon-based expansion. But we were just coming out of *Cataclysm*, which was very destruction/death-oriented. No one was inspired to jump back into something that could potentially be even darker," Robinson explains. "We had gone quite a ways down the road of writing up the story line, but I think the art team in general just felt really bad about the direction. So everyone said, 'All right, what if we did the polar opposite?'"

Using the pandaren as a gateway to reinvigorate *WoW*'s themes of fantasy, mythology, and exploration stood out as the clear choice. Fans appreciated the more lighthearted, inspirational tone to the expansion, a nice palate cleanser from Azeroth's dark days past. But building an entirely new zone and race around the pandaren theme came with its own unique considerations. The team had limited source material, and the task of building it out visually fell to artists like lead visual development artist Jimmy Lo. "We looked at Sammy's stuff in the very beginning—what are the pandaren about, what's been done with them, their designs, shape language, personality—and we used that as a springboard for new ideas. There wasn't a whole lot compared to an older race like the night elves, so it gave us a lot of creative freedom to explore things like language, scrolls, wall-mural designs, various symbolisms, and motifs."

While the finished expansion was critically acclaimed, it remained somewhat polarizing for fans. Some, no doubt, would have preferred the darker-themed expansion, but there were plenty who embraced the pandaren as a breath of fresh air. Robinson reflects, "The minute the pandaren came out, my mom made a pandaren female, red fox version. She fell in love with it. It was the only game she'd played in her entire life, and she's a high-end raider now who plays almost every day. That pandaren is still her main."

TOP LEFT: Chris Robinson
TOP RIGHT: Wei Wang
OPPOSITE, TOP: John Polidora

OPPOSITE, MIDDLE: Laurel Austin
OPPOSITE, BOTTOM: Glenn Rane

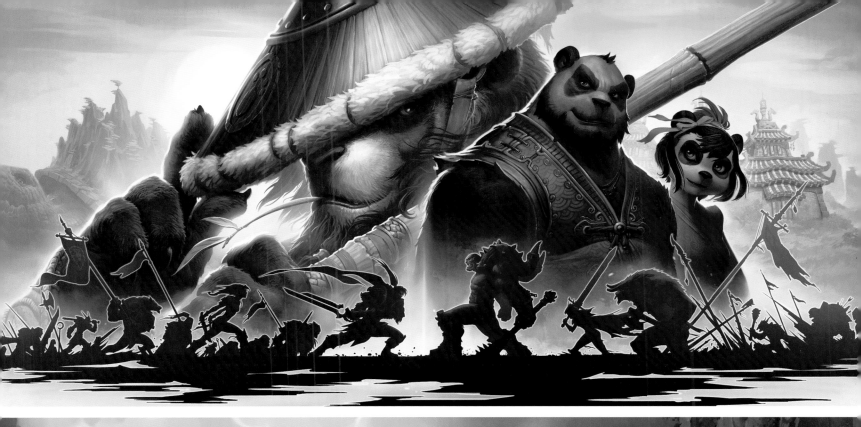

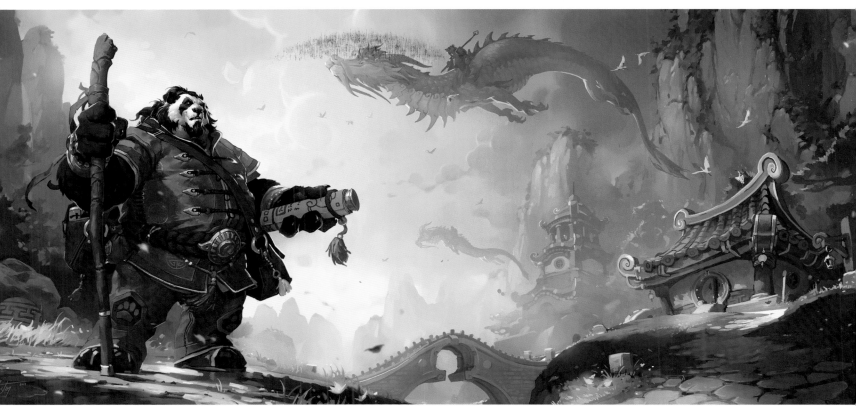

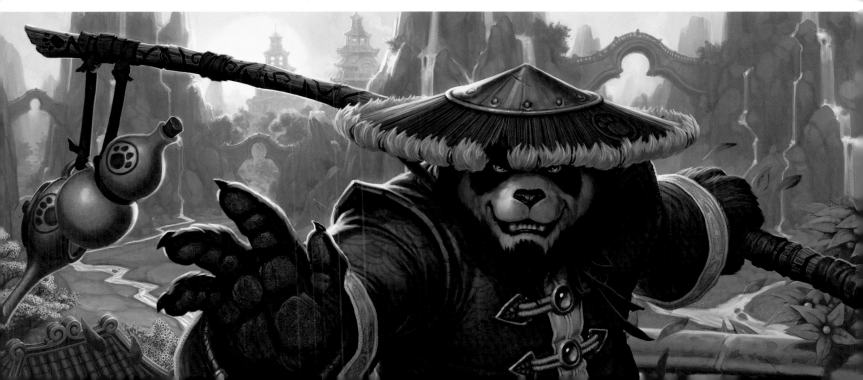

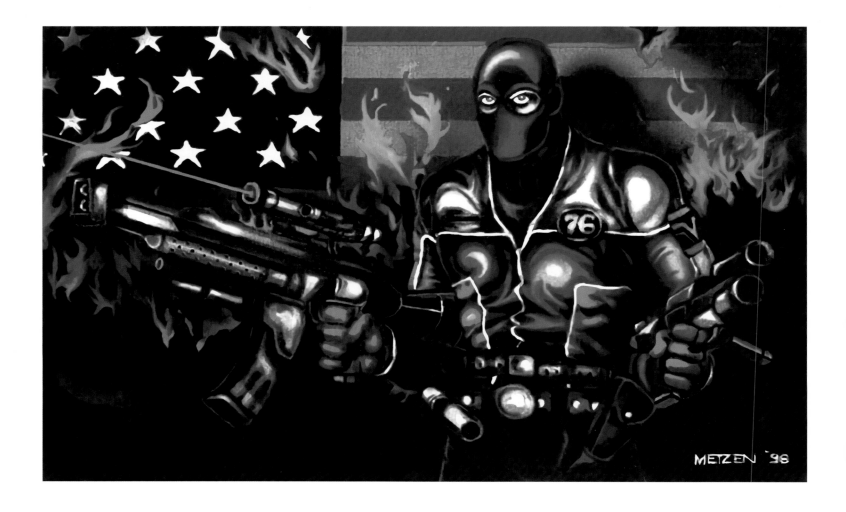

76: AN OLD SOLDIER GETS A NEW LEASE ON LIFE

AS we learned in the previous segment, sometimes characters that end up in Blizzard games are closely tied to the hearts, minds, and experiences of individual developers. Soldier: 76, one of *Overwatch*'s main player characters, is a prime example.

Similar to Samwise's pandaren, Soldier: 76 was a deeply personal creation of Metzen's. He initially intended to pursue the character as a side project. "Soldier: 76 was a fusion of characters that were beloved to me as a kid," Metzen recalls. "Grim, driven, lonely. He's an archetype. I chose the name Soldier: 76 to evoke the ghost of patriotism (1776), but I loved the idea that he was very much a soldier without a country and his war was ambiguous."

Metzen had already filled in much of the character's backstory by the time *Overwatch* kicked off. "At some point in the nineties I started to work on a real story, and the predicating fiction was that there was a second American Civil War, a socioeconomic collapse. There's this lonely guy, drifting from town to town and seeing the plights of people. Things are rough, and the more he travels through this broken America, the more he relearns what it meant to him back in the day when he was a soldier, what it meant to fight for something greater than himself. And he ultimately chooses a side and becomes a champion of the people again."

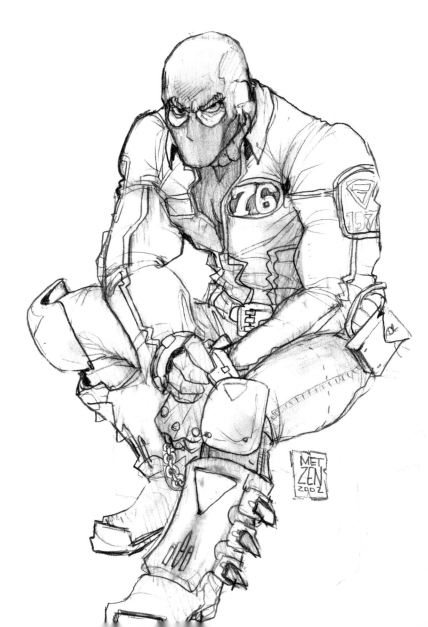

ALL IMAGES: Chris Metzen

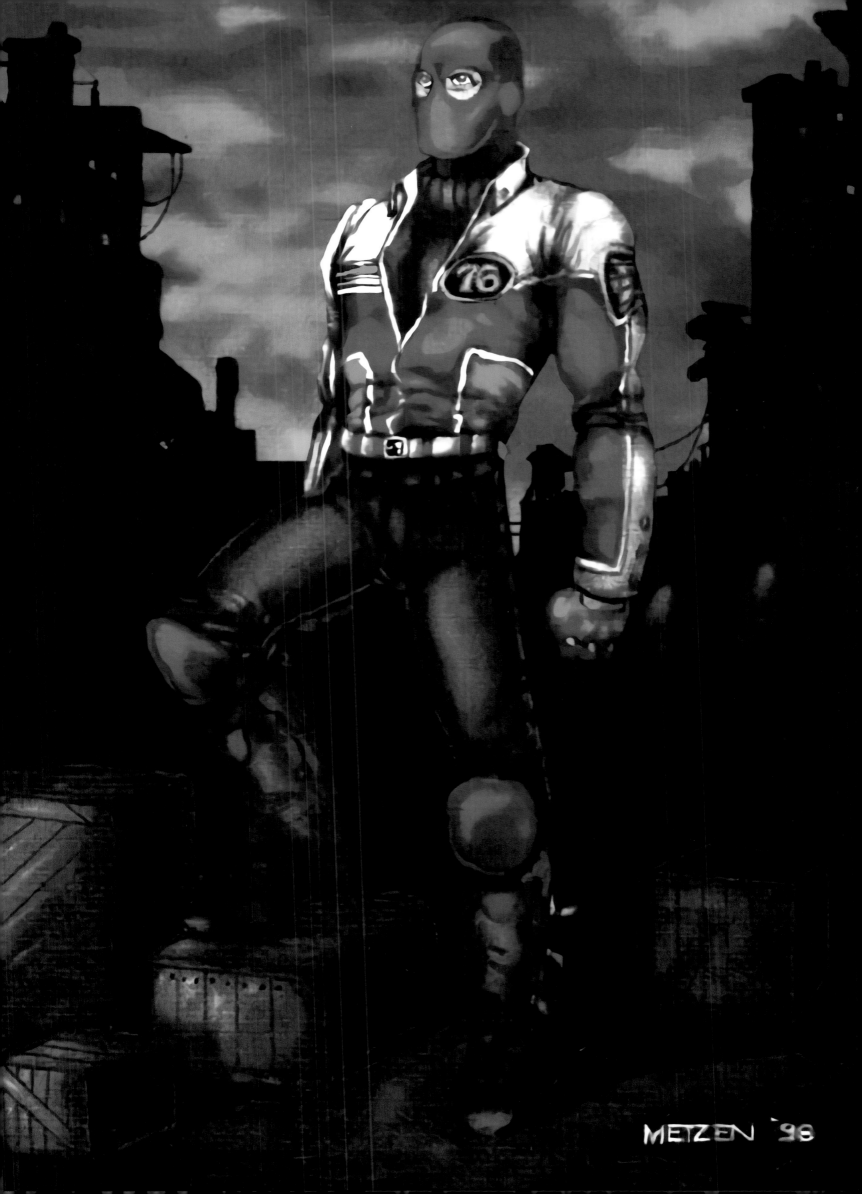

STARS ALIGN

AS *Overwatch* evolved, Metzen began to see obvious parallels between the game's story and the character he was developing. Overwatch itself was an organization built on the highest ideals, and it once defended the people—before falling. But when Overwatch is needed again, its agents come together—a little banged up but wiser—to find redemption. "I had really started thinking, 'His story feels like an echo of this meta story,'" Metzen says. "It's like this one guy embodies all of it, so beaten up by the failures and tragedies of his past. All he longs for is a mission again, to be a soldier, to be in service of something greater. It felt like a perfect match."

As luck would have it, things came together on the game-design front as well. *Overwatch* character art director Arnold Tsang was weeding through the remains of *Titan*'s aforementioned ranger class, looking for a soldier character who could lay down a medium stream of fire, maybe heal a little.

Metzen laughs at the memory. "I said, 'Guys, I don't know if this is the craziest thing you ever heard, but I kinda have this character that's near and dear to my heart—maybe he'd be perfect for this.' I was feeling it on the theme front, and they were feeling it on the functional, practical design front."

Tsang took Metzen's original sketches from the nineties and updated them with some design exploration. From there, Soldier: 76 was off and running, and in time the tired old soldier found not only a new mission but a permanent home as well. It was a resolution that Metzen was pleased with. "I was delighted that this idea could find an audience, that maybe this thing that I loved would be seen by millions of people."

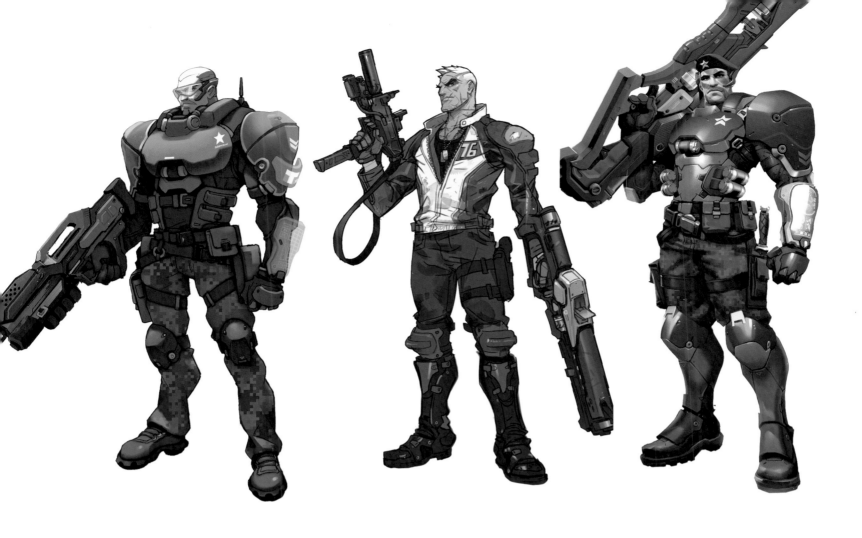

CHAPTER **FOUR**
CORE CONCEPTS

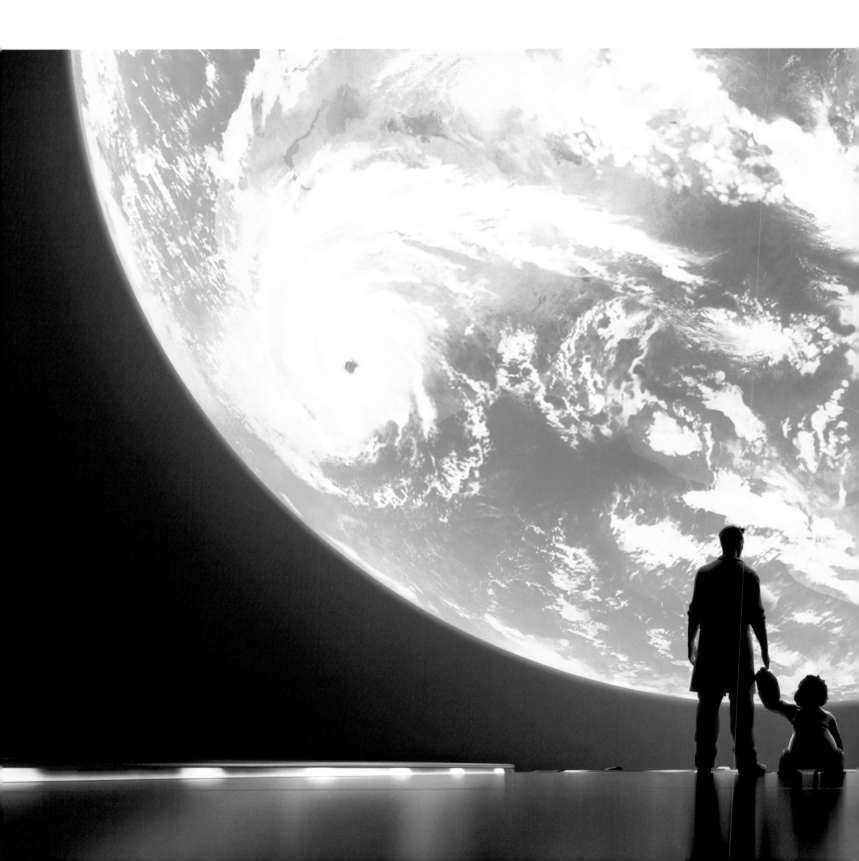

Art is powerful. An image can tell a story or create meaningful conversation. It can call for change or inspire a community to act. From the insightful optimism of the **Overwatch** "Recall" cinematic to the orc wolf rider statue and the core values engraved in its base, we'll study the Blizzard images and ideas that provoked thought and sparked reflection.

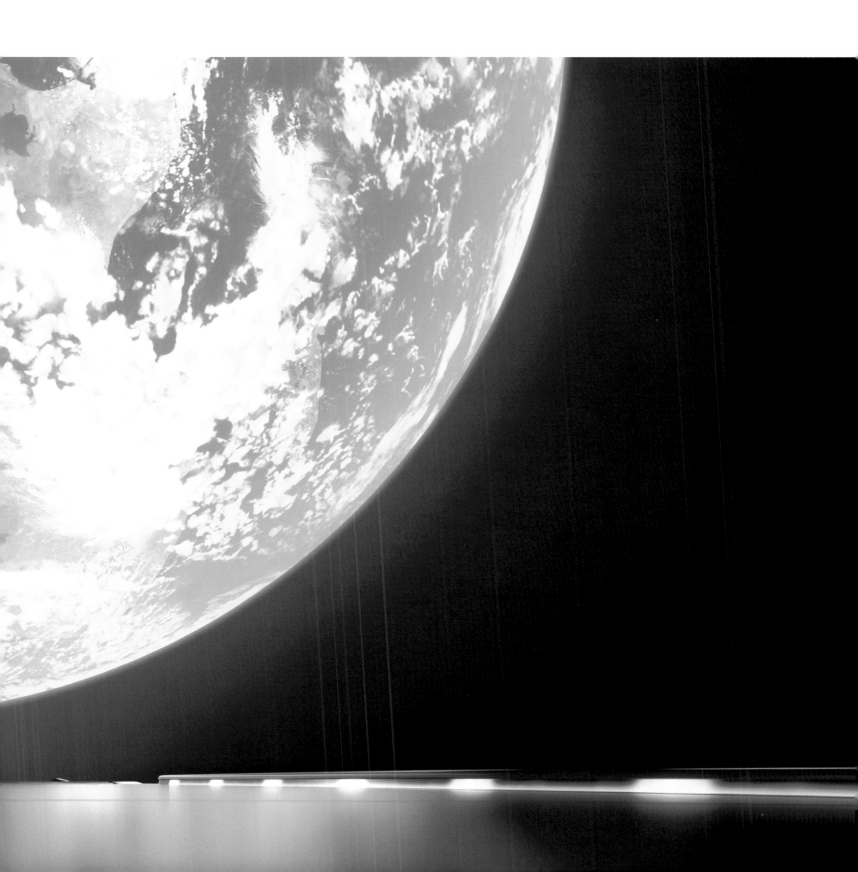

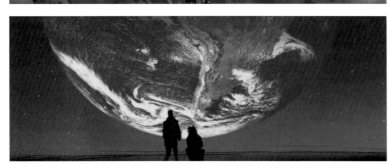

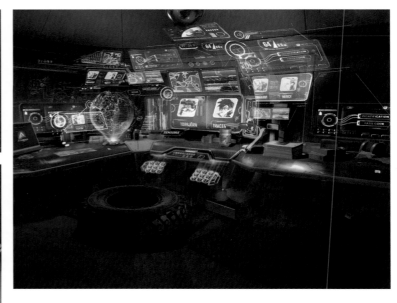

OVERWATCH: THINK GLOBALLY

OVERWATCH's "Recall" cinematic opens with Winston, a former Overwatch agent, at a crossroads. The world around him seems engulfed in crisis. Overwatch has been shut down, deemed illegal by the international authorities, but with the push of a button, Winston could recall the agents to active duty and organize them to save the world. The cinematic takes viewers between the current game time and flashbacks from Winston's childhood on a moon base. During one of those flashbacks, a young Winston is taken by Dr. Harold Winston, a father figure and scientist, to an observatory where Earth is visible from the moon.

The image of Dr. Harold Winston and young Winston looking out at Earth is one that is displayed in various locations around the Blizzard campus. Both the image and the quote associated with it ("Never accept the world as it appears to be. Dare to see it for what it could be.") were created during a brainstorming session meant to evoke the game's theme of a future worth fighting for.

"We asked ourselves, 'How do you render that? What does that look like?'" remembers former vice president of art and cinematic development Nick Carpenter.

1, 2, 8, 10, & 11: Mathias Verhasselt 5: Roman Kenney
3: Ben Dai 6 & 7: Blizzard Animation
4: Tae Young Choi 9: Haylee Herrick

"Then [former senior vice president, story and franchise development, Chris] Metzen started kicking the ball around, and we were talking about this wonderment: 'Instead of looking to the stars, look home. This is the thing worth fighting for.' It was unanimous, so fast—the only image that could represent that was a picture of Earth. You're looking at young Winston looking at Earth, and it was really an opportunity to see it through a child's eyes."

The quote especially resonated with *Overwatch* character art director Arnold Tsang. "It's about the world that *we* aspire to have in our own future. That quote encompasses the spirit of *Overwatch*, that the world needs heroes, and these heroes can bring about a future that we can aspire to have for ourselves."

Perhaps more interesting are the thoughts conjured by the image on its own, outside the context of the quote. For senior art director Chris Robinson, the beauty of the image is that it forces the viewer to ask questions. "It embodies the spirit of storytelling in an image," Robinson says. "You have to think about it. Are the characters looking at Earth because it's ruined, and they're sad that they're leaving it? Or are they looking at it because they're protecting it, and it's hopeful?"

For senior art director Samwise Didier, the image carries not just a message for the future, but a message for those who will carry the future forward. "The doctor gives Winston his glasses, and they carry over into Winston's present-day character design," says Samwise. "It's symbolic—the older generation handing the world off to the new generation, saying, 'You can create whatever you want.'"

CAMPUS BEAUTIFICATION:
EPIC HALLS

In Blizzard's early days, employees decorated wall space with inspiration from favorite artists, bands, and movies. As the company grew, and especially when the move was made to the main campus in Irvine, the focus shifted to showcasing the incredible art created for the company's various IPs.

"*World of Warcraft* moves so fast," says Robinson. "When we relocated to our new campus, no one gave any thought to beautification. If you walked around the *WoW* work area, we had some stuff framed, but it was what we had carried over from the old building, kind of haphazardly put up on a bunch of gray walls. We could have been a bank."

Enter Blizzard's Vault team. "Our mission is to preserve Blizzard's art and cultural artifacts so they can be shared and used as a source of enjoyment and inspiration in the future," says curator Dana Bishop. "When people are looking for art, they think of our team because we're that central location where everything lives. Beautification wasn't just about beautifying the campus, it served to immerse you in our worlds, sparking creativity and connection."

"Journeying into the vault is always such a fun trip for us. They'll have art for BlizzCon or any number of things," says Robinson. "Rather than storing it in some huge warehouse, we like to put it up, so we'll go to the Vault team and pick the coolest pieces. It's usually collected in themes, so we'll have a hallway with all the patch art that was done for *WoW*, we'll have a hallway of cover art or announcement pieces, and then we have our favorites, like the Horley hand-painted *Warlords* piece."

Whenever possible, the *WoW* team uses their wall art to tell visitors a story.

"We wanted to really make our team area and specifically the design area feel like you're going on a quest that encapsulates the experience of how an actual story line gets put into the game," explains Robinson. "The concept was, 'Here's where the quest design team is, here's where the event design team is, here's the art team and the animators,' and every wall would

have artwork to tell the story of how they interact to put things into the game."

Fortunately, art that's informative to visitors is also inspiring for employees.

"Seeing these pieces on the walls really sets the bar in your mind as an artist," says *WoW* art director Ely Cannon. "It's intimidating and inspiring at the same time; it gives you that compass point to aim for, and it really reinforces the fantasy of the world you're creating. It's the gravity of it too—these epic heroes and villains and far-off places, and the idea of being able to transport somebody into this fantasy world. Those images are a constant reminder of the breadth of the fantasy we're investing in and creating on a daily basis."

To spice things up, the *WoW* team dedicates time and space to non-Blizzard art as well.

"We have a gallery where we encourage everyone to make art outside of work," Robinson explains. "Anything from personal projects to one-off paintings to photography. We have monthly art shows where we close everything down at five o'clock, bring in some wine and food, and people can come check it out. It's great to see what inspires the artists, what kind of work they do when they're not on the clock."

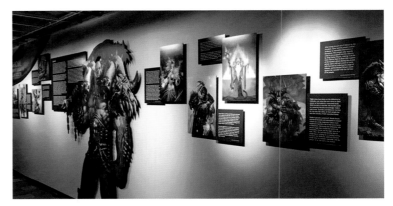

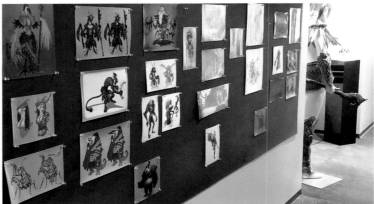

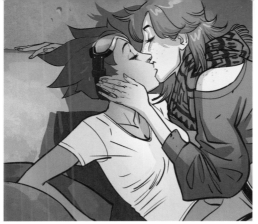
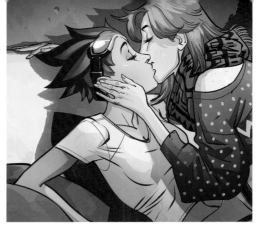

"REFLECTIONS" COMIC:
EVERY VOICE MATTERS

THE *Overwatch* comic "Reflections" explores how various heroes spend their holidays. But as this simple idea unfolded, it also took a step forward for representation, revealing that one of the game's most prominent characters—Tracer—was a member of the LGBTQ+ community, sparking conversation and critical praise.

"We're always very mindful of how we reveal the sexuality of our heroes," says Tsang. "We don't want our heroes to be solely defined by that. We want it to feel like it's a natural part of who they are."

Knowing that the comic represented an important chapter in Tracer's character arc, the *Overwatch* team sought out expert comic book illustrator Miki Montlló.

"I was very excited when they told me Tracer was going to be the main character of the comic," Montlló enthuses. "Blizzard saw my work and thought I would be appropriate because there were similarities between what I do and the very rendered style of *Overwatch*, but I didn't have to adjust completely to the style of Blizzard. What Blizzard wanted from me was my own take on the characters."

Miki wasn't given story specifics up front but was informed that the comic would feature a character revelation. "They told me it was going to be an important one," Montlló recalls, "and that people would probably talk a lot about it."

The key scene in the comic shows Tracer returning home from some speedy gift shopping where it's revealed that she has a girlfriend, Emily.

"I did a few takes on that scene to have different points of view," says Montlló. "And we discussed what would be the best approach. I wanted people to connect with the character; I wanted to show that she had a very loving and warm relationship."

Tsang, and fans, agreed. "I liked the way we did it," Tsang says. "It felt natural, like we were just learning more about Tracer's story."

"People really liked it," Montlló affirms. "People even sent their cosplays of Tracer and Emily. It was cool for me to see that fans were really excited about it."

THIS PAGE: Miki Montlló
OPPOSITE: photos by Steven Dowling, Jr.

53

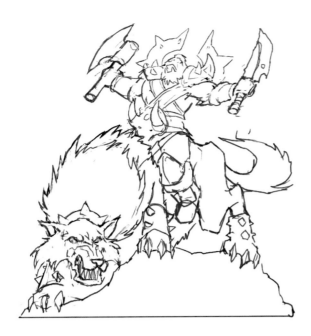

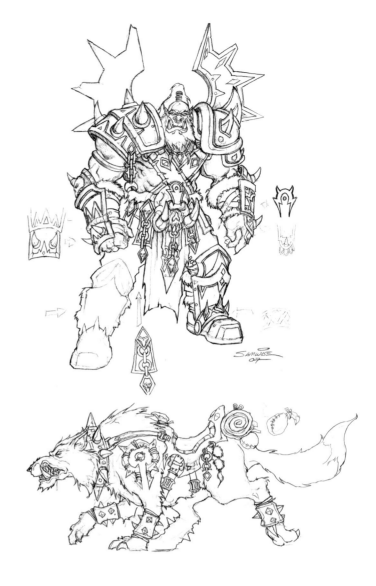

MONUMENTAL: THE ORC WOLF RIDER STATUE AND BLIZZARD'S CORE VALUES

THE practice of creating statues of Blizzard characters began with neoprene versions made for BlizzCon and other trade shows, a process that was overseen by former vice president of art and cinematic development Nick Carpenter. It wasn't long before the idea was brought up in an executive meeting to have a more permanent statue made for Blizzard's campus courtyard.

"Doing a physical statue that's going to stand the test of time is totally different from doing one of the neoprene characters," Carpenter observes. "The neoprene material is made to look believable, not to last. It was a totally different discipline, and I didn't have a lot of experience with bronze. I didn't understand the inner workings of it. So first and foremost, I had to figure out, 'How the hell are we going to make this thing?'"

Carpenter spoke to several shops that were motivated to sculpt the statue, but he was unsure how to make it. Having seen some film-based statues done by Weta Workshop, Carpenter chose to make a call.

"I reached out to Richard Taylor, the person running Weta Workshop. He didn't even hesitate, he said, 'You're doing what? We're in.'"

The next question became what character to feature.

"The biggest challenge was that we had multiple IPs at the time," recalls Robinson. "If we focused on one, did that mean we were diminishing the others?"

The trick was to choose a figure that would represent Blizzard as a whole and would tell a story of the company's origins. For many high-level employees, that was an orc.

"It's not just an orc," says Robinson. "When you look at it, you get a sense of Blizzard's roots. Other IP characters had holes in that sense, but the orc checked every box, representing where Blizzard came from, where it was currently, and where we were going in the future."

Samwise did a few concepts of the statue, while Carpenter mocked it up in 3D.

"Outside the art, there was all this behind-the-scenes stuff that you don't think about," Carpenter remembers. "We didn't know it at the time, but the orc had a plinth it needed to sit on. It had to be earthquake proof, which meant that it had to have proper bolts that go down into the foundation."

Weta Workshop spent hundreds of hours sculpting a proof-of-concept maquette that went through rounds of feedback. Preparations had already begun for the full-size version when a new consideration arose, centered around a set of core values the company had been discussing.

"Honestly, at the start I wondered if the core values would be a waste of time," remembers Metzen. "Empty platitudes. But as the leadership group started really talking about them, I wound up loving the process. I love what we came out with."

Ultimately, Blizzard came out with a set of eight core values:

- Gameplay First
- Commit to Quality
- Play Nice; Play Fair
- Embrace Your Inner Geek
- Every Voice Matters
- Learn and Grow
- Think Globally
- Lead Responsibly

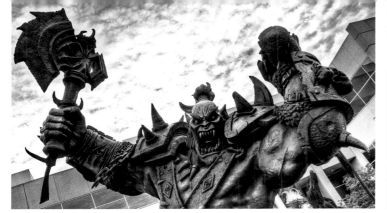
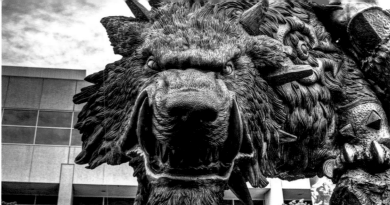
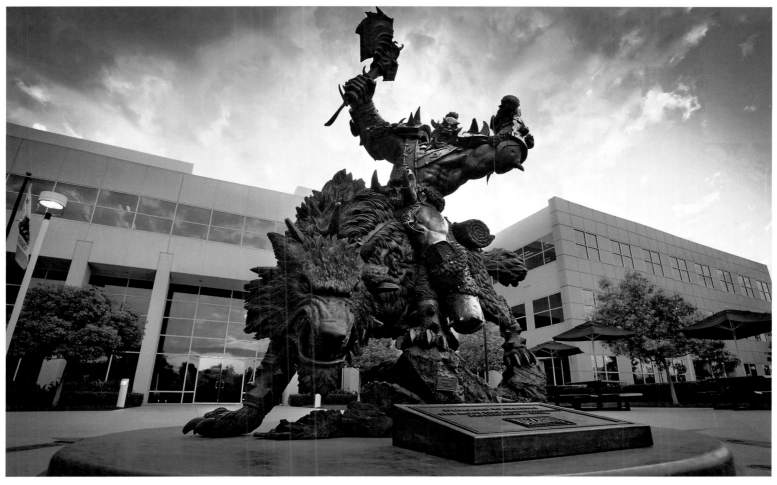

"The process of digging out the values forced us to talk about things that normally we would not talk about," Metzen says, "whether they felt taboo or they felt like someone else's jurisdiction. In discussing them, we had to test them: Do we really do this? It forced us to be really thoughtful about, ultimately, how we treated one another, how we did our business and treated the fans."

With the core values established, the notion was raised to solidify and celebrate the statements by engraving them at the base of the statue.

"I had already built out the 3D base, had figured out how it would all go together," Carpenter recalls. "And then I got a note saying, 'We'd actually like to see the values in bronze around it.' I threw away all the base work, re-figured out how to do it, and pitched it to Richard again. He was on board."

The time came for work to begin. Weta Workshop flew sculptors to a foundry in China, where they milled the statue out of foam and began blocking it together.

"They started sculpting, and for the most part it felt like it was in line with what we had signed off on," Carpenter says. "But then some of the structure and anatomy just started shifting and looking really different. Their lead was in the middle of a movie, but he could see it too. He flew to China with two of his guys to sit there and sculpt. They worked on it for a month. I owe them my allegiance for what they did."

The statue was flown to California and bolted in. "It was an incredible experience to work with people who were like-minded," says Carpenter. "Richard and his group just *got it*. Their mission is to create awesome art and put it out into the world."

Just as meaningful as the art are the values forever etched into the statue's base.

"Those values weren't something that we hit every day," Metzen says. "No one could. No one's perfect; no organization is perfect. But it's not about perfect—it's about compass points, north stars. It's about what we strive to be. For me, walking past that orc every day was a call to action. As an officer, as an artist, and as a brother in that family."

CHAPTER FIVE
OUT OF MANY, ONE

THIS SPREAD: Bill Petras, Roman Kenney, Justin Thavirat, Chris Robinson

They say that good art creates conversation, but at Blizzard, good art *is* a conversation, especially when several artists contribute to a single piece. The team might bring on additional artists to help them meet a tight deadline, or multiple artists will pool their specialties to bring the illustration to the level of "Blizzard polish." Either way, Blizzard takes artistic collaboration to a new level.

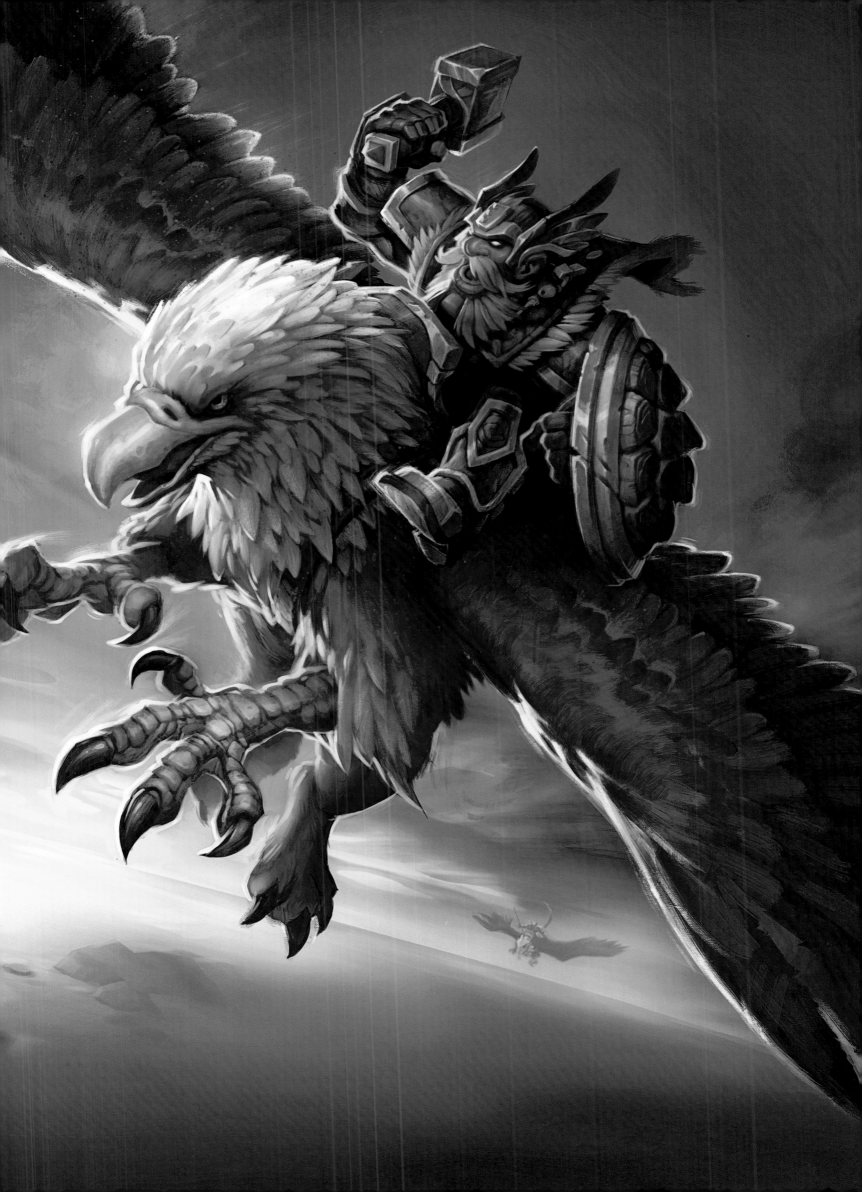

58

TOP LEFT: Ludo Lullabi, Konstantin Turovec
TOP RIGHT: Trevor Jacobs
BOTTOM: Trent Kaniuga

ALL ABOARD

WHY assign more than one artist to a single piece of work? Reasons vary. According to senior art director Samwise Didier, it can be a matter of necessity. "Sometimes an artist will start something, finish, and then move on to something else, and we'll say, 'Oh, we've changed the way that character or monster looks; we need someone to go over it.' Or maybe the artist had to move on before the piece was finished, so we put another person on it."

When one artist has been working on a single piece over a long period of time, it can also be beneficial to bring in a new and different artistic perspective, a fresh set of eyes. In the company's early days, this often happened while refining the image—bringing it to the level of "Blizzard polish," which means making something the absolute best it can be. "That was what we really became known for," says Samwise. "The high-quality games and the philosophy of 'It's not finished until it ships.'"

Over time, that philosophy, Samwise says, has become ingrained in the mission of the studio and in the hundreds of people on various teams. "What's nice about that is that on almost every team there are some people from old-school Blizzard who are still able to keep that identity going forward. I think that's a huge part of what makes Blizzard games so successful."

WINDS OF CHANGE

SOMETIMES, one image will undergo a process of evolution, through various media, in order to achieve multiple goals over time. Such was the case with the illustration of the gryphon rider.

It began with a concept drawing of a dwarf riding a gryphon and a rapidly approaching deadline to complete beautiful, full-color illustrations for the soon-to-be released *World of Warcraft* game. "Back then, things were scrappy," says principal artist II Justin Thavirat. "There was no marketing or illustration department—it was just 'What do we have?' The drawing was dynamic and cool and had a ton of personality, so we started there."

The task called for a piece that would communicate the tone and feel of the new game.

"We wanted to show off the world," says Samwise. "We wanted to make it feel expansive and to show fans something that they'd never seen before in *Warcraft*." For a game series that had featured a top-down isometric view across several real-time strategy installments, one thing players had never seen before was *Warcraft*'s sky.

Senior art director Bill Petras painted a sky and ocean background. "He's phenomenal at that," Thavirat says. "So he put the sunset over Azeroth. Then I comped the gryphon rider sketch over that background and helped illustrate the gryphon and some of the dwarf. Everybody was on it because it was needed immediately. Everyone played to their strengths and put it together. There were a lot of images like that, done in the spirit of selfless collaboration, of 'What do we need to do to get the job done and make this look awesome?'"

Despite the pieced-together approach and tight timeframe, the resulting gryphon windrider image was something everyone could be proud of. "Oddly enough," reflects Thavirat, "it was relatively cohesive looking. And it definitely captured the spirit and the game experience, of this vast world of possibilities where anything could happen."

The piece turned out to be one that would stand the test of time. Years later, the *World of Warcraft* team began selecting images for an art book, and the gryphon rider illustration stood out.

"We were looking for an image that encompassed everything, from the very early days to when *WoW* shipped to where we were at the time," recalls senior art director Chris Robinson. "So we kept looking at images, and the gryphon rider kept cropping up for very interesting reasons, primarily because of all the people who had touched it."

One concern was that the image felt aged and more relevant to *World of Warcraft* at the time of its release than the subsequent expansions. In addition, the team didn't want to simply regurgitate old material for the art book. The solution: "I asked if I could clear my schedule for a while and take a crack at updating it," Robinson says. "I left the background alone entirely and repainted the dwarf and the gryphon."

Some consideration was given to choosing a clan-specific dwarf and updating the armor, but in the end, Robinson chose not to touch it. One reason? He appreciated that the image might subvert expectations. But there was also another, more important factor: "It felt almost sacrilegious to go into such a key piece from the early days and change it, just based on the fact that the dwarf was not a dwarf in the game."

For Robinson and the rest of the *World of Warcraft* art team, the image itself, as well as its storied history, held a profound meaning. "It wasn't just Billy painting the background and Roman doing the concept and Thavirat rendering it . . . it was how everybody on the environment team *talked* about it. That background represents the world in a way that's not hyperdetailed and overwhelming. It's just beautiful and colorful, and it makes you want to go and explore that world. And from a character-animation-storytelling perspective, the dwarf is a hero that, if you play Horde, he doesn't turn you off. So there was a lot of thought that went into that image."

The teamwork of Roman Kenney, Bill Petras, and Justin Thavirat resonated with Robinson in another way as well. "You might tell somebody, 'Paint this environment with this character and this action happening,' and they might go and render the hell out of it and it's beautiful . . . but then you look at it and think, 'It's falling flat for me. I don't feel that depth of storytelling and development that went into it.' To me, that's because you didn't include the team—you didn't include all those voices. We always say that the *WoW* art team and the game of *WoW* isn't just one person sitting in an office and telling everybody what to do. It really is that Blizzard core value of 'every voice matters.'"

LEFT: Roman Kenney
RIGHT: Justin Thavirat
OPPOSITE, TOP & BOTTOM: Justin Thavirat,
Bill Petras, Roman Kenney, Chris Robinson

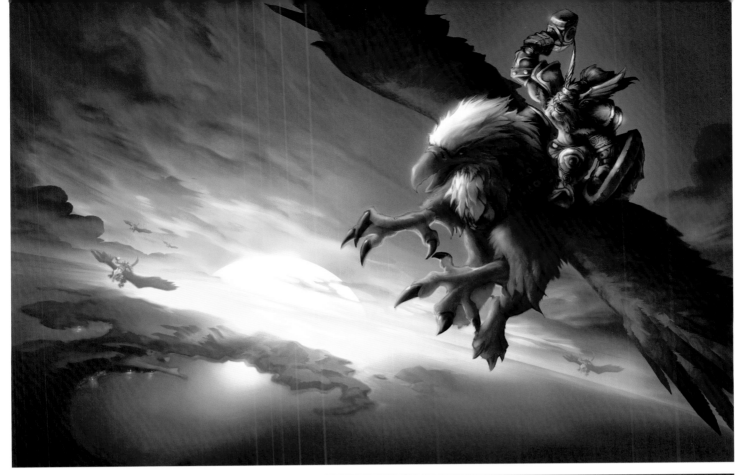

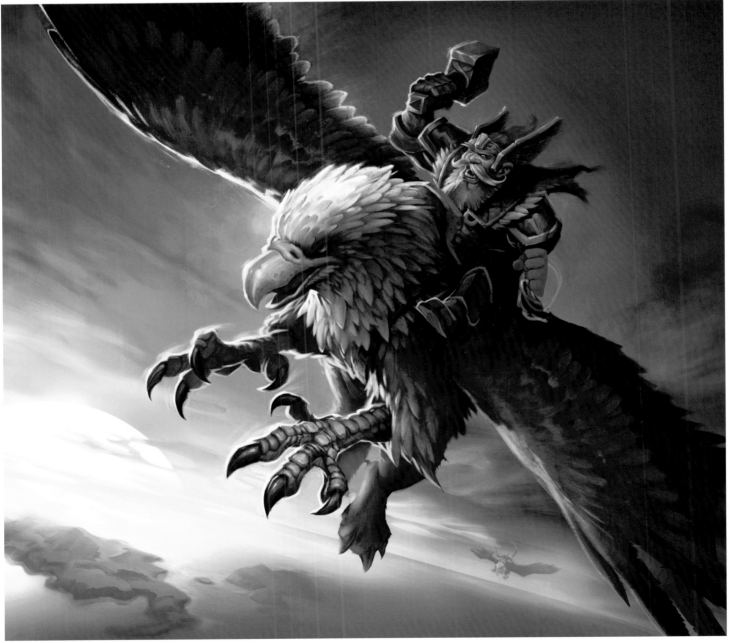

ALL HANDS ON DEATH

WITH projects that are touched by many artistic hands, sometimes the biggest challenge can come from maintaining a consistent style.

For the *Hearthstone: Knights of the Frozen Throne* cinematic, visual development department artist Will Murai came up with an elegant solution. "After much tweaking, the pipeline used to create these cinematics is a lot more efficient today," Murai says. "But back in the day, we'd assign different artists for each of the shots. While there are many advantages to that, it caused some inconsistencies when you had the same character being painted by two or three different artists. We wanted to try something new, so this project was done entirely inside our vis-dev team."

Murai would take all the various components, put them into shots, and compose single illustrations to achieve a consistent look.

"If you have a character like Jaina, painted by different artists in different shots, you can have a really inconsistent look due to the stylistic variation," Murai notes. "So this method assured that each element would be painted by the same artist. I painted Jaina in all shots, Yewon Park did all background art, and Jonathan Fletcher did all the creatures in the cinematic."

For the iconic final lineup of the heroes in their undead versions, all the artists on the team contributed. "This shot was a crazy scene to paint, with too many characters to render," Murai reveals, "We had the deadline approaching, so the whole department jumped in to help us with completing the task! Each artist was assigned a character to render, and we assembled them in the shot! It was very intense, but I dearly remember the team coming together to complete the task on time!"

ABOVE: Jonathan Fletcher, Jungan Lee, Will Murai,
Yewon Park, Josh Tallman, Justin Thavirat, Vasili Zorin

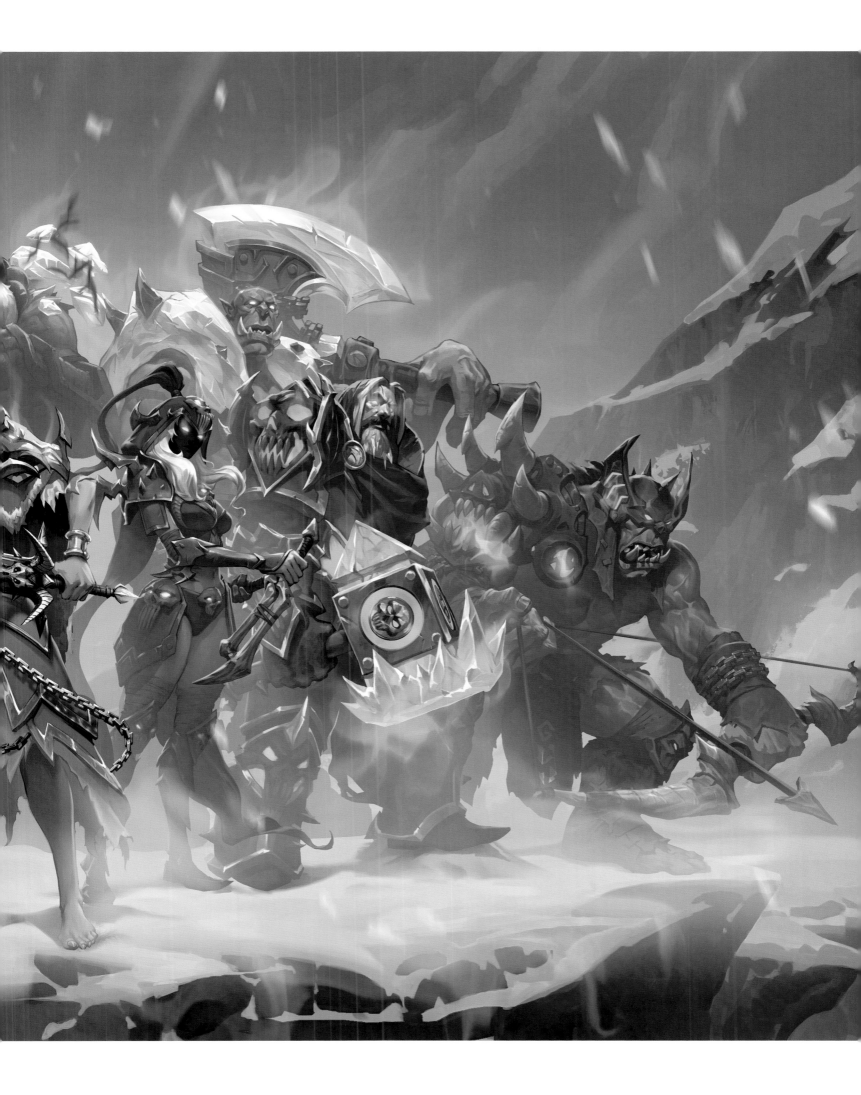

CHAPTER **SIX**

FINDING YOUR VOICE

It may be set in the **Warcraft** universe, but through a mixture of art, humor, and game design, *Hearthstone* established a style and personality all its own. In this chapter, we'll take a closer look at how *Hearthstone* shaped its own destiny.

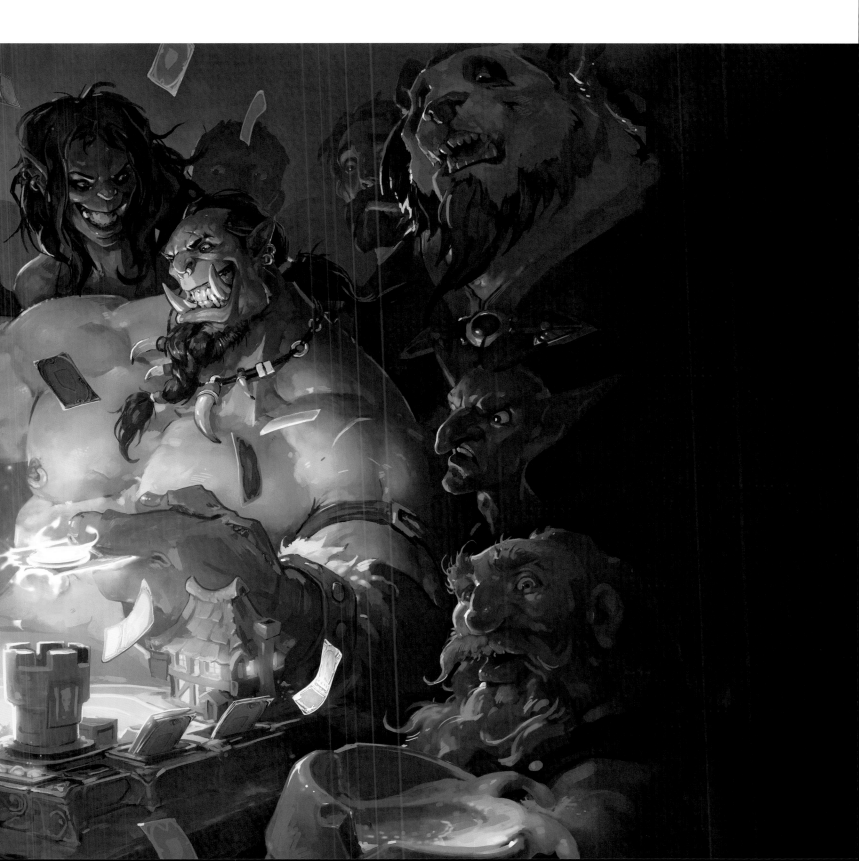

ZOOMING IN ON
WARCRAFT'S LIGHTER SIDE

THE game that became *Hearthstone* began largely with an attempt to recapture elements of the *Warcraft* real-time strategy games. "If you go back to the old *Warcraft* RTS games," says former *Hearthstone* creative director Ben Thompson, "epic things happened, but the game had a lot of tongue-in-cheek moments, and a lot of laughs. It had this feel of little play pieces on a board."

With *World of Warcraft*, focus shifted to an epic scale—casting players in the role of heroes saving the world of Azeroth with each expansion. "With *Hearthstone*," Thompson says, "it felt like, 'Here's a chance to bring back some of that tongue-in-cheek feel, some of that irreverence, some of that wit and charm.'"

"We're creating content for the single player experience," observes art outsource manager Bree Lawlor. "So taking such an expansive world and reimagining it in a more focused setting has given us a lot of visual differences that we hope enhances the experience for players."

One way the team set about differentiating was by returning to the "play pieces on a board" feel, using a game board and cards instead of pieces.

TOP: Ivan Fomin
BOTTOM: Blizzard Animation
OPPOSITE, TOP: Ben Thompson
OPPOSITE, BOTTOM: *Hearthstone* Team

Click Deck to modify
or
Click New Deck

Non selected decks clop in sequence to expose deck

Selected deck is pushed to top by slide up tray.
if
New deck hero tray locks into place.

Chosen hero is added to new deck
if
Modifying deck
Ⓐ Hero tray is not present
Ⓑ existing deck rolled out.

Hero tray slides away exposing the cards in collection to build with
or
if modifying, the player is free to add to tray

~ Deck Create/edit ~

Tabs

Box
Tray
Tiles

Pages

Paste inn.

Buttons

= removes as seperate element of game from box

- Widescreen -

Waiting...

SETTING THE STAKES

EARLY on, the team knew they would be walking a tightrope between remaining faithful to the visual and spiritual hallmarks of *Warcraft* and carving out their own identity.

During the game's inception phase, the team came up with "four stakes in the ground" for decisions that would be made on everything in the game, outlined here by Thompson:

RULE #1: CHARMING AND WHIMSICAL. "Tonally, we wanted to hit this in everything that we did. Even if it was epic, we felt like it had to be epically charming and wonderful in its own way. Not just epic for the sake of it."

RULE #2: SIMPLE AND CLEAN. "We felt that things needed to be immediately recognizable, readable, approachable, and not require a lot of communication from a visual standpoint to know exactly what you were looking at and what we wanted you to get from it."

TOP LEFT: Sam Nielson
BOTTOM LEFT: Steve Prescott
TOP RIGHT: Matt Cavotta

MIDDLE RIGHT: Zoltan Boros, Gabor Szikszai
BOTTOM RIGHT: Glenn Rane

RULE #3: REAL AND PHYSICAL. "There's a value to the physicality that comes from card games and tabletop games. Having spent as much time in the digital world as we had to this point, especially creating this fantastical world with *World of Warcraft*, we came to realize something. If you're going to present a tabletop-game-style approach like *Hearthstone* represents, it is best to do so in a way that conveys its physicality and realness wherever possible."

RULE #4: A VALUABLE COLLECTIBLE. "This kind of goes hand in hand with 'real and physical.' Because this is a digital space, we don't have to worry about material costs. We can make cards out of fine leathers with gold embossing and gems and magic, and craft equally cool effects that happen when you play them."

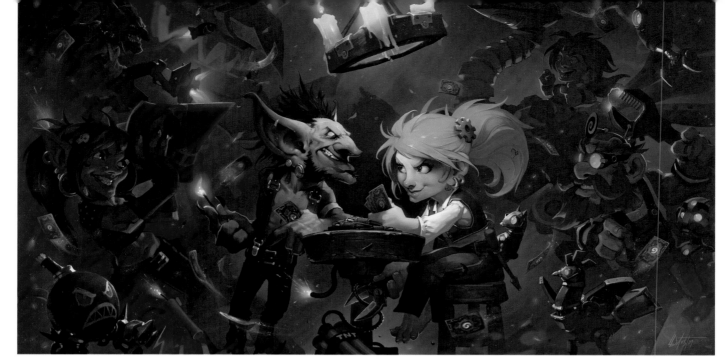

TOUGH ROOM

THE team's take on their as-yet-unnamed game was not an easy sell to the rest of the company.

"We were definitely aware that we were rooting the game in one of Blizzard's most beloved franchises, with regard to *Warcraft*," notes Thompson. "We wanted to approach it in such a way that it was more about what a game like ours *added* to the universe, that it showed a facet of *Warcraft* that people might not have seen before or might not have thought of for a long time."

One stumbling block early on, however, was the idea that the game would not focus on Horde versus Alliance. What kind of *Warcraft* game wouldn't pit orcs and humans against each other?

To help envision a different path, former principal artist Laurel Austin illustrated the first piece of key art for the game. It not only showed Alliance and Horde sitting in the same room together but also playing a game and having fun.

"It was by design that everybody you encounter in the tavern and the game itself come from a variety of backgrounds and even opposing factions," Thompson reveals. "For the first time, we really were saying as a company, as a franchise, that Horde and Alliance could actually get along. They could come to the tavern, shake hands, sit down, and fight it out in a friendlier environment where it was safe, fun, and welcoming."

That single piece of art proved critical in warming others to the idea of the game.

"We pulled up Laurel's piece," Thompson continues, "saying, 'We want you to take a look at this. This is the key art we want to go out with, and we think it conveys all the stuff we've shared with you.' [Former senior vice president, story and franchise development] Chris Metzen took about twenty seconds looking at it, walking up to it, backing off, and then he just started shaking his head. Our production director asked, 'What do you think, Chris?' and he said, 'What do I think? I think this is the coolest piece of *Warcraft* art I've ever seen. I love it!'"

THIS PAGE; OPPOSITE, MIDDLE & BOTTOM: Laurel Austin
OPPOSITE, TOP: Will Murai

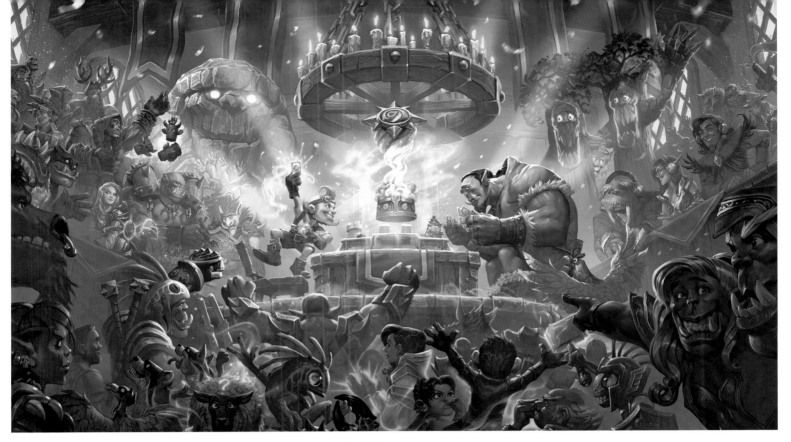

CLARITY IS KING

SO what were some secrets of the art piece that swayed doubters? The artist herself, Laurel Austin, weighs in: "*Hearthstone* takes the lighter, sillier stuff and makes hay with it. So initially I was thinking, 'What's the lightest, happiest tone of *Warcraft*?' There's plenty of light and happy stuff, so just take that and make that the core of it."

While general rules that Austin applied involved depth and portraying a sense of three dimensions or a "sculptural" feel, keen technical knowledge and careful execution was required to achieve the lighthearted tone.

The foremost consideration was clarity, especially regarding character expressions. "There's a friendliness to the faces," Austin observes. "And a greater emphasis on their appeal and the quality of their appeal. What you want for a character with a lighter tone is a very readable face and a very readable pose."

This emphasis on readability was specifically geared toward making the game accessible to a wide demographic. "When you want something to be very light and happy and cute, and appealing to everybody in the same way as cartoons, you want to make sure eyes and mouths are very readable so that when you look at it, you know what's going on in an instant."

Shapes play an important role as well, says Austin. "You sometimes have rounder shapes, rounder eyes, larger foreheads so things look cuter, but even if it's an orc, it's five or ten percent of a change from a *World of Warcraft*–type orc to a *Hearthstone* orc. They have all the same things, but what you emphasize is different."

ABOVE: Sean McNally

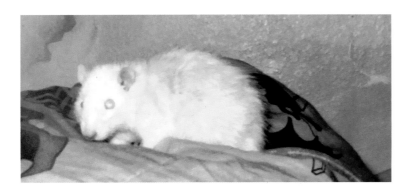

THE NAME OF THE GAME

EVEN before they landed on the name *Hearthstone*, the team knew they wanted the game to feel warm, familiar, and inviting.

"Taverns hold a special place in *World of Warcraft*," says Thompson. "It's where you go at the end of a game if you want your experience to double at a greater rate. It's where you go to be safe because you're not going to be attacked or raided, often by the opposite faction."

There was also a sense among players that taverns were hubs, or at least starting and ending points for adventures. Taverns evoked thoughts of soft, glowing lights through windows, of welcoming voices and music drifting from open doors, of a warm place by the fire. More and more, the idea of a tavern conveyed the mood and tone the developers were aiming for.

As for the title, the team put out an open call to the entire company for ideas. *Hearthstone* was a suggested name, and one that the developers kept coming back to.

"We thought, 'You know what's really cool about this?'" Thompson recalls. "You hearth home to safety, you use your hearthstone to come back to the tavern. From a visual perspective and from an art direction perspective, a hearthstone itself comes loaded with iconography that we can play with all day. As a creative, having such a simple and recognizable iconography on which to build fall into your lap like that is a gift. It unlocks so many possibilities."

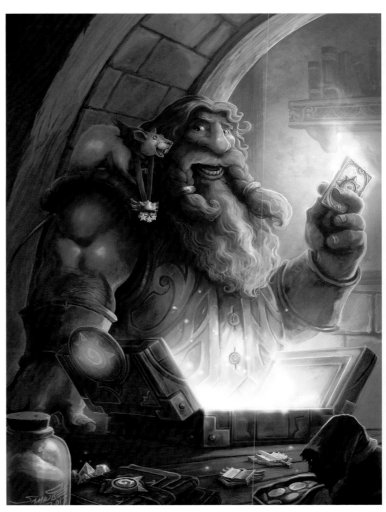

In looking for a character to be the face of the game, the team thought of, naturally enough, a tavernkeeper, the god of the tavern domain. "We had [senior art director] Samwise Didier do some early concepts," Thompson says. "And he came back with this big jovial character who has a rat on his shoulder, and I asked, 'What's up with the rat?' to which Sammy answered without a pause or hesitation "That's Sarge, his business partner at the tavern. He is wearing a medal because he is really good at the game."

The rat, it turns out, came from a childhood pet. "It was actually based off my rat when I was a kid," Samwise says. "His name was Sargent. I think he even had a little red cape on too, because he was a superhero."

"Sarge" has been part of the game ever since.

TOP LEFT & BOTTOM RIGHT: Samwise Didier
TOP RIGHT & MIDDLE RIGHT: Blizzard Animation

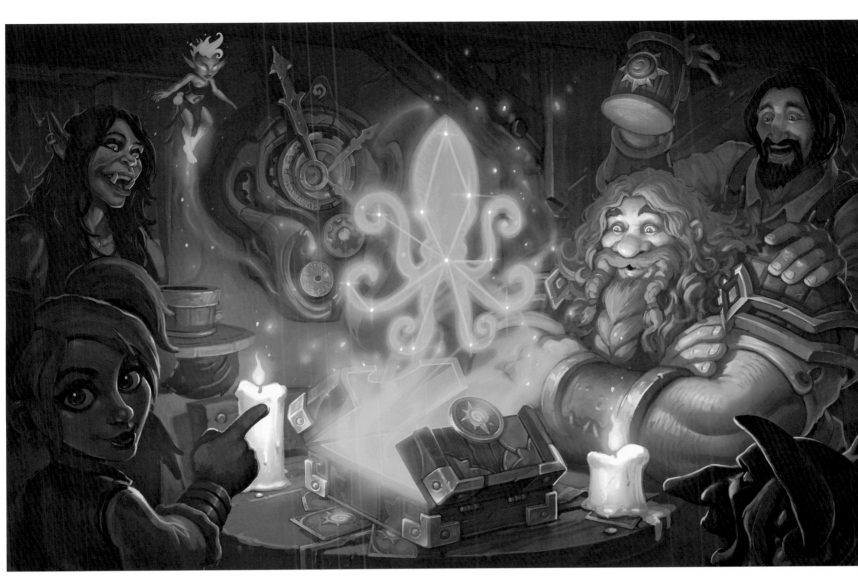

TOP: Charlène Le Scanff, Jomaro Kindred
BOTTOM: Laurel Austin

77

SELL IT WITH A SONG

WHILE art went a long way toward cementing *Hearthstone*'s style and tone, it was, in the opinion of Thompson, a specific trailer that sealed the game's identity. "It was our second release cinematic where [cinematics director] Jeramiah Johnson was given *Goblins vs Gnomes*. He said, 'I've got an idea. It's kind of radical, but just hear me out.' He didn't show anything—he just got up, set his wallet and keys on the table, and started singing, and we were like, 'What are we hearing right now?' He had a full dance and everything."

Ultimately, the unorthodox pitch was a success.

"We said, 'We need exactly that, and if there's not a bouncing ball on the words so you can sing along at BlizzCon, something's wrong.' Others agreed, and it was just an understood thing: 'I guess we're singing now. Sure.' If there's a game that's going to do it, *Hearthstone*'s going to do it. That song got stuck in our heads, the whole team, forever after that."

TOP LEFT: Guangjian Huang
BOTTOM LEFT: Mike Nicholson
TOP RIGHT: Jesper Ejsing
MIDDLE RIGHT: Trent Kaniuga

BOTTOM RIGHT: original art by
Leo Che, FX added by
Blizzard Animation

FULL CIRCLE

AS the game went on, *Hearthstone* began creating its own characters and reimagining *Warcraft* settings by asking, "What if?"

"What if we showed this moment you never saw before?" asks senior outsource manager I Jeremy Cranford. "One really fun one was Karazhan. In *WoW*, everybody loved the Karazhan dungeon—this haunted, creepy old tower—and we said, 'What would it look like before it was haunted, when Medivh was young? What would it be like if he was throwing a party?'"

Ultimately, *World of Warcraft* embraced *Hearthstone*'s unique identity, as evidenced in *WoW* itself: "You could go into certain taverns," Thompson says, "in any one of the home cities, and you'd see a *Hearthstone* board lying on one of the tables."

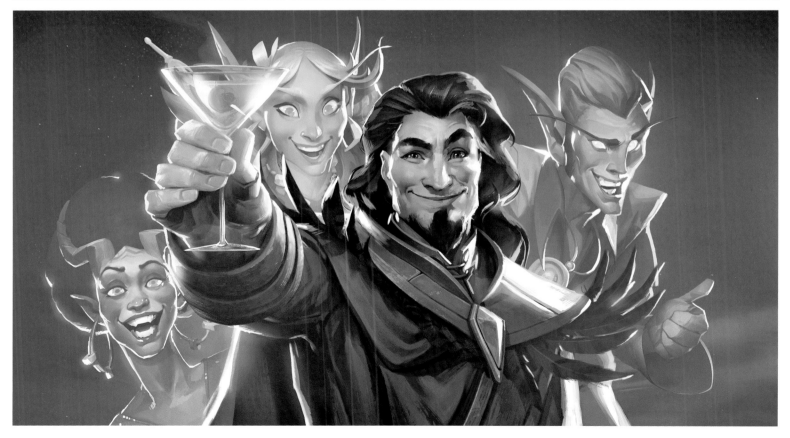

TOP LEFT: Armand Serrano
MIDDLE LEFT: Peter Stapleton
MIDDLE RIGHT: Rudy Siswanto
BOTTOM: Max Grecke, Laurel Austin

FAMILIAR, BUT NEW

OPPOSITE: Luke Mancini

StarCraft was a groundbreaking real-time strategy game that featured three unique forces locked in a struggle for galactic control. The terran, protoss, and zerg races combined familiar archetypes with a fresh vision, setting *StarCraft* on a path to worldwide success and helping to cement its status as the early king of esports. In this chapter, we'll look at the artistic journey that forged *StarCraft*'s peerless vision—a new kind of science fiction.

LEARNING A NEW CRAFT

OVER the course of developing the *Warcraft* real-time strategy games, Blizzard artists used various methods for displaying units, buildings, and vehicles in-game. *Warcraft I* used 2D pixel art. In *Warcraft II*, artists painted over still images of 3D renders—a method they would bring to the company's next RTS title, *StarCraft*.

The process resulted in tiny, low-resolution models with three to six frames of animation. This presented a challenge to *StarCraft* artists: convey clear, readable, stylized models that look distinct yet consistent, so that all three races—stylistically, at least—appear like they belong in the same universe.

GETTING INSPIRED

THE "race kit" for terrans—the human faction—began with general guidelines to help differentiate them from other popular science-fiction franchises of the time. "We wanted to do something that wasn't super clean or fancy or hard sci-fi tech," recalls senior art director Samwise Didier.

Developers zeroed in on a drawing by former senior vice president, story and franchise development Chris Metzen (an image featured in chapter 8, "Cross-Pollination"). "Metzen did a picture of a cowboy," Samwise says, "so we ran with the idea of *StarCraft* as a space Western. Instead of riding around on space horses, we had terrans riding vulture bikes."

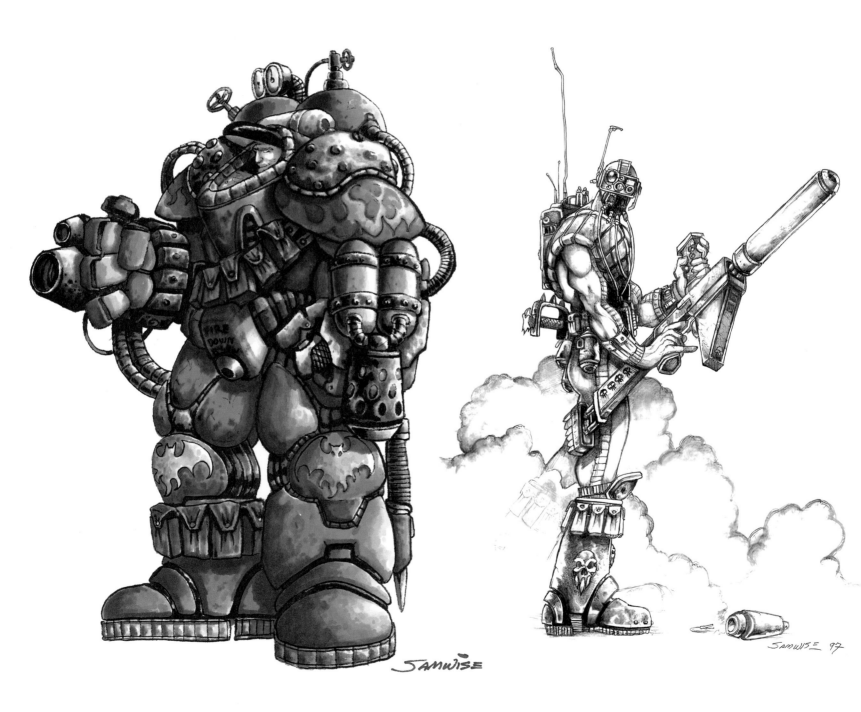

ALL IMAGES: Samwise Didier
OPPOSITE: Justin Thavirat

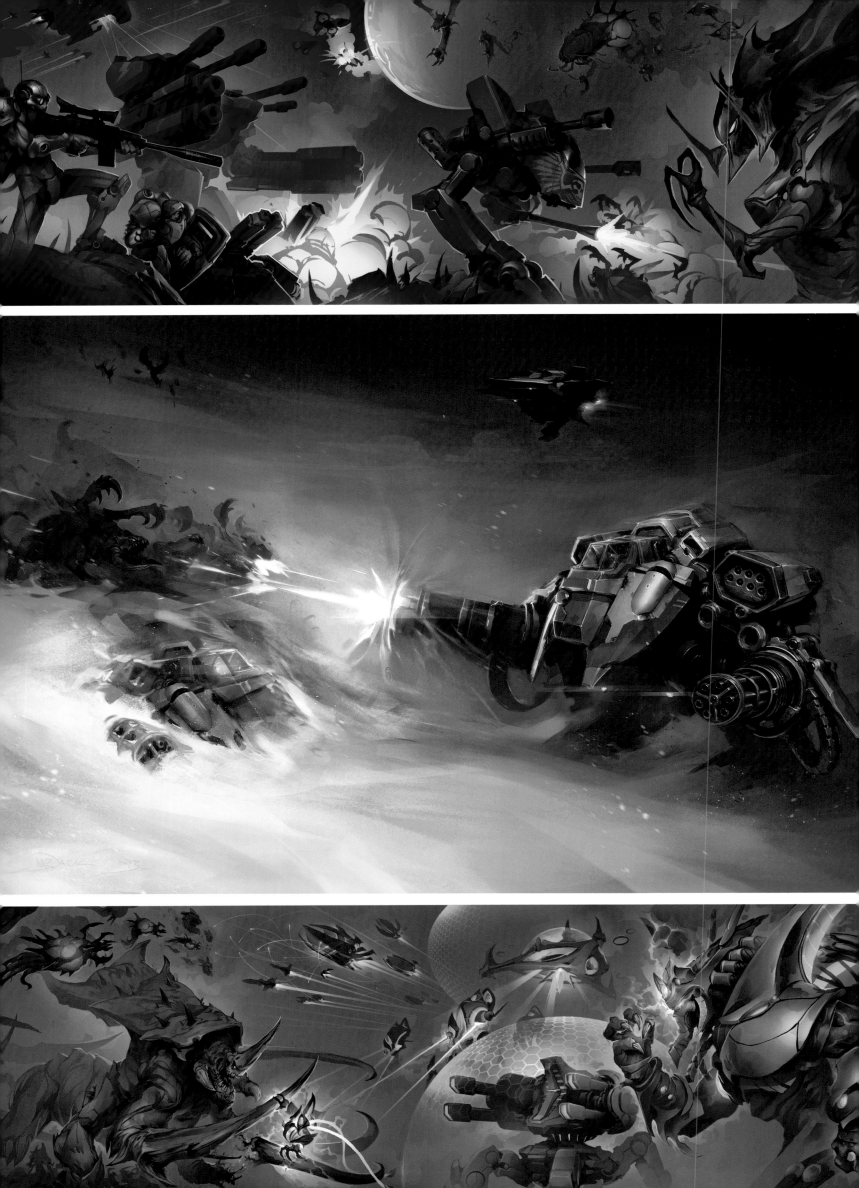

Samwise 97

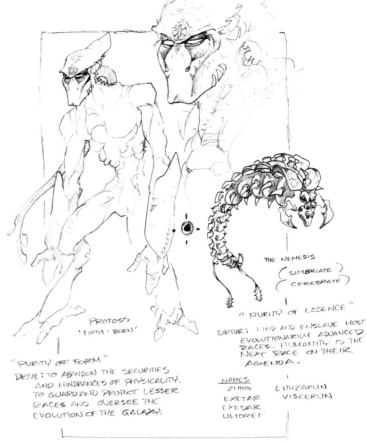

PROTOSS
'FIRST-BORN'

"PURITY OF FORM"
DRIVE: TO ABANDON THE SECURITIES
AND HINDRANCES OF PHYSICALITY,
TO GUARD AND PROTECT LESSER
RACES AND OVERSEE THE
EVOLUTION OF THE GALAXY.

THE NEMESIS
(SIMBRIATE)
(CEREBRATE)

"PURITY OF ESSENCE"
DRIVE: FIND AND ENSLAVE MOST
EVOLUTIONARILY ADVANCED
RACES. HUMANITY IS THE
NEXT RACE ON THEIR
AGENDA.

NAMES: LITHZARUN
ZURROG VISCERUN
EXETAR
EXETAR
ULTOREI

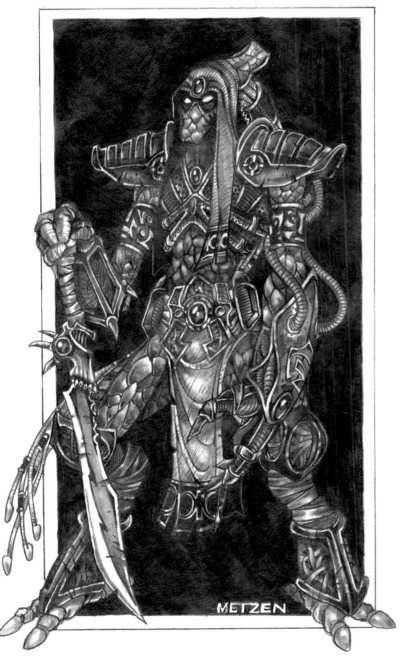

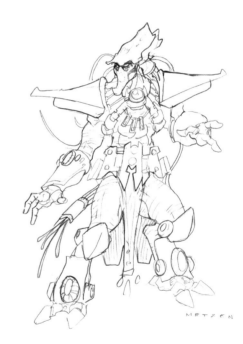

For the remaining races, developers looked to existing hallmarks of popular science fiction for inspiration. "With the protoss," Samwise says, "we knew we wanted to make a variation of the standard gray aliens that you see in movies and cartoons, but we needed to make them different."

The artists started on new concepts, taking a similar tack to how they differentiated the night elves of *Warcraft* from general fantasy elves. They wanted to stay true to the spirit of the archetype while adding new ideas to make the concept feel fresh.

"Instead of making them four feet tall, we made them eight or nine feet," Samwise explains. The predominant color for the protoss was gold with various accents, lit in cool tones like blues and teals.

OPPOSITE: Luke Mancini
TOP LEFT: Samwise Didier
ABOVE: Chris Metzen

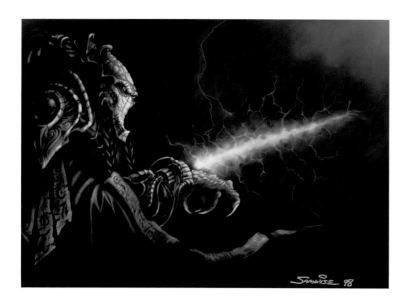

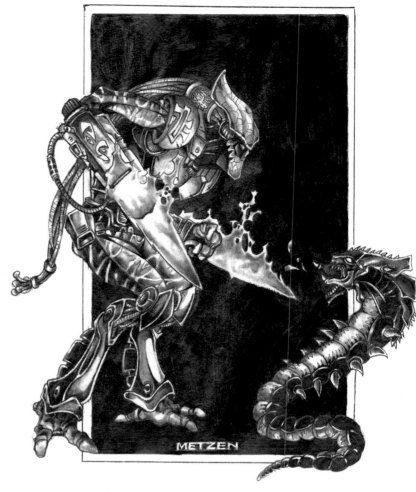

According to Samwise, another touchstone from the developers also began to stick: a sort of space samurai theme. "They had their armor, they had their honor, and they had psi-blades."

The psi-blade, a glowing energy sword that projected from a protoss's wrist, borrowed from other light-based weapons that were well established in science fiction at the time. "Keeping with the motif of the space samurai," Samwise says, "the samurai and their sword are inseparable, so our concept for the psi-blades reinforced what we were going for. People understood immediately."

For the zerg, artists looked to another prevailing science-fiction theme: terrifying parasites that assimilated their host. "Any living thing the zerg touch, they weaponize," Samwise notes. "What was really fun was we could design these characters to look like anything."

"The original *Brood War* concepts were a mix of crustaceans, mammals, and cat-looking things," senior concept artist II Luke Mancini adds. "As we went toward *StarCraft II*, we chose elements that we liked more by using overlapping plates and adjusting the ratio of toothiness to glowing pustules to tentacle-y bits."

And when the zerg "infested" other units, it made for fun combinations. "If they took over a space marine," Samwise says, "the marine sprouted horns and had tentacles wrapping around his gauss rifle. In future *StarCraft* games, we even had them take over siege tanks and other weaponry, so they became more of a biomechanical race at the end of the day."

The first step in the process of visualizing *StarCraft*'s individual units, buildings, and vehicles was generally accomplished through concept art. While style guides or visual bibles didn't exist in those early days to establish the "rules" of each race, patterns began to emerge. General guidelines eventually developed, primarily around shape language.

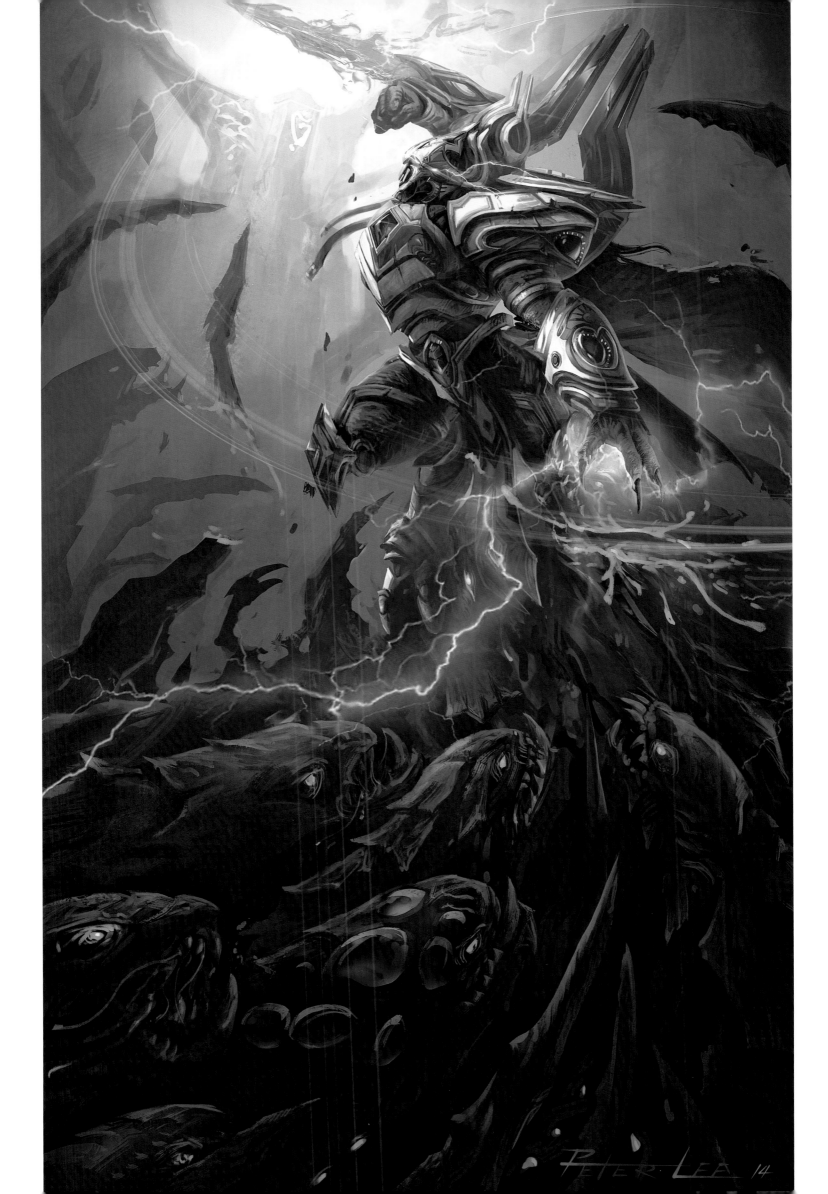

MR·JACK·09.

SAMWISE 97

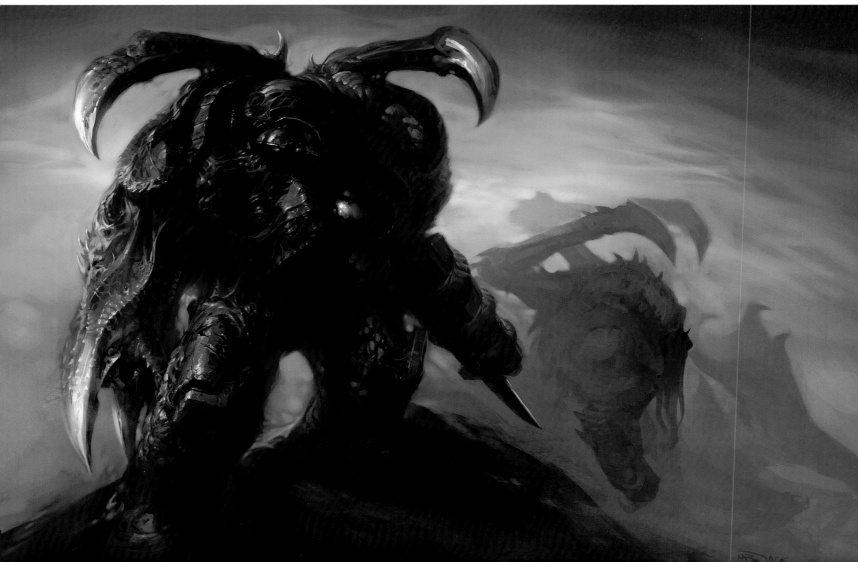

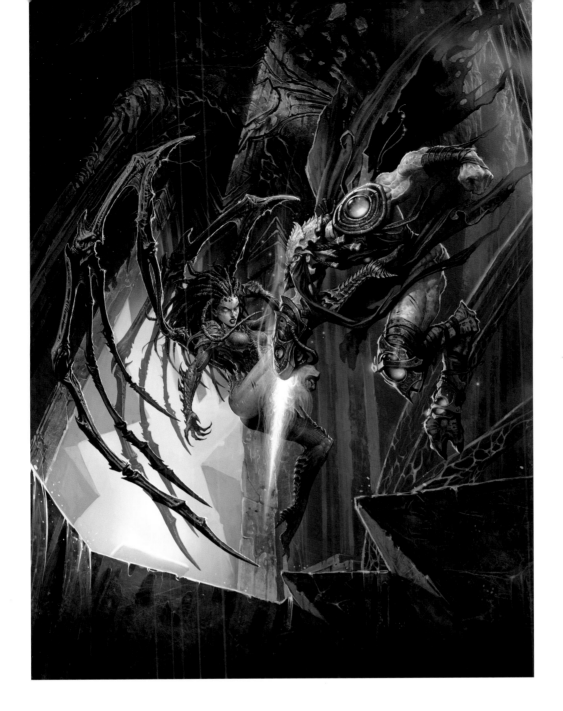

LANGUAGE LESSONS

ARTISTS use shape language in their work to convey everything from general flavor to individual character attributes. Round shapes, for instance, are often used to portray friendly characters, where points and sharp edges most likely indicate a threat. Square shapes can represent power and stability. To assist new artists in visual development for the different races, Samwise applied shape language theory in a loose set of parameters.

"This wasn't quite one hundred percent true," Samwise advises, "but in general, when you think of terrans, think boxes—their barracks, their factory. They're usually blocky, thick, clunky; their tech looks like construction worker equipment. Nothing fancy."

With a few exceptions, protoss shape language often leaned into more elegant lines: "Everything is elliptical," Samwise says. "Arcs, ovals, things like that."

Though zerg body types were often rounded and organic in appearance, the shape Samwise most associates with the third race is triangles. "Most people wonder what I mean, but lots of things about the zerg themselves are represented in triangles: claws, fangs, spikes. Everything is spiky and jagged."

"A lot of it came down to what worked in-game and in that isometric view," says principal artist Justin Thavirat. "It was the natural way that guys like Sammy and Metzen drew their concepts; Sammy's got a great way of distilling things down into the simplest shapes."

The style established in those concepts and early units was then applied throughout. "We looked at those early sketches," Thavirat says. "We extracted things that felt cool about them and translated them, and then we made sure all the structures, units, and vehicles had that consistency."

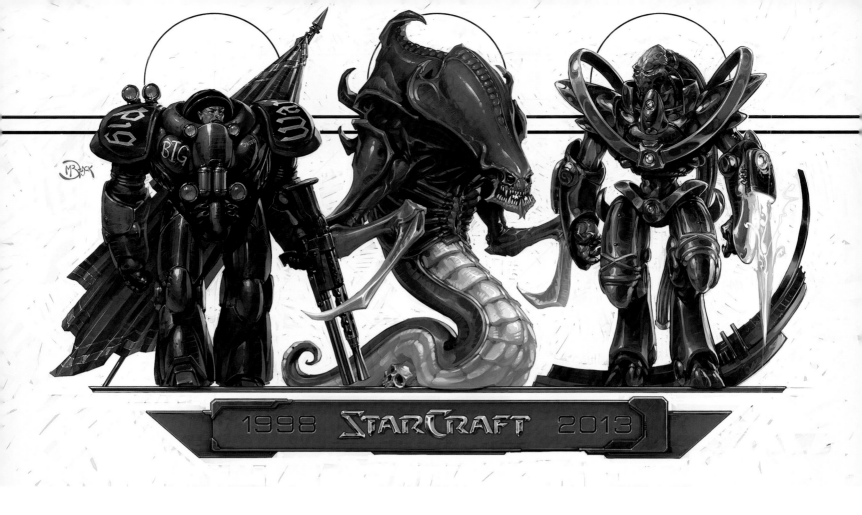

1998 STARCRAFT 2013

BACKGROUND CHECK

ALONG with the various units showcased in *StarCraft*, a diverse array of tilesets was presented as well—backgrounds that needed to follow similar rules.

"For readability, the best practice is to keep the shapes and the colors simple," says senior environment artist Dave Berggren. "The shape of the grass, the rocks, et cetera, needs to be very clean, very readable, very chunky. Don't worry about micro details—worry about big brushstrokes."

One of the biggest challenges for Berggren came in transitioning from *Warcraft* to the newly established *StarCraft* style: "*Warcraft* was more stylized and illustrated," Berggren says. "*StarCraft* was a hybrid photorealistic but still stylized look. That was the hardest thing to nail down."

The zerg presented a different kind of challenge by spreading a type of slime called "creep" across any terrain they built on. "It was easy to make that look too busy," Berggren notes. "It's a bunch of undulating biomaterial."

The trick was to convey the messiness of creep while keeping the contrast at a level that wasn't too overwhelming for the eye. "When you're playing," Berggren says, "you don't want to be distracted by the background. It's a weird balance, keeping it complex enough to convey what it is but simple in the visual language and contrast."

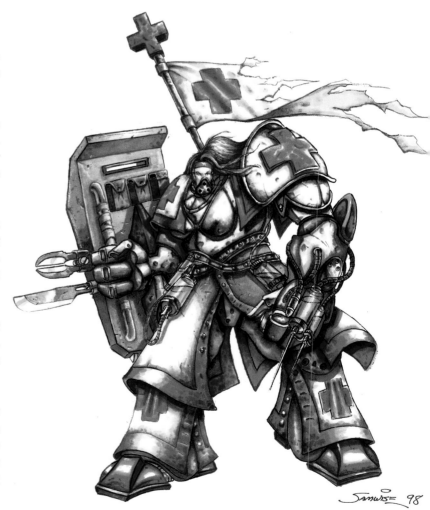

TOP: Luke Mancini
BOTTOM: Samwise Didier
OPPOSITE: *StarCraft* Team

SWARMING THE COMPETITIVE GAMING SCENE

SHORTLY after its release, *StarCraft* became a global esports phenomenon. Game design, balance, and mechanics were all driving factors in *StarCraft*'s competitive gaming ascension, but, as Samwise argues, visual development played a part as well. "The races were different enough visually that you could tell a protoss from a terran from a zerg ninety-nine percent of the time. We made them distinct, not only from other races but among themselves."

This meant that even when units were clustered together, players could usually count how many of each unit type they had. And in the precision world of esports, this kind of at-a-glance information could mean the difference between victory or defeat.

CHAPTER EIGHT
CROSS-POLLINATION

It's no secret: great ideas have a way of catching on. Sometimes it's just a name or an idea or a theme that resonates. Other times, a minor character commands so much attention that they are unintentionally thrust into the spotlight. One thing's for sure, though: when a concept catches on, it can bridge any boundary, even entire worlds.

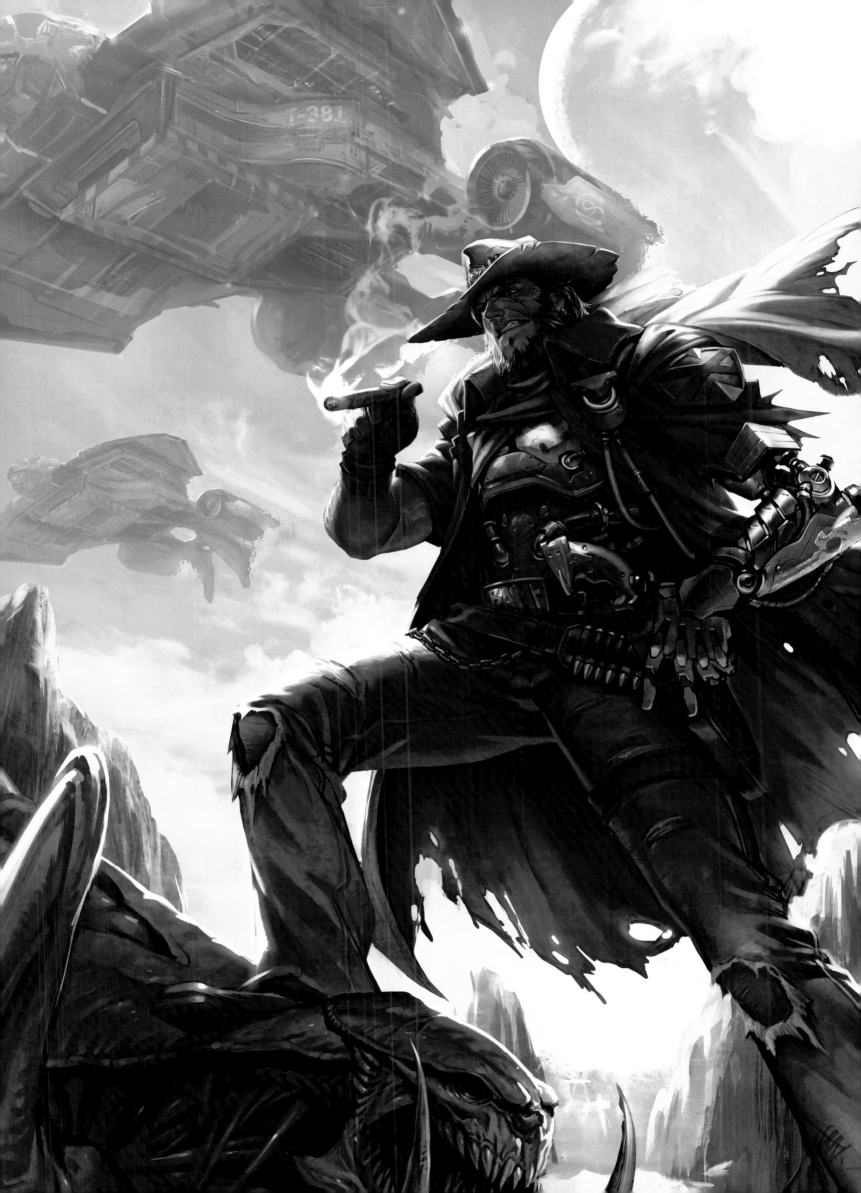

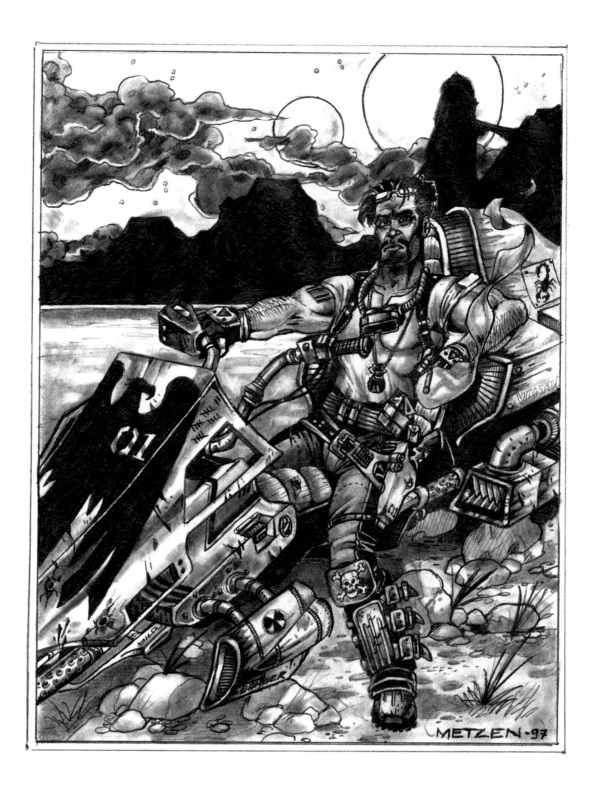

FRONTIER JUSTICE

IN 2013, following the cancellation of project *Titan*, a small but determined group of developers focused their attention on crafting a winning idea for a make-or-break pitch to company executives.

"There was this lingering hope," former senior vice president, story and franchise development Chris Metzen remembers. "What if we conjured something so cool that they would have to let us make it? So we spent a couple months meeting in small groups and thinking about a handful of things we might do." One of those ideas was for a dynamic team-based shooter, but not the one you might expect.

"We said, 'What if it's based in *StarCraft*?'" Metzen continues. "I called it *StarCraft: Frontiers*. It would take place way out in space, just prospectors out on the edge of things ripping each other off and fighting for a stake to survive in the harsh galactic rim."

Team members discovered a Metzen piece from old *StarCraft* manual art, an illustration created as part of a story thread that was never chased down: "I loved the idea that there would be prospectors out there on the worlds we don't know about yet, eking out a living, exploring, exploiting resources, fighting pirates and fighting each other. I drew that character in the manual, but I never really ran with the concept. It was a cool hook, but the more *StarCraft* took shape, it was really tangential, and it never really came into focus as a driving narrative component."

TOP: Chris Metzen
OPPOSITE: Wei Wang

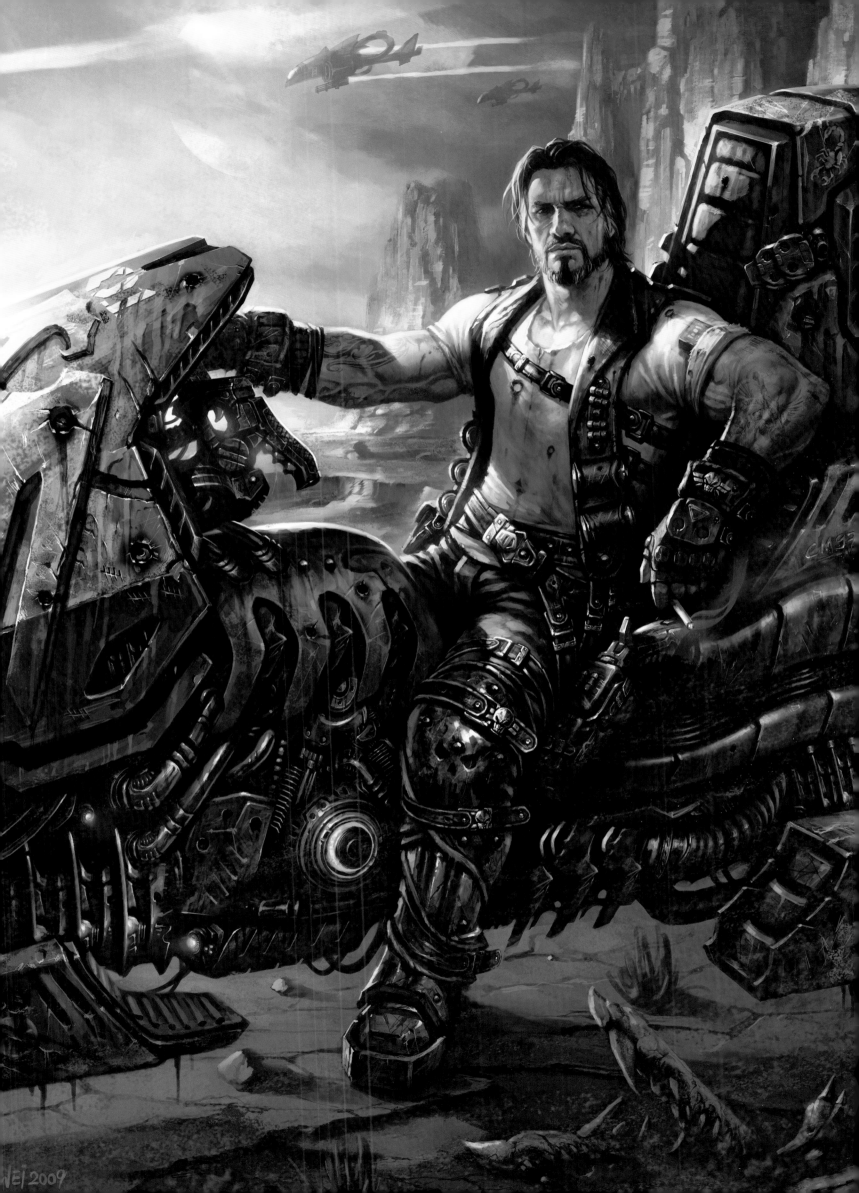

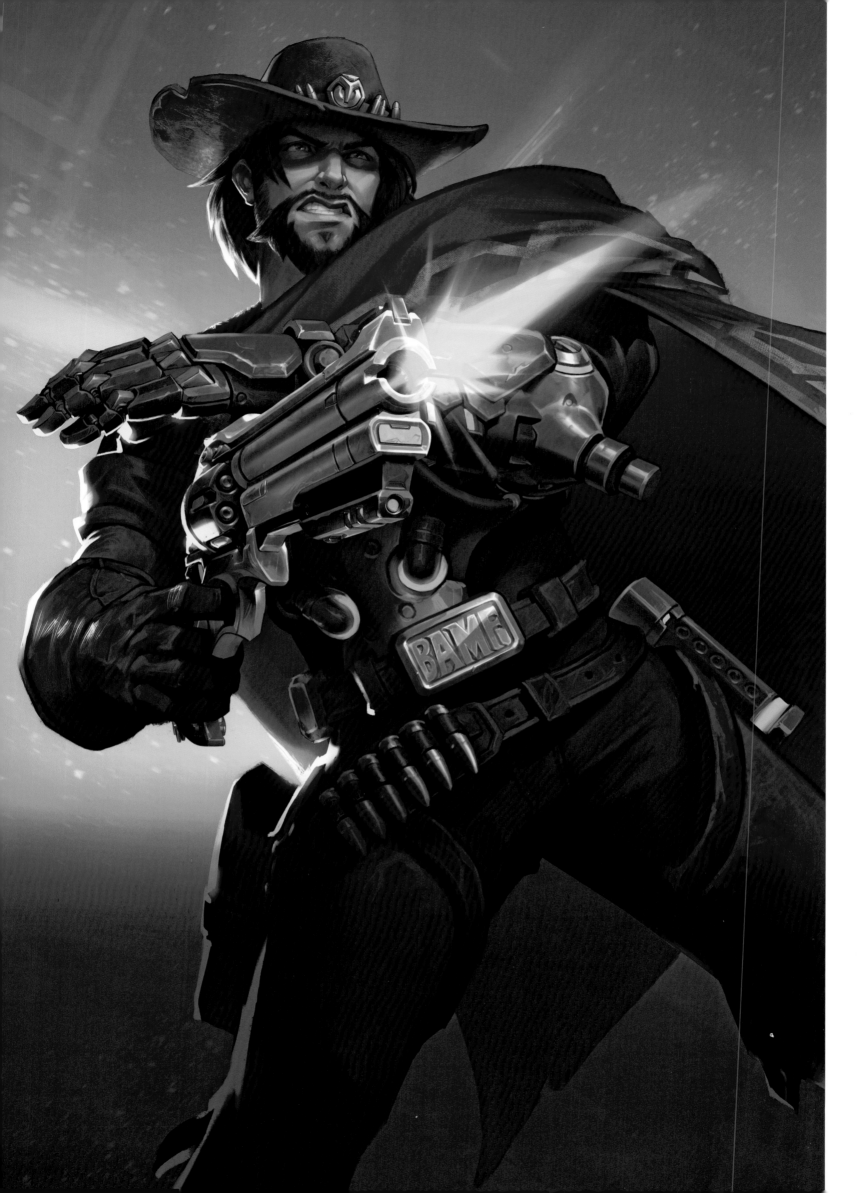

The creative team, especially character art director Arnold Tsang, felt it was perfect for their new take on *StarCraft*: "We wanted to have a marquee illustration, and one of my favorite pieces of art was a reimagining Wei Wang did of an old Metzen piece, of Raynor on his vulture. So I thought, 'Let's do that—let's take a Metzen drawing and reimagine it for *Frontiers*.' And the one we chose was the prospector because no one really knew who he was. He was just a random character who showed you a different side of the *StarCraft* world that wasn't all big mechs and aliens—just this guy making do on this planet."

Arn painted the piece, with principal concept artist Peter Lee providing the background. And while the painting was used as the cover for the *Frontiers* pitch deck, the *StarCraft* shooter was ultimately abandoned in favor of another first-person shooter concept, set in an entirely new universe, a game called *Overwatch*.

The tough-as-nails cowboy-prospector, however, lingered in the team's consciousness, according to Tsang. "When we started *Overwatch*, it was like, 'Hey, what if we made that guy into a hero?' So we translated that character into McCree."

The character has been a huge success, and he's one that holds a deeper meaning to many team members, including *Overwatch* art director Bill Petras: "The attitude of McCree and his personality are very Blizzard to me. Blizzard often creates design themes that have an edge to the design, making them memorable. McCree rounds out our hero lineup: He's a mysterious gunslinger, but also a reflection of a *StarCraft: Frontiers* concept of the Prospector—a true badass."

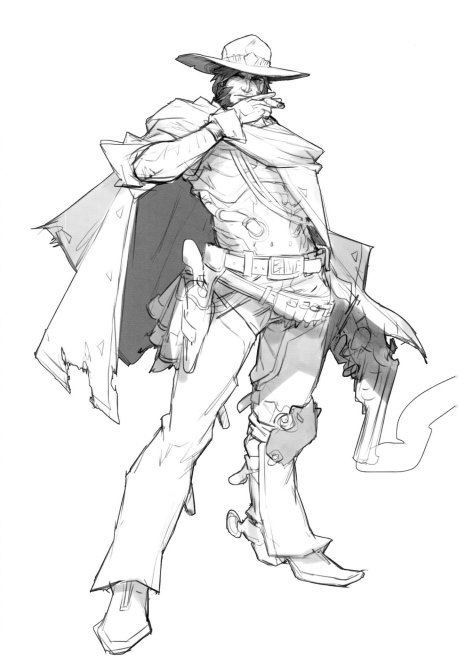

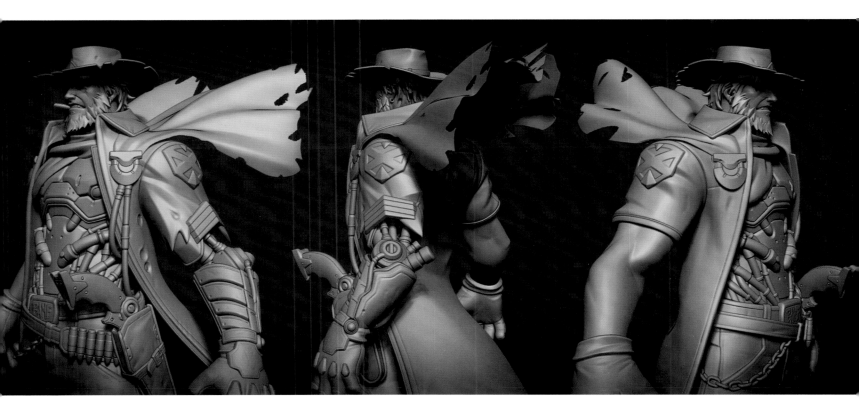

TOP: Arnold Tsang
BOTTOM: Renaud Galand
OPPOSITE: Will Murai

97

BLOODLINES:
NAME RECOGNITION

BACK when Blizzard had finished the *Warcraft* real-time strategy game and was considering new titles to pursue, former senior vice president, story and franchise development Chris Metzen and former vice president of art and cinematic development Nick Carpenter began working on a pitch, a first-person shooter set in a world of vampires, called *Bloodlines*.

Metzen wanted to build worlds with big, grinding story lines, and he loved the thought of mixing vampires with science fiction. "I came up with these dynasties or royal families of space vampires, some of them mutated and monstrous, some cool and sexy lords of the dark. They lived in this really gritty, crime-ridden science-fiction universe—spaceships, alien species—but really the civilization I was trying to frame up was at the mercy of these warring houses."

"The main character, I believe, was named Lon'Tiernan," senior art director Samwise Didier recalls. "He had a super-cool ship, and he was adventuring around and dealing with the intrigues and the politics and the infighting of all the random houses of different vampires."

There were other names associated with characters in the game, names that *Warcraft* fans might recognize: Tichondrius and Mal'Ganis.

"I didn't want them to have the normal compound-noun space names," Metzen says. "The *Bloodlines* postgothic aesthetic led me to names that wanted to sound like they were ancient but were really just mashed up and riddled with apostrophes. Many of those names worked their way into later content."

Metzen and Carpenter created 3D demos, design work, and concept art. Metzen recalls that the president of Blizzard at the time, Allen Adham, had other plans. *Bloodlines* was going to be a big lift, and it would need a lot of time, money, and manpower to get to the next level. *Bloodlines* was ultimately shelved as the team shifted focus to what would become *StarCraft*.

Tichondrius and Mal'Ganis endured, to be later reincarnated in the pseudo-vampiric form of the nathrezim: "In *Warcraft*, nathrezim are basically vampires," Samwise says. "They steal souls and energy and things like that, so we were able to take the name and a similar idea and bring it into *Warcraft*. Then we just did a *Warcraft* version of it instead of a sci-fi version."

While the vampires did survive, albeit in a new form, Metzen ponders an alternate scenario, in which *Bloodlines* forged ahead: "Imagine that having gone another way. We could have been another kind of studio that chased more one-off story ideas as opposed to big franchise ideas."

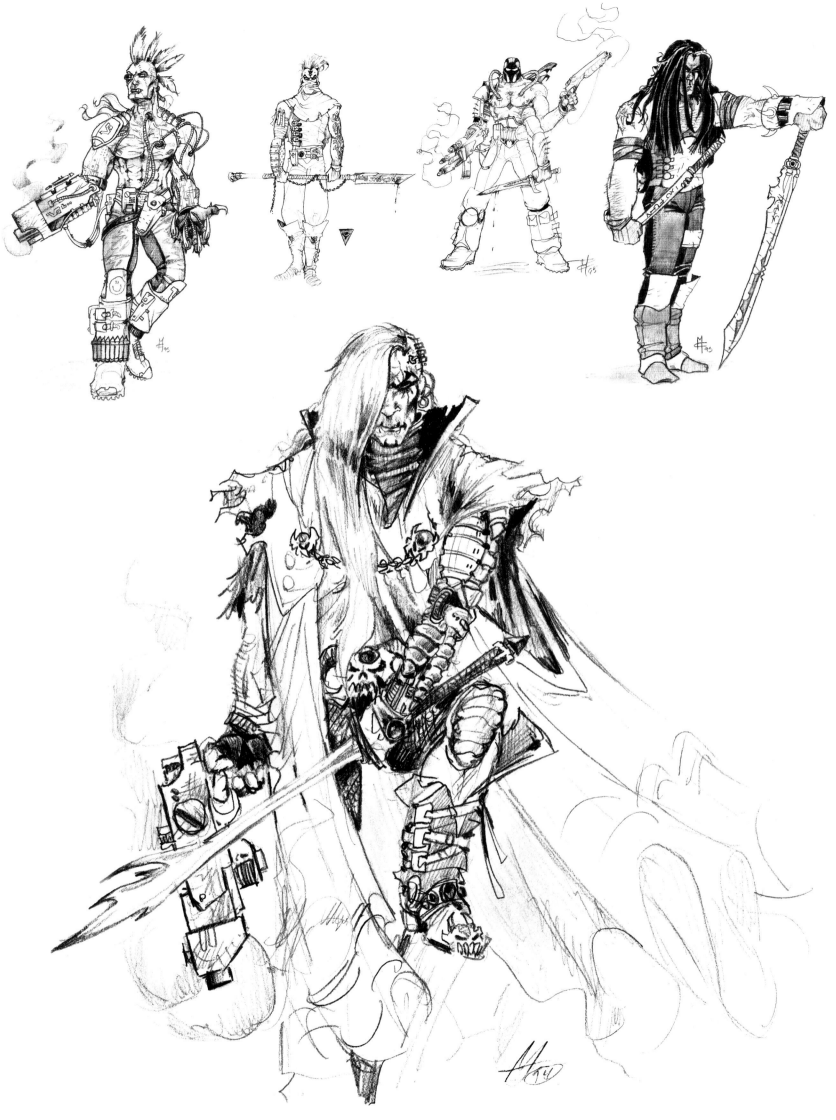

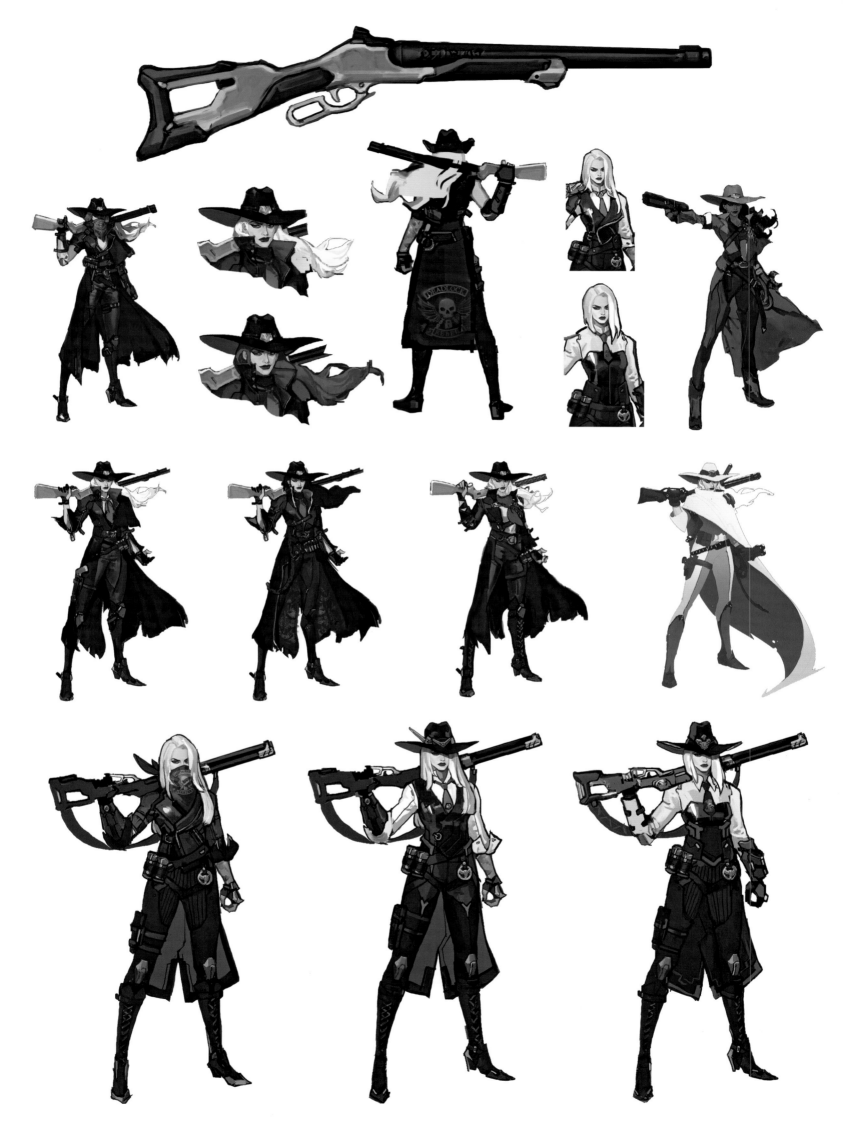

THIS PAGE & OPPOSITE, TOP & MIDDLE: Jungah Lee
OPPOSITE, BOTTOM: Mio Del Rosario

THE UNEXPECTED RISE OF ASHE

WHEN the *Overwatch* team decided to debut its new hero, Echo, work began on an announcement cinematic. Senior concept artist Jungah Lee created a supporting cast of characters for the main stars of the piece, Echo and McCree.

Among those supporting characters was a tough talker named Ashe, the boss of McCree's old gang, the Deadlock Rebels. Lee gave Ashe a strong look, a chopper, and a hulking omnic sidekick named B.O.B. (short for Big Omnic Butler).

"For the look of Ashe, I was inspired by the map, Route 66," Lee says. She also built and sprinkled in a layer of backstory: "I made a little illustration for a scene where you see Ashe's motorcycle instrument panel; she has an old photo of her, McCree, and B.O.B. playing cards. McCree was ripped from the photo when he left the gang, but it's been taped together again to show that maybe she can't quite let him go."

While the adrenaline-fueled cinematic "Reunion" was a hit, ultimately Ashe and B.O.B. stole the show—*literally*. The *Overwatch* team delayed adding Echo to the game in favor of making Ashe the new hero, with B.O.B. as her ultimate ability. It was a first for *Overwatch*—a playable hero who emerged not from game development but from related media.

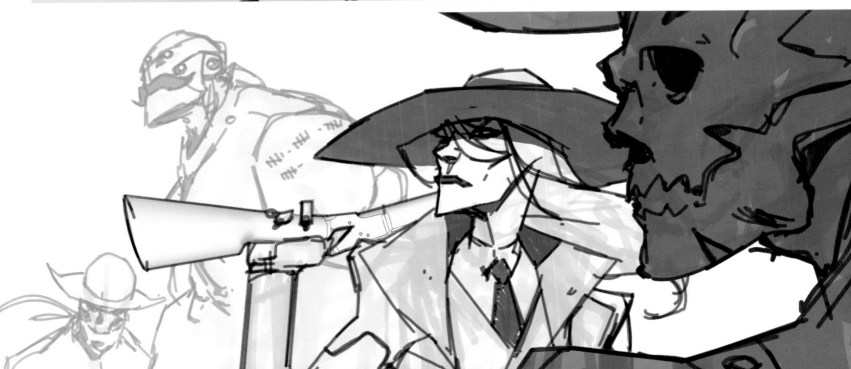

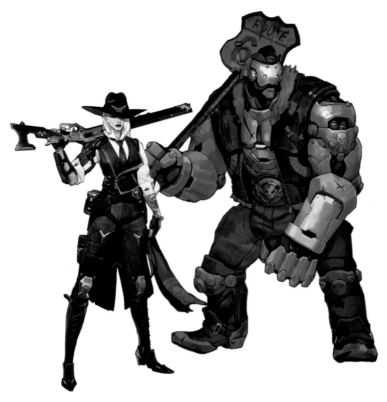

LEFT: Jungah Lee
OPPOSITE & BOTTOM: Blizzard Animation

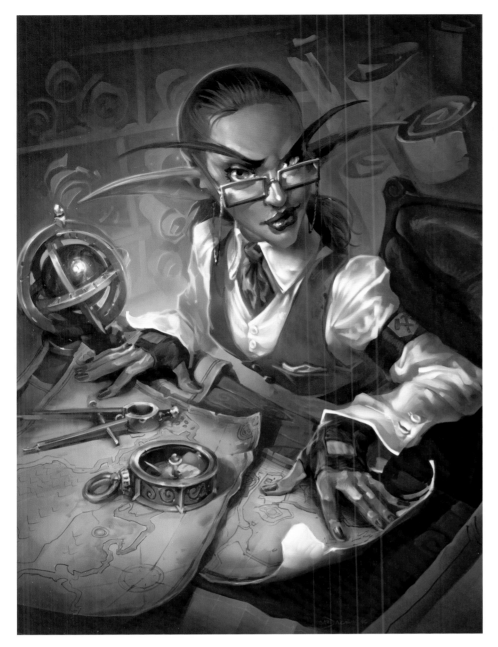

EXPLORING THE
LEAGUE OF EXPLORERS

SOMETIMES the transition of characters from one game to another opens up new possibilities.

When *Hearthstone* began work on its *League of Explorers* set, the character of Brann Bronzebeard provided a bridge both to *Warcraft* and to the exact high-fantasy/adventure flavor the team wanted. Former Hearthstone creative director Ben Thompson looks back: "I mean, who *doesn't* love a fedora and whip—those elements that point to high adventure: overgrown jungles, cutting through the brush to find the temple where some golden artifact is found. Brann became a touchstone to so many things that are present in fantasy, but in an adventure story specifically. *League of Explorers* felt like a good place to go with the expansion, but we needed an ensemble cast."

To build that cast, the *Hearthstone* team created their own set of unique adventurers. It was the first time the *Warcraft*-based

game would feature homegrown characters with substantial backstories and personalities, rather than just a face on a card.

"We had Brann Bronzebeard, Sir Finley Mrrgglton, Reno Jackson, and Elise Starseeker," Thompson continues, "and they played off one another really, really well. You get the sense of adventure, the arrogance, the innocence, and the educated, strong leader."

Elise was a surprising leader to some, who expected that Brann, as the known character, would take the reins. Thompson challenged these notions: "In many ways, Elise was the mind and heart of the whole team. Brann was our link to *Warcraft*, but through Elise we were able to speak with more of a *Hearthstone* voice. She will always be my favorite of the four."

LEFT: Luke Mancini
TOP RIGHT: KD Stanton
BOTTOM RIGHT: Laurel Austin
OPPOSITE: Max Grecke

THE LOST VIKINGS AND BLIZZARD'S LEGACY OF DWARVES

DWARVES and Blizzard games seem to be inseparable; it's a connection that stretches all the way back to the first Blizzard games. While the Vikings from *The Lost Vikings* weren't technically dwarves, their design was heavily influenced by dwarven designs from mythology and folklore. And as time went on, something about dwarves stuck.

One of the Vikings, Olaf the Stout, was the first to make an appearance in another Blizzard title—*Rock n' Roll Racing*—but it certainly wasn't the last fans would see of them. Later, the Vikings' look would heavily influence the development of the dwarven race in *Warcraft*, from which several prominent characters—including the aforementioned Brann Bronzebeard—would make their way into *Hearthstone*. So how did Blizzard become so synonymous with dwarves, and are they featured in every IP?

"Not every game, just the ones I'm involved in," jokes senior art director Samwise Didier. "For *StarCraft*, that character was Rory Swann. He wasn't a short, heavily bearded guy, but he had the thicker proportions. We wanted to get different shapes in the game so you could immediately see who's who between Raynor, Tychus, and Swann, because in some levels you control all three."

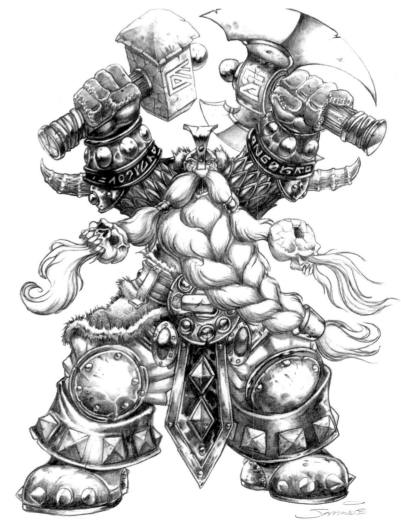

THIS PAGE & OPPOSITE, TOP: Samwise Didier
OPPOSITE, MIDDLE: Marcelo Vignali
OPPOSITE, BOTTOM: Blizzard Animation

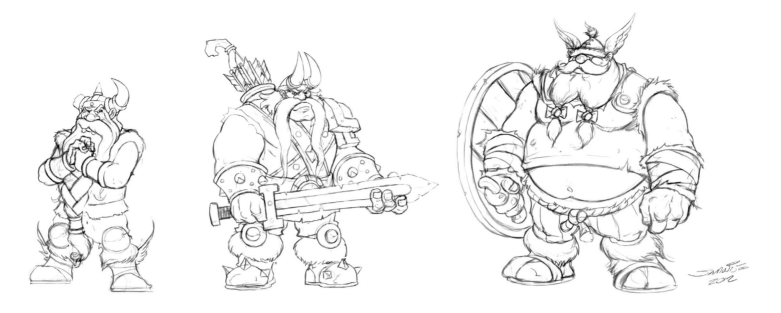

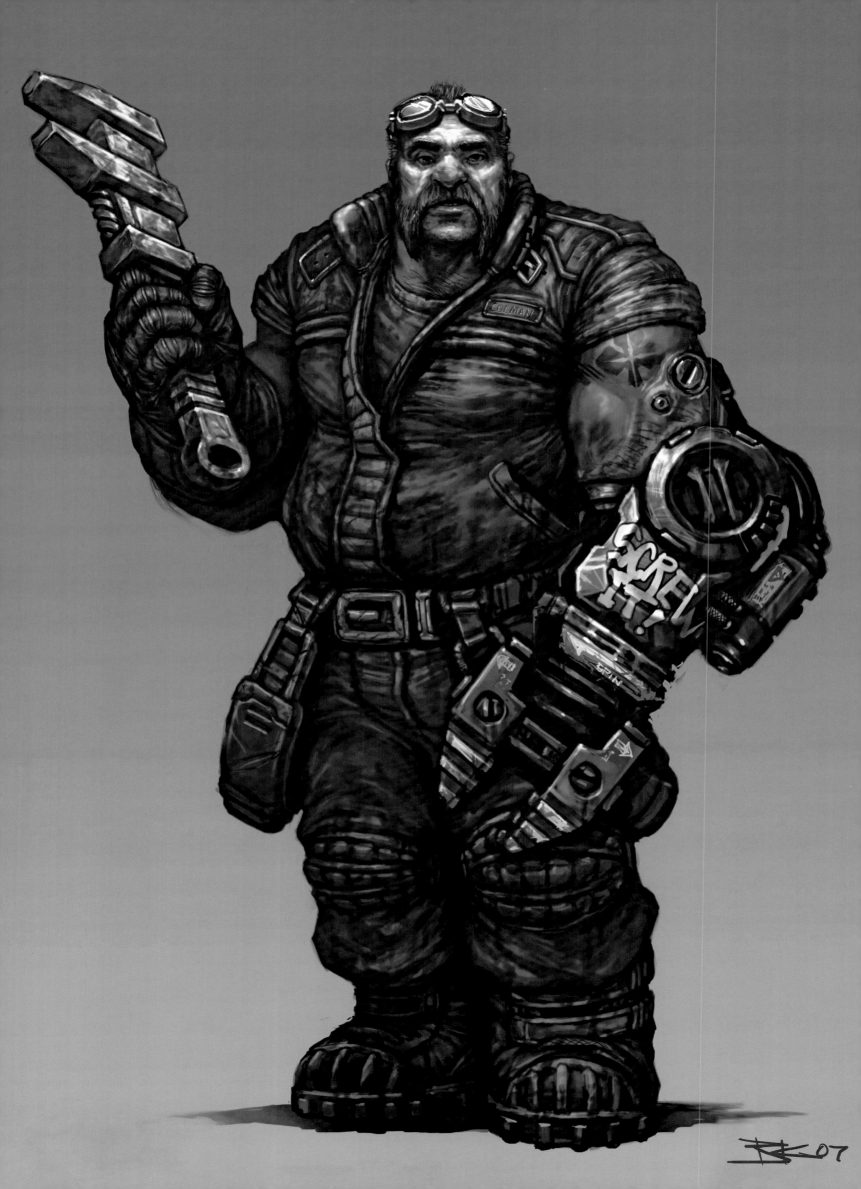

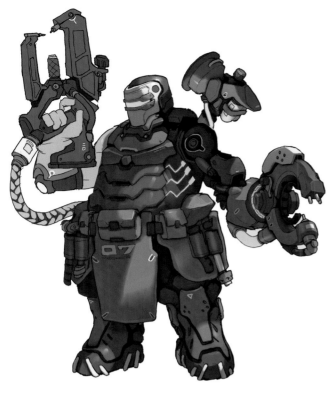

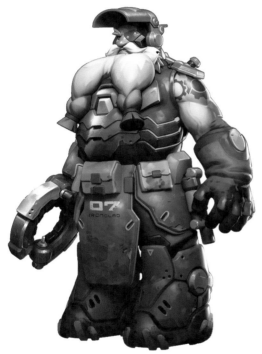

And then, of course, there's *Overwatch*. Early in the development of the game, the team was looking for a bridge to other Blizzard properties. "Back then, when you saw someone like Tracer, you didn't immediately go, 'Oh, that's made by Blizzard,'" Samwise notes.

That bridge came in the form of Torbjörn. *Overwatch* character art director Arnold Tsang weighs in. "There was a class in *Titan* called the mechanic, and he looked a lot like Torbjörn except he had this welding mask on. You couldn't see his face, but he had those *Warcraft* dwarf proportions—short and stocky, big belly, super-thick arms—but he didn't have the big beard, so we said, 'Let's take this mechanic, slap a dwarf head on him, and see what happens.'"

Tsang then took their concept to Samwise. "We showed Sammy our character, and he's like, 'Yeah, that's not dwarven

enough,' so he ended up making him like twenty-five percent wider and just way cooler than what we had. We incorporated almost everything he threw at us." And bringing things full circle, Torbjörn was given a backstory rooted in Scandinavia, complete with a Viking skin.

Ultimately, Torbjörn offered more than just a tie-in to Blizzard's style: he provided a test case for *Overwatch* artists to perfect the game's overall style as well. Former lead character artist Renaud Galand fondly remembers: "Through that character we consolidated the style that we wanted for the game. When it comes to the art style for the sculpting, the painting style, the texturing—all of those elements that would end up being on players' screens were to some extent started while making that very first model that happened to be Torbjörn."

That's a lot to come from three lost Vikings.

TOP LEFT: Arnold Tsang BOTTOM: Renaud Galand, Arnold Tsang
TOP RIGHT: Ben Zhang OPPOSITE: Bernie Kang

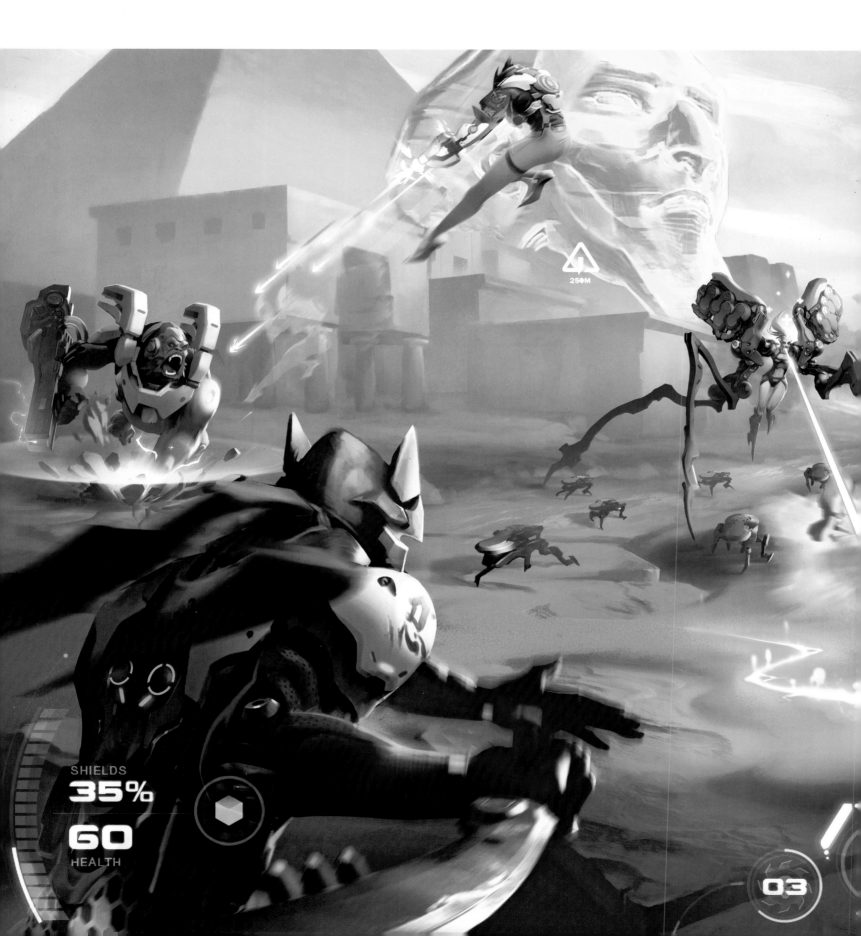

Everyone knows the old saying, "A picture's worth a thousand words," but in game development there has never been a phrase so true. Art has the power to take disparate elements of a game and meld them into a cohesive whole. One carefully crafted image can communicate a host of ideas, establish a specific theme, and unite individuals behind a central vision.

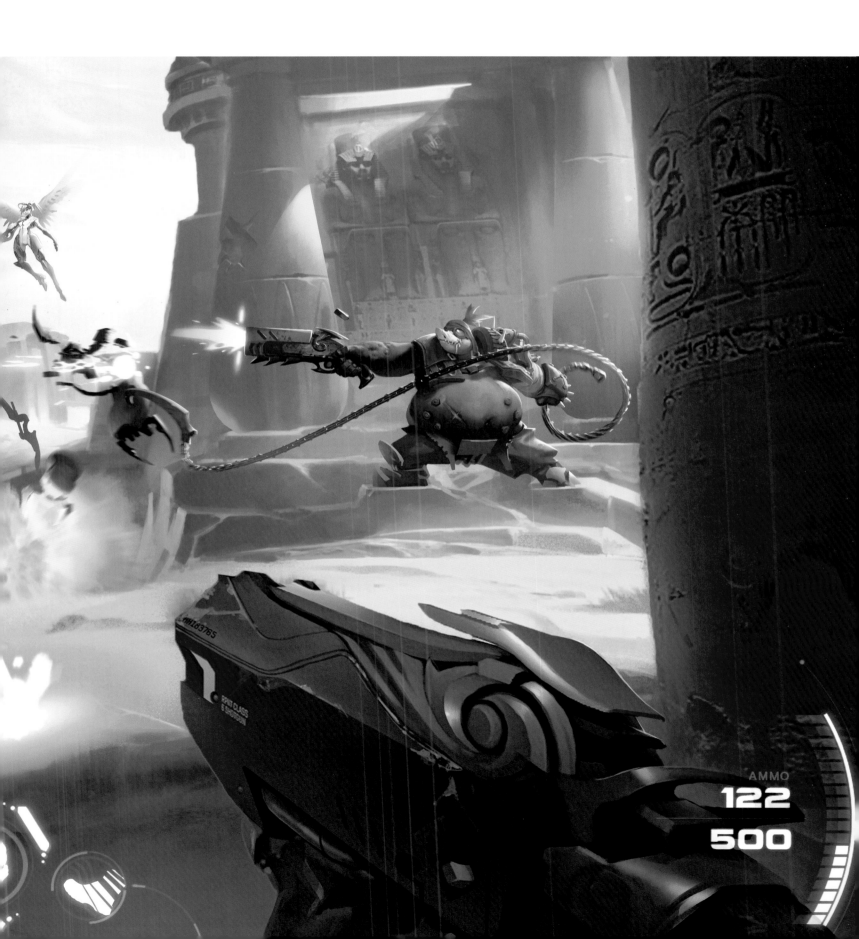

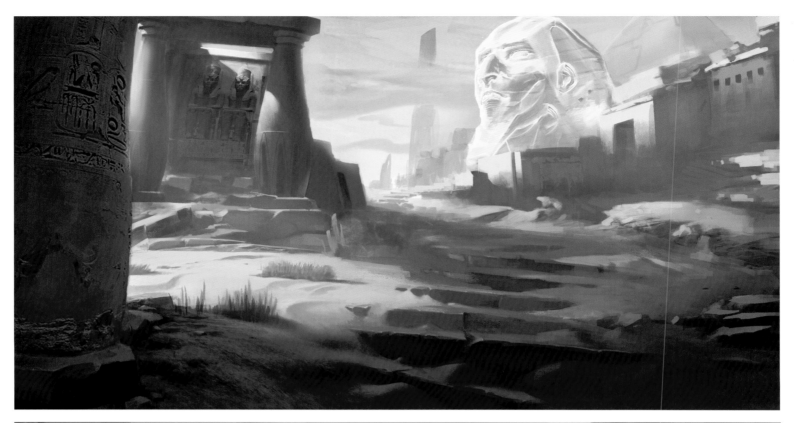

CAPTURING A NEW IP

EARLY in the development of *Overwatch*, the team focused on the unique DNA of the new universe. A senior concept artist at the time, Ben Zhang, put together an artistic mock-up of gameplay that not only helped establish the look and feel of the game—it laid a foundation for the entire world of *Overwatch*.

Overwatch character art director Arnold Tsang elaborates, "When you're making a new game, especially a new IP, one of

the most important pieces of art early on is an imagining of what the game will look like." The image needed to showcase the first-person shooter perspective and the different heroes using their abilities within a diverse and visually engaging, futuristic world. "We had a couple of the heroes already, and we thought, 'How can we make an image that shows the type of gameplay that we want and how exciting it is?'"

For *Overwatch* senior art director Bill Petras, the piece was key to ensuring the team had a clear goal to aim for. "After coming off *Titan*, it was imperative that we always had a target as

far as visual direction. Within that picture, it was important to show what the game would feel like. Not just the art, but what *kind* of game is it? 'Oh, I'm a first-person player, I see. I'm shooting at these really unique heroes. They all look different and diverse with different abilities. I get it. The world, it's got some sci-fi, it's a little futuristic, but relatable.' *Relatable* was really important for us."

Another element illustrated by the art piece is user interface. For a game like *Overwatch*, the UI needed to be simple, elegant, and unobtrusive, so as not to interfere with gameplay.

This was another area where previous work on *Titan* came in handy. Tsang noted, "The UI, I think, was from *Titan*. It's what we were working with at the time, so we superimposed it over the image to make it feel like you were in the game."

A HOPEFUL
BUT DANGEROUS WORLD

ONE of the most critical elements of the mock-up came in communicating the overall message of *Overwatch*: "This is a future worth fighting for." A bright and hopeful future, however, doesn't mean a lack of danger. Yet another benefit of Zhang's piece was to communicate a specific level of peril.

"It shows the lethality and balances the hopeful tone of the game," Petras explains. "Even though the colors are bright and beautiful, these heroes deal a lot of damage. We wanted to have an edge to the world, and I think it proved that out. The other interesting thing is we didn't want it to be overly gory—it's not like people are going to get eviscerated, blood everywhere. We wanted to have the lethality, but in a way that was more approachable."

114 ALL IMAGES: Arnold Tsang
OPPOSITE, BOTTOM RIGHT: Arnold Tsang, Joe Peterson

THE EVERGREEN APPEAL OF MOUTH LASERS

THE mock-up also showcased something that would come to define the gameplay of *Overwatch* in the years to come: the limitless possibilities—and endless replay potential—that came from a team of diverse heroes.

"We wanted every hero in this piece to be super different, to show the frenetic gameplay," Tsang explains. "So you see Tracer blinking. We had Winston doing his leap. Genji—this was before Genji and Hanzo were split into two characters—was the assassin. Reaper in first person, he's only got one shotgun—I think because we wanted to show Genji in there, but we always imagined Reaper with two. Roadhog is using his hook, and then Mercy's back there, still based on the old Valkyrie design that had red armor."

While most of the characters in the mock-up transitioned to *Overwatch*, there is one notable exception. "The one in the middle's a character from *Titan*," Tsang recalls. "I think she was called the Recluse; she was this cybernetic spider lady with a mouth laser. I still want to make that character. I think she's really cool. She's sending out her spider bots. We've tried to bring the mouth laser back so many times . . . It's hard in a first-person shooter because there's no mouth in first person, so it doesn't make any sense. We tried a version of Echo's Focusing Beam that came from her face, but it didn't work."

TAKING NOTES

ONE of Blizzard's core company values is "every voice matters." The team applied this from the outset of *Overwatch*, soliciting feedback from other game teams. They took *Overwatch*'s pitch, visual, and game guides to various directors in a sort of traveling roadshow, with their sample screenshot as the first or second page.

The roadshow produced some eye-opening revelations. Petras recalls one in particular, which demonstrated the importance of concept art. "On Tracer, our concept had very exaggerated legs, and we actually shortened her legs a bit because we were worried it might look too awkward in the game animation. We showed it to the cinematics team when they were building the Tracer model for the announcement cinematic, and they said, 'Why did you guys lose the stylization in her legs?' Cinematics helped us realize, 'Wait a minute, go back to the concept, go back to the model. If it's a great idea and you love it, then follow it.' We learned to stay true to our original vision, make it very clear, and make it our champion on the visual side. Always have that concept to point back to."

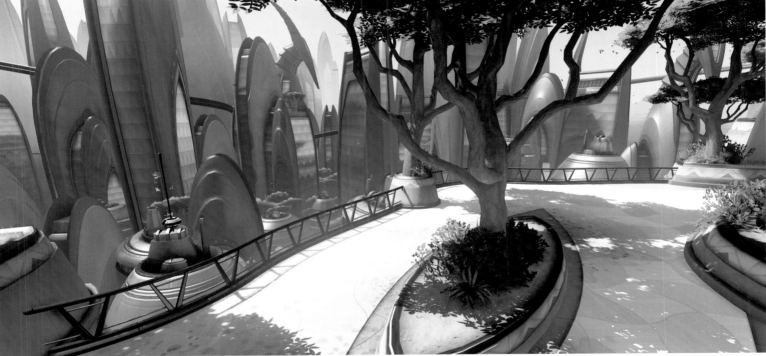

HEAVY LIFTING

TONE. Color palette. First-person shooter. A bright and hopeful futuristic environment. A dangerous world, but not gory. User interface. Visual effects. A diverse cast of characters exhibiting myriad abilities. A near-future world featuring exciting and familiar real-life locations.

These are all the building blocks that would come to define *Overwatch*, and all were captured in a single key image. For the entire team, the mock-up was truly a critical piece of art, as

attested to by Petras: "That was a very powerful piece for us. We would always look back on it and point to it. It's difficult to work with a lot of unknowns on an image, and Ben did such a good job. What's important about an image like this is you can talk all day long and write design docs about the type of game you want to make, but no matter what game it is, you have to do that screen mock-up. It was a huge lesson from *Titan*, to always have an achievable visual target as soon as possible."

CHAPTER **TEN**
WORLDBUILDING

World of Warcraft marked a watershed moment for Blizzard. For the first time, developers were no longer limited by the isometric view of real-time strategy games, and instead they placed fans in the heart of Azeroth. On the ground and in the air, players set out to explore the world as never before . . . a prospect that presented both new opportunities and new challenges for the artists and developers constructing the world around them. As Blizzard learned, in a world of seemingly limitless possibilities, artists still have to keep up with growing worlds, evolving game mechanics, and curious players looking to test every boundary.

FIRST STEPS

ENVISIONING Azeroth from the ground level was no simple task. What should the scale be? What should the style be? How much detail was called for?

One of the first major steps in conveying player view came in the form of concept art, specifically a piece depicting Stranglethorn Vale illustrated by senior art director Bill Petras.

"It was really important to show that the world has a lot of character, to make the world unique and memorable," Petras explains. "You spend a lot of time looking at the land form itself—the ground. I was definitely inspired by the tilesets from *StarCraft*, how detailed they were. For Stranglethorn, I wanted to show the vines on the ground, give the ground plane a unique, handcrafted, gnarled feel."

Petras also wanted to impart a sense of exploration. "I wanted to show that there's an ancient world for the player to discover. If you look hard enough, you think, 'What's that shape? Is there a face on that idol? Was there an ancient civilization here?' It was also meant to show the depth and scale of the world, and immersion—the feeling that you could be discovering the world through that image."

The finished piece proved to be a visual rallying point for the *World of Warcraft* art team. "You can sit a group of artists from different disciplines in a room and tell them to use *Warcraft* RTS as inspiration, but to make it third person and much more expansive," says senior art director Chris Robinson. "But what are the mountains going to look like in the background? Will it be overly detailed and lush or cartoon-style and simplified? The magic of the Stranglethorn piece is that, rather than using words, where everybody's going to execute their own version of what they think they heard in that meeting, Billy provided a target that other people could look at and get the visual language. It's a thousand times more effective."

The picture acted as a keystone not just for the team but for employees in general. Senior art director Samwise Didier remembers, "It immediately put in my mind what this game would look like: beautiful, bright, vibrant colors; rendering with more style, not so realistic where it felt like we were trying to copy reality. The way I usually say it is that the image made me feel like I was in a theme park, waiting in line to go into Stranglethorn Vale."

Perhaps more importantly in Samwise's eyes, the image achieved Petras's central goal: portraying character. "The environment is the largest character in the game. When players walked from one environment to the next, we wanted to make sure it wasn't just a rehash of the place you were just in. We wanted each of these environments to feel like a new character that you were going to be spending some time with."

Principal concept artist Peter Lee also espouses the philosophy of environment as character: "You design a cool character because you want people to be more engaged with the game. Same thing with the environment. The philosophy is similar in my mind—think about the shape designs, the flow of the piece, the color balance. Different fundamental knowledge is needed, but at a higher level, the goal of creating these pieces should be the same: to help make the best game experience."

THE PATHS MORE TRAVELED

SOMETIMES the aesthetic established in concept art can be lost in the translation to in-game, 3D geometry. One early goal of *World of Warcraft* was to maintain the conceptual style.

"A lot of environments in *Warcraft* generally rely on a hand-drawn look," says Samwise. "So even if the models are done in 3D, we still want them to feel sculpted. We don't want them to feel like they were machined with fine bevels and edges and razor-sharp markings. We want things to look like they were sculpted by a real sculptor or painted by a real painter, so a lot of the concepts can be used as an exact reference to what the model would look like."

The job of bringing environment concepts to life in the game fell to specialists like principal level designer I Gary Platner. "As we started to make more zones, Bill would do a key piece that the two of us would jam on," Platner remembers. "Then I would take his piece and color-match the fog and the sky and get the lighting just right. The concept was the cornerstone to everything."

Having fully colored, beautifully illustrated environment concepts to work from also served more practical purposes in terms of efficiency. "We knew if we had a concept and everybody liked the mood and the colors of it, we could get close to duplicating it in-game," Platner reflects. "As tools became better, we did a better job of making the visual things come alive, but we always relied on the concept piece."

From there, level designers concentrated on telling the story of the game through environments. "With *WoW*, we wanted people to do things and understand the story without looking at a manual, without looking at anything," says Platner. "They should just be able to look at the world and know the story and know where to go or who to talk to."

In an open world where players could venture almost anywhere, it quickly became important to learn methods of guiding players along optimal paths for the best storytelling and gameplay experience. Platner noted his favorite part of the work was helping the cinematic, linear storytelling and game direction unfold through the world itself.

Platner applied lessons learned from experts in guiding crowds through theme parks. "People in theme parks can go wherever they want, so it's the same thing," Platner notes. "At a theme park attraction, the story starts in the line and gets more concise until all you see is the story of that attraction, and then you move on to the next. I could do these things as a principal level designer, to help guide our players, reward them, and then give them little hints on where to go next."

The team's focus on environmental storytelling continues to this day, including in the *World of Warcraft: Shadowlands* zone Ardenweald, described here by lead environment artist Tina Wang. "Ardenweald was described to us as a 'magical forest where nature spirits rest for rebirth,' which gave us fun opportunities to shape the details of the story. We leaned into the idea of a celestial forest and emphasized the themes of rest and slumber by creating these giant trees with canopies and branches woven into shapes inspired by dream catchers."

TOP: Natacha Nielsen OPPOSITE, TOP: Sukjoo Choi
BOTTOM & OPPOSITE, BOTTOM: Gabriel Gonzalez

SKY'S THE LIMIT

WHEN flying mounts were introduced to *World of Warcraft*, many of the rules generated for guiding once-grounded players went out the window.

"Adding the sky and flying mounts changed everything," Platner confides. "The player suddenly had a different perspective that we didn't have any control over. And at the time we first introduced that, either you couldn't see very far or you could see things we never intended for players to see."

A significant amount of game art had to be modified. "The biggest thing we had to do was rebuild Stormwind, because it didn't have any rooftops," says Platner. "Back in the day, we only built what was needed. A lot of things were facades or didn't exist beyond what the player could see or get to."

Years of work went into Stormwind's reconstruction, most of it not readily apparent to players. "There wasn't much to show for it," Platner says, "except that players could land on rooftops they assumed had been there anyway."

Every time the game adds a new playstyle or unique gameplay-related story elements, the team must either create new technology or revisit the old. Even *Shadowlands*, which largely was about building a set of new zones, had to introduce new visual rules around transporting players between worlds.

But beyond expansions, it probably comes as no surprise that players often like to go where they're not supposed to. For level designers, it's a constant battle between making everything look good from every possible view and players who test the limits.

"It's always a struggle to keep people from seeing behind the curtain," Platner admits. "Players will always try to get where they shouldn't, through whatever crazy means. Sometimes we'll hide a reward for players in difficult-to-reach places."

EVOLVING DOOR

"I like to think that if we never had a Dark Portal, we never would have had a **Warcraft** *game,"* Samwise laughs. *"That was the origin of the Alliance's real troubles . . . when the big green machine, the orcs, came in! Without the Dark Portal, it was more or less smooth sailing."*

As with many buildings and doodads (props like rocks, trees, etc.) in the **Warcraft** real-time strategy games, the Dark Portal had humble beginnings.

Samwise continues: *"When we were coming up with the ideas for it in* **Warcraft II**, *it was more or less smooth sailing."*

For incarnations of the Dark Portal outside the RTS games, such as the book cover to **Warcraft: The Last Guardian**, more detail and character was added.

"It needed to look unique and something that wasn't necessarily of human origin," Samwise explains. *"Something different. At the time, 'something different' was two sort of spectral dudes hanging out at the sides, with swords and braziers under them and above them, and a serpent infinity symbol. We didn't spend too long on it at the time, but as we've developed the lore, we've taken time to push it. For* **Burning Crusade** *when we did the portal again, Peter Lee worked with the* **WoW** *team to make it feel very orcish, and that's a better rendition of it than the original, in my opinion."*

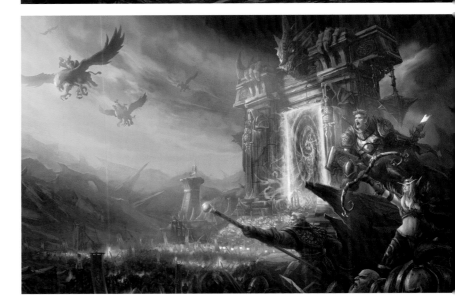

LEFT: Samwise Didier
RIGHT: Peter C. Lee **125**

LIGHT, AND DARK PLACES

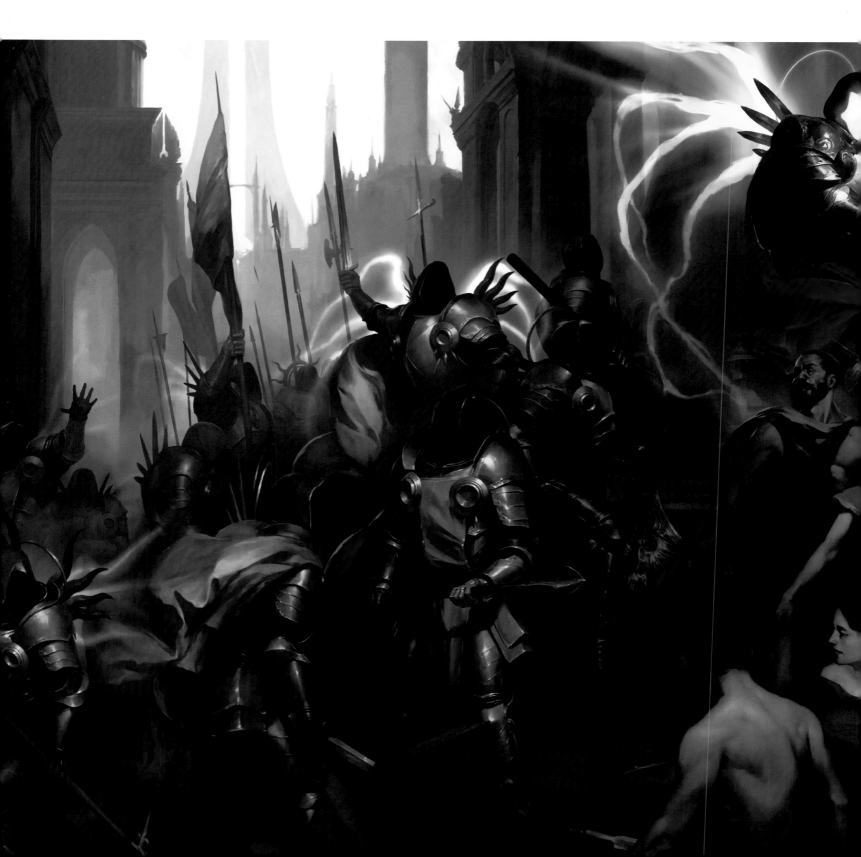

Lighting is an often-overlooked aspect of game art. On the practical side, it illuminates the player's field of vision and is integral to effective level design. But look closer and you'll find that how a game is lit can impact the player's emotions, convey the intended tone of the game, and serve as a beacon of hope . . . or despair. In this chapter, we'll take a closer look at art and lighting in *Diablo*.

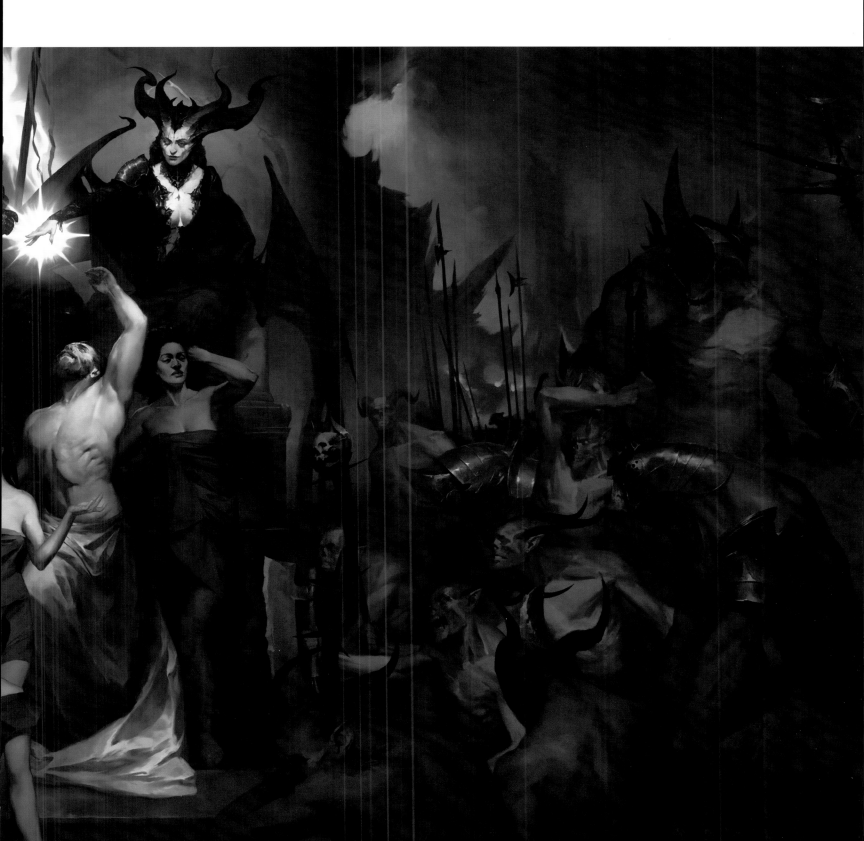

DIABLO: THE DARKER SIDE OF LIGHTING

IF there's one thing that's integral to *Diablo*'s inherent horror, it's the idea of being alone, at the mercy of the ancient, all-powerful, unforgiving forces that lurk in the dark. That's the message conveyed by lighting in the world of *Diablo*.

Wherever you go in *Diablo*, your character is ensconced in a cone of light. While this effect is a bit more subtle when you're walking around, say, Tristram, once you find yourself in one of the game's many dungeons, the lighting not only enhances the feelings of suspense and impending doom—it becomes a critical component of the gameplay.

In many of the game's dungeons, the area outside your character's cone of light is varying degrees of darkness, all the way to pitch black. Monstrous enemies lurk unseen in the shadows and may attack your character from any angle, at any time, either singly or in groups. In these scenarios, fear of the unknown is ratcheted up to its highest, scariest level, and it's the game's lighting that does the heavy lifting.

KEEPING IT REAL

From the beginning, a sense of realism has made *Diablo* one of the scariest games around; when the world feels real, the threats feel real. For *Diablo IV*, the team wanted to honor the realism that had become a hallmark of the franchise.

"Lighting is something that's always been iconic in *Diablo*, and we've really tried to do the best version of that in *Diablo IV*," says *Diablo* art director John Mueller. "We wanted to lean into the parts we loved about *Diablo II*—the dark, gothic, gritty, realistic setting that they depicted. It gave the world a much higher threat level because you could relate to things; you could relate to the dark forest, and you could relate to Lut Gholein, and you could relate to the different hubs and towns. Lighting is the thing that drives atmosphere. And atmosphere, when people think about *Diablo* and when we say this is a return to darkness for the franchise, it is physically about the light and the amount of light and brightness in a scene, which really translates to mood."

In crafting *Diablo IV*, the team scouted real-world locations to help foster a sense of exploration in players. These surface areas are rooted in nature, bright with stark landscapes of snow and ice, colored with lush areas of vegetation and rain. "*Diablo*'s not a highly stylized world," Mueller explains. "It's a very grounded, dark, gothic, medieval setting, and we translate that in different ways through the lighting."

So in a world that's grounded in realism, is there any room for the extraordinary, as far as lighting is concerned? There is. And the way it's used not only tells a story—it also informs the player that the truly frightening part of this world is what lies beneath.

"We might have you go into a dungeon that's filled with cultists and they're worshipping Diablo and the Prime Evils, so I want to have the whole area up-lit with red lighting from below," Mueller says. "That raises the question of where's the light coming from? It's like a hellish magic light. It doesn't exist. It's pushing into a spectrum of color that feels a little more magical. We use light to punctuate the moment because you really feel like you're entering another world. When you're wandering around Sanctuary, it feels like the real world, but when you go in a cave or you go underground, that's when you're entering another world, one that has a lot of supernatural elements to it."

OLD AND NEW

ART-INCLINED *Diablo IV* players may detect a Renaissance feel to the game's environments. That's no accident. And yet again, lighting plays a key role.

One early example of *Diablo*'s use of classical style in key art is embodied in the painting *The Creation of the Nephalem* by senior concept artist II Igor Sidorenko. The painting features stark contrasts between light and dark, a technique called chiaroscuro, which was developed and used by early masters such as da Vinci, Rembrandt, and Caravaggio.

"The overall color scheme and how you work with light have a huge impact on mood," Sidorenko observes. "Classic artists were masters of understanding how that works. I try to keep the palettes narrow, using accents to amplify what I want to focus on. And of course, lighting is the main pointer. You use light to draw attention to a certain area."

Mueller, who's always felt a very strong connection to medieval art, encouraged *Diablo* artists to embrace classical theory and application, all with an eye toward accomplishing his goal of making *Diablo IV* a "medieval masterpiece."

Instrumental in this vision for the latest *Diablo* installment was one classical piece of art in particular. "One of the very first paintings I had an emotional reaction to is called *The Raft of the Medusa*," Mueller reflects. "It's super dark and very medieval, and the story it's telling is essentially this raft and the survivors of this wreck. Everything about that painting to me feels like what *Diablo* represents, which is this light of hope on the horizon, but you are surrounded by threat and hopelessness. But as in the painting, there are a couple people who are reaching for that light, just trying to live another day. And then there are people who have completely given up, people getting eaten by sharks."

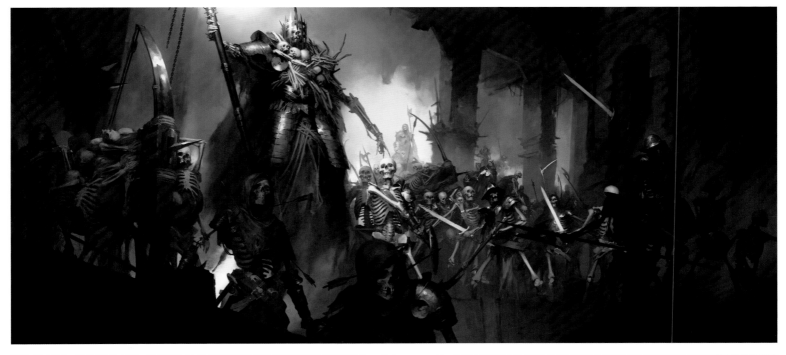

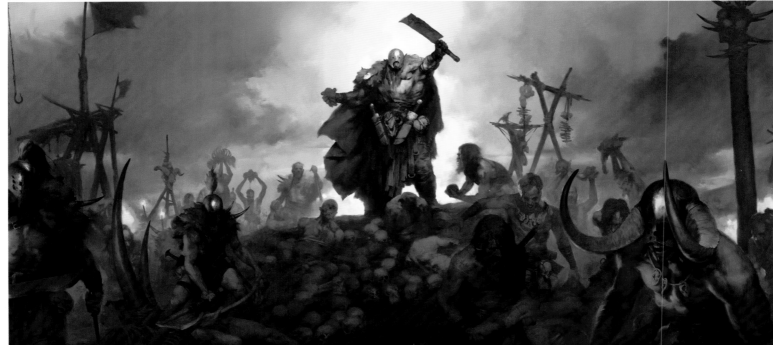

That painting was very much on Mueller's mind as he provided art direction for *Diablo IV*. "I always feel that *Diablo* is medieval, but it's not Tolkien-type fiction—there aren't orcs and elves. It's very much about mankind—angels and demons torturing man—and that's from our own world, so I look at medieval history, and I want the world to feel like that on the surface. It was very intentional, to evoke this medieval presence in the way our art was executed."

Another Renaissance inspiration is Albrecht Dürer, one of the world's first mass-produced artists, famous for his woodcut prints. "There's an older man who's in a monk's robe, and he's balding with a long beard, and he's got a book and he's telling stories, and there's angels and demons and you just feel like, 'This could be Deckard Cain,'" Mueller notes. "But it was done five hundred years ago."

Mueller also referenced a time-honored technique used in a school of painting called the Hudson River School, a nineteenth century landscape movement centered on themes of discovery, exploration, and settlement. The naturalistic palettes and lighting used by the painters of the Hudson River School once again reinforced the grounded realism Mueller wanted to express in *Diablo* moving forward.

So . . . that covers the old, but what about the new? Turns out, modern technology allows *Diablo IV* to explore lighting as never before.

"The technical term for what we're using is 'physically based rendered lighting,'" Mueller explains. "It's a fairly recent innovation in engineering, and what it means is you put a light in the world and it behaves like real light. Traditionally in games, the way we would light things was not very accurate. There's bounce light that happens, there's fills that you can use, there's different things that were not available previously, like translucency, the way light passes through objects like cloth . . . or skin. Those are again things that add a bit of believability to the lighting."

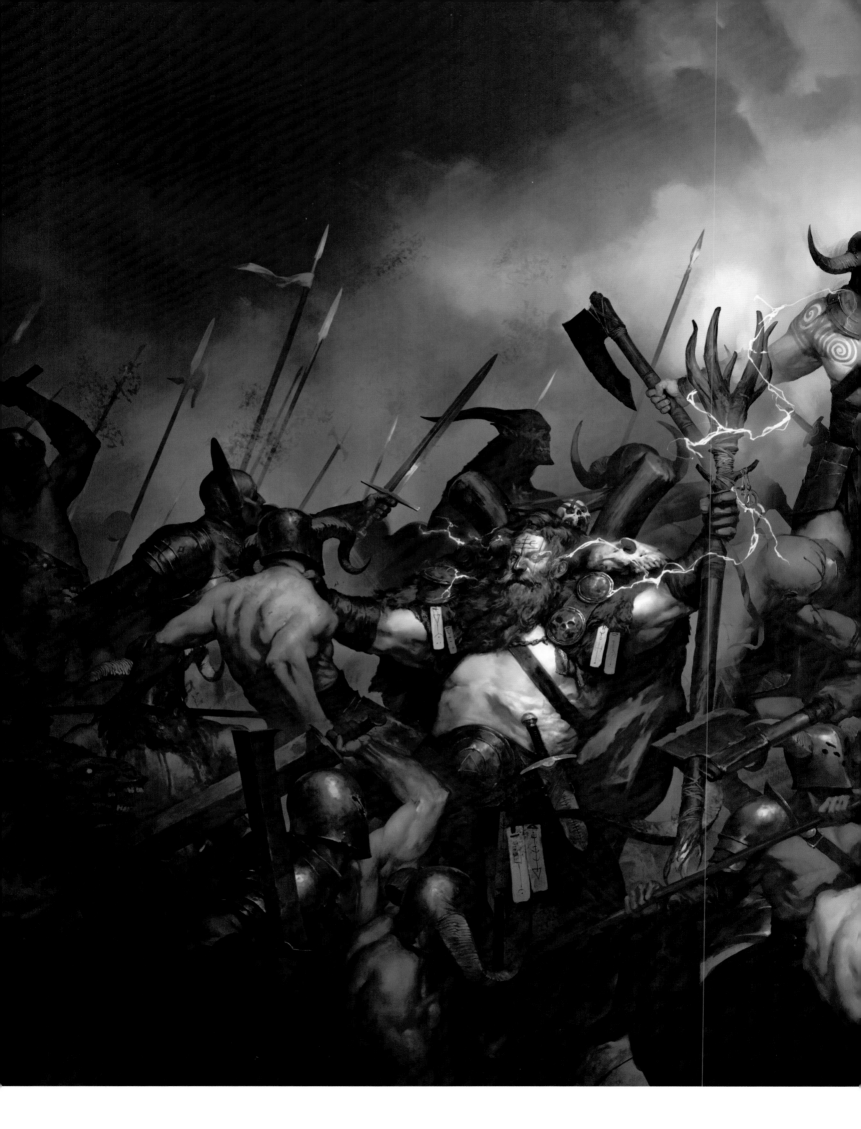

ABOVE: Igor Sidorenko

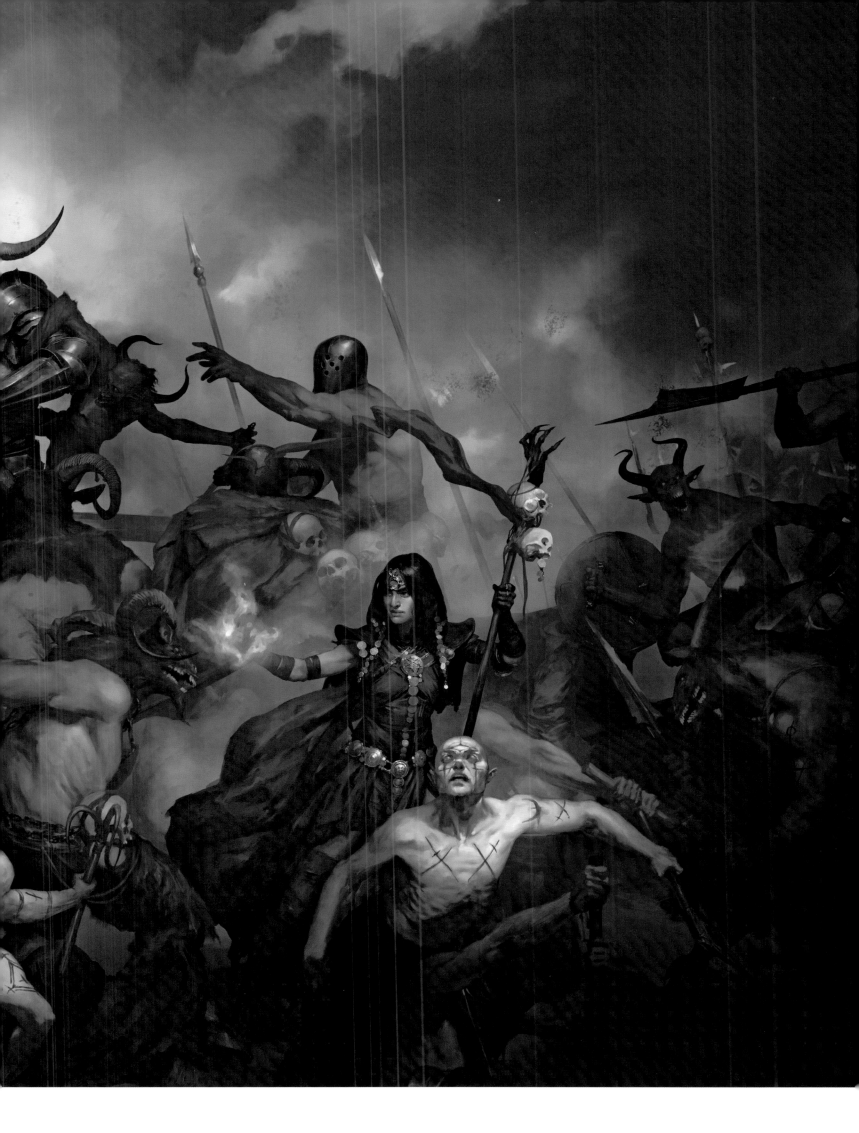

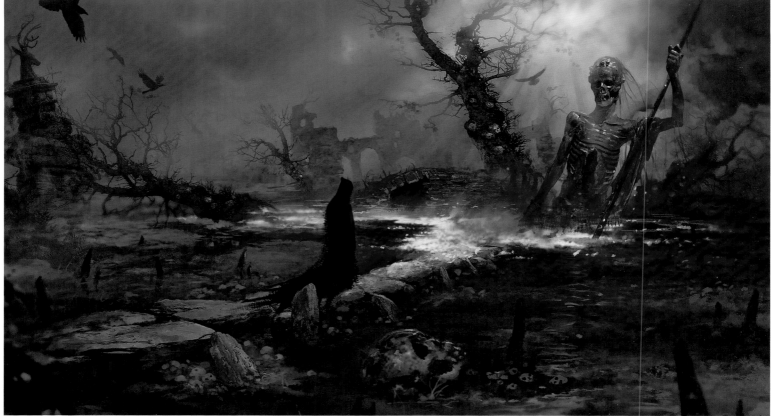

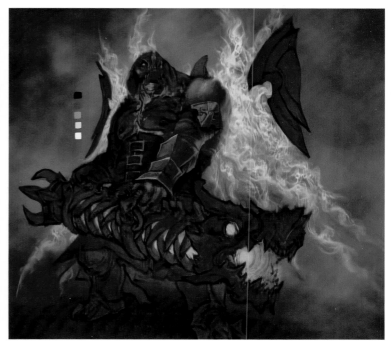

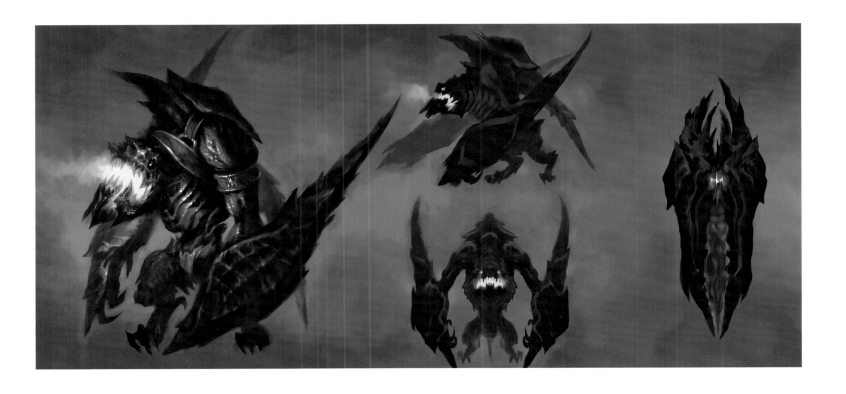

THE COLORS OF EVIL

MOOD is conveyed not only by light but also by color. No surprise, then, that *Diablo*'s color palette plays such an important role in evoking the game's warring feelings of hope and doom.

So what are the rules for color in the game, and how does an art director go about choosing those colors for a storied franchise like *Diablo*? According to Mueller, it starts with emphasis, or where to put the colors. "Because visual effects are such a big part of gameplay, that's where most of the colors exist. And that's where they *should* exist because we want that to be clear when you're in the world. If everything is colorful, it starts to feel very noisy; it's hard to follow the action."

With effects taking center stage from a palette perspective, the background becomes just that: background. "We've really pushed the environments back. I call it sit-back. I want the environments to sit back, and I want the color and emphasis to be on the spells and abilities. I wanted to get better readability so you don't feel like, 'I'm just mashing buttons, and I don't understand what's happening.' This played well with the Hudson River School approach of a naturalistic palette, not letting the colors get too saturated or vibrant. Everything sits back, so it's not trying to be the star of the show."

This subtle approach, however, doesn't mean that every background looks the same. Mueller and his team crafted unique color scripts for each zone, each dungeon tileset. "We don't ever want to repeat ourselves. It takes a lot of effort to bring those to life. I'm always saying, 'What makes this stand out? Why do it unless it's different from previous dungeon tilesets?' If you have something like a medieval dungeon, you really only need one of those. We do variants, so we have flooded or ice or overgrown roots, which really adds to the atmosphere, but we're very purposeful about how we use color in those areas."

CHAPTER TWELVE
THE FUTURE LOOKS BRIGHT

THIS SPREAD: Ben Zhang

While *Diablo* thrusts players into a world largely dominated by evil, dread, and doom, Blizzard's FPS hit *Overwatch* portrays a futuristic setting that exudes light, color, hope, and optimism, with maps that are similarly meant to reflect real-life locations and environments. But getting there was no small task . . .

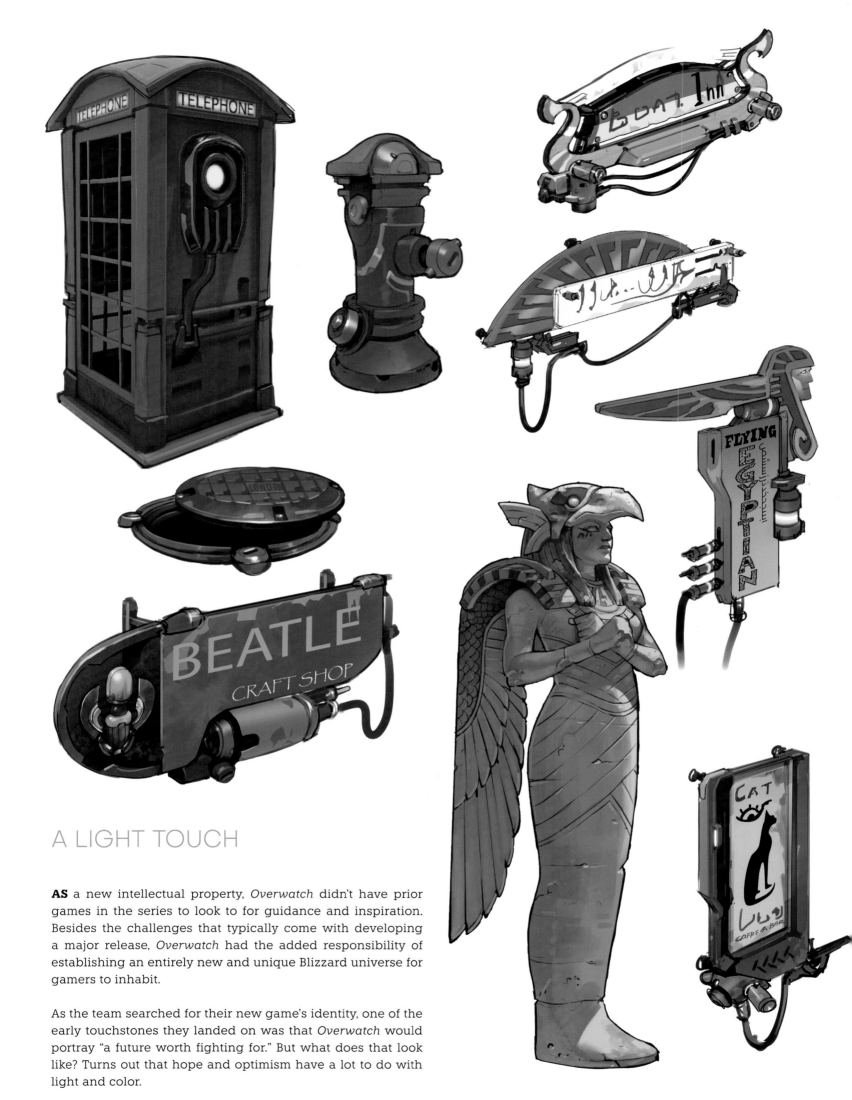

A LIGHT TOUCH

AS a new intellectual property, *Overwatch* didn't have prior games in the series to look to for guidance and inspiration. Besides the challenges that typically come with developing a major release, *Overwatch* had the added responsibility of establishing an entirely new and unique Blizzard universe for gamers to inhabit.

As the team searched for their new game's identity, one of the early touchstones they landed on was that *Overwatch* would portray "a future worth fighting for." But what does that look like? Turns out that hope and optimism have a lot to do with light and color.

THIS PAGE: Al Crutchley, Anh Dang, Arnold Tsang, Ben Zhang
OPPOSITE, LEFT: Peter C. Lee
OPPOSITE, RIGHT & BOTTOM: Ben Zhang

SPOTLIGHT: TEMPLE OF ANUBIS AND KING'S ROW

IN the beginning of *Overwatch* development, the team generated two environments as proof of concept for the precise style and mood that the artists wanted to convey. These were Temple of Anubis, set in Cairo, and King's Row, set in London. *Overwatch* senior art director Bill Petras recalls, "Working closely with [associate art director] Dion Rogers, there were a couple early maps that I absolutely love. I'm a huge fan of the Temple of Anubis lighting, just that warm, sunny tone. And King's Row at night, showing a more mysterious experience with an industrial city in the background and this omnic city under the factory—which nobody really looks at unless they fall and die—I thought it was really amazing."

Finding the style, tone, and level of detail for Temple of Anubis began by embracing the cutting-edge lighting technology of the time. "We knew we needed to catch up to where the industry was when it came to game rendering," Rogers notes. "One piece was physically based rendering, which was all the rage back when *Overwatch* first started. This is an engine technique that gives a lot of realism to the environments and characters, materials like metals and plastic. Everything about the world with physically based rendering starts to feel more tangible or real, including the lighting."

While this tangible, photo-like quality was something new and exciting for the team, the initial lighting pass also revealed the absence of something *in*tangible, according to Rogers. "We were looking at a scene that felt very good realistically, but it didn't feel like *Blizzard*. It lacked stylization, this handcrafted feeling. I looked at Cairo, and I started to play with pushing the color, doubling the energy of the textures, just pushing everything a hundred and ten percent—including the lighting. A lot of times the material's response informs how you perceive lighting: when light hits metal, is it chrome-y, is it dirty, is it weathered? It's about your perception, so I tweaked a bunch of things and pushed Cairo in this range that was much more exaggerated than the realism we were looking at from the initial tests."

It wasn't until the Torbjörn character (who had recently gone through his own concepting phase, detailed in chapter 8 in this book) was added to the scene, however, that the experiment really took off. Once the team could see how the newly tweaked lighting interacted with his model, they knew they were onto something.

"Without editing anything, his reds jumped off. It felt like a Blizzard character," Rogers recalls. "He was much bolder in his color, in the chrome parts on his body. What we call 'material separation' was much clearer—you could see the metals, the plastics. This started to feel like the right direction for *Overwatch*."

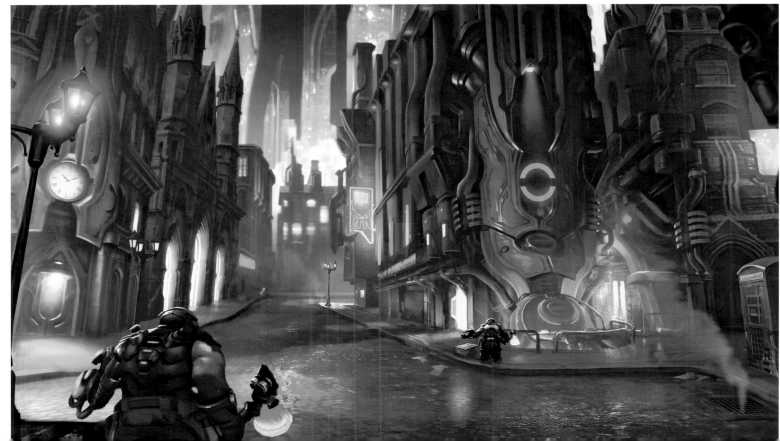

WHAT'S THE BRIGHT IDEA?

LIGHTING can be an essential but highly technical aspect of art creation. Lighting artists have several techniques available to them:

- **Physically Based Rendering** is a more modern innovation that uses computer wizardry to capture how light behaves in the real world and translate it into video game settings.

- **Material Separation** ensures that different materials—cloth, metal, plastic—read appropriately and are clearly distinguishable from one another.

- **Radiosity and Bounce Light** are used in film, where reflectors bounce the light from its source to the actor, scene, or subject. The same effect—softer, more spread-out light—can be artificially replicated in games. An algorithm is used to capture all sources of light, including light reflecting off other surfaces.

TOP: Overwatch Team
BOTTOM: Ben Zhang

DARK, BUT NOT TOO DARK

WITH the Temple of Anubis lighting amounting to a huge success, the next experiment came in replicating the hopeful style and tone in a nighttime environment. For this test, Rogers selected London's King's Row.

"London started off with a very realistic feel, which looked really good: cool radiosity was happening, bounced lights. You turn on a streetlamp and it does a really great job of filling the scene with light . . . but it needed more to make it feel like a Blizzard environment."

Rogers and the team delved deeper, looking for other elements that would either cast light on the scene or diffuse it in interesting ways. "When we speak of lighting, it's the *atmosphere* that you feel sometimes, not necessarily the actual light. It's all the things together that create the impression of lighting, so this is what we needed to do to London. We added fog and this beautiful full moon, along with these cyberpunk-ish bluish-greens playing off the warm brown bricks of the buildings. It needed all these things to address how we felt about the lighting."

As with Temple of Anubis, the ever-helpful Torbjörn model was added to the scene to gauge material separation in a darker environment. The transition to nighttime also resulted in a universal rule for *Overwatch* moving forward. In Rogers's words, "We decided at this time that the color black, zero-zero-zero black, was not a part of *Overwatch*'s palette. Alleyways and side routes would get too dark; the players felt like they were being ambushed, it was difficult to see opponents. This rule applied to the character color palettes as well—you had a character like Reaper whose outfit is naturally black, but we had to find the sweet spot on him, not to go perfectly black. We never do perfect white either."

TOP: Overwatch Team
UPPER & BOTTOM LEFT: Ben Zhang **143**
MIDDLE LEFT: Nick Carver

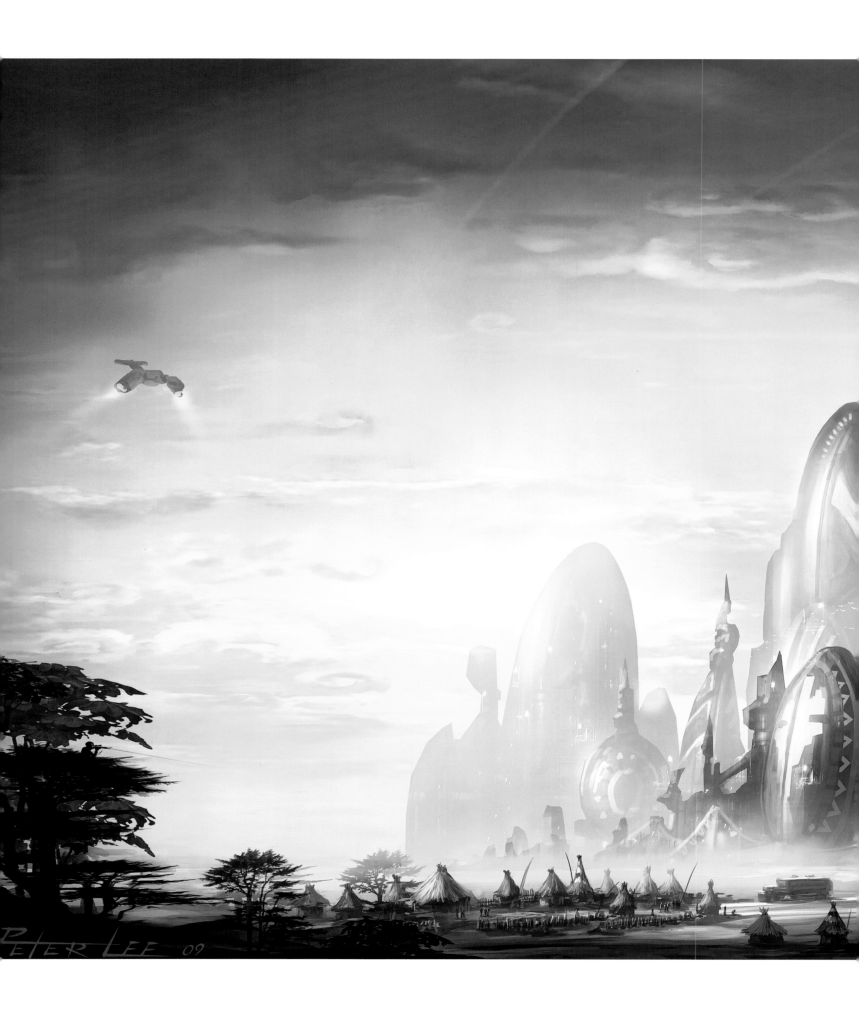

ABOVE: Peter C. Lee

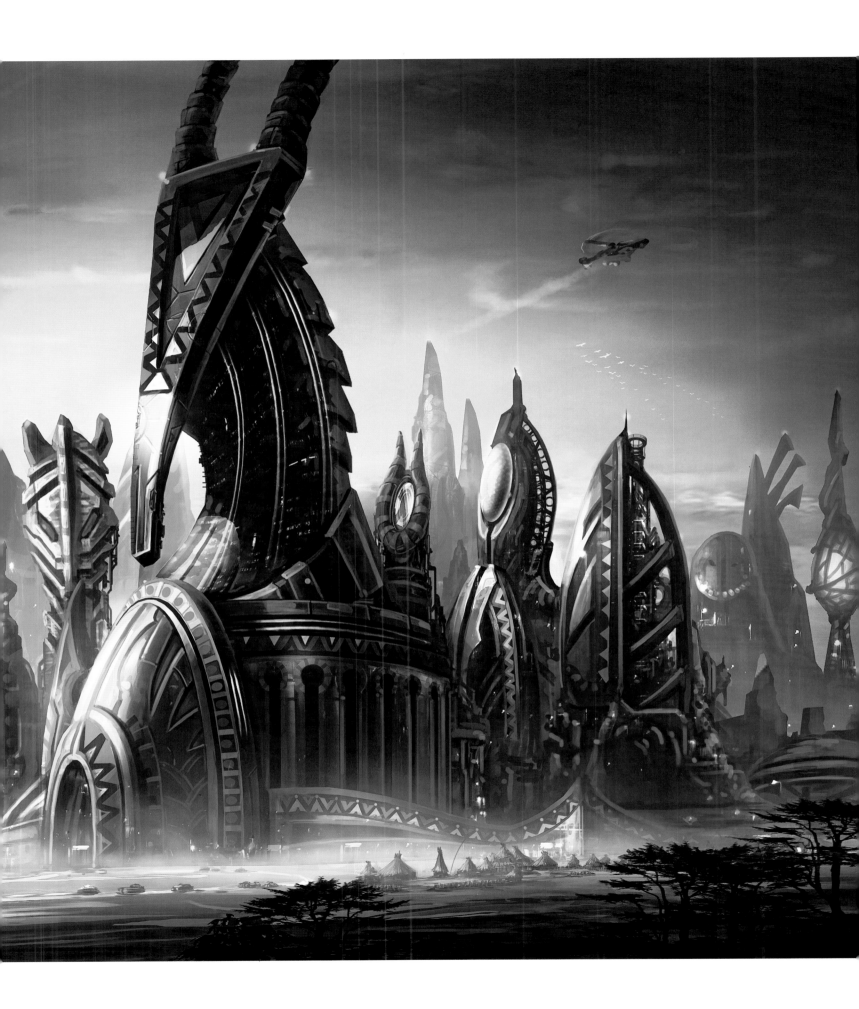

READING LESSONS

FOR Petras, the process of establishing these key levels defined two major goals for *Overwatch* lighting moving forward: readability and mood.

Petras sees "readability" as a blanket term to describe not just how well players can "read" or distinguish characters from the background but also how well players can read what they're doing in the game. "We wanted the heroes to read first, and so the question was, how did the light react off the heroes? Were they easily readable? Did you get a good feeling of the tone of the hero? And then the effects—the effects were really bright, but we couldn't blow them out totally, so how did lighting affect the visual effects? And how did the user interface sit on top of that? And then there was the actual background as well, so we developed this hierarchy of readability."

Part of this hierarchy is something called "navigational lighting," which essentially means using lighting to show players where to go in the game, a concept well known

to Rogers. "Good navigational lighting teaches the player gameplay without the player realizing it. So certain parts of the map are dark because that's not the optimal route to travel, though it might be perfect for characters like Reaper, McCree, or Soldier: 76, who like to flank. They take the darker alleyways, while the main path is very well lit. It's something we want to make sure is always clear: the intended, most optimal route to the objective."

But knowing *when* to light something is also important. Artists and designers are conscious of gameplay at all times.

"If there's a control point that's a key part of the game mode, on the lighting side you have to be aware that there's a lot of people fighting here," Petras notes. "Performance is very important, so we don't want to add a lot of complexity around the control point. It's constantly about knowing the technical side, the performance side, the gameplay, and the aesthetics. It's a whole different language, and it's mind-blowing what goes on behind the scenes. It's very in-depth. Most players don't even realize it, and that's the wonderful part."

TOP LEFT & RIGHT: Ben Zhang
BOTTOM: Overwatch Team
OPPOSITE: Peter C. Lee

GETTING MOODY

THAT about covers readability, but the second major goal in *Overwatch* lighting—setting the mood—can be just as complex to achieve. From the outset, every level in *Overwatch* is designed to convey a very particular mood or tone that fits with the overall vision for the game.

With the sky accounting for roughly half of players' screens, *Overwatch* artists make particular use of that real estate to elicit emotions. Everyone loves a sunny day, but the artists are careful not to be too repetitive.

"We play with romantic sunsets, warm evenings, twilight, and beautiful mornings, things like that. We are inspired by artwork that feels inviting and hopeful," Rogers explains. "That feeling you get in real life when you see an amazing fireworks display or look up at the open blue sky, we want to apply that feeling to the game. The sky really drives the color of the shadows and the bounce light, so we're very careful about the color we choose for the sky because it has a map-wide effect."

But as beautiful as a romantic twilight is, the artists are careful to ground their work in a sense of realism and believability. "We want the game to show the believability of the world, where you see that vista and the layered fog and the city beyond the city and these rays of light that come in and suggest this hopeful future," Petras reflects. "To do that, we had to rethink everything we were doing. We used to create hand-painted lighting information onto materials and textures. We couldn't do that anymore. We had to relearn how to accomplish this production based on our new lighting system. We had to change our whole mindset."

This level of believability is tied to real-world places. While Hanamura was ultimately placed near Tokyo, it was initially crafted using concepts from Kyoto, Japan. The team strived to capture the sensations experienced both by people visiting the city as well as residents, all the while keeping in mind something Rogers calls the "perceived fantasy" of the city. "So if you visit Kyoto in real life, it's a very peaceful city, it celebrates its culture, and there's this warmth about the weather there. This is something that stands out to a visitor, so from a lighting perspective, we decided to try a very warm, inviting sun, this perfect day in summer, beautiful blue skies filled with fluffy white clouds."

As chapter 11 explained, lighting pairs with color to convey mood. So how does the *Overwatch* team use color to impact player emotions, to portray their vision of hope and optimism?

"We wanted *Overwatch* to feel like this aspirational, hopeful version of the world that's so inviting, you can *feel* the warmth of the lighting. Especially when you step out of the spawn rooms," Rogers explains. "The emotional impact often comes from how we make the player feel going from interiors to exteriors. You step outside, and there's this light dust of sand blowing in the air, a beautiful purple haze in the sky. We want you to feel transported, basically."

READABILITY, navigational lighting, mood, realism—how do these elements combine to provide the game experience that *Overwatch* players have come to know and love? It takes a lot of collaboration with the design team, who explain the focus of any given map up front. This information is then applied as artists create the environment.

Rogers provides a play-by-play: "We call it the visual progression of the map. If you're starting inside in the attacker spawn room, you step out into this bright, hopeful world—sunny, beautiful blue sky. But as you make your way to the capture point, the lighting might come down a little. When you get to the capture point, there's something much more dramatic about it. King's Row is a good example—there's an

object above the final checkpoint that gives off this very bright, electric energy. You can feel this intense, reddish light from a distance. This helps the gameplay because if you're fighting on the capture point and, say, you lose and respawn, you get this immediate contrast—you're back in the spawn room, at the beginning of the visual progression."

London

LEFT: Aaron Keller
RIGHT: Nick Carver
OPPOSITE, TOP: Ben Zhang
OPPOSITE, BOTTOM: Nick Carver

LOOKING AHEAD

IN a bright and hopeful world, the future of *Overwatch* continues to shine, and it shows no signs of stopping. For the artists, the creation and manipulation of lighting in the game is a labor of love.

"I feel that lighting is one of the most impactful things on the art side because the light touches every pixel on the screen," Petras says. "It's such a powerful component of what we do."

CHAPTER THIRTEEN
LEGACY OF DARKNESS

In the world of Sanctuary, darkness is much more than the absence of light. While **Diablo** thrusts players into a grim world filled with horrific visuals, what the development team understands—and we're about to learn—is that sometimes the most effective horror lies in what you **don't** see.

ACT II DEMON HIVE
VIK NOV 2004

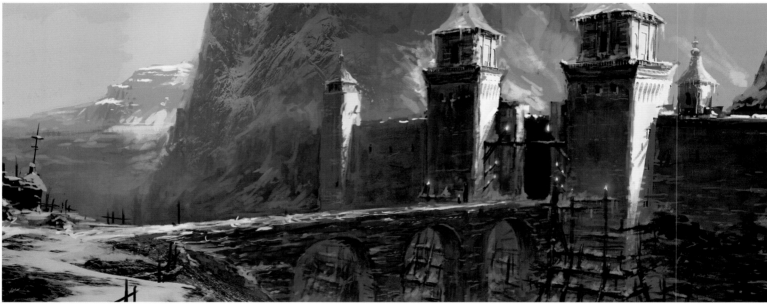

REAL FEAR

THROUGHOUT *Diablo*'s history, developers have evaluated the franchise on a spectrum. At one end sits the staples of the genre: blood, guts, and shock value. At the other sits suspense—the knowledge that something terrible is likely to happen at any given moment.

Diablo has always leaned more toward suspense in its narrative, art, and game development. Players know that demons and other unspeakable things are out there, hiding in the shadows; what they *don't* know is when those nightmarish creatures will strike. "You're basically one human in this world, caught between the forces of the High Heavens and the Burning Hells," senior art director Samwise Didier observes. "So it's a pretty bleak existence, and the only way to get out of the horror is to go through it."

Going through the horror involves facing threats that hide behind every corner. Part of what makes these threats feel imminent is a realistic, carefully crafted world design woven into every fiber of the game, from environments to armor sets. "One of the first things we do for character concepts is look at real-world examples," notes lead artist Richie Marella. "We make armor relatable and grounded, using a lot of reference before we go fantastical."

THIS PAGE: Victor Lee
OPPOSITE: Igor Sidorenko

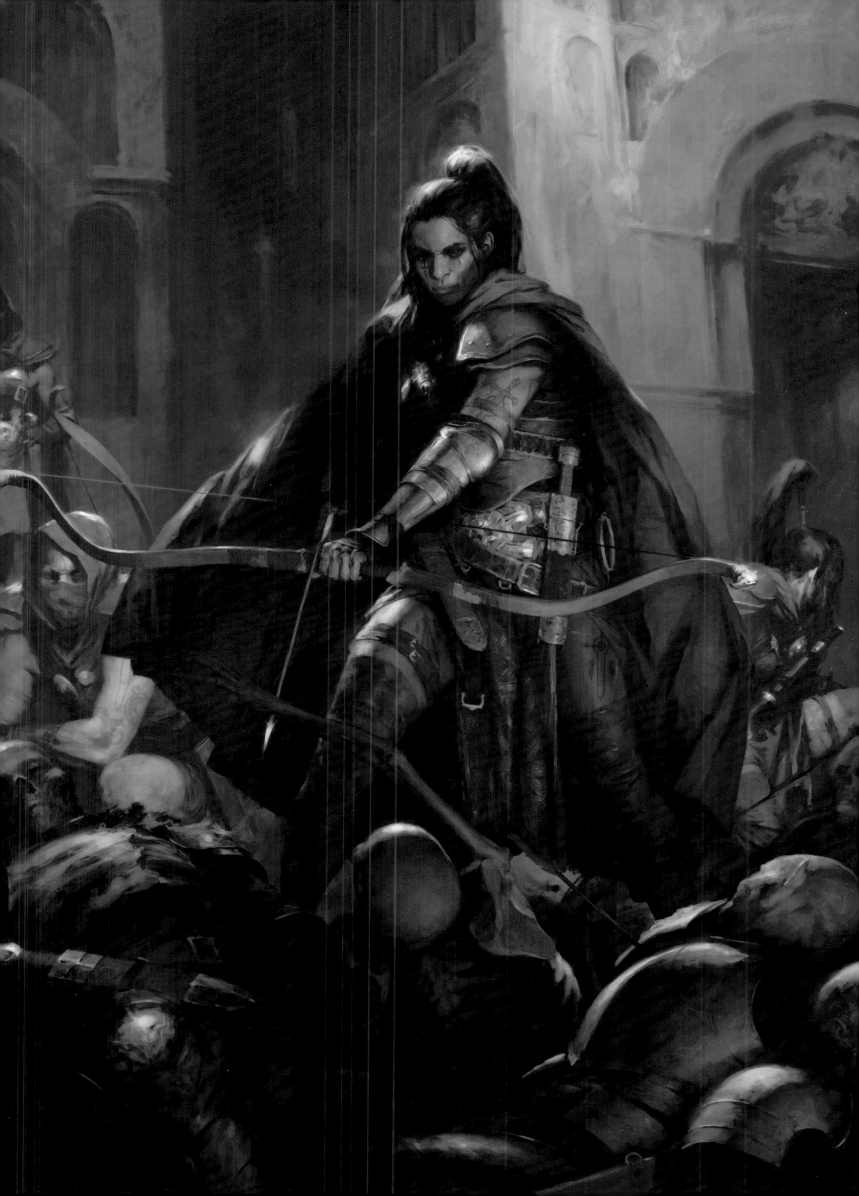

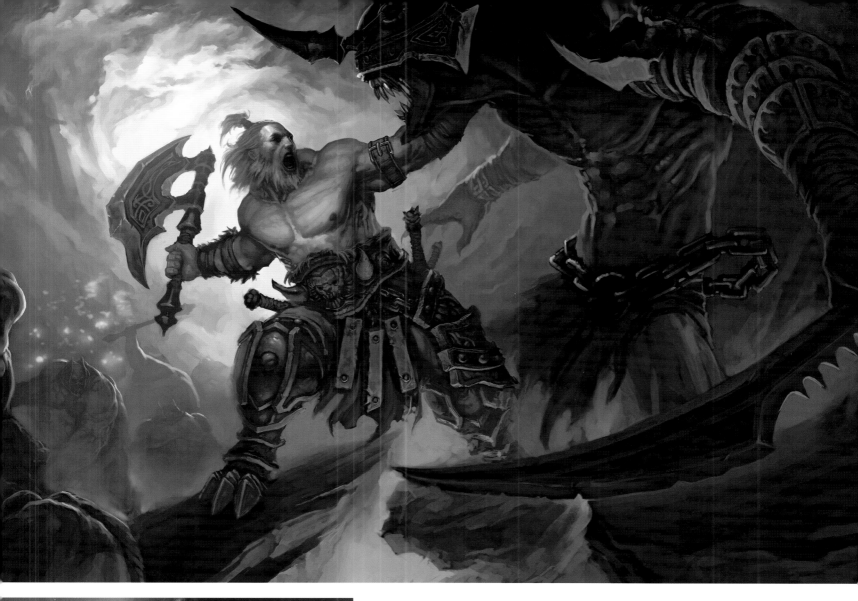

DEEP THOUGHTS

THE deeper the shadows, the greater the odds that something is hiding inside them.

Senior concept artist II Igor Sidorenko uses dramatic lighting, high contrast, and deep shadows to instill a sense of loneliness and danger. "It's not just making it dark for no reason," Sidorenko points out. "It's making a secret, this area that's not revealed, and in *Diablo* something that isn't revealed is dangerous. Darkness is the enemy."

Sometimes that enemy needs a little in-game push. Sidorenko continues: "With the current level of technology, shadow is in some ways artificial. In the old days, we could just make deep shadows, but now we're limited by the technology of our engines. When they represent light the proper way, you have to put in extra effort to make dark areas really dark."

ABANDON HOPE

IN *Diablo* concept art, illustrators cleverly use light to signify that hope is always just out of reach. "Even when I paint a bright day scene, I intentionally make the size of the sun smaller than what it would be in real life," principal concept artist Peter Lee reveals. "Even at the brightest time of day, which a lot of people perceive as a hopeful moment, I try to minimize that hope. I give the sun a bloody color to increase the dread and melancholy."

As with Sidorenko, Lee uses shadows strategically: "Even though it's a daytime scene, we can see a great amount of the shadow is covering the foreground and the big structures. It's a nuanced approach to suggest that something dark is happening in the town."

What about a location that seems as though it should represent the ultimate hope, someplace like the High Heavens? Here Lee subverts expectations: "I tried to give the High Heavens an uneasy feeling. They're beautiful with bright light, but the shape language is very aggressive, spiky. If you look at the formations of the buildings, you feel awed, but you don't feel comfortable. That's the overall theme—no one should feel comfortable in any location."

In a world where comfort is scarce and even the High Heavens exude a sense of danger, churches certainly don't get a free pass. Lee once again crushes hope: "When you think about a church, it should be a safe place against the demons, but the doors are busted, the religious elements and symbols are broken and twisted. The idea is that no one is here to save you. You have to save yourself."

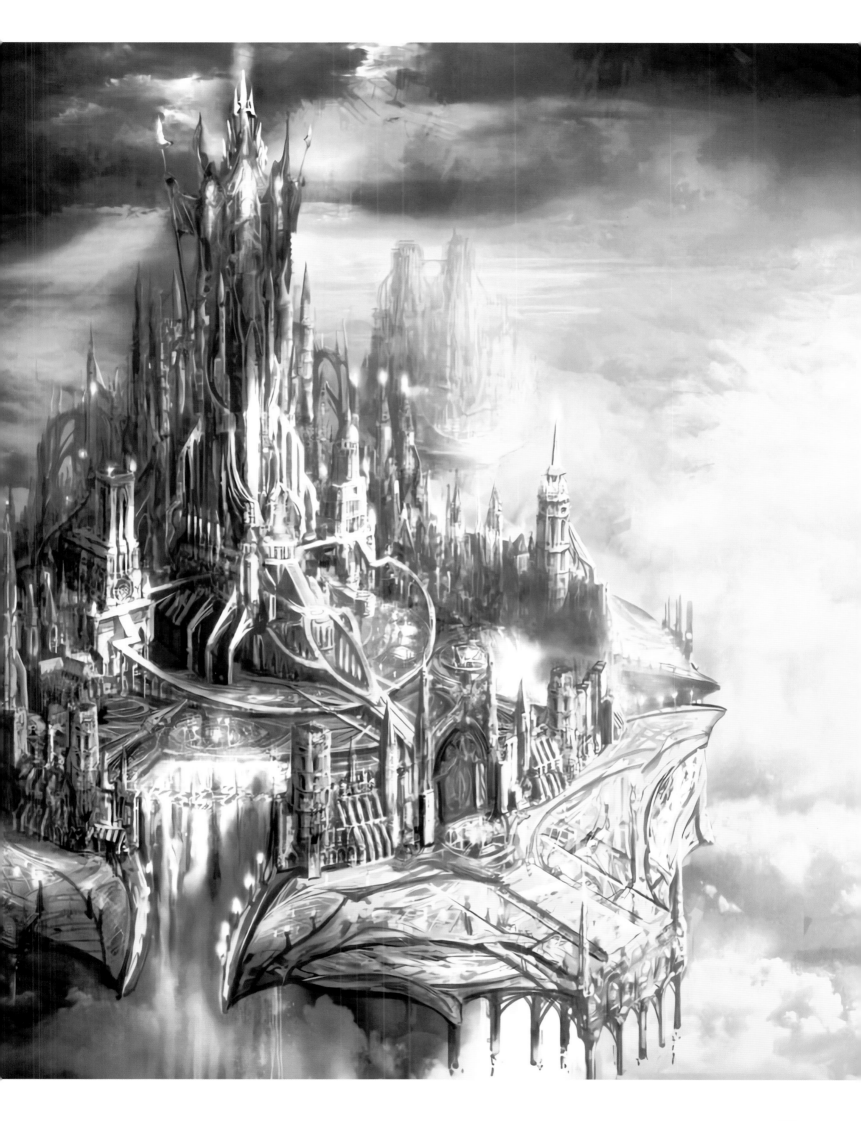

159

EVERY PICTURE TELLS A STORY

EVERY *Diablo* location has a history, a story that is conveyed by concept artists, but this story can require careful reading on the part of players. Terror is often best accomplished through nuance and subtlety.

"For me, the biggest challenge is how can we tell a story, even without direct visuals," Lee explains. "Even when I draw a simple house, I think about what else could have happened, like maybe this house belonged to a normal family, a mom and dad raising kids, but then horrible things happened. I try to capture that painful moment by painting scratch marks on the door. Those scratch marks tell so much story that I don't have to be so literal with a corpse or monsters. Or let's say I paint old prison cells. Instead of adding skulls or dead bodies, I put rust over a surface or dried blood on the floors."

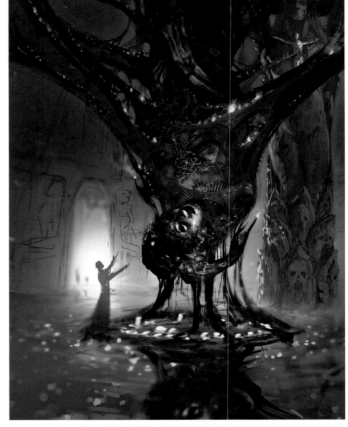

OUT OF THE DARK

SHADOWS that hide the unknown, suppressing any signifier of hope, subtly suggesting the story of the horrors that happened before and are sure to happen again . . . these are all the ingredients for true horror, but without the talent of specialists like lead animator Careena Kingdom, things in *Diablo* would not go bump in the night.

"Sound and animation can be subtle or overt, and both can have a huge impact on the player," Kingdom explains. "When it comes to combat animation, a lot of animation in video games always has two beats. There's the Anticipation, which is the sword rearing back—the player anticipating what's about to happen—and then there's the Reaction. Communicating these through animation to the player is what turns a passive visual experience into an interactive one. And then when you add in sound to both beats, this takes it to a whole new level. For example, if I'm walking through a dark, creepy dungeon and I just hear skeleton bones cracking in the distance, that's

Anticipation in itself, and as an animator, I can play off that. Since I know the player is already reacting to the sound, I can focus the animation on being more direct, having a skeleton jump out of darkness."

Animators can even use your own imagination against you. "First impressions are important with every character," says Kingdom. "Having things move in emotive and suggestive ways really helps tell a character's story before you even get to plot or dialogue. With just a glance you can communicate a creepy or insidious character. And pairing really good sound design with these characters helps keep them alive in players' minds even when they're off-screen."

If you've played *Diablo* before and you think there's comfort to be found in familiarity, think again. "I want to break the mold," Kingdom warns. "I don't want characters just climbing out of the ground. I want to throw you off, so you're never quite sure what you're going to see next."

Best stay on your guard.

CHAPTER **FOURTEEN**

MAKING MONSTERS

Zombies. Skeletons. Succubi. Demons. Monsters. They are among the most recognizable elements of the horror genre, and they are quintessentially *Diablo*. In this chapter, we'll examine the process used by *Diablo* artists to bring their nightmare creations to terrifying, three-dimensional reality.

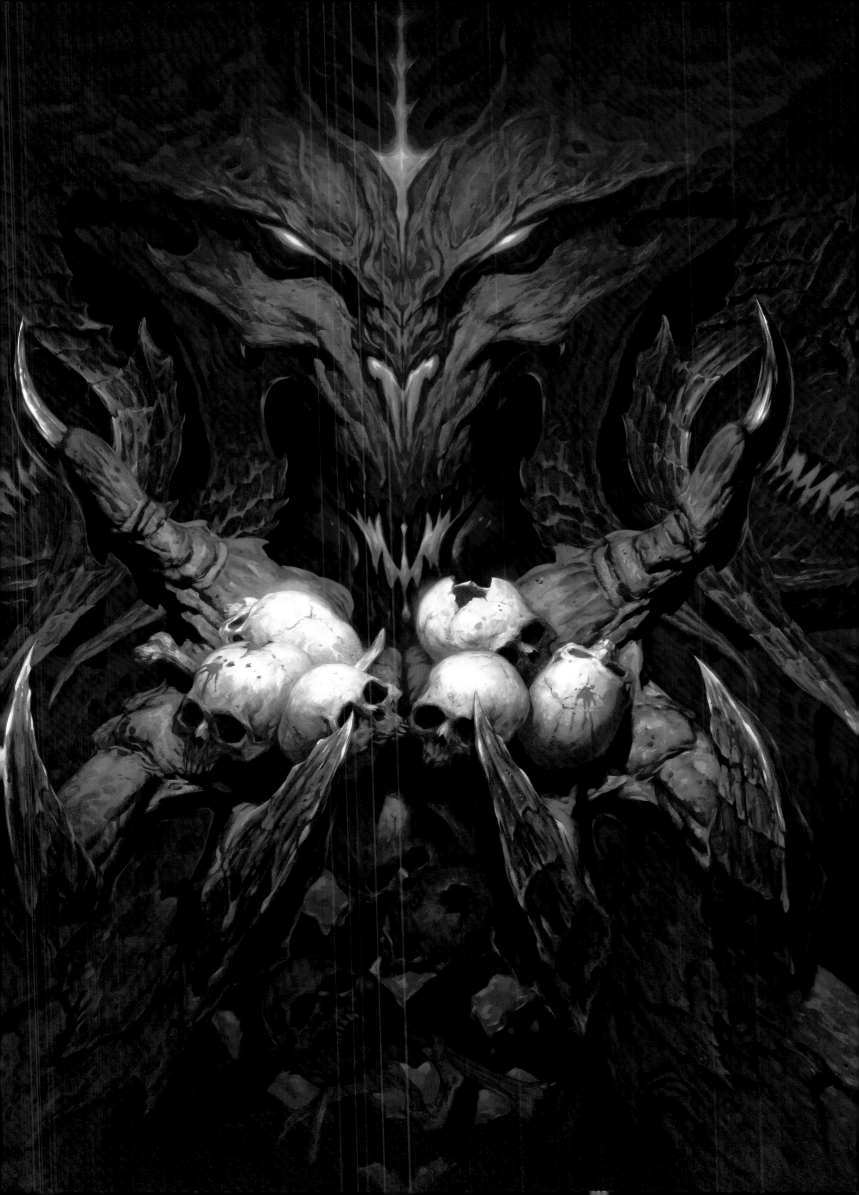

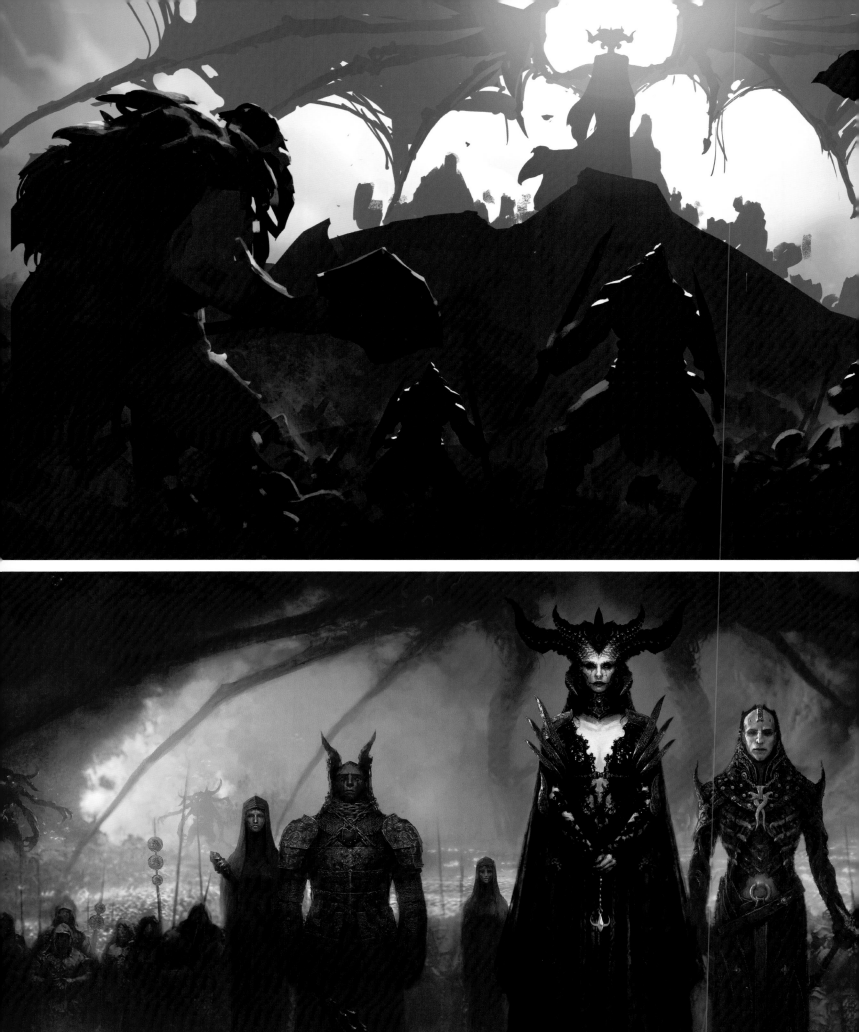

AGAINST ALL ODDS

SOME games allow players to take on the roles of space gods, superheroes, or brilliant generals commanding enormous armies. In *Diablo*, it's just you against the darkness and all the horrors that lurk within it. Armed with nothing but grit, your sword, and an iron will, you descend into the gloomy depths to take on the seemingly inexhaustible, rampaging masses of the Burning Hells.

TOP & OPPOSITE, BOTTOM: Victor Lee
BOTTOM: Mark Gibbons
OPPOSITE, TOP: Josh Tallman

165

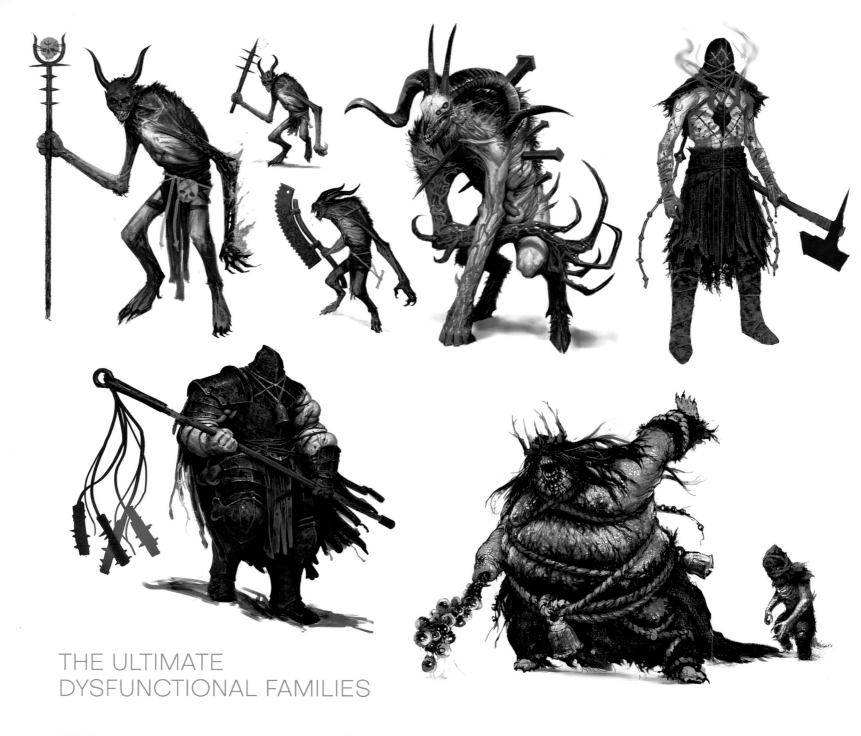

THE ULTIMATE
DYSFUNCTIONAL FAMILIES

THE first step of monster creation comes in classifying the type. You may not think of *Diablo* creatures as "families," but *Diablo* art director John Mueller does. "It's a very sweet idea, that monsters go home and have dinner and talk to their kids, but for demons it's function first, 'gameplay first.' We really take a lot of direction from the design team on what they're trying to achieve as the first priority, and then we put a visual to it that lets us geek out about 'Okay, what's the monster family for this demon?'"

Lead concept artist Victor Lee elaborates, "From design I find out what they need the monster to do. Is it a melee monster or a caster? Do I have to merge that functionality with the demands of story? From story I find out what they need it to look like—is it ethereal, is it a physical thing? Is it blood and guts or full of horns? Those kinds of guidelines."

One might assume that all *Diablo* enemies are grotesque or repulsive. *Diablo* artists are careful, however, not to paint all monsters with the same brush. "Some monsters are elegant—Lilith is an example of that," Mueller notes. "We worked on that design with [fantasy artist] Brom. Victor Lee actually did the

design, and Brom kind of interpreted that design, and it's a very elegant, beautiful demon. There's that part of the lore around demons, that they tempt mankind into making all kinds of bad choices. Their elegance is a way that they present themselves, but truly, underneath, they're monsters."

Elegant monsters are another way to add variety, a key element for Lee and his team. "Some are just brutal—they maybe have just a loincloth, a couple of chains, and wield huge weapons. And some are more aristocratic—they have a culture and high intelligence. In that way, we have a whole spectrum of monsters. Some are brutes, and some are more intellectual—they care about how they look, they wear jewelry maybe, they might have piercings. It's like humans—there are all kinds."

While diversity is key, there is one aspect that Victor endeavors to instill in every one of his creations: "I don't want to design something that, two years from now, someone will look at and say, 'Oh, that's so dated. That's the trend of that time period.' I want to make it timeless."

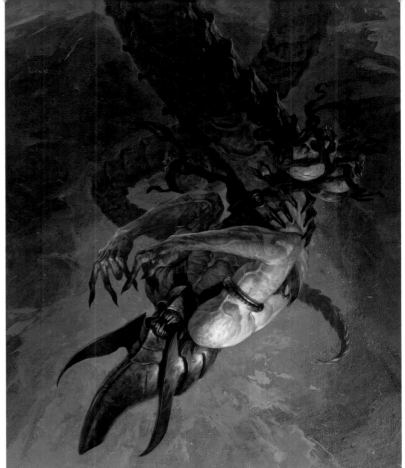
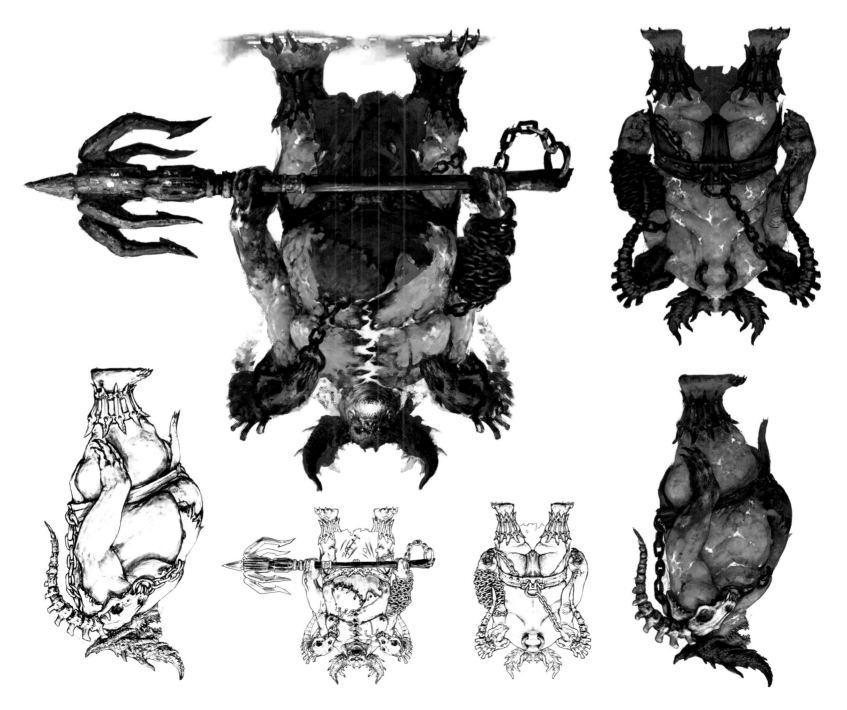

FRESHER MEAT

DURING the development of *Diablo III*, the decision was made to update one of the franchise's most fondly remembered—and feared—characters, the Butcher. Senior art director Samwise Didier remembers, "When we made the Butcher, he was just sort of a big scary dude. I believe he had a smaller set of horns. What was so scary about him wasn't just the artwork. It was also a dark game, and when you open the door, you hear 'FRESH MEAT!' So when we were going over it for future *Diablo* content, we thought, 'Ah, it's just kind of a big, fat, chef-lookin' kinda guy. What can we do to beef this character up?' As the game evolved and we were able to create more fidelity with our artwork, the Butcher was one of the ones that we needed to make feel as scary as he felt in the original, but now he needed to be visually scary, so he wasn't just a fat guy in an apron."

Powerhouse fantasy artist Brom was already a *Diablo* fan when he joined Blizzard's Creative Development team in a part-time capacity. One of his fondest memories of that period involves a painting he created for the Butcher, a painting that would prove to be definitive. "The Butcher was my favorite character when I played *Diablo II*. I believe my version of it is closer to how the Butcher originally was. The original Butcher is very pixelated and small, so it's kind of hard to see, but I think the color schemes are a bit closer to that. I know in *Diablo III* they were trying to really push things in different directions, and I remember there were several different versions being worked on, and I was just trying to put my spin on it."

That spin was a hit.

"Everyone recognizes that Brom painting now as the default Butcher," Samwise muses. "Moving forward, every version of him has to look at least that cool."

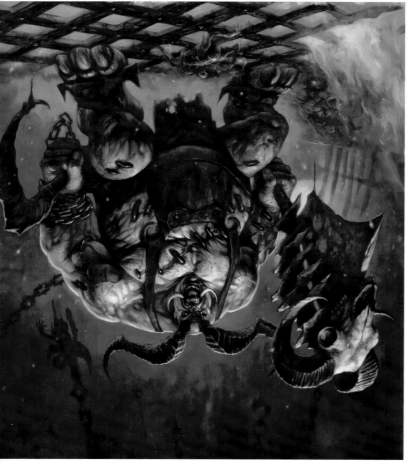

A MATTER OF PERSPECTIVE

Diablo monsters are designed to look good from every angle and distance, but above all, the team keeps in mind the game's top-down, isometric perspective. "We always talk about readability," Mueller explains. "If someone wants to have an armor set themed around a snake god, those details have to be a little bigger in order for them to read, because you're seeing it from an isometric camera. That really affects how we design pretty much everything."

The desire to make each monster type unique must also take into account the isometric view. "For me that usually means, 'How can I make them look different in that top-down view?'" Lee notes. "For characters, armor, monster silhouettes, all the differences have to be thought of from that angle. For characters, it could be the helm or the shape of the shoulder pads. That's where the biggest silhouette lies. The other thing I think about is how much volume a character has. For example, maybe it works very well from game-cam if this monster weighs half a ton and is more spherical in volume."

In the game, monster sizes and shapes help to clue players in on what strategies to use. "Players have to know what each monster does," Lee explains. "If you can't see them on-screen among all the spells and effects, then it's very hard to play the game, so we make it very clear, like, 'This super-thick guy is a melee monster.' You have to have all of this information available to you, which is why monster silhouettes are so important."

ANIMATING OR REANIMATING?

STEP two in *Diablo*'s monster creation process is to put the creatures in-game. Most concept artists work in 2D first. The team then moves these concepts to a "blockout," where they place the character in-game, from camera. "When you're designing a character, it's hard to draw it from that angle and capture the mood you want," Mueller says. "We'll bring the camera in so you see the character from different angles. That's when it feels like, 'Oh, this is an awesome character.' That doesn't always come through in just the top-down isometric. It usually comes through in a fight when you see them moving. Sometimes they'll face the camera, and you get a sense of the character design, but we tend to go from 2D concept to blockout very quickly."

In the blockout phase, animation is critical. Motion experts like lead animator Careena Kingdom play a key role in bringing *Diablo* monsters to life—or undeath—in a process that poses its own unique challenges. "With monster or character design, scale is something that can always be tricky. The larger the character, the slower they naturally move, but if the design team wants an attack to happen within five or six milliseconds, if it's a big character, that can start to break the reality of what it should feel like. We always say it doesn't just need to look good, it needs to feel good."

And as with Lee, Kingdom is constantly paying attention to the monster's silhouette, how its shape and form read to the player. "Because we're a top-down camera, silhouette is really important. A lot of characters that are bottom heavy disappear when you think of the silhouette. Turn off all the lights—can I read what they're doing at a glance?"

Some of the fun comes in experimenting with new ways to explore monster movement—or, in some cases, revisiting older ways, as with skeleton animation. "For the skeletons, we used stop-motion. It works so well with sound because they're rickety; we animate them on twos, which is twelve poses per second versus twenty-four so they have their own movement style. Sure, we could motion-capture all the characters and make them as perfect as possible, but the choice to go back to that classic, retro art form in a 3D environment makes them feel different, more physical."

HOME STRETCH

AFTER all the necessary tweaking to hone the monster's mechanics in the blockout phase, the team prepares to move to the third step, which is final art.

"There's a lot of back-and-forth—if from game-cam it doesn't look good, if certain proportions are not right, we would need to fix it," Lee elaborates. "So there's a lot of communication between me, story, animation, modeling, lighting, texturing, all that—I'm constantly talking to these people so that everything comes together in one cohesive design."

And with the final stage, yet another terror-inducing monster is born into the *Diablo* universe. But as the franchise moves into its fourth installment, does the process of coming up with new, unique ideas for monsters become more difficult?

Mueller doesn't think so. "It's more like we don't have enough time to fully render all the ideas we want."

Lee echoes the sentiment that the team is never at a loss for fresh ideas. "I always want to go for a fresh design, a fresh look so that people don't get bored. There's always new things that you can combine and find permutations of and experiment with, and eventually you'll get something fresh and cool."

Perhaps most important, though not surprising, is the fact that making monsters is just plain fun. "I mean, if I go back to my fourteen-year-old self, it's what I was doing," Mueller laughs. "And now it's a job and you have a job title, but you're drawing the same things you were drawing when you were a kid. You think of video games and there's all different genres, but as far as creating the art for a game, there's nothing more fun than *Diablo*."

LEFT & BOTTOM RIGHT: Mike Franchina
TOP RIGHT: Victor Lee
OPPOSITE, TOP: Igor Sidorenko
OPPOSITE, BOTTOM: Brom

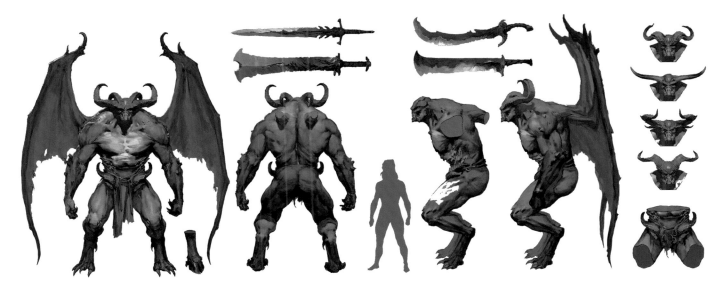

CHAPTER **FIFTEEN**
FANS MAKE THE GAME

THIS SPREAD: Wei Wang

From the beginning, Blizzard has been carving out a name for community engagement. From polls to contests to educational outreach programs, the studio recognizes that it would not exist without the fans—both external and internal—who love and live in their universes. But beyond the love that keeps the game teams going, Blizzard's passionate and dedicated fan base has directly influenced game content.

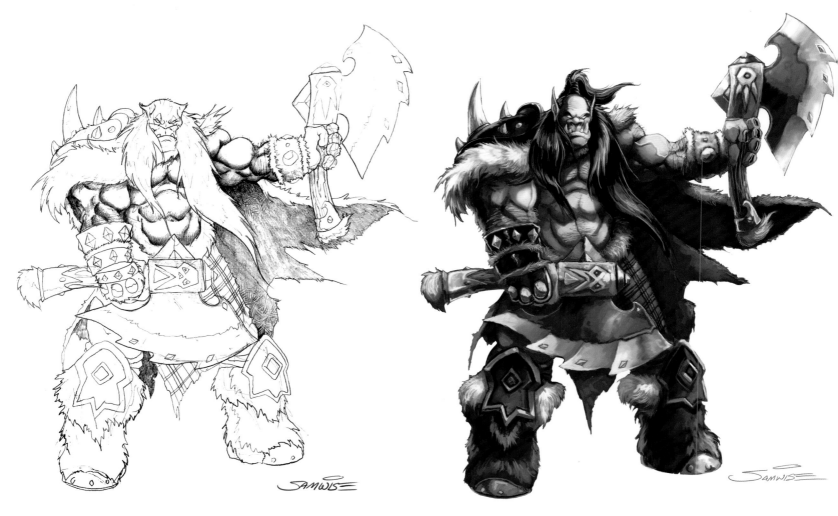

REXXAR'S LONG JOURNEY

EVERYBODY loves Rexxar.

The half-orc, half-ogre nomad, along with his bear companion Misha, is a favorite among fans, despite his fairly humble origins.

"I had done the original concept—an orc gladiator—for one of our RPG books," explains senior art director Samwise Didier. "We needed a beastmaster, so I took the gladiator, put the wolf cowl on him, gave him two axes, made him big and beefy, and added a bear."

The design was repurposed in the *Warcraft III* real-time strategy game, and Rexxar became an instant hit among players. Afterward, the enigmatic half-ogre faded into the background from a game standpoint. He remained popular, however, not just in the community but among employees as well. Wei Wang, former principal artist, crafted a meticulously detailed illustration of both Rexxar and Misha for the *World of Warcraft Trading Card Game*.

"Rexxar does not have a magnificent plot like other protagonists," Wang observes, "but it is his marginal hero status that makes me particularly like this character. He is a wanderer and a quiet hero who lives in his own world. I have only done one illustration for Rexxar, but I definitely incorporated my deep affection for this character into that illustration."

Rexxar was featured in the *World of Warcraft* expansion *The Burning Crusade*, though senior art director Chris Robinson admits he didn't receive preferential treatment. "No real artistic love was given to him. He was just a color-shifted orc who was scaled up and dressed by a quest designer in random clothing that approximated Sammy's drawings."

Through the years, one fact remained clear: fans wanted more of Rexxar. Much more.

Around the time that the *Hearthstone* team referenced Wei Wang's Rexxar illustration for card art, the same painting made the rounds among the *World of Warcraft* team. Once again, it was an employee-fan who breathed new life into the wandering hero.

TOP: Samwise Didier
BOTTOM: Matthew McKeown

"One of our character artists saw the image and started working on their own version of it because they just loved it so much," Robinson says. "When the team saw the result, we actually put it into full production, giving him his own custom model, textures, rigging, and animation."

Rexxar was also embraced by *Heroes of the Storm*, using the same Wei Wang reference painting. "It was the biggest, thickest, most lavish picture that we had seen of Rexxar to

date," says Samwise. "So for *Heroes*, we basically modeled the character off that and made his axes a little more detailed, gave him more armor in the form of animal skulls and other things."

And so it was that after a life of wandering, Rexxar found not just one home but many, assisted along the way by fans—both inside the company and out—who refused to let him fade into obscurity.

ARTCRAFT:
SHARING THE DREAM

WHEN the *World of Warcraft* team set about upgrading textures for its old game models, they knew they would be tweaking long-established and well-loved character art.

"Because people identify so much with these player characters, there was a huge risk," says Robinson. "If we went in the wrong direction or took it too far, it could alienate our player base and make people feel like we ruined their connection to the world."

After much deliberation, a potential solution was proposed: Rather than simply unleash the finished product on the public when the work was complete, why not give fans visibility into the process? "We thought, why don't we piecemeal it out?" Robinson explains. "So as we were working on it, the players could actually see what we were doing and give us relevant feedback."

In response, players went above and beyond the call of duty, not just offering opinions but also performing paintovers of Blizzard artists' work, and in some cases providing artwork of their own to communicate their ideas and direction.

"Artcraft was an amazing outreach," notes *World of Warcraft* art director Ely Cannon. "Not just for players but also for potential artists who might want to work at Blizzard, or art students who might be looking at a future in the game industry, or even just in fantasy art. I hope it inspired people to go out and pursue a creative profession in general."

The program was enough of a success that it carried over to animations. "As we started going into core class combat revamps," says Robinson, "we used Artcraft to get a lot of those animations out in front of our players."

Players responded to everything from new animations to effects. "We received a lot of valuable feedback," recalls Robinson. "Everything from 'It doesn't feel like I'm a frost mage anymore; you changed the color of the spells too much,' to 'I don't like that the camera shakes now when I do this move; it's making me sick.'"

In the end, Artcraft was a successful experiment and a prime example of game developers working hard and listening carefully to the fans. As Cannon reflects, "One of the things that drives me is remembering that the art of this game and the worlds we create are not just ours as the developers—they really do belong to our players and our community."

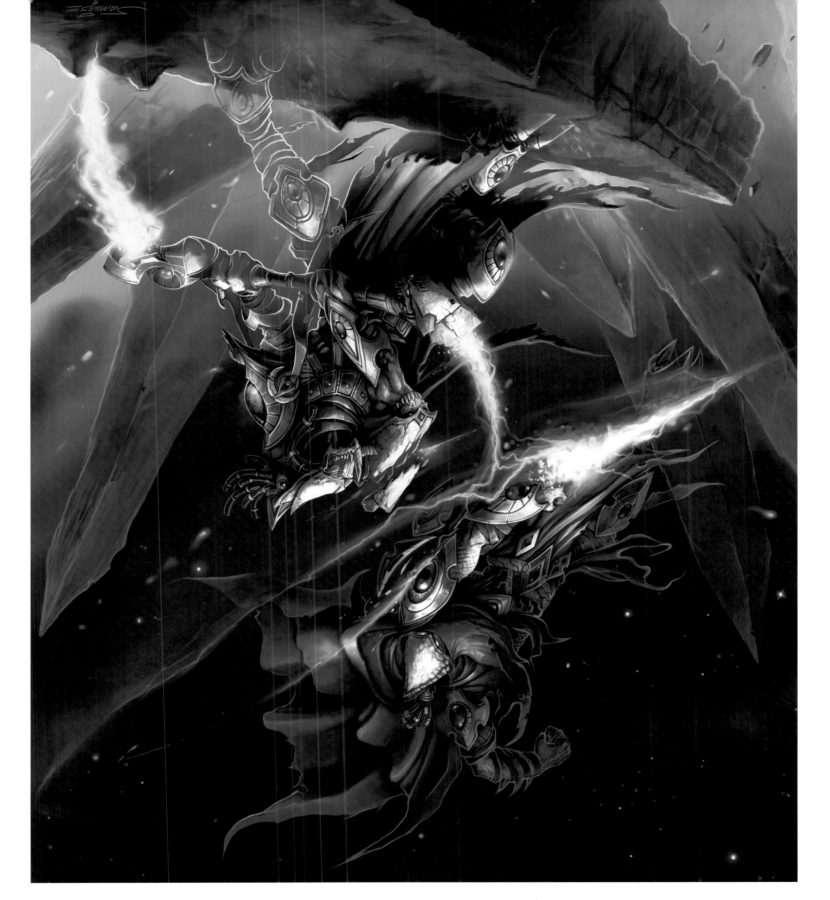

WHEN TEMPLARS BATTLE, FANS WIN

When fans fall in love with a character or character type, drastic changes are often met with frustration, a fact that Samwise discovered when he reenvisioned the beloved **StarCraft** dark templar design ahead of **StarCraft II**.

"I made a dark templar that was more heavily armored," explains Samwise. "He had a different weapon and was wearing zerg bones as armor. Fans were not happy."

The backlash sparked an idea. "I did this picture of an old dark templar and a new dark templar battling it out," says Samwise. "It was called **When Darkness and Shadow Collide**. We had a contest and said, "Which one will survive?""

Fans were given not two but three choices:

A. The old templar would survive.

B. The new templar would survive.

C. Both templars would survive and be featured in the game.

"C won by about two-thirds of the vote," Samwise reveals. "It drove home a rule I've come to value over the years: Don't replace something that people love purely because it's old. Just make something new if you want to make something new."

HEROES OF THE STORM
TEAMS UP WITH FANS

WHEN the fans speak, *Heroes of the Storm* listens.

Because *Heroes of the Storm* is set in an alternate universe, the game can feature characters from all Blizzard IPs, offering ample opportunities for outlandish and creative skins.

Oftentimes, those skin ideas come from the community, as in the case of Azmodunk.

"In *Heroes* tournaments," says Samwise, "everyone would say that Azmodan, our demon character from *Diablo*, was 'dunking' on people because his fireball kind of looked like a big basketball and he hurled it like he was throwing a three-pointer."

The nickname Azmodunk was coined, and the community desire for a skin based on the idea caught fire, something that did not go unnoticed by the *Heroes* team. "We create skins on a schedule," Samwise explains. "So we had to figure out a place where we could do it. Eventually we found a spot, and we took Azmodan, this horrific, split-bellied, split-mouthed demon, and we dressed him in a tank top, basketball shorts, headband, and sneakers. Everyone loved it."

Azmodunk led to Cheerleader Kerrigan. This was followed by a fan art contest-winning skin based on *Diablo*'s King Leoric—who became Janitor Leoric. A nineties grunge skin of Orphea—a character that had been dreamed up solely for *Heroes of the Storm*—called Slacker was created as well, completing a set of skins that envisioned characters in a high school setting.

"So we were able to pull all of them into this mini-realm," says art director Trevor Jacobs. "When we released it, we made some fun key art for BlizzCon, like a kid's notebook with stickers, phone numbers crossed out; there are so many fun ideas in that high school world."

FANNING THE FLAMES

When *Heroes* fans clamored for *Warcraft*'s Deathwing, their voices were heard, though as with Azmodunk, it took time. During the waiting period, the *Heroes* team decided to have a little fun with the community, putting together a video that teased a legendary dragon . . .

"So the trailer was this buildup to the Deathwing Hero," says Jacobs. "People are running from some flaming dragon, and the machinima team made it so rad. They panned over . . . and it was Brightwing in a Deathwing skin. For half a second fans are sitting there, like, 'Freaking Blizzard,' this hardcore tease, and then bam! Deathwing comes in, full badass beauty shot."

"We need to make sure that these characters and skins live up to the hype," says Samwise. "It takes so long because we want to create them in a way that makes players love them."

Jacobs echoes the sentiment: "Sometimes fan favorites take a while to come out, but we see and acknowledge what the community loves, and we try to make as many of those as possible. We really give the fans credit because that's who we make the game for; our fans are the best."

OVERWATCH: A FUTURE WORTH COLLABORATING ON

THE *Overwatch* team has been working with the community from day one. Specifically on sprays—mini-illustrations that players can get from loot boxes and place on surfaces in-game.

"When we first came up with the system, the internal team did a whole bunch of sprays," recalls character art director Arnold Tsang. "But to ship the game we really needed to reach out to external artists."

This early collaboration led to developers casting a wider net. "As the game progressed, we wanted to find a bigger variety of artists to work with," says Tsang. "There are so many great artists out there in the community; it wasn't hard to connect with those we felt matched the spirit of the game and the styles of the sprays we like to do."

The relationship has been both successful and mutually beneficial. "If you just rely on your own skills, you only get so far," Tsang observes. "It's the same with any kind of art medium—the more people you reach out to, the more perspective you get, the larger variety of styles you get. You can't really solve all the problems yourself. Fans see things in our heroes and in our game that we might not see."

And as the game has evolved, so have the fans' artistic interpretations. "That's why we're able to have super-stylized versions of our characters," Tsang says. "But people can still recognize, 'Oh, that's Hanzo, that's Tracer,' so once your IP gets to that level of maturity, you can engage with all the different artists in the community who have their own unique styles. It's exciting to see how those styles match up with our heroes, and it's amazing that artists who *we're* fans of are imagining our world through their eyes."

OPPOSITE: *Heroes of the Storm Team*

1: Arnold Tsang
2: John Polidora
3: Janice Chu
4: Andrew Hou
5: David Kang
6: tinysnails
7: ONEMEGAWATT
8: Javeria Khoso

183

CHAPTER SIXTEEN
PAINTING THE FUTURE

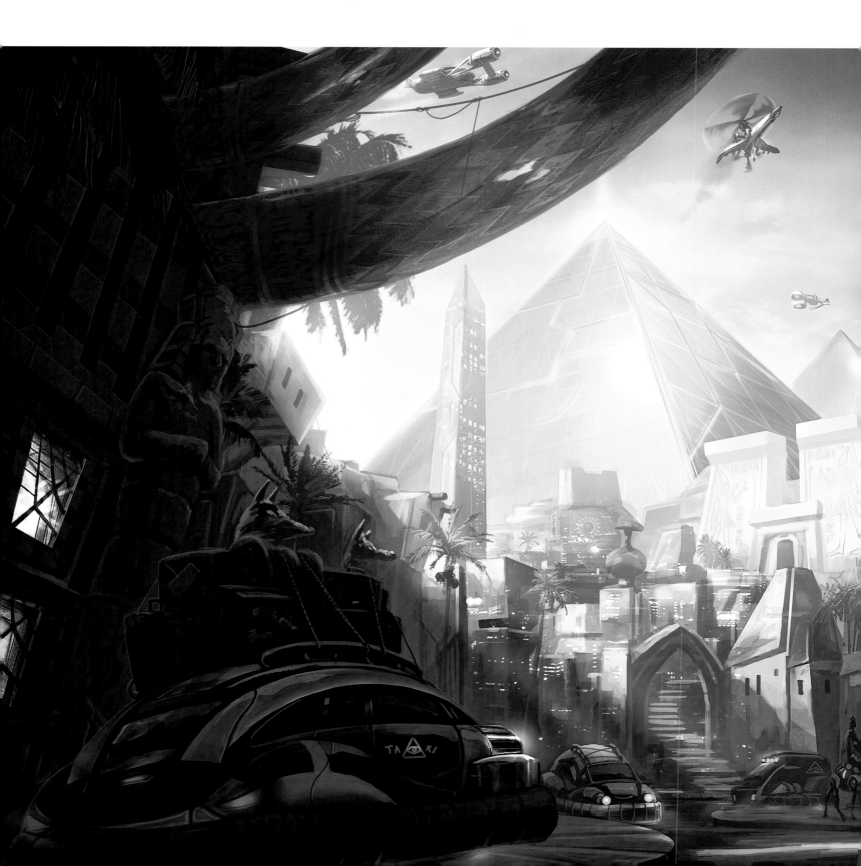

Overwatch imagined a bright near-future world, one where humanity's problems were seemingly solved through fantastical and unique technology . . . before it all came crashing down in a crisis on a global scale. But more than that, *Overwatch* was the first time Blizzard transported fans not to an alternate universe but rather placed its own lens on our modern world. In this chapter, we'll take a close look at how *Overwatch* reimagined the world we know with fresh eyes.

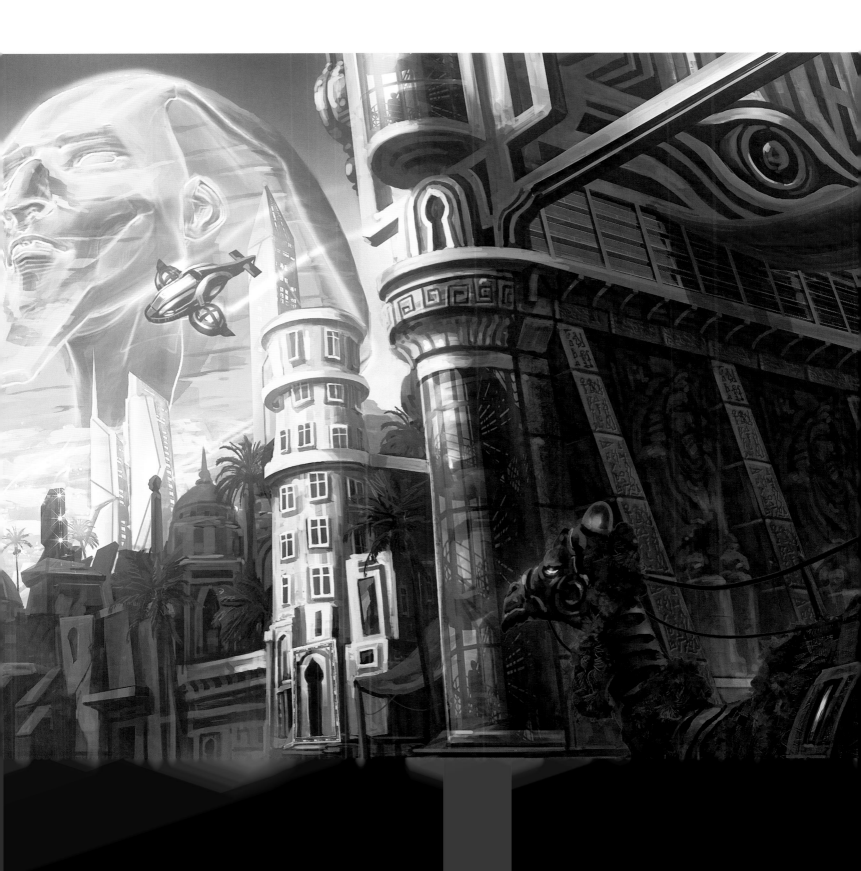

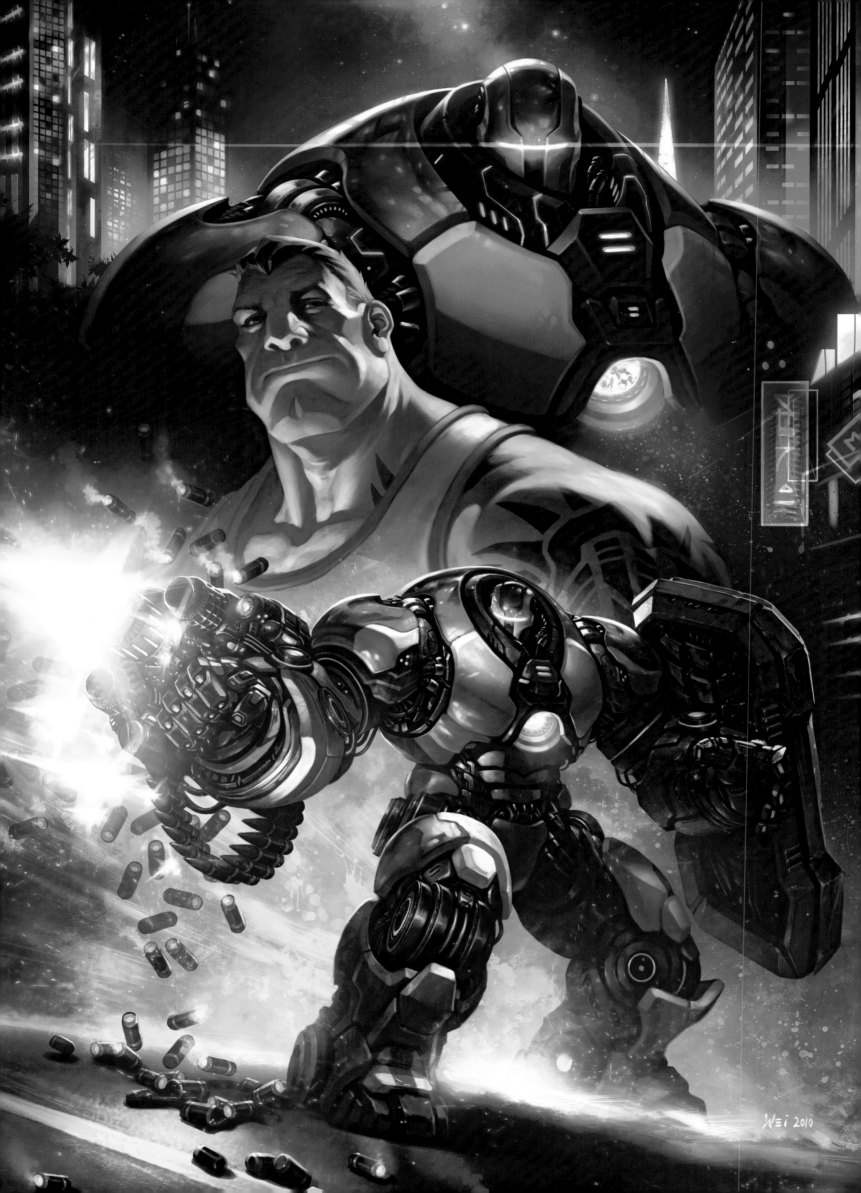

BLUE SKY

THE universe initially imagined by project *Titan* was an ambitious endeavor: a mix of genres, set in a near-future world, with almost limitless open-world possibilities. *Overwatch* character art director Arnold Tsang recollects, "There were so many ideas—we wanted it to be everything from a competitive first-person shooter all the way to customizing your house with different furniture; having a fireplace that would open up into a secret cave, driving around in your car, going out into these futuristic cities and talking to NPCs and getting missions and fighting all of these different world groups."

The game was to be Blizzard's first wholly new intellectual property in almost two decades. When the project was canceled, the small team left behind to pick up the pieces chose a new path forward. Part of what carried over from *Titan* were hard-learned lessons, as described by *Overwatch* senior art director Bill Petras: "*Titan* taught us to eliminate and put off to the side a lot of potentially good ideas so that we could focus on fewer, stronger core ideas."

One of the strongest core ideas that would help build *Overwatch* was the setting—a near-future world with an uncommon vision.

TOP: John Polidora
BOTTOM & OPPOSITE: Wei Wang

LOCATION, LOCATION, LOCATION

CREATING a first-person shooter meant having opposing forces—not just armies facing off against each other but unique, individual characters. Looking back on old fighter games he loved as a kid, Tsang homed in on something that had stuck with him: diversity. "I loved the concept of these characters from different countries, with parts of their culture showing up not just in who they are but also in their design."

And with a highly diverse cast came the next question: Where did these characters come from? "In some classic fighting games, there's a little plane and you fly to that map, so there's a location associated with the character. That's how I saw *Overwatch* early on—we take real-world locations; we create aspirational versions of places like Cairo, London, and Kyoto; and we have characters that are from these places."

But what would these real-world locations look like in a near-future setting? And most importantly, how would artists make this bold new world fit with the iconic Blizzard style?

LEFT, TOP, & OPPOSITE, TOP: Arnold Tsang
BOTTOM RIGHT: Ben Zhang

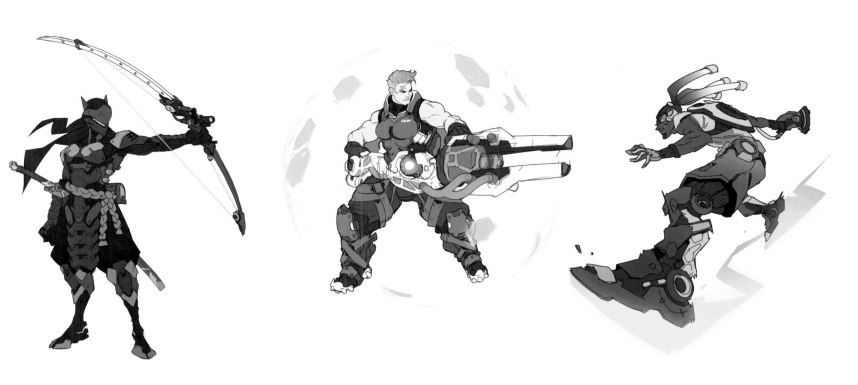

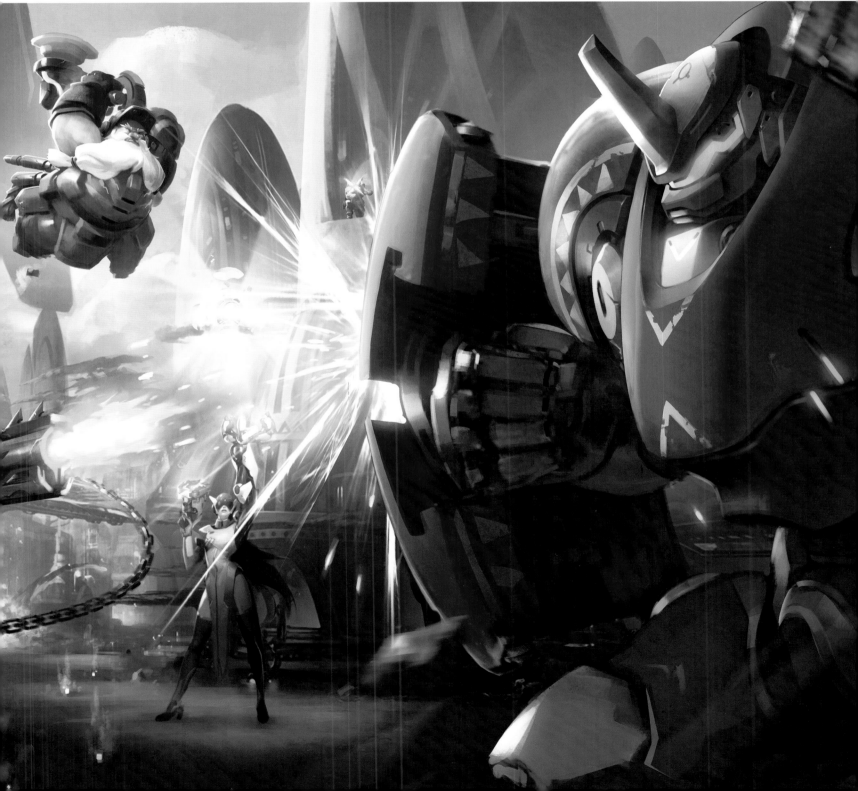

A FUTURE TO BELIEVE IN

FOR the *Overwatch* team, creating something new for a studio that had built a pantheon of game franchises was a powerful and thrilling challenge. Relatability was high on the list of goals. Here again, developers applied knowledge gained from *Titan*: "*Titan* had a very clean procedural look," Petras remembers. "For a game to become a Blizzard franchise, it has to feel handcrafted, created by loving hands. We really wanted *Overwatch* to feel like a lived-in, believable world."

Concept art would play a key role in conveying the vision of *Overwatch*, a look that would need to strike a careful balance between realism and Blizzard's well-established aesthetic.

For inspiration, the team turned to work originally crafted by principal concept artist Peter Lee for *Titan*. Former Blizzard vice president and *Overwatch* game director Jeff Kaplan fondly recalls, "The Egypt piece was always one of our favorite images. It has so many little details, like the robotic camel and the hovercars. We were instantly attracted to it as the first map we wanted to make."

"Each building is skewed and has more of a handmade feel rather than being cookie-cutter or mass-manufactured," Lee explains. He also carefully contemplated the color palette to cast the concept in: "I didn't want a high-noon sun, since it doesn't have much mood to it. Instead, I picked the golden hour, which is warmer light with a cooler shadow. I wanted the location to feel playful and inviting."

Another primary ingredient in the image spoke to the lived-in quality sought by the team. "What's future to us is the present for characters in the game," Lee observes. "The future doesn't mean something new suddenly exists—it's the world these people lived in until that point. Whatever fresh look we create, we need to put layers of history and story into it."

In the mind of Lee, the old, battered Sphinx with the holographic face became analogous to the game itself. "We were not trying to invent the history—we were adding to the history we already know."

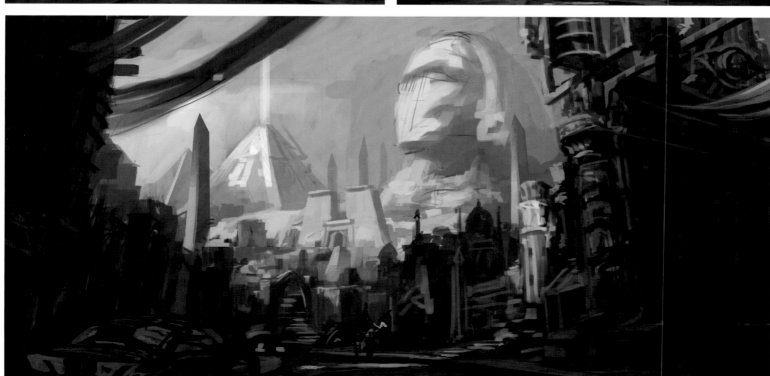

スペースピンポン

炭火たん焼

風下に

LAYING DOWN THE LAW

LEE's image was added to others in a pitch deck that was presented to Blizzard and Activision-Blizzard-King executives. The game was greenlit (see chapter 17), and *Overwatch* was off and running.

While the existing concept work had provided much-needed direction, the visual style of *Overwatch* was far from being locked down. Important questions still needed to be answered. How futuristic was too futuristic? For example, was hovercar technology too advanced for a near-future setting?

To answer these questions, developers came up with a set of rules, as outlined below, in the words of Petras:

- **The 80/20 Rule:** "Eighty percent is relatable and believable, and twenty percent is pushed. We want the player to identify things that they can relate to, that are worth fighting for. If you're on some generic space station orbiting Mars, you might not care so much. We want you to care about the *Overwtach world.*"

- **To Hover or Not to Hover:** "On *Titan*, we didn't make hovering vehicles. In *Overwatch*, we said, 'Let's try it.' We made hovercars relatable, made them follow the 80/20 rule, but most importantly they pushed the near-future aspect. Transportation is a great model for showing the level of technology in the universe."

- **Leading-Person Syndrome:** "We never want one object to stand out when it's not supposed to. If you have a dumpster, do not make it a hovering dumpster with a massive number of little buttons and have it compress garbage—just make it a dumpster. If it's practical and it works, it stays as-is."

- **Keep It Simple:** "We want our technology to be believable. If you can't understand what it does, we don't want to make it."

- **Functional Is Fun:** "For tech, it's also important for it to feel like it's usable. We always want to have control panels at the height of the player's character hands. You should be able to see how to enter a vehicle, recognize front from back, et cetera. You'd be surprised how abstract things can get without a target."

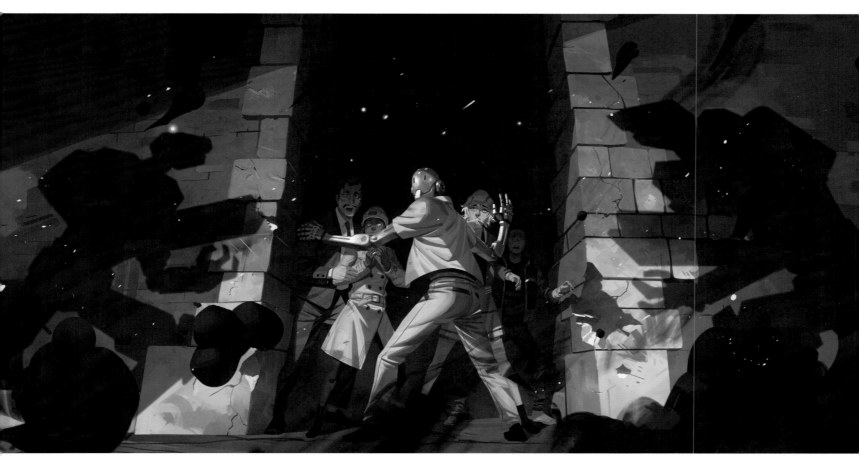

TOP: Roman Kenney
MIDDLE & OPPOSITE, LEFT: Arnold Tsang
BOTTOM: Nesskain
OPPOSITE, RIGHT: Laurel Austin

OMNICS: A NEW RACE FOR SCI-FI

ONE way in which *Overwatch* created its own vision of the future was by introducing a unique race—reimagined, sentient robots called omnics. Story seeds, settings, and characters in the game originated with the hero Zenyatta.

"Omnics weren't a thing until after Zenyatta," Tsang points out. "We had done a couple of different characters, but we wanted variety, and we kept pushing for our next character to be different. Then in one of the meetings [former senior vice president, story and franchise development] Chris Metzen said, 'What if there's a cybermonk?' And everybody latched on to that—it seemed really enticing. So we designed Zenyatta."

The creation of Zenyatta opened up new story pathways and brought up intriguing questions. Were there more characters like Zenyatta? If so, what was their story? "From there we did a bunch of early sketches of omnics," Tsang says.

For one specific image, former principal artist Laurel Austin created a piece that was intended to show how humans interacted with omnics. "It was a magazine cover photo of a nanny omnic and a little girl," Austin shares. "The nanny was being attacked by the military, and the little girl, of course, was distraught."

As the image attests, the relationship depicted between omnics and humans was not always congenial, a story thread that came to define much of *Overwatch*'s history.

"In King's Row," says Petras, "along the player's path with the payload, you'll see spray-painted messages on the wall. Human slogans that are negative towards omnics, like, 'Go home—you're not welcome here.' So it feels like the people and omnics who live in that world, and this is their expression."

Early on, one of the most pressing issues among the development team was giving players a reason to care about omnics. It's easy enough to call a robot sentient, but winning fans' investment in this idea was another matter entirely. As with environments, the answer came with relatability—giving omnics individuality and personalities, making them relatable. "Their personalities are translated through their aesthetic and visual design," says Petras. "They have clothing, they have relationships, they collect things and live their lives, and that's reflected in the art." All of which points to the fact that even though not all humans in *Overwatch* relate to omnics, omnics are at least trying to relate to them.

And while most robots share a similar design sense, not all are cast in the same mold. Two in particular—Echo and Orisa—deviate from the Zenyatta design. "Echo and Orisa are definitely outliers," Tsang confirms. "Most of *Overwatch*'s sentient robots, probably ninety percent, look like Zenyatta. Echo and Orisa are special because they were created by brilliant scientists, and they were experimental kind of projects."

194 TOP: David Kang
MIDDLE: Qiu Fang
BOTTOM: Ben Zhang

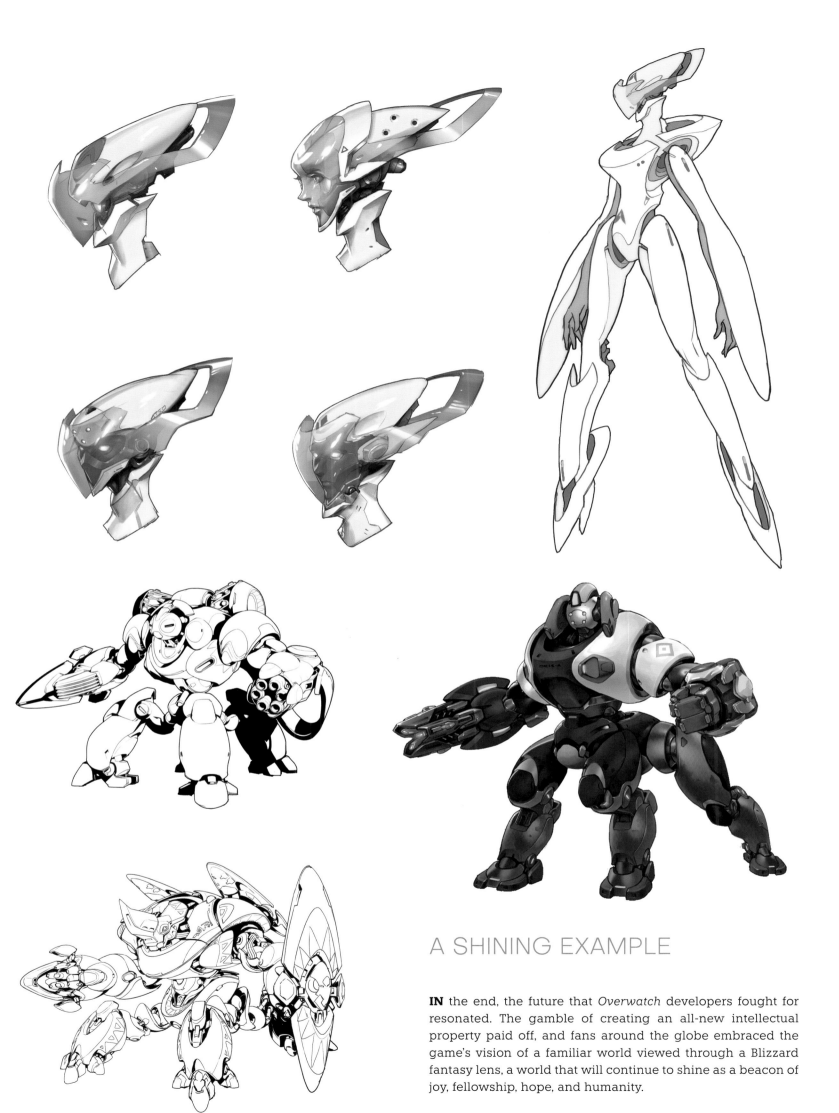

A SHINING EXAMPLE

IN the end, the future that *Overwatch* developers fought for resonated. The gamble of creating an all-new intellectual property paid off, and fans around the globe embraced the game's vision of a familiar world viewed through a Blizzard fantasy lens, a world that will continue to shine as a beacon of joy, fellowship, hope, and humanity.

TOP: Arnold Tsang
BOTTOM: Ben Zhang

THE IMAGE THAT LAUNCHED A UNIVERSE

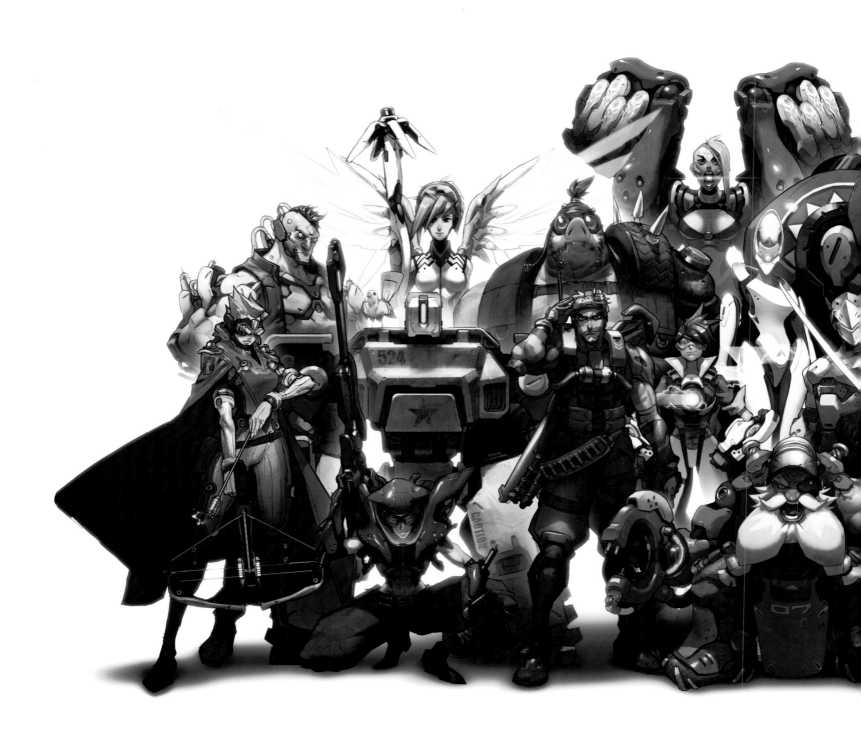

A team of scrappy heroes emerges from past challenges to once again make a difference, to become who they were meant to be. If that sounds like the plot for *Overwatch*, it is. It's also the story of the team that brought the game to life . . . and the stunning comeback that was cemented by one incredible image.

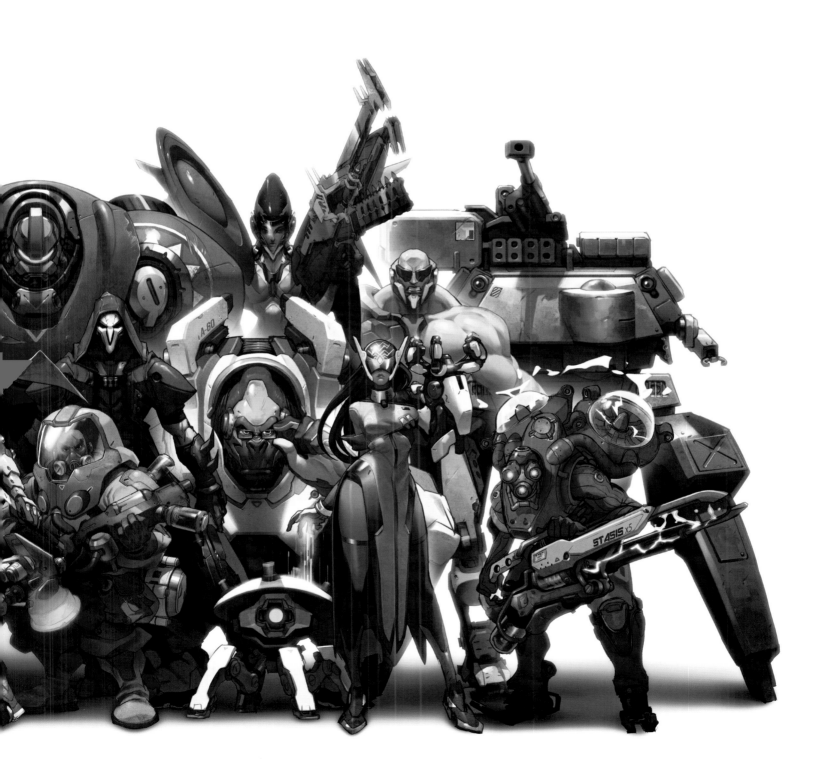

A FIGHTING CHANCE

WE'VE already touched on the cancellation of *Titan*, after which the majority of the game team was reassigned. The small group of developers who remained behind were given an opportunity—"Six weeks to come up with new pitches," recalls former Blizzard vice president and *Overwatch* game director Jeff Kaplan. "Come up with three different game ideas, and at the end of six weeks, pitch those ideas. At that point, the company would decide whether to move forward or redistribute the team."

The pressure was on.

Kaplan continues: "The first thing we worked on was called *StarCraft: Frontiers* [see chapter 8]. It had this awesome *StarCraft* environment. Project number two was *Crossworlds*, which we had a few pieces of art for, but it was during *Crossworlds* that I put together the *Overwatch* pitch. The team got so excited that we never finished the *Crossworlds* pitch. At the end of our six weeks, we only pitched two games, *StarCraft: Frontiers* and *Overwatch*."

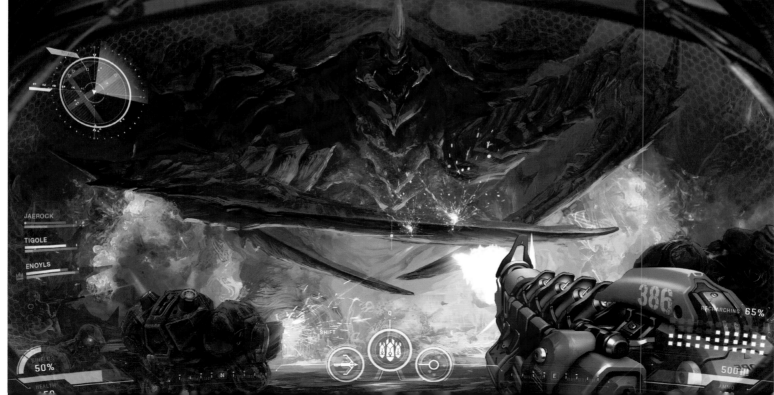

CLASS ACT

KAPLAN and the team came up with the idea for *Overwatch* based on two sources of inspiration. First, from lead hero designer Geoff Goodman, who mentioned a desire to play a game that featured a lot of classes with a narrow set of abilities for each.

The second inspiration came from old *Titan* art created by character art director Arnold Tsang. "We used to have this thing called TitanArts that was in an archive," Kaplan explains. "We'd just look at Arn's *Titan* art all day long because it was so inspiring. I was listening to what Geoff Goodman said about the classes, and then I was looking at all of Arn's character designs, and I thought, 'This is the game we should make.'"

Tsang remembers clearly: "Kaplan said, 'What if we took a bunch of designs from *Titan* and we made each one of those designs into a hero and we made a hero-based shooter?' That idea ignited the *Overwatch* franchise."

Next came the task of putting together a pitch deck that would represent the team's vision. Central to the team's goals was showcasing a wide array of character classes, all illustrated in Arn's signature style.

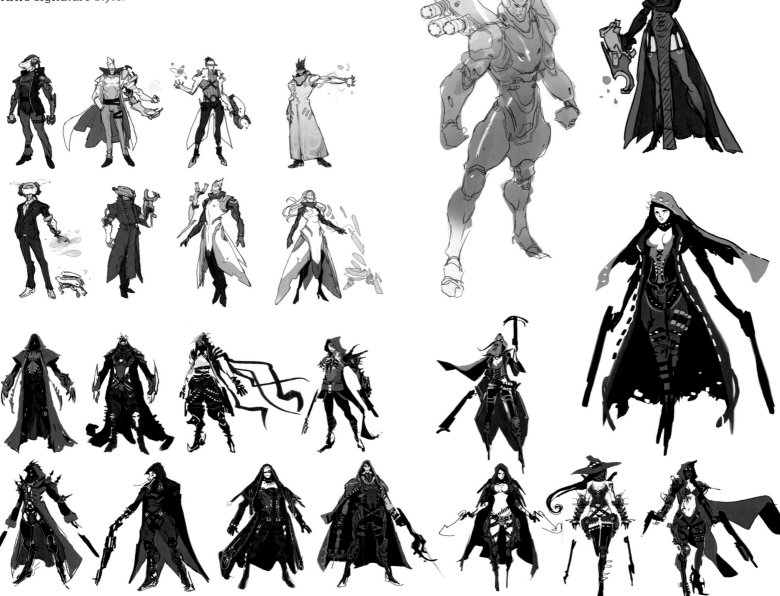

OPPOSITE, TOP & LOWER MIDDLE: Ben Zhang
OPPOSITE, UPPER MIDDLE: Justin Thavirat
OPPOSITE, BOTTOM: Peter C. Lee

TOP RIGHT: Joe Peterson
REMAINING IMAGES: Arnold Tsang

OVERWATCH

LINE 'EM UP

WHAT would come to be known as the *Overwatch* hero lineup began as a desire to exemplify a unique and badass team of champions. "We wanted a piece of art that would sell the idea," Tsang explains. "We had a bunch of designs from *Titan*, but a lot of them were just NPCs. We picked a bunch and redesigned them to make them feel more like heroes rather than just random characters."

Various ideas for an illustrative shot were explored, including one with a black background that had characters dramatically lit. This was discarded, however, as it didn't have the sense of heroism the team was looking for. But the final direction—having a bunch of heroes facing the camera, standing still—wasn't something that immediately sprang to mind for selling an action-oriented game.

"A designer on the team showed me a bunch of images of superheroes lined up over a white background," Tsang remembers. "My brain didn't go there because I was thinking of crazy action poses—the game's all about action, and I wanted something dynamic—but the way he presented it really spoke to *Overwatch*'s final aesthetic: really clean, slick, and futuristic. Having the heroes lined up that way, you could still see their attitude even though they weren't doing crazy flips. They looked cool because you could tell our heroes were different enough—just standing there—that we didn't have to push their poses or use a crazy camera angle."

With the competing designs out of the way, Tsang forged ahead. "We put a lineup together, and people got really excited because at the time it felt different. It felt fresh, and it really encapsulated the spirit of the game—heroes who are very diverse in a colorful world and a bright, hopeful future."

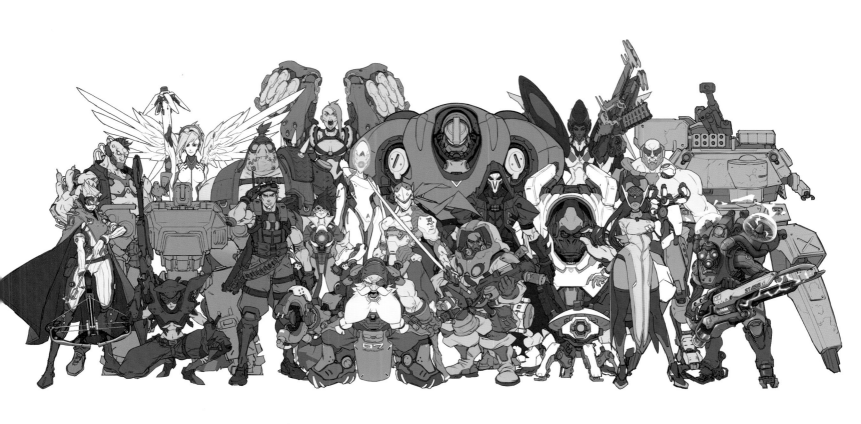

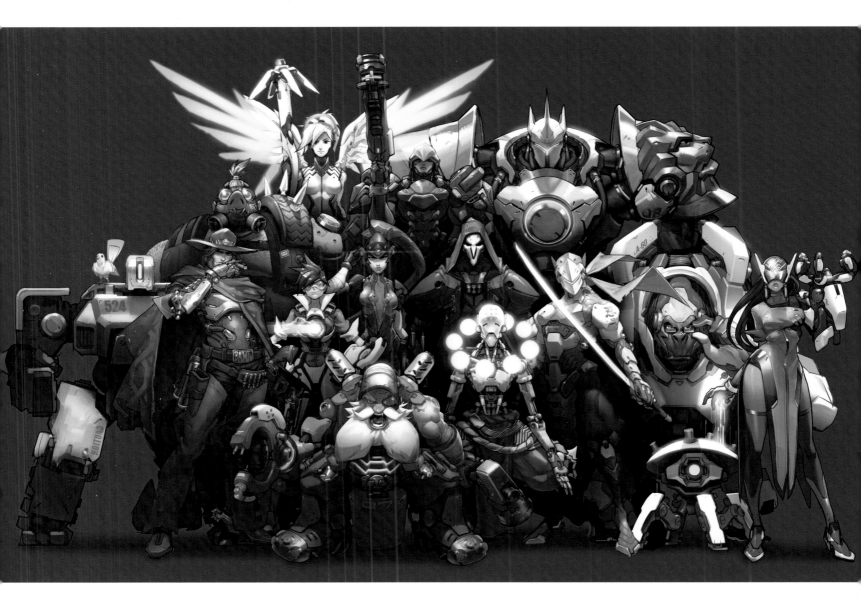

TCHER
f Gun
nsfusion
port

NZO
v
kour
assinate

OST
Axe
patch
Wall

GELICA
l Beam
eport
urrect

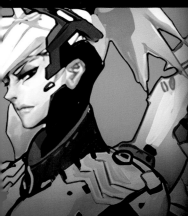

HUNTRESS
| Crossbow
| Multishot
| Imbue shot

REAPER
| Dual Shotguns
| Shadow Walk
| Death Blossom

LONGSHOT
| Sniper Rifle
| Grappling Hook
| Visor

FIRESTARTER
| Slag gun
| Moltovs
| Eruption

RUMBLE
| Siege Mode
| Stationary Shield
| Energy Bolt

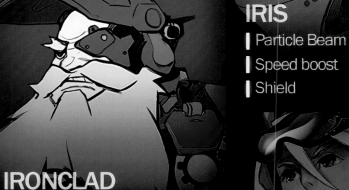

IRONCLAD
| Grav Hammer
| Slam
| Bowling Ball

PSYBLADE
| Super Punch
| Shockwave
| Backbreaker

McCLOUD
| Claymore
| Only One
| Stampede

IRIS
| Particle Beam
| Speed boost
| Shield

BRIT
| Pistol
| Support Mech
| Attack Mech

OVERWATCH aficionados will note differences from the pitch lineup to the in-game characters. "I don't think any of the heroes from the original version made it exactly to what we shipped," Tsang notes. "Tracer's on there, but she has blue hair. Hanzo's on there, but he's still a Hanzo/Genji amalgamation."

While some characters, like the one in the hazmat suit, did not continue on, a few evolved. The character in the back with the red face shield became Pharah. Interestingly enough, at the time she was called Mercy.

Other slides were added to the pitch deck, including the gameplay mock-up featured in chapter 9 of this book and the environment piece featured in chapter 16.

Another slide, of hero portraits, was included as well. Developers wanted to convey a team with individual identities, including names and backstories. Resources, however, were limited. "We said we were going to make a lot of characters, but we didn't have a lot of unique art to work with," Kaplan explains. "Arn had only drawn a few images specifically for *Overwatch* at this point, like Winston. Most were from *Titan*. We had a guy named Jeremy Craig who was a brilliant designer and UI artist who put this slide together, so he very deliberately put people on the edge where you start to look and say, 'Wait, who's that? There's gonna be more?' And he put little abilities and names by them. This image was meant to excite people and get people imagining a game with infinite heroes."

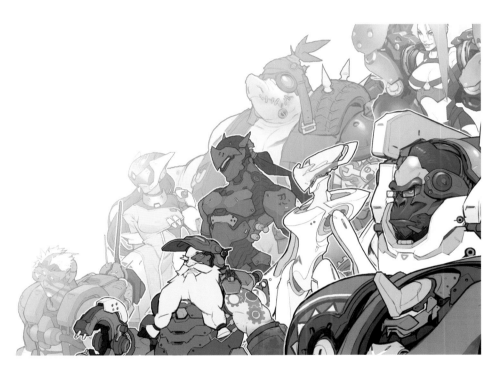

HEROES AND VILLAINS

Heroes from **World of Warcraft** have been featured in numerous stunning pieces of artwork. Until the **Warcraft** hero lineup illustrated by Wei Wang, "supporting cast" characters had not been seen as often, and certainly not all in one image.

Wang aimed for a style that was "realistic and vivid." The greatest challenge, in Wang's own words, was "for the characters to represent my imagination while aligning with the understanding in the hearts of players."

Wei's interpretation was a resounding success. "This image showed all the people, all the leaders of the different races of the Alliance and Horde together," senior art director Samwise Didier points out. "You'd never see them this way in-game; it's more how you would imagine seeing them if we were building a superhero team of **World of Warcraft** characters. It was **Warcraft's** Mount Rushmore."

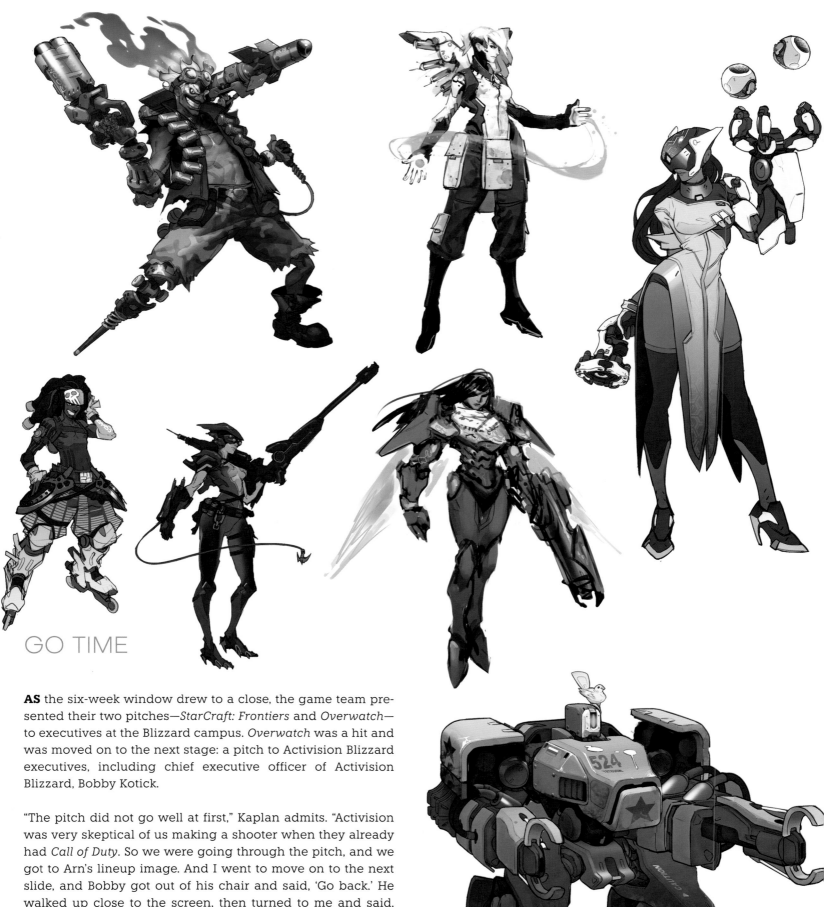

GO TIME

AS the six-week window drew to a close, the game team presented their two pitches—*StarCraft: Frontiers* and *Overwatch*—to executives at the Blizzard campus. *Overwatch* was a hit and was moved on to the next stage: a pitch to Activision Blizzard executives, including chief executive officer of Activision Blizzard, Bobby Kotick.

"The pitch did not go well at first," Kaplan admits. "Activision was very skeptical of us making a shooter when they already had *Call of Duty*. So we were going through the pitch, and we got to Arn's lineup image. And I went to move on to the next slide, and Bobby got out of his chair and said, 'Go back.' He walked up close to the screen, then turned to me and said, 'I've never seen characters like this before. These are the most memorable characters I've ever seen. This is going to be amazing.' It stopped all the discussion. It became about the art at that point, that we were pitching a character-based game and he had never seen characters like those."

Not only would the team not be redistributed—they had just taken the first steps toward creating one of the most popular first-person shooter games of all time.

ABOVE: Arnold Tsang
BOTTOM RIGHT: Ben Zhang

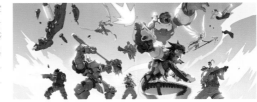

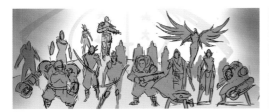
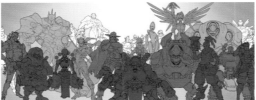
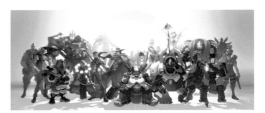

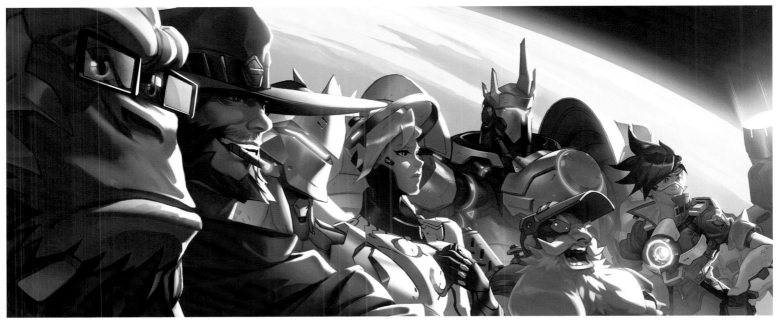

AFTERMATH

LATER that year, the lineup was updated with newly developed characters for the BlizzCon reveal. Elements of the first lineup remained, however, in the announcement cinematic: "There's a bunch of prototypical versions of our heroes in that lineup, and a lot of them actually made it into the announcement cinematic with the 2.5D opening sequence," Tsang recollects. "There's one shot that has a bunch of the silhouettes from that lineup, and I remember when we announced the game, fans were looking at every single pixel and trying to figure out who these heroes were, trying to make up names for them."

The lineup shot was updated once again for the final game. But it was that original image, in all its glory, that set *Overwatch* on the path of a very bright and prosperous future.

Former senior vice president, story and franchise development Chris Metzen, who oversaw the *Overwatch* story line at the time, sees the game's narrative—of a beleaguered team that finds redemption—as subtext for the people who made it. "It was literally our story. We had set out to build the biggest, craziest, strangest MMO you can build, and for any number of reasons we didn't bring it off. The whole process of making *Overwatch* was a group of people learning how to come together, learning how to jam again and make music again."

The man who came up with the game concept, Jeff Kaplan, felt that sense of relief as well: "It was a very wonderful storybook ending."

A THOUSAND WORDS

OPPOSITE: Joseph Lacroix

Whether it's a rough sketch on a sticky note, squiggles on whiteboards, or a chart for *Warcraft* schools of magic, sometimes even the simplest image can be worth a thousand words—especially when it comes to conveying complex ideas. And those doodles have had big ripple effects, even influencing Blizzard gameplay, worldbuilding, and character creation.

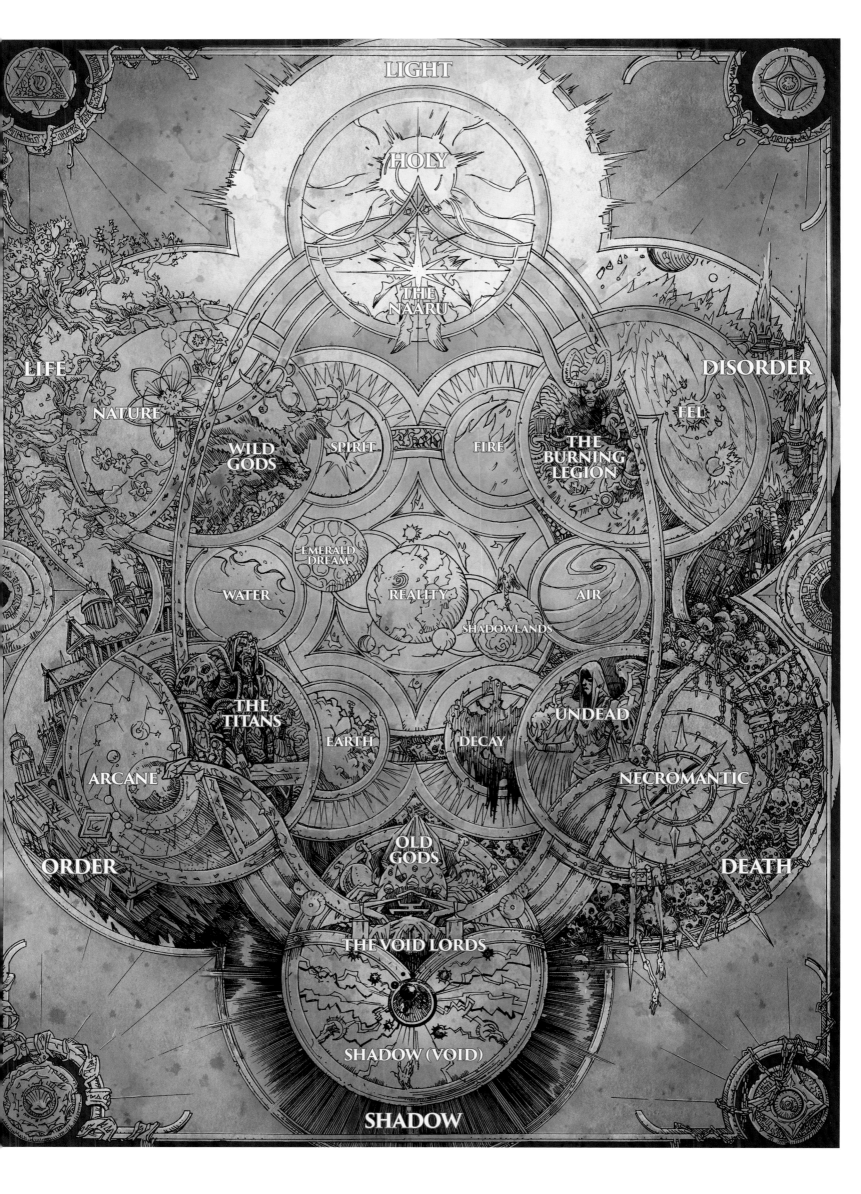

MAKING MAGIC

ARCANE, light, shadow, fel . . . *Warcraft* features magic, and lots of it. These disciplines each come with their own set of rules, both artistically and narratively. Up until the creation of the cosmology chart featured in this chapter, a visual representation of *Warcraft*'s schools of magic had not existed.

Artist Joseph Lacroix crafted the illustration for a lore book called *World of Warcraft: Chronicle*, billed as the definitive guide to *Warcraft*'s complex history and mythos. "They gave me a schematic," recalls Lacroix, "circles with the names and a lot of references for each part, as well as illustrations from Blizzard artists and screenshots from the game. I understood that it was an important piece for the book, but they didn't have a precise idea of what it should look like. They told me it was Titan-related and that I should look at Doric and Ionic architecture."

Lacroix's primary concern was composing the piece so that it would fit on the page. "I had to improvise a lot because I had never done anything like it. So I took a big piece of paper and a compass and tried to remember my geometrical lessons from school."

Once the shapes were in place, Lacroix added details to the blank spaces. "I tried to keep each part unique and also have transitions between them," Lacroix says. "It was a little bit like a game: 'If I draw this here, I should draw this at the opposite.'"

After minor art direction notes, Lacroix inked the piece and included a transition from light at the top to shadow at the bottom, to represent a shift from good to evil.

Unknown to anyone at the time, the image would prove to have further-reaching impact than the lore book for which it was crafted. The comprehensive yet straightforward visualization of *Warcraft* magic became an asset to *World of Warcraft*'s visual development, design, and FX departments.

"The chart is one of our key images," says lead visual development artist Jimmy Lo. "Each of us have it on our computers. The effects team has a big printout of it in their office."

"We started using the cosmology chart as an anchor and jumping-off point," says lead FX artist Sarah Carmody. "It helps provide structure, organize existing magic, and make sure we're in unique territory when crafting brand-new magic."

The chart was also helpful in communicating the FX team's vision and intentions to other departments. "We started creating anima knowing that we needed something mysterious and unexpected in the 'death' magic school for *World of Warcraft: Shadowlands*," Carmody reveals. "FX wanted to make an expansion-spanning unifier to visually remind the player that they're not on Azeroth anymore. We started by pointing to that death circle on the cosmology chart and discussing what that new thing should be. What hadn't we done before? What would be both memorable and help highlight themes of *Shadowlands*?"

A magical theme or motif may even pervade an entire race, informing everything from armor sets to architecture. The influence of magic disciplines in *Warcraft*—how they're understood by the development team and how they're portrayed in the game—is deeply significant, a fact that is not always evident to the player.

"Elements like this make the world feel real," says Lo. "Hopefully players make that connection. They may not see it directly, but we want them to feel it."

The chart's impact, it turns out, was a surprise to the artist as well. "I understood later that it had some success," says Lacroix. "Mostly because one day a Blizzard employee sent me a picture of someone with the chart tattooed on their back. That, and I once read a strange and heavily discussed thread on a *WoW*-related forum."

DEVIOUS DOODLE

IT doesn't always take a lovingly crafted, meticulously designed illustration to convey an idea or artistic vision. Sticky notes, scratch paper, and napkins have all been used with surprising success. One such example rests with the diabolically disturbing *Heroes of the Storm* skin Bikini Stitches.

"When we came up with the idea," remembers senior art director Samwise Didier, "the artist asked, 'What would it be, just Stitches in a bikini?'"

Samwise used a sticky note to quickly communicate what he envisioned: "I did a really quick, rough sketch, just a front view, but it basically showed Stitches with two little pom-poms on the side of his head, a plastic shovel in one hand and a plastic bucket in his other hand to take the place of the cleaver and the hook, and we even did a little skeleton dog that hung off the back of his bikini trunks. I said, 'Something like this,' and the artist said, 'Okay, I think I got it.'"

Senior artist II Andrew Kinabrew took the sticky note and ran with it. "I assumed we would need a real concept, but Andrew must have seen the power, the glory, and the majesty of the Bikini Stitches," Samwise quips, "because he built the model straight from that. Really, though, it's nice that the essence of what we're trying to convey can be done very quickly, and if you give it to the right type of artist, they can take a scribble and make a masterpiece out of it."

KALIMDOR

THE WORLD OF AZEROTH

WARCRAFT II • DESIGN

KALIMDOR THE WORLD OF WARCRAFT

THE BALLAD OF THE BOARDS

WHILE sticky notes can be a perfect vehicle when a quick, rough example is needed, whiteboards offer a similar benefit on a much larger scale.

In *World of Warcraft*'s early development days, former senior vice president, story and franchise development Chris Metzen requisitioned eight roving whiteboards, capable of being moved from bullpens to individual offices, for the purpose of laying out the game's many locations and zones.

"These things were big and awkward," Metzen laughs. "But over the course of a couple weeks, I just hung out in these open areas where we'd sometimes have little chats, and I conjured the highest-altitude map of the world and its zones. I had one big board that was the world map that kept changing—'Oh, we have to put this zone in here'—so I was constantly erasing and moving things around, no one else there, just me with a bunch of whiteboards and markers being as purely nerdy and creative as I get. I had the time of my life."

The whiteboards provided the perfect visual aid for Chris to impart his ideas and guidance to the rest of the team. "I would line these boards up and walk them through. 'This is Elwynn Forest, and there's this big river, and a tower over here, and this is where the Riverpaw Gnolls are.' It was just this cascade of places and races and why they were there and who they hated and, on top of it, this sense of what it would feel like when it all began to knit together."

It's a time that Metzen looks back on fondly.

"It was bliss for me. And the idea that from those simple marker boards, people from the level team would run off and two days later come back and say, 'I think I have it.' And I would look at their computer, and *there's Elwynn*. It's asinine at the highest altitude, until the character artist takes you into their office and shows you the first gnoll with trinkets hanging under his neck and spotting on his fur, and I just thought, 'Wow, they did it. They made the thing.'"

The creative process at the time was one that Metzen likens to musical jam sessions. "Those whiteboards were me playing a baseline. 'What do you guys think of this?' And then the guitarist picks it up and starts doing his own chord progression, and the singer jumps in with cuckoo-bird lyrics and this melody. And the drums and percussion kick in, and suddenly you're in rhythm, and there's music that not one of us could have conjured on our own. All that mattered at the end was the music."

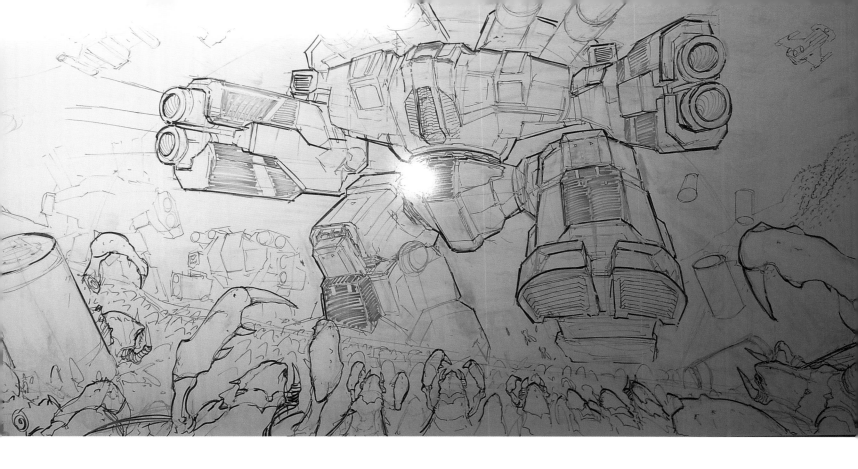

DUELING IDENTITIES

One incredible illustration that began as a whiteboard image also—allegedly—sparked a good-natured signature feud. The painting in question is submitted here for review, along with commentary from the participants.

"I remember Peter Lee doing a picture of a giant Thor from *StarCraft* fighting a bunch of zerglings. He forgot to sign the whiteboard," claims Samwise. "So I just signed it 'Samwise' in the style that Peter Lee writes his name. Which is kind of similar. He crossed it out and signed 'Peter Lee' in my style."

Events unfolded differently, according to Peter Lee's memory.

"I came to the office really late at night, midnight, cracked a bottle of beer, and I was drinking and sketching this wall-size whiteboard drawing of Thor crushing a swarm of zerglings. I signed on the bottom. Next morning when Sammy came into the office and saw it, he must have thought, 'Ooh, this is awesome. I'm going to take it over.' And he deleted my signature and put his own signature on it! I said, 'Okay, is that how you want to do it?' and after the whiteboard was erased, I did a crappy drawing and put Sammy's signature on it."

"It was obvious that I didn't do the drawing in the first place," Samwise responds, "because it had perspective."

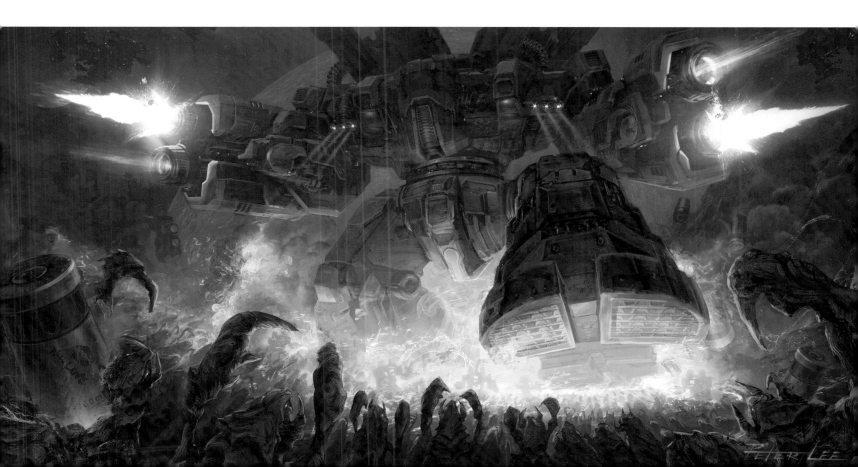

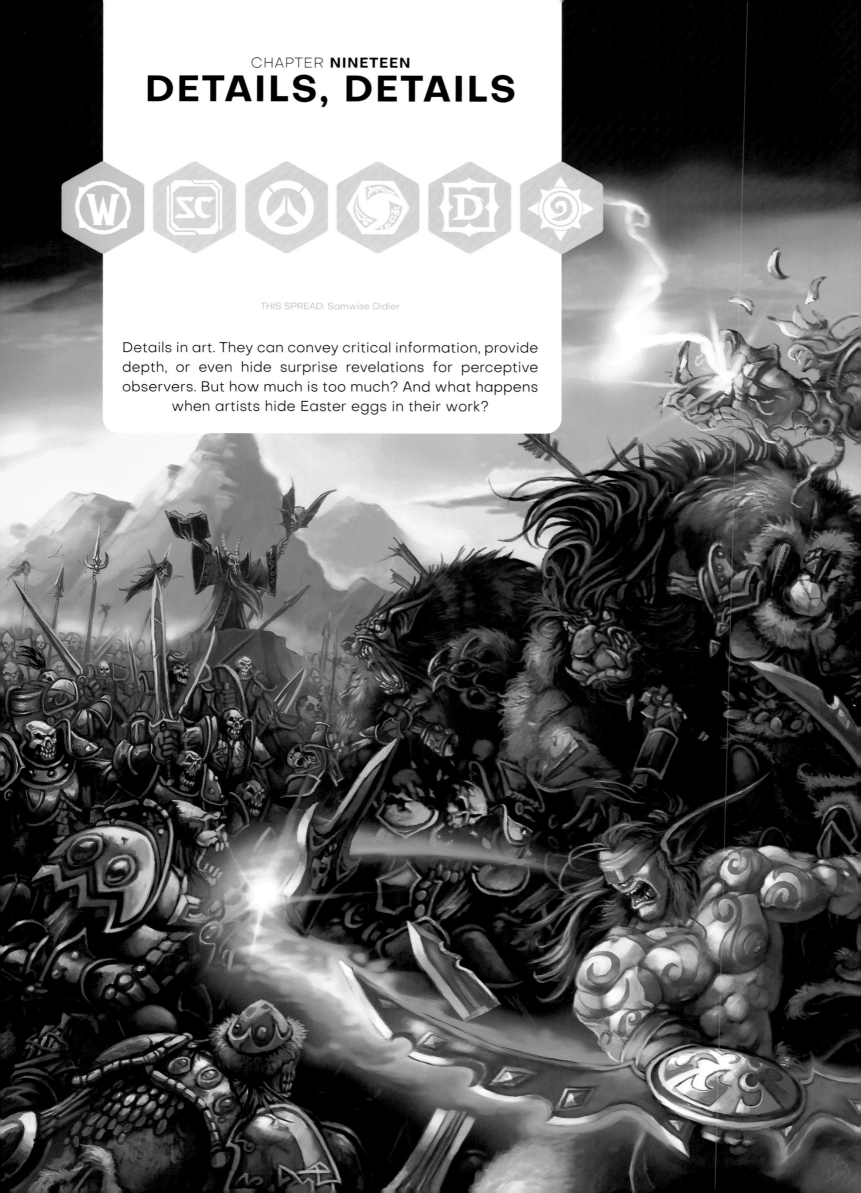

CHAPTER NINETEEN
DETAILS, DETAILS

THIS SPREAD: Samwise Didier

Details in art. They can convey critical information, provide depth, or even hide surprise revelations for perceptive observers. But how much is too much? And what happens when artists hide Easter eggs in their work?

THE BIG LITTLE THINGS

ONE very good reason for an illustration to be highly detailed is to provide fidelity when the art is displayed at a larger size. Promotional pieces, such as a game's "key art," are designed for just such a purpose and may end up on banners, posters, or even jumbo screens at esports events.

There is a long history of outstanding key art at Blizzard, and the artists who carry on that legacy take great pride in their work. A single piece can take months to complete, with multiple rounds of revisions across multiple game teams. Blizzard even bakes time for key art into artists' schedules up to a year in advance. "One of the things we work really hard to do is to protect two parts of the process," explains visual development supervisor Dennis Bredow. "The first is the creative process to make sure that the illustration is on target in terms of messaging, but then we protect the last part of the process, for all of the detail and polish work that needs to go into it."

Part of the reason for setting aside that time is to make room for an additional part of the process—a lore pass. "All key art goes to the lore team," Bredow notes, "to make sure we're representing every character and costume accurately, that every type of magic has the right color, or that everyone has the right number of fingers and toes."

TOP: Sean McNally
MIDDLE: Wei Wang
BOTTOM: Todd Lockwood

HALLOWED HALLS

PROMOTIONAL pieces aren't just for the public.

At a time when senior art director Samwise Didier was learning the ins and outs of digital paint programs, he began work on a promotional piece for *Warcraft III*. What began as a small human-versus-orc face-off turned into a full-blown Alliance-versus-Horde clash. "Each character took a day and a half to two days," says Samwise. "And it was such a large file it took me five minutes to save each one, but at the end of the whole thing, we had our first full-color picture of armies battling."

The illustration was turned into a poster that shipped inside the *Warcraft III* game box. That poster can still be found hanging on walls and cubicles throughout the Blizzard campus, a source of inspiration.

"It's not the best image by today's standards," Samwise says. "The proportions are off, and it's a little janky, but it's still meaningful. For some people, this was the first moment they said, 'This is what *Warcraft* looks like.' I think it really conveyed the vibe of what our fantasy game was all about."

Detailed concept art can also directly impact a game, as with a detailed Wei Wang Icecrown Citadel image that was scaled up and displayed in the *World of Warcraft* team area during the development of *Wrath of the Lich King*.

"That one concept gave us enough information to build out our in-game area for *Wrath of the Lich King*," senior art director Chris Robinson recalls. "We took everything we needed from that single concept to build a place in the game where players spent months, if not a year, in that one spot."

THE NUTS AND BOLTS OF DETAIL

FORMER vice president of art and cinematic development Nick Carpenter was already known for turning out hyperdetailed work when he began delving into the new—at the time—medium of 3D art. "We were just coming out of this 2D space where we were building everything by pixels," Carpenter reflects. "Then in 3D it was like, 'I can just keep zooming in to this object? Whoa!'"

Carpenter, who grew up on science-fiction films set in believable worlds, took detailing in 3D to entirely new heights. "Details were a tool," Carpenter says. "There was this quote about detail that basically said the audience might not see it, but they'll feel it if it's not there. That hit me. I was like a kid with a hammer, just swinging—everything was a nail."

Or a bolt. Carpenter remembers a specific example of taking detail too far, when he built a hallway for a *StarCraft* cinematic.

"They were getting ready to use it, but the software couldn't generate the image. One of them went in and started pulling bolts out, and he said, 'What is this? There are threads on these bolts! No one's even gonna *see* the bolts!' I think they ended up just taking photos of the hallway and making textures out of them."

Carpenter recalled advice he had been given by Samwise: "Don't forget the bigger picture; you can get lost in the details if you don't learn how to balance that. Use your details where it makes the most sense."

It was a lesson that Carpenter passed on to his team. "What you learn is where do you place that information—where does it matter?" Carpenter says. "If you hit it and you hit it right, people will feel it. A lot of kids I was hiring at the time were really into that thought process, and we just made a church of detail, and now these people are setting the industry on fire."

DETAILS YOU CAN TOUCH

SENIOR sculptor II Brian Fay has a rule when it comes to detail: "It shouldn't feel random; it should be added with a purpose."

Fay put that rule to use when he crafted a sculpt for the Blizzard Collectible *Diablo IV* Lilith statue. At the time, Fay was using a Brom concept painting for reference, a painting with deep shadows that left certain details to the imagination. "In the painting there are a lot of dark areas, and we don't see the back,," Fay says. "So I looked at Lilith's father, Mephisto. He's creepy, he doesn't even have legs, but he has a long, bone-like tail."

Fay pitched the idea of including the bone tail in Lilith's composition. "We look like our parents, right? I thought it'd be cool if there was some trace of her father. They said, 'Go for it.'"

The other details Fay added were appropriately gruesome: "The corset she had was pierced into her skin. On the back were buckles and clips; I felt like it should be painful and creepy."

The result was such a success that the model ended up not only being used in the *Diablo IV* announcement cinematic, "By Three They Come," but it was also used in the game itself. For Fay, it was a one-of-a-kind experience, a chance to bring life to a character that had not yet been fully realized. "It was challenging, but it was fun," Fay says, "because I had an opportunity to move the needle. There are people who like doing fifteen different versions of a model. I just do the one. I don't want fifteen versions—I want the one, and I want people to be really happy with it."

EASTER EGGS:
HIDING IN PLAIN SIGHT

LOOK close enough at the primary image for this chapter and you'll find a hydralisk. Play a certain map in *Warcraft II* and you can find the name "Samwise" written in yellow in the snow. A palette glitch revealed secret messages in the background of the *Diablo I* install screen . . . All are examples of Easter eggs— secret words, images, symbols, messages, et cetera, that artists cleverly conceal in their work. But why do it?

"The real and honest reason is because we can," Samwise laughs. "If you're working on something, for example, the Scourge versus the night elves, you may get tired of drawing dozens and dozens of skeletons. There's not a lot of variety. Every once in a while, you throw in something fun."

Like a hydralisk. Sometimes Easter eggs are created for fun, sometimes to express annoyance. "There was a symbol on Illidan's glaives that we had to change repeatedly," Samwise reveals. "I was being a baby about it, and I put a panda face on there. No one really knew for the longest time until some- one noticed and said, 'Is that an angry panda face on Illidan's glaives?'"

Artists are notorious for including all kinds of secrets in their art. Usually names, birth dates, or initials. "I'll occasionally use numbers that are relevant," senior concept artist II Luke Mancini confesses. "My wife's birthday or the day we got married."

Easter eggs can also be part of gameplay itself. On a certain map in *StarCraft II: Wings of Liberty*, if players clicked on an outhouse enough times, a tauren marine would come out.

Even sculptors like Brian Fay are not immune. "On some of the statues, I carve my name somewhere hidden, often on the base," Fay admits. "Wrinkles, it turns out, are a great way to hide initials. "Wrinkles make shapes, what they call *XYZs*. It's not hard for me to use those shapes and a little finesse to spell out my last name."

Easter eggs are, for the most part, harmless. But can they be taken too far?

EGGS-TRAVAGANZA

World of Warcraft developers began noticing non-*Warcraft* runes, glyphs, and initials on pommels of swords or the undersides of desks. "Easter eggs are neat, but at the same time, it's a slippery slope," senior art director Chris Robinson says. "If one artist is doing it, then the artist next to them is going to want to do it, and the game becomes a tag yard where everybody's drawing on top of one another."

World of Warcraft now keeps an eye out for unwanted material. A similar situation crept up on the *StarCraft* team, in which the number fifty-four (see sidebar) has shown up in *StarCraft* for years. "*StarCraft II* is littered with five-fours," says lead character artist Ted Park.

"Five-fours actually got too heavy-handed," Mancini admits, "to where every terran thing we did had five-four on it. By the time we were on *Heroes*, everything had five-four plastered on it."

OPPOSITE, TOP RIGHT: model by Allen Dilling, texture by Samwise Didier
OPPOSITE, BOTTOM: *StarCraft* Team

ROTTEN EGGS

ARTISTS sometimes spend many hours and go to great lengths to create Easter eggs. Sometimes, it turns out, all that work is for naught.

"There were times I'd work all night on Easter eggs," says lead artist Allen Dilling. "I thought everyone would notice and love it and day one of ship I'd go onto forums and everyone would be talking about it, but almost every single time I never heard a word about any of it. Either people didn't find it or they didn't care."

On the *StarCraft II* Port Zion map, Dilling made a conveyor belt beneath a grate, where homages to canceled games went passing by. To commemorate *StarCraft: Ghost*, Dilling made a Spectre wobble-headed figure and texture-mapped his own face to it. "I took a picture of myself," Dilling remembers, "emailed it to myself, which was hard back then because phones were terrible, and wrapped it around the head. It was hard to tell it was me, but I was in the game. No one mentioned it, ever."

WHAT IS THE 54?

*Far back in Blizzard history, when the **StarCraft** team was transitioning to new office space, an artist returning from working with the cinematics team arrived to find that the bullpen had already been filled, meaning he and one other artist would be relegated to a smaller space down the hall.*

It was quickly determined by the duo that their "outcast" office should become party central for the company. The name "Players Club 54" was coined.

The Players Club hosted everything from mariachi bands to cheeseburger-eating contests. It even included a monkey fund, which, yes, was intended to fund the renting of live monkeys. Sadly, that goal was never realized. (Monkeys, it turns out, are harder to rent than one might imagine.)

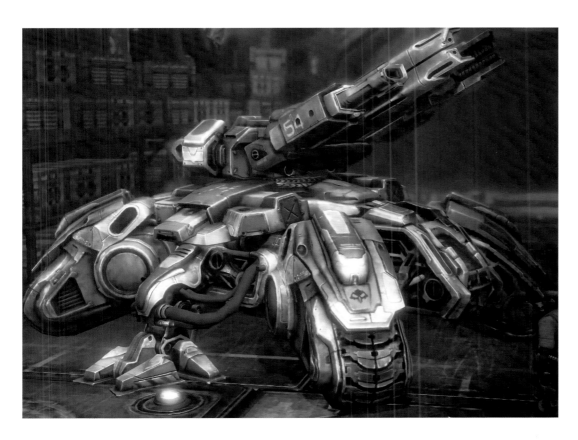

It's no small feat to encapsulate the DNA of an organization, class, or people in a single icon, especially when that DNA is distilled from a winding history or a complex world. Though often overlooked, logos, crests, and user interface (UI) are critical to the game experience . . . and navigating Blizzard's storied franchises would be nearly impossible without them.

LOGO LEGACY

A consumer's first impression of a game will often come from its logo. Tone, style, and clarity all need to be conveyed at a glance with one compelling, quick read.

Sometimes graphic artists will nail a great logo right out of the gate. Such was the case with *Overwatch*. Former senior II UI artist Randal Dumoret developed the wordmark and partnered with the lead feature designer for the *Overwatch O* sigil, both of which were an instant hit with the team. Despite additional versions being explored by various departments through the company, the early designs stuck.

"Building this universe, and the logo, was so interesting and exciting for us," says *Overwatch* senior art director Bill Petras. "More creative groups got involved, and people were really passionate about these ideas. The marketing group had a ton of different versions of the logo, and there was also the logo from the team. We just kept going back to the original. Because it was so clean, the graphic design felt futuristic. It felt positive."

The look was a departure from other Blizzard logos—enough to cause early concern. "Blizzard logos have a lot of character," says Petras. "A handcrafted feeling, like they're pounded out of metal. We were worried about our logo being relatable to the Blizzard portfolio of IPs."

In an attempt to bring the logo in line with other Blizzard properties, a version was made that was used in early cinematics, with brushed, pitted metal and sparks. "We looked at it and said, 'We gotta change that,'" recalls Dumoret. "That's when I did the one you see everywhere today, the more white background with the triangles and the light. Everything's bright, with light purples and light blues. We pushed to make it brighter and more open and more accessible. We didn't want it to look like you were about to join a war game."

Two versions of the cleaner, brighter logo were used going forward. "I did the black graphite one against the shiny background, and then I also did a holographic one because all of the *Overwatch* UI was presented in this holographic style, so that's the thing you see at the start of the game. I think that was our favorite, but it doesn't hold up well against a lot of print, so we needed different versions."

But where *Overwatch* charted a sleek new logo style for Blizzard, *Hearthstone* faced a different challenge: establishing its own identity while also maintaining its connection to *World of Warcraft*.

"We asked, 'What font is *not* going to say *epic, edgy, spiky, red*?'" says former *Hearthstone* creative director Ben Thompson. "'What's the thing that's *not* going to play into one faction or the other?' It had to have a fun and playful feel to it, but it still needed to feel *World of Warcraft*. It still needed to read easily in both gold and stone."

The *Warcraft* connection was also evidenced in early versions of the logo that included the dropped subtitle "Heroes of Warcraft."

"We agonized over the right way to go out with the game. We felt it was wrong not to lean into what we were a part of," Thompson says. "Later when we removed it, it was a matter of *Hearthstone* having become its own world as well. Players could play *Hearthstone* and get a good understanding of *Warcraft* without going to *World of Warcraft*. It had developed its own look and feel as a game, and the naming change reflected this."

TOP: Overwatch Team
MIDDLE: Jeremy Craig
BOTTOM RIGHT: Hearthstone Team
OPPOSITE: Blizzard Creative Services

WORLD OF WARCRAFT: FORGING AHEAD

WITH eight expansions under their belt, the *World of Warcraft* team works closely with marketing when it comes to logo creation.

"There really isn't a lot of time for anybody internally to go in and noodle on something that's not putting pixels on-screen," says senior art director Chris Robinson. "So we work closely with marketing from the get-go when we hammer down a definitive direction on a patch or expansion."

For the marketing team, each expansion is a new and welcome challenge. "Now that some of the IPs are more than twenty years old, it's a question of, 'How do you stay true to the game but evolve it? How do we progress the franchise but still give each game its own voice?'" says senior design lead Mike Carrillo. "We do these studies where we look at each game all the way back—the core colors, the graphic devices, the major themes, the pieces of art from each sequel or expansion. We put them into these buckets and say, 'This was the breadth of the first, the second, et cetera, so how do we make the latest one unique?'"

Sometimes this can be done by focusing on elements such as new heroes, villains, environments, or story arcs. Sometimes it comes from motifs or stylistic elements that are particular to those expansions. Whatever the case, it's a process that requires collaboration. "We give them the briefing of what the expansion's all about," says Robinson. "Then we throw them materials, textures, anything they can pull from."

Marketing then chooses what to focus on. "Is it color?" asks Carrillo. "Is it certain materials? How do we leverage that? How do we distill this story into its core elements?"

For certain expansions, the *WoW* team has another tool to help marketing envision new logos: crests. Crests are icons found in-game that represent different races, classes, or factions. They feature a combination of graphic elements that convey that group's identity.

"When we know we're doing a major new race or kit," says Robinson, "we'll create those crests that are kind of like inspiration pieces. Typically, the first ones sit for quite a while and evolve over time as we're building out the kit. We'll do the initial sketch, sort of a rough color, and we won't really finalize them until we've worked on the culture kit for quite some time. Each piece represents a certain race or part of the game and evolves along with the expansion, the patch, or whatever it might be."

Senior art director Samwise Didier has been designing crests since the earliest days of the *Warcraft* franchise.

"I try to just think of the most iconic things about the race," says Samwise. "For blood elves, say, they're very elite and arrogant, consumed with magic. They're very beautiful and elegant, but they're dangerous, so you make this beautiful shield that has a lot of sharp edges; it's overly ornate. A lot of the races have certain color schemes that go with them, so you add that in there too. It's basically creating a physical representation or a character of what the race is."

As the team develops the crests, they share the progress with marketing to pull new elements.

"In the end, we want that whole thing to look like it was developed in tandem, like it all fits together and makes sense," says Robinson. "It's a really cool partnership between the dev team and our marketing team, to make sure we're not both going in different directions and just trying to pull it all together in the end."

SHELF LIFE

As we've seen, a major task for Blizzard developers is to ensure every game or expansion maintains the spirit of its franchise, while also breaking new ground. This same consideration extends to one of the most prized possessions for any diehard Blizzard fan: collector's edition boxes.

"We take a lot of pride in them," says Carrillo. "One of the most fun ones was the **Diablo III** collector's edition, where we decided to hint at a major story reveal without being overt about it. Everything we knew about **Diablo** was black and fire and the Burning Hells, so we said, 'What if we made the box a dirty white, to nod toward the High Heavens in this expansion? But it's not the pristine heaven you think you know . . .' We kept that direction as almost a hidden story arc of the collector's edition."

Marketing artists and designers have to be flexible to meet the needs of all Blizzard IPs. For collector's edition boxes, everything they do is geared toward the super fan.

"Now unboxing videos are a thing on the internet," says Carrillo. "So we stack what's inside the boxes in a specific way, layered, being mindful of 'What is the first experience when the box is opened? What is the first thing they remove? What is the second? The third?'"

For gamers who are fans not just of a specific title but of Blizzard in general, designers make the boxes all roughly the same size, across the different IPs, to provide cohesion when a collection sits on the shelf.

"Collector's editions have always been some of the most fun and unique projects that come through our department," Carrillo says. "Fans celebrate them—they don't get tucked away in a box in the garage. It's always a thrill to see fans post pictures of how they present their collector's editions."

UI: CONTROL ISSUES

USER interface (UI) is the fans' gateway to the game, the way gamers execute commands and control what happens in the virtual world. UI differs greatly from game to game.

"In an RTS game like a *Warcraft* or *StarCraft*, you issue all your commands to your units," says lead character artist Ted Park, who designed user interfaces for games including *Warcraft III* to *World of Warcraft*. "UI gives you the information you need to make decisions over the course of a game."

UI wasn't necessarily something that received a lot of attention from video game developers, especially in the early days. "Back then, it was just a gray bar with some buttons," says Samwise. "But we wanted to make our UI a work of art. It needed to be elegant and simple, but 'simple' doesn't give you an excuse to not make something cool."

Blizzard used UI to portray the tiny units players controlled in the RTS games.

"In *Warcraft*," Samwise says, "the UI for the orcs was this hammered and beaten wood, and the buttons looked like they were made out of rock. On each one we would hand draw not just a silhouette of the orc grunt—we would draw their face so you knew immediately what these guys looked like. This was before we had portraits in games, so we took the opportunity with the UI to not only make it functional but to help players familiarize themselves with the units."

UI also uses stylistic elements or motifs to communicate the personality of different races. "In *StarCraft*, terrans gotta feel terran," says lead artist Allen Dilling. "We'd have to figure out the iconic thing to represent this race, like a hazard stripe at the bottom is instantly terran. Protoss, it's all about energy lines. Zerg, some spikes. It's always a challenge, but design had to come first; then everything else was up to how far we could push it and be creative on the art side. As we'd get new artists on *StarCraft*, I'd say, 'Okay, you got the metal, now don't overdo it, but put a hazard stripe on that sucker.'"

Many UI elements have become iconic and are closely associated with the games they're featured in.

"First and foremost, when you look at the UI, without anyone saying anything a player should think, 'Hey, that's a *Diablo* UI,'" says *Diablo* lead artist Richie Marella. "One of our art pillars is to embrace the legacy, have elements like the angel and demon on the action bar. Those are legacy things that we don't want to stray away from. So embracing the legacy is number one, but also pushing it, asking what can we do better."

While UI was especially integral for Blizzard's real-time strategy games, later titles, like *World of Warcraft*, minimized UI to maximize the player's experience. "We designed the UI in *WoW* to be less intrusive," says Park. "Because we wanted the game to be immersive—we wanted you to be in that world—so we pushed a lot of the elements to the edges rather than having them take up too much space in front of you."

And while *World of Warcraft* was fairly light on UI, that didn't necessarily equate to a lighter art lift.

"For *World of Warcraft*, there were tons of things that you could make and cook and forge and harvest," says Samwise. "Each of those needed cool-looking buttons. Nowadays we hire people specifically as UI artists, but in the earlier days it was just someone who was either free or someone who didn't mind working on UI buttons. Or," Samwise says with a smile, "no one else would do it, so the most senior artist on the team got stuck making two thousand buttons."

Buttons, as with other UI elements, had to communicate a very clear message using symbols and color.

"We'd use symbols like a wolf footprint against a green background. You see that for 'nature magic' and get it very easily," explains Samwise. "The symbols and colors matter because if you're trying to say something is a holy blessing and the spell is brown and black and has a goat head for a symbol, that wouldn't feel right. But if it's a golden or warm color, with smooth, elegant symbols, you think, 'Okay, I feel this is a beneficial spell.'"

One thing that was always at a premium with UI was space.

"We would always get into these discussions," says Ted Park. "'Does this need to be smaller? Does the border need to be thinner? Does this button need to be moved a pixel or two to the right or to the left?' I remember one time someone asked to make something thinner, and we were already down to one pixel. We were so invested in being efficient with our space that we got to the point of 'Can we do the impossible? How do half pixels work?'"

For a game like *Hearthstone*, many of the traditional video game UI rules were thrown out the window.

"I always refer to *Hearthstone* as the game that UI built," says Thompson. "With any tabletop game, everything that you choose to incorporate or leave out will either make the game harder or easier to visually understand. The game board is fun and whimsical, but it's doing real work immediately outside of those four corners when you see where the mana counter is, where the mana gems go, clearly understanding my side versus my opponent's side of the board, how I view your hero across from my hero, how many cards are in your hand or my hand—all of those things are very informational moments."

From an overall design perspective, *Hearthstone* used UI to help depict a "real" sense of sitting across from another player at a tavern.

"Good card players say, 'You don't play the game—you play the player,'" says Thompson. "We wanted to convey the idea of somebody you can't see sitting across from you, so we added the visual cue by which you could see them mouse over cards in their hand and you can see it highlight and you can start to build stories in your head about, 'Oh, they haven't played that card in four rounds—that's gotta be a big one.' Bluffing became possible in a digital card game where you're not seeing the other person. All those things pointed to the fact that, as a tabletop game, the entirety of the game space *is* the UI. As with any good UI, the most successful one is the one you don't see."

CHAPTER **TWENTY-ONE**
SLINGIN' ART

OPPOSITE: Ludo Lullabi, Konstantin Turovec

Blizzard's digital card game **Hearthstone** uses warm, whimsical art to transport players from the wide-open **World of Warcraft** to a single game board inside an inviting tavern. In this chapter, we'll peek behind the curtain at **Hearthstone**'s amazing game, card, and key art.

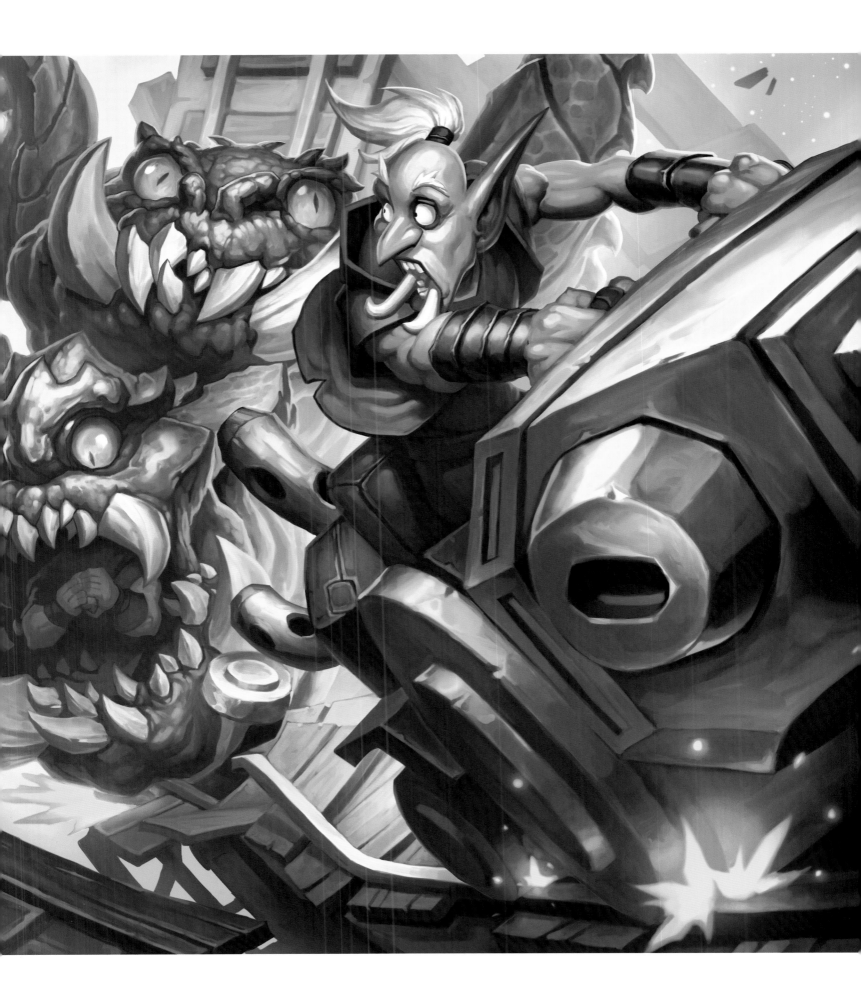

WHY A CARD GAME?

HEARTHSTONE wasn't born from metrics or surveys or algorithms suggesting a fantasy card game would be a hit among players. The team simply chose to make a game they themselves would want to play.

"The group making *Hearthstone* was made up of players and fans of card games," says former Hearthstone creative director Ben Thompson. "We knew how players felt because we were players of this style of game ourselves. We knew going into this, and we refer to it all the time in a very self-referential way, 'If *World of Warcraft* and the games that we love to make and play are the nerdier side of gaming, card games with all of their numbers and inherent math might be the nerdiest of the nerdy. But this doesn't mean that they aren't also incredibly FUN!'"

Fantasy card games are a place where math, fantasy, and strategy come together, and they typically have a high barrier to entry. *Hearthstone* developers wanted to build a bigger table, one where any kind of gamer could fit. From the beginning, the challenge for Thompson and team was how to make a game that's reliant on a number of things—math, strategy, abstraction of thought, not hack and slash—*and* make it approachable, something that you play and love before you realize what it is you fell in love with.

One of the many ways *Hearthstone* achieved these goals was by conveying personality and character through art.

THIS PAGE: Ben Thompson
OPPOSITE, NUMBERED LEFT TO RIGHT:
Ben Thompson: 1–4, 7, 8–11, 18, 21, 27, 34
Jason Kang: 5, 16
Jomaro Kindred: 6, 13, 15, 17, 19, 20, 22, 23, 25, 26, 29–33

Jomaro Kindred/Ben Thompson: 12, 24, 28
Jesse Brophy/Ben Tompson: 14
Jerry Mascho: 36, 37
Jas Tham: 38
Charlène Le Scanff: 35, 39

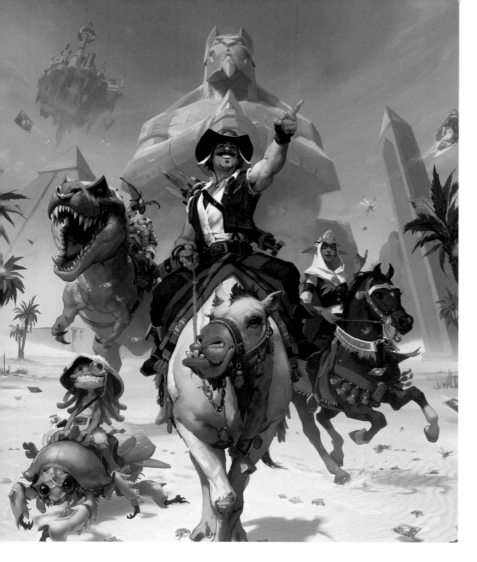

KEY EXAMPLES

KEY art is generally large and portrays multiple characters, either in action poses or sometimes engaged in battle. The pieces are used to promote the game in everything from social media banners to posters. More recently, key art has been added as an in-game asset, a portrait for each expansion, displayed at the start of the game.

"Key art used to be different aspect ratios," says former principal artist Laurel Austin. "Tall, wide, square, whatever. But when they decided to put them in the game, they had to fit in this nearly square box. So really a piece either has to crop to fit in or it just has to be *made* to fit in."

Which is why most current key art uses radial symmetry. "The point of focus is in the center," Austin points out. "Everything else is in this globe around it. We also make heavy use of fish-eye perspectives so all the perspective lines kind of bow around the edges and you can fit even more material in there. I make some key art tall, to look kind of like movie posters, but they all crop down to fit in that in-game screen."

Despite the many ways it can be used, in the view of senior art outsource manager I Bree Lawlor, key art accomplishes one major goal: "Key art is that awesome storytelling moment where you really feel you're a part of this huge, epic scene. It's setting you up for what we hope is an awesome experience you're about to have playing the game."

TOP LEFT, TOP RIGHT, & BOTTOM: Laurel Austin
UPPER MIDDLE: Matt Dixon
LOWER MIDDLE: Luke Mancini
OPPOSITE: Ben Thompson & Hearthstone Team

BOARD, BUT NOT BORING

HEARTHSTONE's zoomed-in scale allowed it to capture *Warcraft* style at a level of detail unattainable in *World of Warcraft*'s sprawling universe. That aesthetic, however, took time to develop.

"Initially, the boards were very austere," Thompson reveals. "Like a chessboard with four corners, some pieces, even squares where all the pieces would go, and what we found immediately was that it felt formal and rules-y."

Artists moved forward using established *Warcraft* style as a guide: bright, saturated colors, exaggerated proportions, and avoidance of straight lines. To this they added an aged, handcrafted feel.

"Also, because it was going to be mobile, we tried to push things thicker and chunkier," observes senior outsource manager I Jeremy Cranford. "We wanted it to be for all ages, so that gave us the cute and the charming—the squishier version—and we embraced that."

Throughout development, the team searched for ways to highlight character and whimsy.

"There are whole portions of this game where, as a player, you are not doing anything," says Thompson. "Like when you are waiting for your opponent to make a move. Ultimately the first 3D artist on the team was modeling the catapult on the Orgrimmar board, and he said out loud, almost to himself, 'This should actually do something . . .'"

That gave Thompson an idea: make it launch.

"We didn't tell anybody initially," Thompson says. "It just kind of sat there. People started playing, and they said, 'Wait, did that just shoot a rock?' They realized if they clicked it, they could crank it back down and put another rock in and shoot it again."

For the developers, it harkened back to a lighter side of the *Warcraft* real-time strategy games, where players could click repeatedly on a unit to hear humorous responses. It was a concept the whole team rallied behind.

"All the way to the audio team," Thompson confides. "We had [principal sound designer I] Andy Brock, who said, 'You've got some bones here. I'm going to make it so you can play them like a xylophone.' It was awesome to see how much the team enjoyed a non-game-specific thing that brought so much charm to the experience."

But through all the fun, there was a golden rule, Thompson says. "Ultimately, we don't want people playing the board and not playing the game. Nothing affects the game space or the pieces in it—that's sacrosanct."

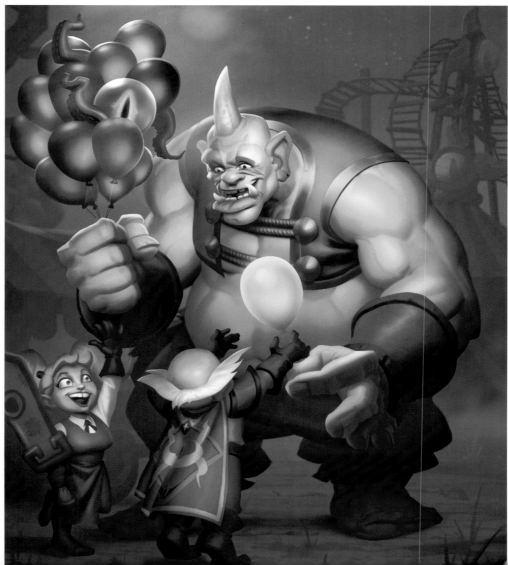

ROLE CALL

CARD art presented the team with an entirely different set of challenges. For many years at Blizzard, it was considered far from standard to outsource a substantial amount of game art. But for a card game that would average roughly two hundred cards per expansion, the sheer volume made in-house execution impossible.

"I would ask, 'Who wants to illustrate?' And I would have maybe six internal artists who could do a card. Great. Now I only need one hundred and ninety-four more . . . and we have to launch in three months," Cranford laughs. "The only model that works is contracting."

For some, this was a cause for concern. *Warcraft* already had a very distinctive style, one that was often difficult for artists to nail. *Hearthstone* took this already tricky style and made it even more specific. Would artists produce the expected level of quality within the bounds of the schedule?

Thompson felt the time was right. "If you do this too early in a franchise, you run the risk of watering it down or changing what the franchise is saying. But *Warcraft* had been around for so long. We were blessed with a host of artists who not only understood the aesthetic but were excited to take part in the creation of it. And those who didn't understand it inherently could usually come around pretty quickly because it's very approachable."

For some, there was another concern: What if players liked an external artist's take on a character better than that of an internal artist?

"You know what the best part is, when it comes to the overheard debates between fans of, 'I like this *Hearthstone* art better or I like that *Hearthstone* art better'?" Thompson says with a smile. "They're all talking about *Hearthstone*."

LEFT: Mike Krahulik (Penny Arcade)
RIGHT: Mike Sass
BOTTOM: Matt Dixon
OPPOSITE, TOP LEFT: Ludo Lullabi, Konstantin Turovec

OPPOSITE, MIDDLE LEFT: Arthur Bozonnet
OPPOSITE, BOTTOM LEFT: Anton Zemskov
OPPOSITE, TOP RIGHT: Anzka Nguyen
OPPOSITE, BOTTOM RIGHT: Forrest Imel

CARDS ON THE TABLE

SO, what special rules do cards adhere to?

Size is the biggest consideration. "Card art is functional," says Cranford. "We have half our players on the phone. There's a lot of stuff going on if you have the board filled with your cards and the opponent's cards, so utility first, which means rules of reduction."

One of the primary rules of reduction involves having a simple silhouette. In the case of card art, a silhouette can represent either the character or the action.

"For a good character read," Cranford continues, "it has to separate from the background. When it's small, a backlit character on a dark background is just a blob."

Another rule deals with values, hues ranging from light to dark. Generally, a strong contrast between background and character values is desired. "If I can have three values in a picture," Austin says, "I want a big group of black, a big group of white, and a big group of gray. And those things will be easy to see and tell the shape of when they're small."

Colors are addressed in rules of reduction as well. *Hearthstone* uses a bright, saturated color palette. "We use RGB," Cranford says, referring to the red, green, blue color camp used in digital media. "And we use pretty much every inch of that color spectrum. It has almost candy colors, and we just embrace that." Color groups in backgrounds are blown out to one similar color, to help the foreground pop.

The penultimate consideration is lighting, or what the team refers to as "spotlighting."

"We steal theatrical lighting, just like an actor on a stage," says Cranford. "We always light them straight, top down—head, shoulders, and chest. The rest fades into shadow because it allows your eye to focus."

Last, with few exceptions, cards tend to feature a single subject, engaged in what Lawlor describes as a snapshot: "With stylistic choices and storytelling, it's really about that snapshot in time, capturing that exact awesome moment where a character is flying through the air or casting this epic firebolt."

LEFT: MAR Studio
RIGHT: Max Grecke

PROCESS OF ILLUMINATION

Keeping the above in mind, the trickiest goal to achieve is also one of the most critical: giving the cards a life of their own. "All of our decisions are based on 'How can we make that image cool, give it a unique personality?'" says Cranford.

Alex Horley, a veteran illustrator of the *World of Warcraft Trading Card Game*, explains his process. "I do my homework. I gather as much information as the deadlines allow me to. I go through the lore in order to have the best idea of who the character is and where they're coming from. Then I use some of the tools of the trade I learned from studying and working in comics, namely, how to compose and stage a cover/panel/card, choosing the most effective camera angle, the light sources, and making the character act."

Horley begins with a rough sketch, which he considers to be the most important stage: "That's where you solve most of the problems for the composition and values. I start in a small size to capture the overall feel and develop a strong foundation for the image I am trying to create."

With the sketch scanned into his computer, Horley constantly zooms in and out to make sure the image is readable at card size: "Each plane of the illustration must be separated enough to suggest depth without too many overlapping or crowded areas. The character can't blend into the background. Everything must be rendered, but nothing must steal the focus from the main elements of the painting."

All the while, Horley is focused on creating and maintaining *character* in the character. "Design is very important, but it's crucial that any creature/monster has personality, whether it's brutal, sneaky, or majestic. There must be some element that reveals their emotions."

EXTENDED FAMILY

WHILE using external artists to paint cards was once considered a risky proposition, now it's a valued and integral process on the *Hearthstone* team. And though most card art for the game is out*sourced*, freelance artists are not thought of as out*siders*.

"When people started seeing how good these cards were," says Cranford, "the art felt like it was coming from Blizzard. Today *Overwatch* and *Heroes of the Storm* are doing it too. Now we have part-time, remote, full-time, and contractor employees. We send them gifts, art books, a Christmas card. They're part of the Blizzard family."

TOP LEFT: Skan Srisuwan
BOTTOM LEFT: Alex Horley
TOP RIGHT: Paul Mafayon
BOTTOM RIGHT: James Ryman

OPPOSITE, LEFT: Mike Sass
OPPOSITE, CENTER: Matt Dixon
OPPOSITE, RIGHT: Sean McNally
OPPOSITE, BOTTOM: Nathan Bowden

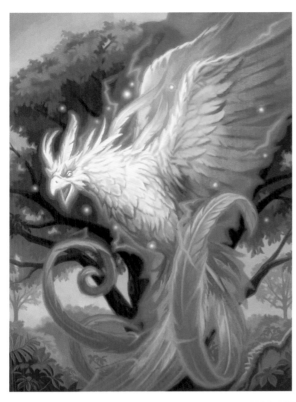

CHAPTER **TWENTY-TWO**
THINKING OUTSIDE THE BOX

OPPOSITE: Justin Thavirat

Blizzard's cinematics are produced by the company's Story and Franchise Development (SFD) division, an award-winning studio renowned for jaw-dropping short films. From prerendered content to stop-motion animation to in-game cinematics, SFD has built an ironclad legacy of extending Blizzard games into film.

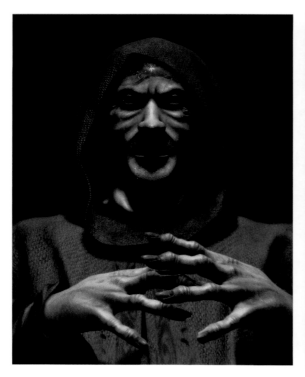
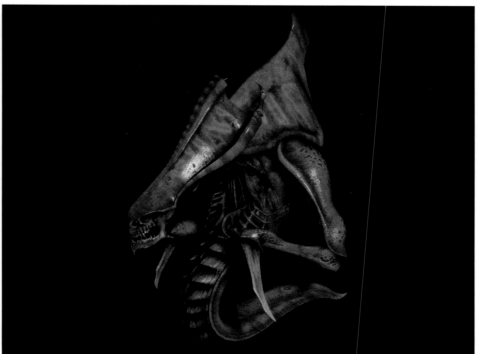

A NEW DIMENSION IN GAMING

BLIZZARD Animation began with just a few artists who were knowledgeable and dedicated to the emerging technology of computer-generated, three-dimensional graphics. Former vice president of art and cinematic development Nick Carpenter was one of the employees who saw the potential of 3D early on. "The possibilities were endless," says Carpenter. "It was hard to deny that 3D was coming on like a freight train. I was creating *StarCraft* glue screens, relying heavily on 3D. I could take all of the fundamentals of 2D and apply them in a 3D space, so it felt like a great fit."

Carpenter also saw 3D as a whole new way to imagine *StarCraft*'s tiny game characters. For a new unit type called a hydralisk, Carpenter began with concept sketches but then moved to a computer-generated version.

"Organic modeling wasn't the thing back then," Carpenter recalls. "Tools didn't really allow for it. So I modeled this thing, and there was a wow factor to it. I had always wanted to be in film; with the hydralisk, I had a virtual set and a character to light. Next thing I know, I'm in there developing shots and thinking about composition and how to tell these stories. It was an amazing feeling. I knew it was my calling."

As the team grew, prerendered cinematics became more integral to Blizzard storytelling.

"[Former senior vice president, story and franchise development] Chris Metzen kept pitching story ideas, and I think cinematics became a fulcrum for him where he'd say, 'I've got this crazy idea,' and I'd say, 'Let's make a movie!' Somehow it legitimized a lot of these ideas that were maybe just in a manual before; now these characters are moving around, and it looks like a professional film. In the back of my mind I thought, 'We don't stop until we hit the stars.'"

The cinematics team became a valuable resource in other areas as well, such as when it came time for principal artist II Justin Thavirat to create box art for *Warcraft III*. The game would feature four different box covers, each with a highly detailed character face representing one of the four main races: orc, human, night elf, and undead.

"The first one I did was just a pure illustration of an orc face," says Thavirat. "I worked on it a long time and moved on to the Arthas illustration and thought, 'I'm gonna try it in 3D just to jump-start the process.'"

Thus began a collaboration between Thavirat and Blizzard creative director and vice president, story and franchise development, Jeff Chamberlain. "I remember when we had that breakthrough that we could just use the 3D assets and paint over them," Chamberlain says. "The joke Justin and I had through the whole thing was—there's this thing called the Fresnel effect. In 3D, it basically means that at a glancing angle, a subject can be lit to give a fake outline, so a head will be lit brighter on the side. The joke was every time he'd say, 'I just need something here—I don't know what it is,' I'd say, 'You want a Fresnel pass on it?' Eventually, he just kept asking for Fresnel passes."

Lighting technicalities aside, the process was one in which cinematic expertise directly informed the game's promotional art, resulting in some of the most striking box covers ever. More importantly, it was an early milestone in what would become a mutually beneficial relationship between Blizzard cinematics and Blizzard game development.

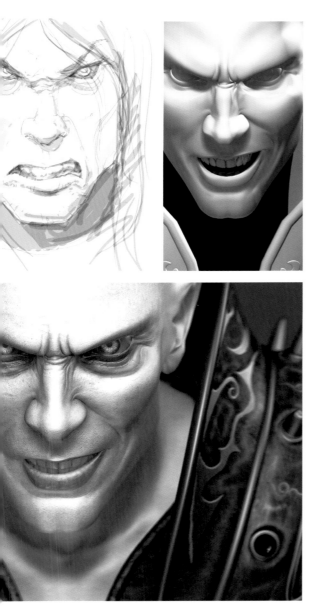
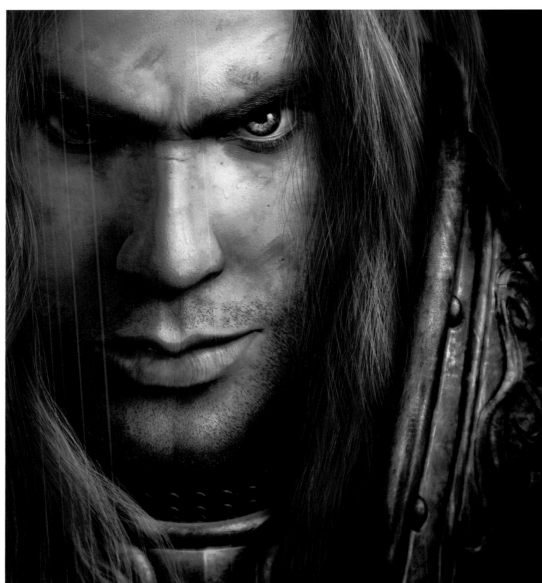
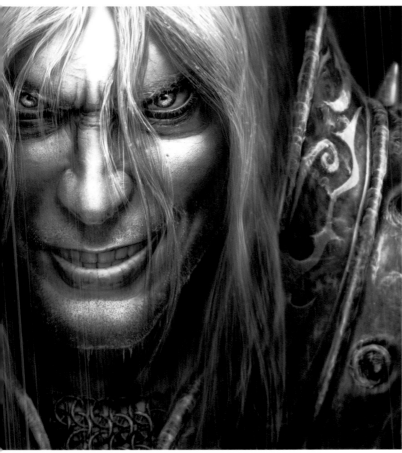

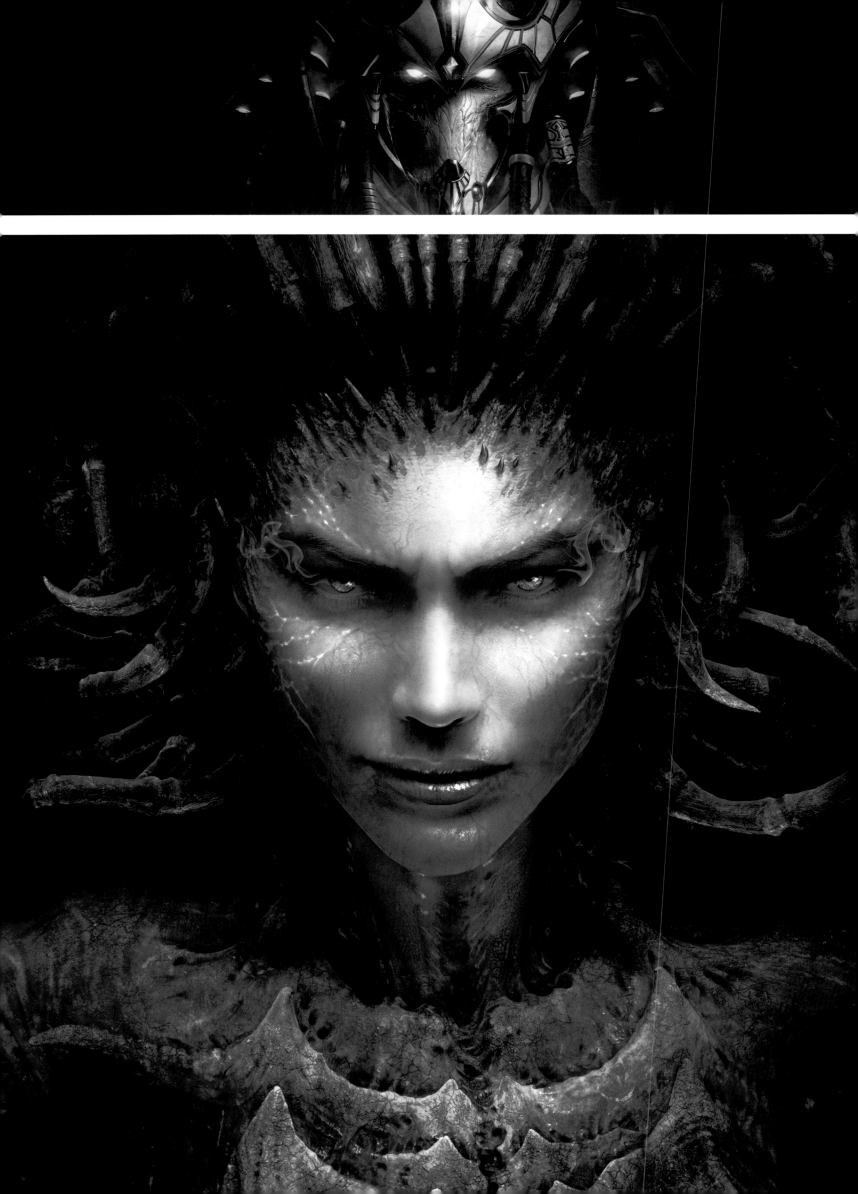

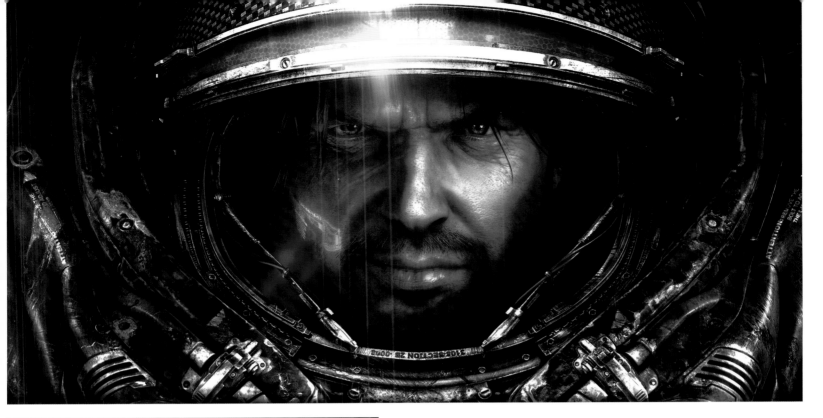

WHY THE FACE?

BACK when all video games came in boxes, a great deal of thought and expertise went into box covers. For much of its cover art, Blizzard opted for large faces staring back at the viewer. But why?

Senior art director Samwise Didier breaks it down. "In those days, boxes sat face-out on a shelf, and you'd walk into a store and be greeted by this wall of console, PC boxes, et cetera. If you put something on the cover like a fight scene or multiple characters, they just turn to mush when you view them from a distance. But when you have this big face staring at you, it gets your attention. One of the most engaging things you can do is have an orc or a night elf or a zerg or protoss staring at you."

Another way Blizzard used box covers as attention-getters was by borrowing from a comic book tactic: variants.

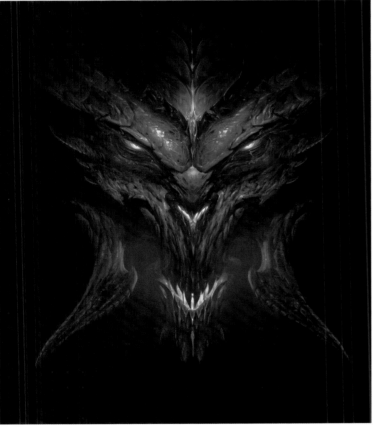

"It started with *StarCraft*, where we did one terran, one protoss, and one zerg," Samwise says. "In the background of each cover we had the silhouettes of the other two races so the people working in the stores placed them next to each other, like they were putting together a puzzle. We dominated wall space. Inside the box, the games were the same. We didn't intend for people to buy all the different copies, but some did. They wanted that full set."

As with the in-game cinematics and manual art, box covers gave the team a chance to convey more lifelike characters.

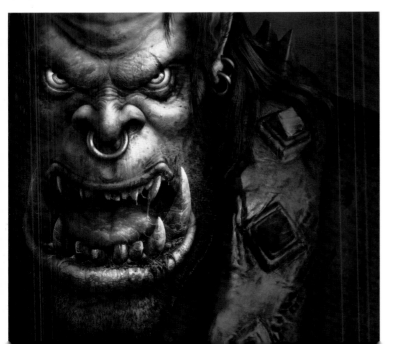

"It was a great opportunity to just pour insane amounts of detail and texture and lighting and polishing that we couldn't do in the game," Samwise explains. "It really allowed us to show the world what a night elf would look like, and we weren't concerned about polygon count or how long it would take to render them in a cinematic. It was just pure illustration."

TOP & OPPOSITE PAGE: Blizzard Animation
MIDDLE LEFT: Wei Wang
BOTTOM LEFT: Justin Thavirat **245**

BUILDING A BETTER CINEMATIC

"IN some ways, there was no reason the cinematics department should have existed at Blizzard," Carpenter declares. "First off, it's one of the most expensive things you can do. Second, you're doing it in California, which is even more expensive. And third, Blizzard made video games—we didn't make movies."

So how did the department come to be the powerhouse it is today?

"Only a few other studios were investing in cinematics the way that Blizzard was," Carpenter says. "Every time the question came up of, 'How much does this cost?' we'd refer to the trade show crowds and excitement in the community. They started accepting us at the executive level because cinematics had become part of the secret sauce."

The value of Blizzard cinematics became clearer with another milestone in the evolution of the department: the "Building a Better Marine" cinematic for *StarCraft II*. The *StarCraft* team wanted an announcement cinematic, but beyond that, there were no specifics.

"I thought, 'Okay, well, I love mechanics. I love hard surfacing,'" recalls Carpenter. "What is it like when you hit 'Train Marine' in the game? Are they in there training, doing combat drills and backflips? What's happening? And I had watched a factory video with these machines that were moving like ballet, and I thought, 'There's something to that.' What if they're literally putting the armor on these marines?"

Carpenter brought a few like-minded artists onto the project and set to work. "I said, 'Nobody's looking right now, so let's put our heads down and make one of the coolest things people

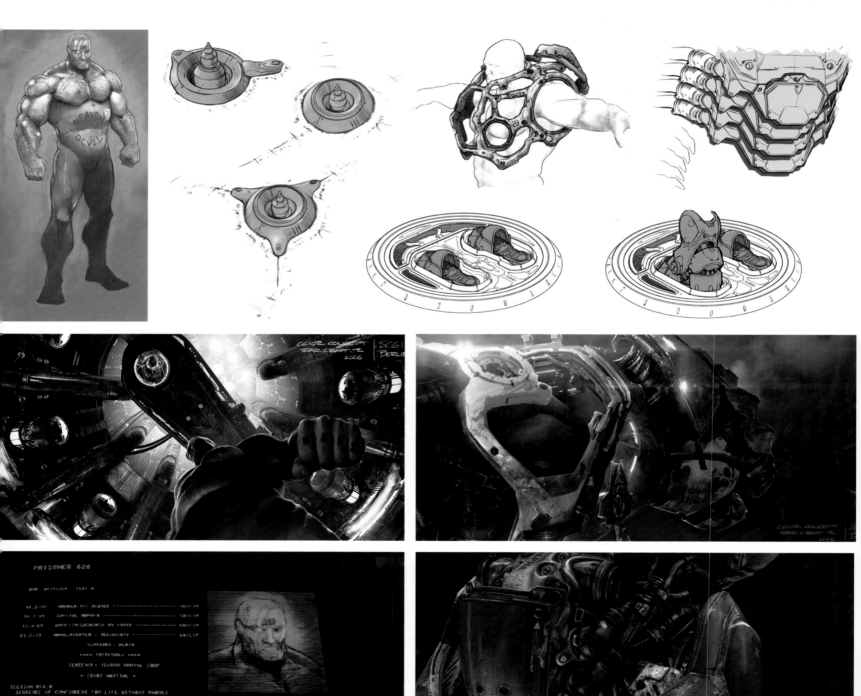

TOP LEFT: Samwise Didier
TOP RIGHT & OPPOSITE, LEFT: Joe Peterson
BOTTOM, & OPPOSITE, BOTTOM & RIGHT: Blizzard Animation

have ever seen.' I made an animatic of these machines making music putting this marine together. I thought, 'What if they put the armor directly on?' They bolt them into these suits, and it's like, 'Good luck, soldier.'"

The creation of the cinematic—and the initially random, rough-and-tumble character being sealed into the suit—ended up aligning with a story arc for a new *StarCraft* character, Tychus Findlay, a prisoner who is temporarily released but confined to his marine armor.

The cinematic was an instant hit, and one that would have far-reaching implications.

"I think that was where the studio hit a new level," says Carpenter. "It wasn't just about me—it was about these other people coming into their own and seeing a common vision and nailing it. It was the most expensive thing we ever made, and it matured us all."

The team was even more pleased to see the cinematic referenced in the wider film industry when sequences similar to "Building a Better Marine" started showing up in blockbuster films.

"Hollywood had already influenced us," Carpenter says. "Not only were we this underdog making cinematics for a game company—now we were setting the pace, so it came full circle. It was amazing to see this ragtag group of kids doing it for passion and taking the world on a ride."

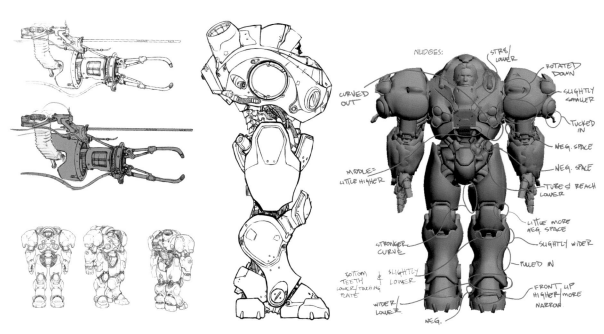

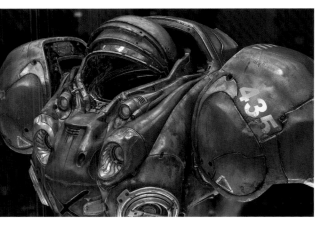

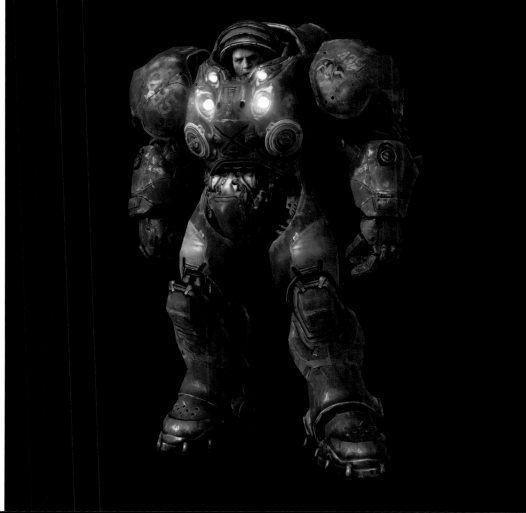

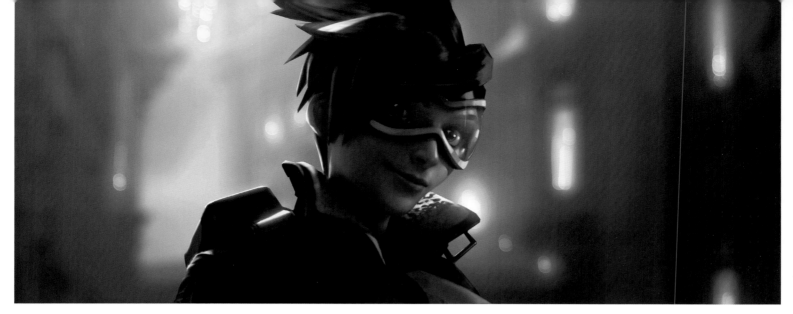

BLURRING LINES

TODAY, Story and Franchise Development works on projects that encompass everything from visual development for all of Blizzard's IPs to lore keeping, book and comic development, motion story, and in-game cinematics.

And as technology progresses, the line between prerendered cinematics and in-game cinematics is thinning. Especially in the case of *Overwatch*.

"We're always trying to get closer to the cinematics," says *Overwatch* character art director Arnold Tsang. "If you look at Blizzard's history, the cinematics have always looked very different from the game. They were a way to flesh out a certain fantasy that you didn't get from the game. You're bridging a gap, giving people the ingredients to build their own mental image of what they're playing. With *Overwatch*, the technology was far enough along that the game was as close to the cinematics as we could get."

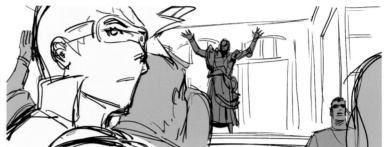

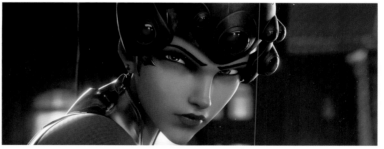

The process of more closely merging the two began in earnest with the *Overwatch* announcement cinematic. "We started with different models," says Tsang. "Blizzard Animation had the cinematic version of Tracer, Winston, Reaper, Widowmaker, but as we went on, we thought, 'Why are we making two versions? People can't really tell.'"

For a while, the team mixed game or cinematic models based on which they liked better. For the "Alive" cinematic, the team used the game model of Tracer. For Widowmaker, however, the team liked the cinematic version—especially the face—more, so they used it.

"If you look at old trailers of *Overwatch* from when we announced," Tsang says, "Widowmaker's face looks totally different."

Eventually, the process led to new character models being created for multiple purposes.

"We have exactly the same model that gets converted to a very high-resolution version for the prerendered, that's the same version for the game and in-game cinematics," says former lead character artist Renaud Galand. "When people look at a

movie and then they go into *Overwatch*, the main feedback we get is people are amazed at how close those assets look. People feel that they're playing with those characters that they saw in the cinematic."

Using one model as a blueprint also helps with style consistency across 2.5D cinematics and comic books.

"Since I'm doing an illustration, I don't have to figure out the design," says visual development artist Kim-Seang Hong, aka Nesskain, referring to the 2.5D cinematics. "Most of the time I can just be suggestive. A lot of people think I figured out the *Overwatch* style, but I'm just giving hints in my illustration. That's the difference between the game team and cinematics: I can be suggestive in motion graphics, but when I was working on the *Overwatch* team, I needed to understand everything—everything had to be figured out."

TOP: Mathias Verhasselt
UPPER MIDDLE: Ted Boonthanakit, Mike Koizumi
LOWER MIDDLE & BOTTOM: Blizzard Animation
OPPOSITE, TOP & MIDDLE LEFT: Roman Kenney

OPPOSITE, MIDDLE RIGHT & ANIMATION: Blizzard Animation
STORYBOARD: Mike Koizumi
COLOR SCRIPT: Stephan Belin

MODELING: Widowmaker by Shih-Hao Jason Huang, Reaper by Chung Kan, Tracer by Boyang Zhu, Winston by Kenson Yu
SURFACING: Widowmaker, Reaper, & Tracer by Wey Wong, Winston by Jongha Baik

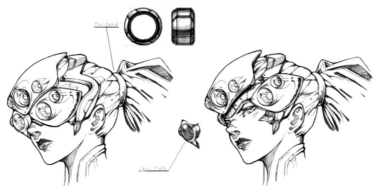
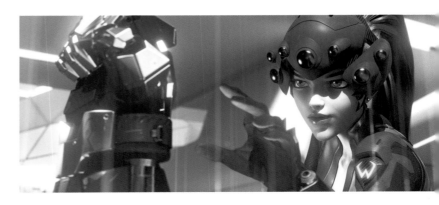

CINEMATICS

storyboard

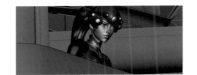
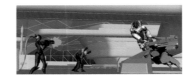
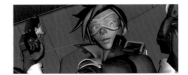

animation

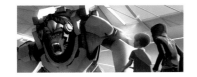

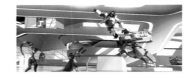

color script

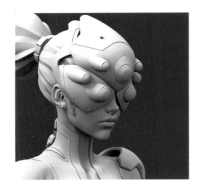
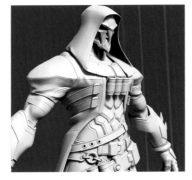
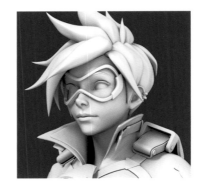
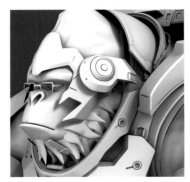

modeling

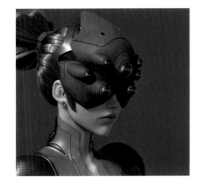

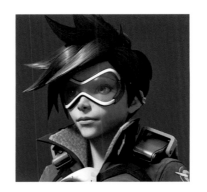

surfacing

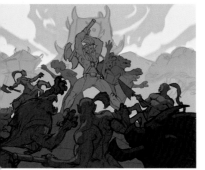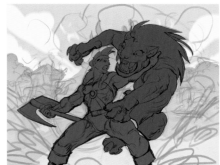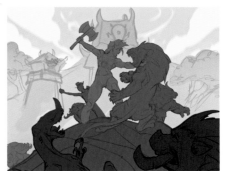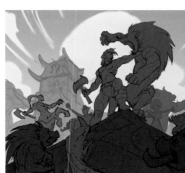

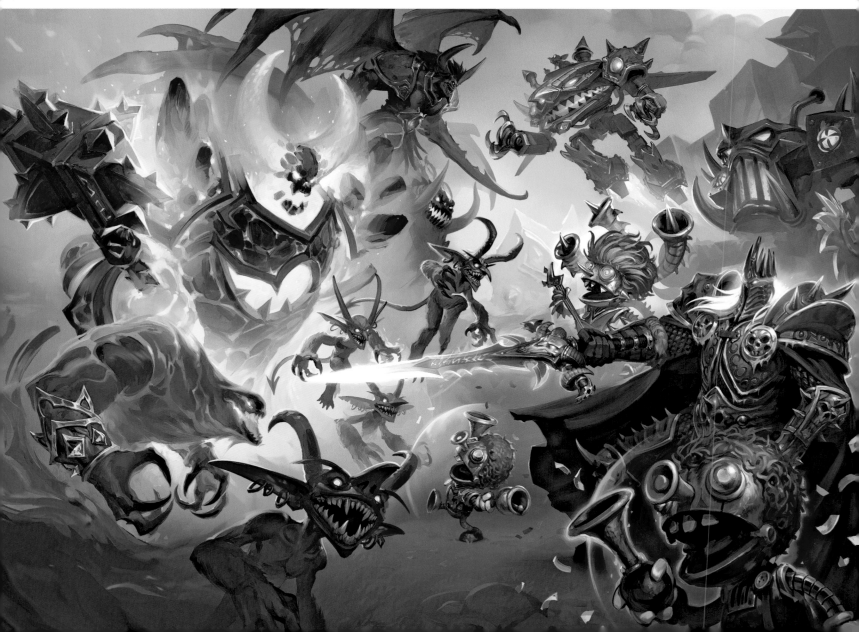

THE SHOW GOES ON

What began as a "ragtag group of kids" is now a team that numbers in the hundreds. With that kind of growth, change is inevitable.

"Before I joined, everyone was a generalist," says visual development principal artist Chris Thunig. "You were as much an animator as you were a modeler. When I got hired, it was at the beginning of trying to have people lock into specialized positions. The team grew, and there were big changes, a lot more structure. I think we're a lot more efficient and streamlined now. We have to be, because there are a lot more shots coming out of this department. Fifteen years ago we produced thirty shots a year, and now it can be thousands."

Despite the increased scope and responsibility, the Story and Franchise Development team has retained the "secret sauce" that made it such a success in the first place.

"It's difficult to create what we created," Carpenter reflects. "But we did it over time, slowly adding people. When you do it slowly, you're able to align yourself to the point where you're finishing each other's sentences. Then you don't have to hand-hold—you can go off and work on your own thing, and you know they're going to hit those notes."

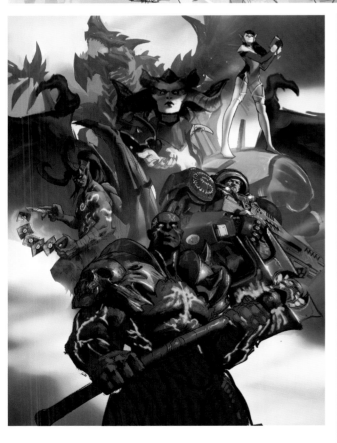

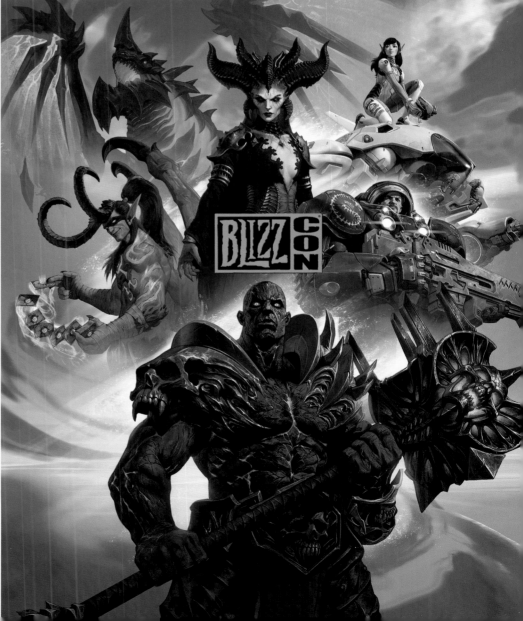

TOP: Nesskain
BOTTOM & OPPOSITE, MIDDLE: Will Murai
OPPOSITE, TOP: Blizzard Animation
OPPOSITE, BOTTOM: Luke Mancini

CHAPTER **TWENTY-THREE**
MAKING IT PERSONAL

OPPOSITE: Igor Sidorenko

Skins, armor sets, weapons, mounts, and pets. Now more than ever, customization exists across all Blizzard properties, with artists pushing limits to create gorgeous, enchanting loot. But making epic weapons and armor sometimes goes beyond the Rule of Cool—even loot has to be cognizant of the lore of its respective universe, even when it actively breaks those rules.

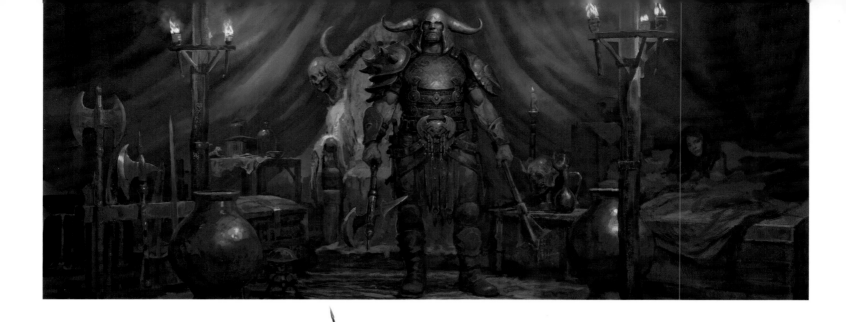

DIABLO: THE WHOLE WIDE WORLD

WHEN designing armor sets and weapons, *Diablo* developers look at items on a scale of quality and epic-ness, from common to magical to rare to legendary. "It's really about creating contrast and building it into the progression," says *Diablo* art director John Mueller. "We always make sure that a 'legendary' feels really special and looks significantly different than the thing you get when you're killing rats in the cellar with a stick."

With that determination made, *Diablo*'s style—a blend of fantasy and functionality—comes into play for both armor and weapons. "We could have a crystal blade," notes lead concept artist Victor Lee. "Maybe it's not just one giant hunk. Maybe the crystal is mounted on a metal frame to make it more believable. Those are things we constantly think about: How do we make something fantastic but believable?"

Artists aim for a variety of shapes and materials, tempered with readability. Can a player tell what the item is at first glance? "If it's a scythe, does it feel like a scythe? Does it look like a scythe?" Lee says. "It still has to look and function like a scythe, even if it's really exotic; otherwise, we can't really call it a scythe."

With *Diablo IV*'s open-world format, a greater variety of items exist than ever before. "Now we've tied weapons and gear to regions of the world," Mueller explains. "So all the items and all the armor and swords and gear that you find in different areas reflect the aesthetic of the place that you found it in."

And of course, character class plays a major role in design. "The rogue is my favorite in terms of weapons and armor because the fantasy is so cool," says Mueller. "Players can become any kind of rogue they want, good or evil, so their armor and weapons and everything in their design reflects this duality."

254
TOP: Justin Sweet
MIDDLE LEFT & RIGHT: Robert Sevilla
BOTTOM: Igor Sidorenko

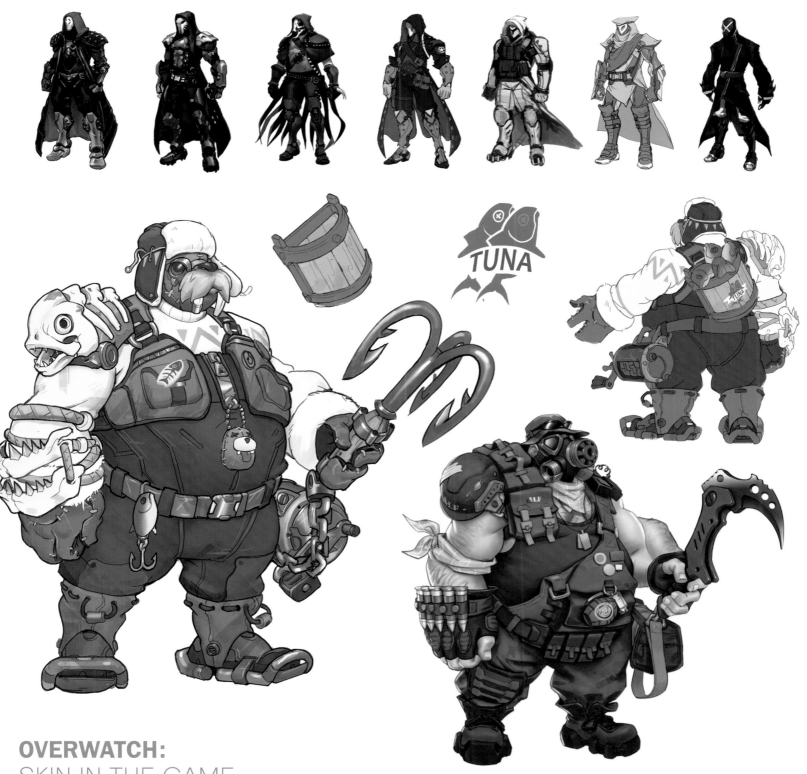

OVERWATCH:
SKIN IN THE GAME

WHEN artists first sit down to design a new *Overwatch* skin, they're encouraged to explore.

"As with our hero-making process, it's very organic, but we like to start with a broad brush," says *Overwatch* character art director Arnold Tsang. "Say you're doing a Reaper skin, you might try three to five different ideas, such as a noir detective Reaper, a steampunk Reaper, or cyberpunk."

While some skins fall into a more humorous category, the team is generally careful to select themes that resonate with the character's personality, tone, and cultural archetype. "We like to preserve a ratio of themes that are grounded in the lore and themes that are wacky," Tsang continues. "Like for Roadhog, we have him in militia gear to represent his time in the Australian

Liberation Front. And we also have an ice fisher Roadhog where he has a walrus face. That's cool, but it's also goofy."

Whether to use a humorous theme or not depends on the character, Tsang explains: "Heroes like Reaper, if you go wacky with him, it becomes a pretty big statement. That's why we have more cool, edgy skins for him."

Once the team has matched a character to a theme, there's no such thing as halfway. "We keep it pretty pure," says former lead character artist Renaud Galand. "Take toxic Roadhog, for instance. It's a skin that screams *poison* and *hazard*. Every single element on that skin reminds you of that theme. It's important for us to concentrate every design element to reinforce the main idea. That's something we do with basically everything."

TOP: Pior Oberson, Arnold Tsang
MIDDLE: Morten Skaalvik
BOTTOM RIGHT: David Kang

255

CAREER HIGHLIGHTS

While skins allow **Overwatch** artists to express themselves, animators express themselves through character highlight intros.

"In fighting games," explains Tsang, "after every match they do this thing where they flex or hit some cool pose, and the camera will freeze on a really dynamic angle with limb foreshortening, so we thought we'd try something similar."

For animators, it's a chance to expand their horizons. In-game animations are less creative in terms of number of frames, looping, and so on. Emotes offer more flexibility, but without camera control. "With a highlight intro, you get all of that," Tsang says. "You get a few seconds to play with. You control the camera, cut the camera, you can play up the action behind character abilities or just the attitude. Animators have a lot of fun."

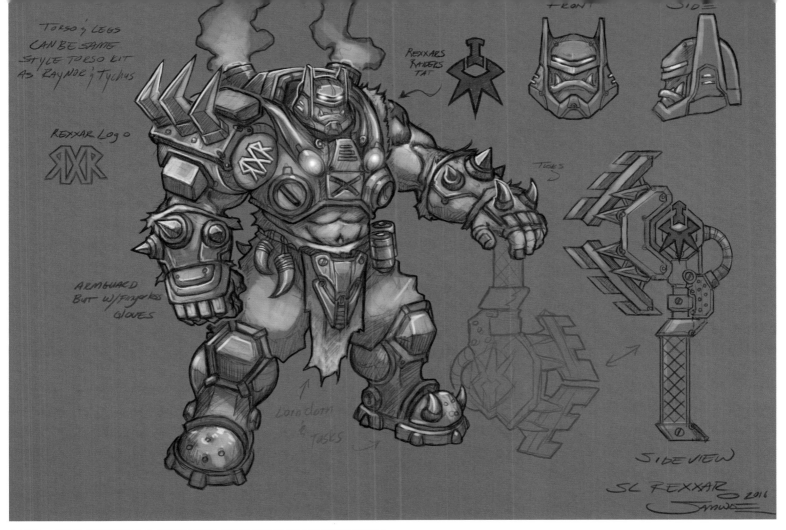

Notes on image: TORSO & LEGS CAN BE SAME STYLE TORSO KIT AS RAYNOR & TYCHUS — REXXAR Logo — ARMGUARD BUT W/FINGERLESS GLOVES — Lion cloth & Tusks — REXXARS RAIDERS TAT — FRONT — SIDE — TUSKS — SIDEVIEW — SC REXXAR 2016 — Samwise

Caption on image: SC MISHA Samwise 2016

HEROES OF THE STORM:
UNLIMITED POSSIBILITY

ARTISTS working on *Heroes of the Storm* get to play with all the Blizzard toys . . . literally. According to senior art director Samwise Didier, one of the first things artists do when creating a new hero skin is to ask, "Can we take this person and put them in another Blizzard universe?"

This makes for some mind-boggling mash-ups. "We put Rexxar in sort of a hodgepodge *StarCraft* marine suit," says Samwise. "We made Misha a cybernetic bear. We gave Tracer a Ghost and Spectre *StarCraft* outfit."

The crossover potential allows creators to build upon fantasy and lore that never happened in the respective Blizzard universes but does draw some fascinating parallels. The result is a visual treat for both the artists and the fans.

"We made Tychus an infested marine," Samwise notes. "At the end of *StarCraft* when he and Raynor fight, Raynor leaves Tychus behind. We never said he was dead, but he did get shot. The idea is that when the zerg lost their queen, they took Tychus and made him . . . well, maybe not the *king*, but definitely a duke."

Another favorite is role reversal. "For *Warcraft* fans, there's a cool dynamic between brothers Malfurion and Illidan," Samwise says. "We did a skin set where we took Malfurion, a Shan'do or archdruid of the night elves, and switched roles with the night-elf-turned-demon Illidan. We ended up with Betrayer Malfurion and Shan'do Illidan."

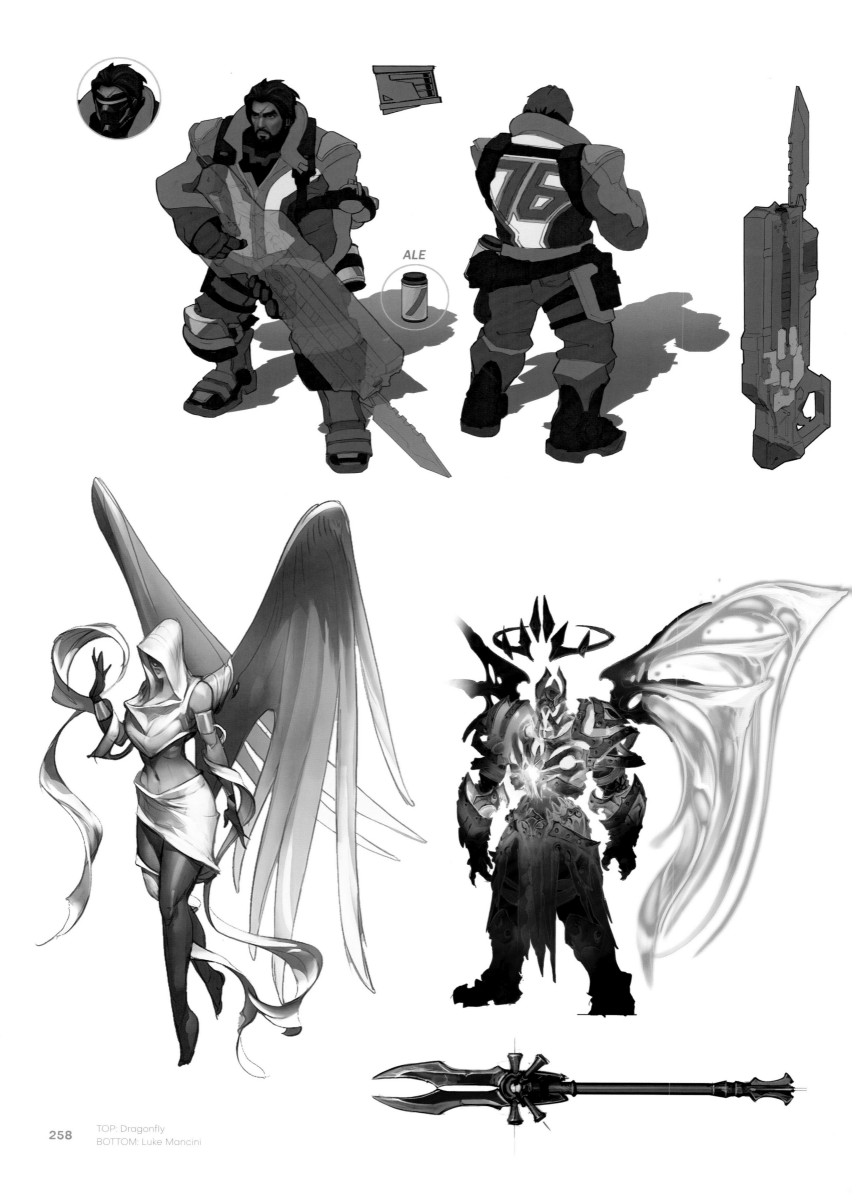

ALE

TOP: Dragonfly
BOTTOM: Luke Mancini

While *Heroes* has fun playing with the lore, one thing they always keep in mind is the core game experience. "We come up with crazy ideas," Samwise explains. "But we don't ruin the games in terms of, 'Now Nova doesn't have her gun; she has a sword,' or 'Arthas doesn't have a sword; he has a bow and arrow.' We kept the gameplay the same but allowed you to customize and kit-bash your favorite characters."

Among the fan favorites are demonic/angelic variations. "Demonic Tyrael was really popular," Samwise recalls. "At first all we did was change his colors, but people loved it so much we did a full skin. We did an angelic version of Valla, *Diablo*'s demon hunter. We gave her little golden wings and a golden halo, and people loved it. We always ran things through the pass of 'What's the demonic or angelic version? You think that would be cool?'"

DVA THE DESTROYER

TOP LEFT: *Heroes of the Storm* Team
TOP RIGHT & BOTTOM: Luke Manicini

TOP LEFT & RIGHT: Matthew McKeown
TOP CENTER: Calvin Boice
MIDDLE: Jon McConnell

BOTTOM: Thomas Yip
OPPOSITE PAGE: Ryan Metcalf

WORLD OF WARCRAFT: A NEW LEVEL OF EPIC

IN *World of Warcraft: Shadowlands*, a multitude of new skin colors, facial types, hairstyles, and eye colors help to transport players from real life to epic fantasy.

"We did everything we possibly could to really allow people to get into the game," explains art director Ely Cannon. "To make something that looks like them and feels like them, something they can really identify with."

Customization, however, isn't just about the player, as Cannon notes. "We try to provide a lot of variation, but we also think about how it serves the fantasy, how it enriches the world and represents the themes of the game. For example, with *Shadowlands* or *Wrath of the Lich King* or *Burning Crusade*, each one of these has specific cultures and locations, so we try to invest those visual style markers into the things we're creating."

Those style markers may include the silhouette of weapon blades and armor pieces, shapes and colors of gems, or various types and textures of materials. Many of these ideas come from the *WoW* character team. "Sometimes it could be as simple as a sketch of a rune or a prop or some kind of set piece that establishes the design," says lead visual development artist Jimmy Lo. "With the fel kit we did for *Legion*, [lead concept artist] Ryan Metcalf painted a fel pillar that had all this design language and the right materials and feel, to the point where everybody said, 'That's it!'"

Artists strive to create items that are visually interesting, thematically appropriate, and tied to the game's storytelling and worldbuilding. "But above and beyond that," says Cannon, "*WoW* is epic. The weapons we create are meaty and powerful and should feel like they will destroy whatever they hit. They are the weapons of the hero and the villain, and as the player

in this game, we are the hero. I want you to feel that you are carrying *the* sword, the most epic, legendary artifact that has ever been created in the history of ever."

It's not only the players who reap the benefits, however. For artists, especially newcomers to the team, creating the most epic armor and weapons in the history of ever can be a heady experience.

"Games generally have development cycles," says senior art director Chris Robinson. "If you work on a AAA title, you'll start out on the team, do the gig for three to seven years until the game comes out. Then people see your artwork publicly and you go back into the hibernation of redeveloping another game for three to seven years before you can show your work again."

Not so with *World of Warcraft*. "With *WoW*, we have artists who start on the team, make something, and it's in a patch in the next week or month," continues Robinson. "Suddenly their stuff is live to the world, and they've gone from coming straight out of school to creating this armor set that millions of people are interacting with."

Perhaps the biggest payoff, however, comes at BlizzCon, where cosplayers who have spent up to a year pouring all their love, talent, and passion into stunning costumes reveal their creations. Robinson was blown away the first time he saw an armor set he designed being worn at BlizzCon. Now he enjoys watching newer artists experience the same.

"It's amazing to see incoming artists build stuff for the game, then go to their first BlizzCon. They stand there, taking pictures with a fan who cared so much about what the artist created that the fan physically brought it into the world. There's nothing like it."

CHAPTER **TWENTY-FOUR**

THE SHOULDERS OF GIANTS

At Blizzard, shoulder pads are much more than just a fashion statement. Giant shoulder pads (or pauldrons) can be traced back to the company's first real-time strategy games. Over the years and through various mediums—from games to cinematics to sculpts—shoulder pads haven't come without their share of challenges . . . especially when concept art writes a check that animators struggle to cash.

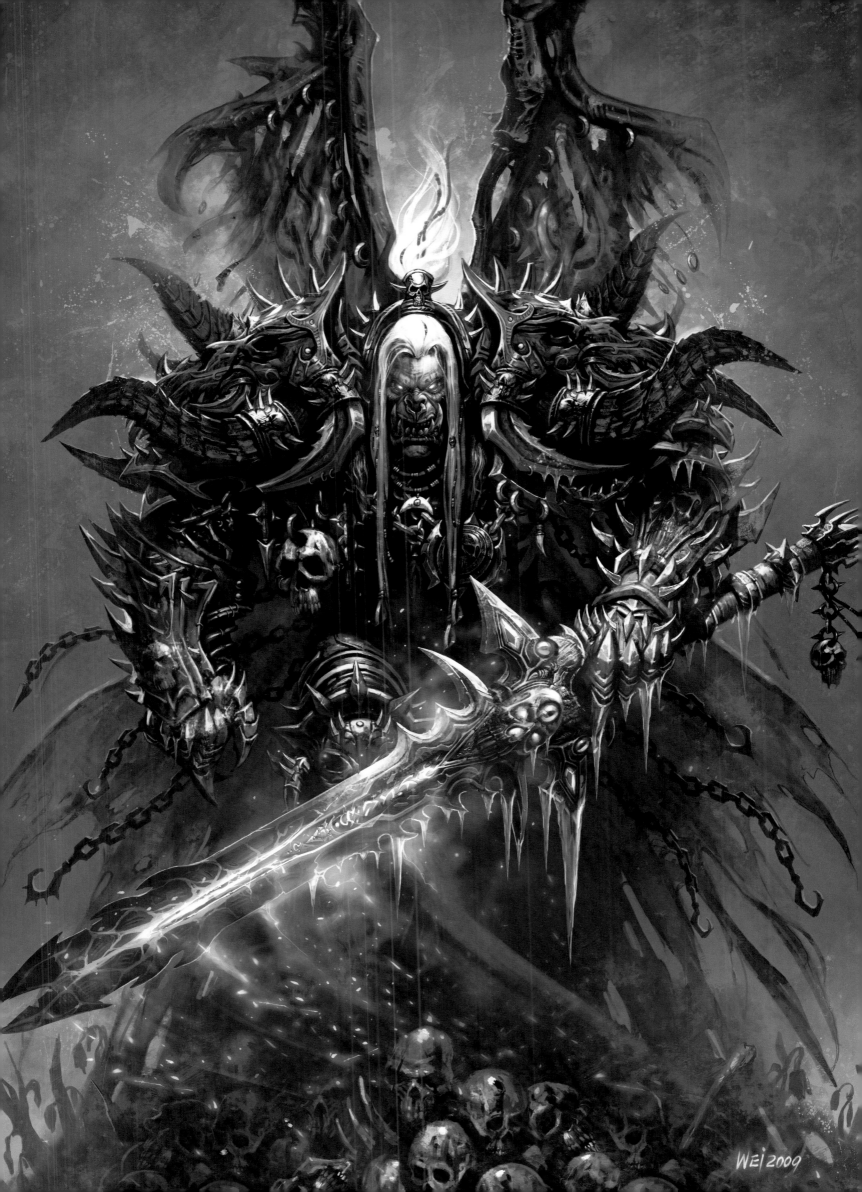

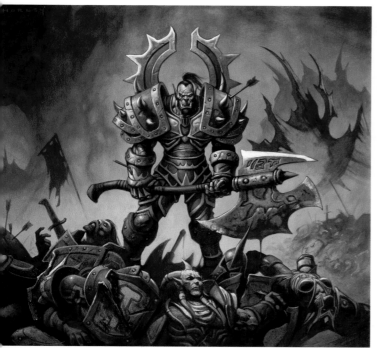

THE RULE OF COOL

THEY'RE bold. They're colorful. They're ridiculously large. They are Blizzard shoulder pads. And they've existed almost since the beginning of the company itself, for a very good reason . . .

In real-time strategy games, individual units are tiny on-screen and sometimes difficult to make out, especially from a top-down view.

"You really wanted units to pop off the screen," says senior art director Samwise Didier. "Identifying a tank or ogre from the isometric perspective is easy, but making out a marine or a footman is tougher. So we just glorified the eighties and took shoulder pads to the Blizzard degree."

Bulky shoulder pads are also ideal for displaying unit colors, to help the player distinguish their units from the enemy's. Practical purposes aside, Samwise explains another reason for giving characters shoulder pads: they're cool.

"Shoulder pads make everything look more powerful," Samwise explains. "I remember a conversation we had for *World of Warcraft* where they wanted only the warriors to have shoulder pads, so that people knew immediately what they were."

Samwise's response?

"No. *Everyone* gets shoulder pads. Just make them look different."

TOP LEFT: Alex Horley
TOP RIGHT: Samwise Didier
BOTTOM LEFT: Luke Mancini
BOTTOM RIGHT: Wei Wang

When magi were singled out to not have shoulder pads, Samwise held the line. "I said, 'No way. Mages already look scrawny.' So, they started off with tiny shoulder pads for magi. Then they slowly started building up and up, as with everything, and now mages can't even squeeze sideways through revolving doors."

StarCraft didn't escape the shoulder-pad sensation either. "Marines are in powered armor. You can't have giant mechanical fists and thighs and hip actuators and no shoulder pads," Samwise reasons. "The zerg don't have shoulder pads, but they have cool spikes coming off the shoulders."

Diablo took a slightly different approach: "Where *Warcraft* has one big shoulder pad with three giant spikes," Samwise

explains, "*Diablo* has ten shoulder pads all put together with twenty little spikes. But it basically takes up the same amount of room—it's just that the detail is finer in *Diablo*."

There's one other reason for big shoulder pads, one that's only slightly related to the cool factor and has nothing to do with visibility from a bird's-eye view: silhouette.

Silhouette in game terms has to do with a character's body outline and getting a quick "read" of who or what the character is. "It's very important," says lead visual development artist Jimmy Lo. "When you look at a character, especially at first glance, you can see the helms and shoulder pads are the biggest pieces that add to the silhouette."

THE bottom line: shoulder pads make everything look cooler. But as the *World of Warcraft* developers soon discovered, looking cool comes at a cost.

"Sometimes you can't lift your arms," Samwise admits. "Sometimes you can't stand next to someone without a shoulder pad clipping through their head. But those are small prices to pay."

"That was something I struggled with when I very first came on," says senior art director Chris Robinson. "It bugged me from an artistic perspective because it felt like we weren't paying attention to the technical aspects of clipping and making sure that every armor set worked on every body type."

Robinson soon learned the extent of the challenges related to characters and clipping. Early on, basic outfits or clothing that characters wore was mapped onto the skin of the body, with no additional polygons. Boots and gloves added geometry but posed few problems since they were at the ends of characters' limbs.

"The real problem," Robinson says, "came with shoulder pads, helmets, and, later on, anything that was floating off the back. Tabards or tauren totems intersected with capes, shields that floated off the arm intersected with gloves, et cetera."

For Robinson and other members of the team, it came down to a choice: "We could either shrink everything down significantly, make it more realistic and solve the clipping problem . . . or we could keep everything bombastic and maintain what felt like a real-time strategy game transformed into an MMORPG [massively multiplayer online role-playing game]. We had to choose one road or the other."

And while bombastic gear, the Rule of Cool, and the idea of "RTS from a different perspective" won out, attempts were made to address clipping issues.

"We tried to add bones to shoulder pads," Robinson says. "So if your character crossed their arms, the pauldrons would actually rotate up and out of the way, but then they just looked like these weird, flappy wing things that would move around oddly as you were animating."

In the end, the team settled for a set of best practices. New armor sets are compared to a known "worst offender," and artists are told not to go beyond that size. A rule of thumb was also established for animations.

"If you're running, standing, walking, or emoting, you should be able to see your character's head," Robinson explains. "But if it's in combat or any extreme movement that happens quickly, there's an acceptable amount of clipping that we'll allow, to capture the essence of what we're going for."

With rules in place, artists have embraced the glory of shoulder pads.

"They're iconic," says Lo. "Many shoulder pads signify the armor's theme and the character's class. Like, if we add a fel crystal to a warlock, we could put it on the chest, but it reads better on the shoulder pad."

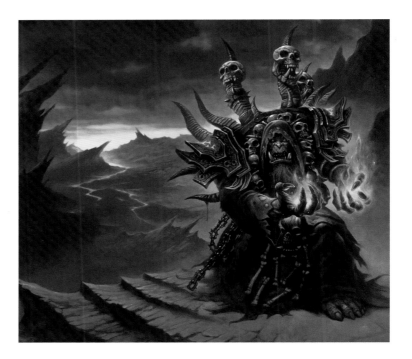

OPPOSITE, TOP LEFT: Kenny McBride
OPPOSITE, TOP CENTER: Rob Sevilla
OPPOSITE, TOP RIGHT: Samwise Didier, Tamara Bakhlycheva
OPPOSITE, BOTTOM: Dusty Nolting

LEFT: Glenn Rane
RIGHT: Alex Horley

CINEMATICS:
FORM MEETS FUNCTION

A certain amount of clipping and intersecting in *World of Warcraft* is expected. But the bar for function in-game is not necessarily the same for Blizzard cinematics, which aim more for realism.

When portraying a *Warcraft* or *StarCraft* character in a fully rendered cinematic, the first consideration is silhouette. "We look to maintain the silhouette," says visual development supervisor Dennis Bredow. "So on the first read you know exactly, 'This is a Blizzard character. This character belongs in *Warcraft*. That's *Warcraft* armor.'"

While keeping this in mind, the team sets about addressing the second goal: "We want to make sure they have room to maneuver," Bredow says. "That they can turn their head, look to the side and see over their shoulder pad if they need to, and if they have a helmet that goes with that, that there's some clearance and mobility there."

One challenging character was Bolvar Fordragon as the Lich King in the *World of Warcraft: Shadowlands* cinematic trailer. "Bolvar needed to have a full set of armor that articulated," Bredow explains. "And he needed an extensive range of motion in a very large and cumbersome armor set. There's a huge amount of design work that goes into that."

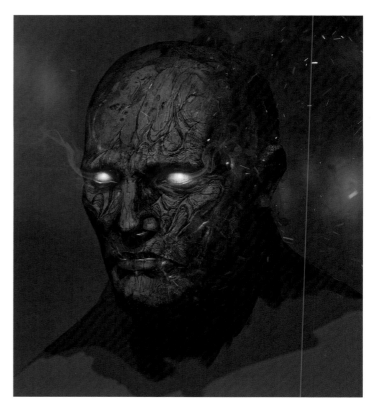

And with characters like Bolvar, it's not just the helm and shoulder pads that animators have to watch. Bolvar also gave the cinematics team a huge skull belt buckle to contend with. "If the character is just standing, it's not a problem," Bredow says. "But Bolvar had to *sit* on the Frozen Throne. We had him recline quite a bit to accommodate that belt buckle. It was hard for him to sit forward and stand up without that buckle penetrating straight through his body. So we had to make some concessions: lower the belt buckle a little, scale it down a bit, and then animation had to get a little clever about how to move him around."

Many cinematics artists have dealt with shoulder pads long enough that they've developed their own process to approach them.

"Often with shoulder pads, I start by scaling them down," says senior in-game modeling artist II Jessica Johnson. "So long as the proportional read overall remains the same, no one will notice the change. You want to make sure the characters can perform, and part of the performance is ensuring that they can move. My animators appreciate it."

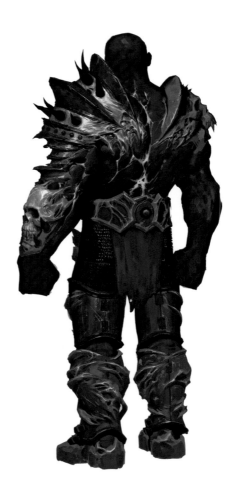

TOP LEFT, RIGHT, & BOTTOM: Josh Tallman
MIDDLE: Dennis Bredow

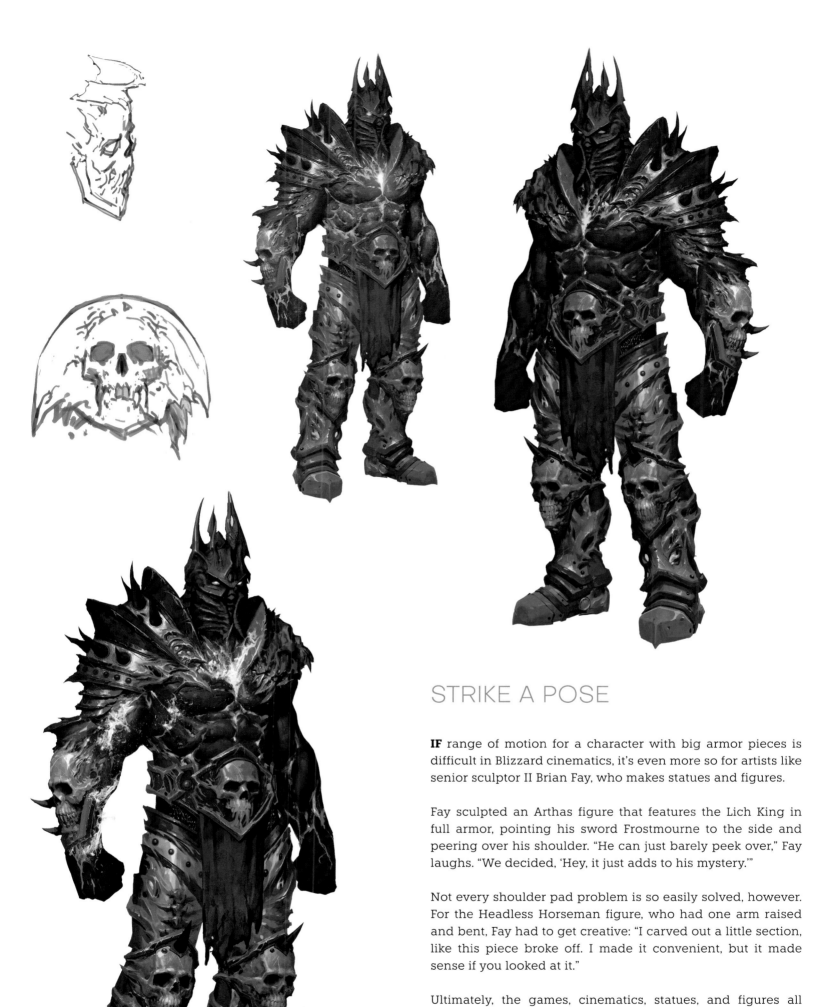

STRIKE A POSE

IF range of motion for a character with big armor pieces is difficult in Blizzard cinematics, it's even more so for artists like senior sculptor II Brian Fay, who makes statues and figures.

Fay sculpted an Arthas figure that features the Lich King in full armor, pointing his sword Frostmourne to the side and peering over his shoulder. "He can just barely peek over," Fay laughs. "We decided, 'Hey, it just adds to his mystery.'"

Not every shoulder pad problem is so easily solved, however. For the Headless Horseman figure, who had one arm raised and bent, Fay had to get creative: "I carved out a little section, like this piece broke off. I made it convenient, but it made sense if you looked at it."

Ultimately, the games, cinematics, statues, and figures all follow the Rule of Cool. As far as the occasional in-game clipping, Samwise says so be it: "I'd rather have it be cool ninety-nine percent of the time and look bad one percent than have something realistic that looks weak."

CHAPTER **TWENTY-FIVE**

HEROES' JOURNEY

Arthas. Kerrigan. Deckard Cain. Names that have become video game legend. Tragic, flawed, and unforgettable. Sometimes heroic, sometimes villainous, sometimes both. Their story arcs, visual designs, and voices have made them instantly recognizable across the world, even as they've sometimes undergone monstrous transformation. In this chapter, we'll chart the journeys of three of Blizzard's most iconic characters.

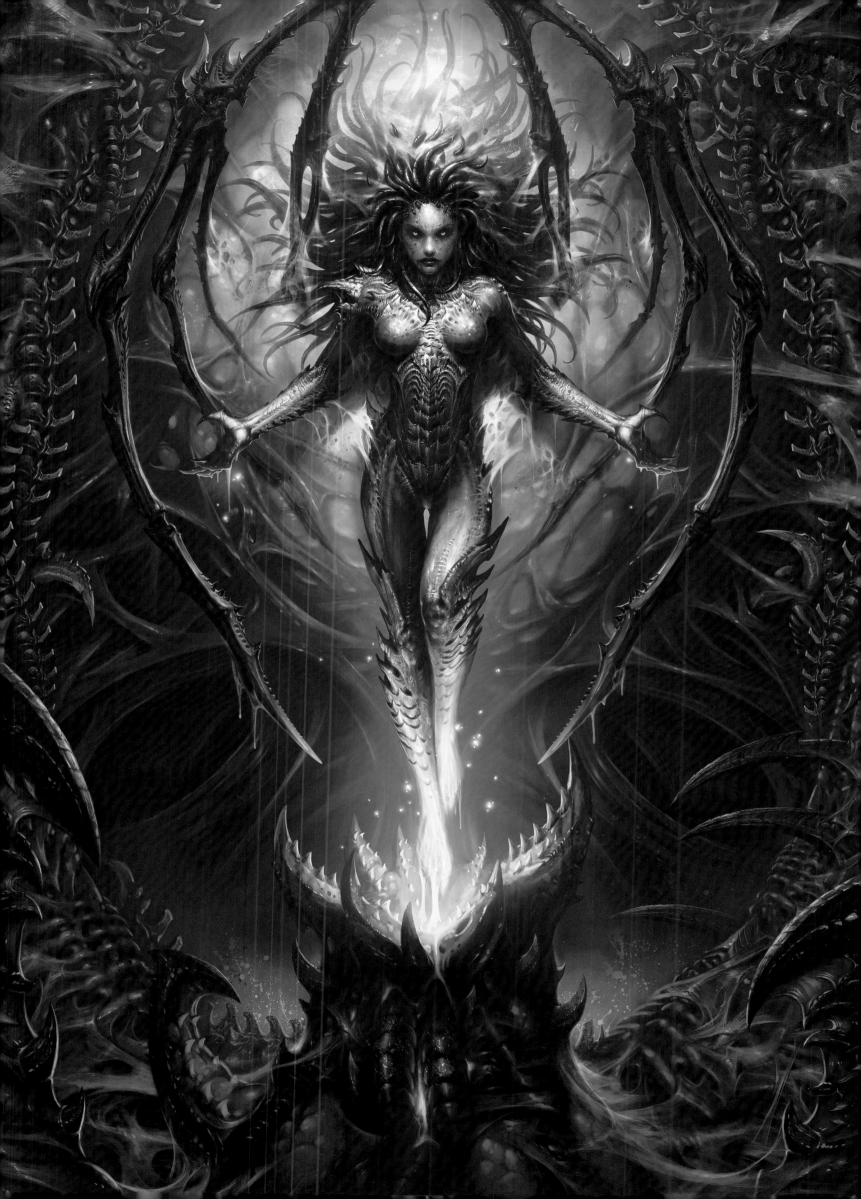

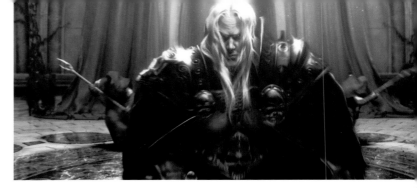

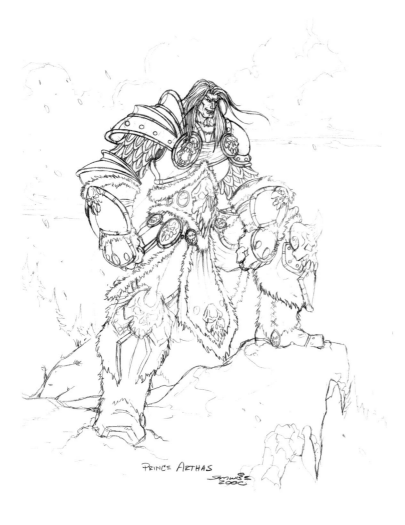

PRINCE ARTHAS

ARTHAS: HEIR TO THE THRONE

ARTHAS'S massive character arc began with former senior vice president, story and franchise development Chris Metzen's desire to explore a classic theme in fiction—that of master and apprentice, with the apprentice choosing a path that will lead to ultimate ruin.

"Arthas kind of surprised me," admits Metzen. "There wasn't a lot to him when I began conjuring the story of *Warcraft III*. Everybody starts somewhere. Some writers start with, 'I've got this character idea, and it's going to go like this.' That was Thrall for me. I knew who he was. Arthas . . . I didn't know."

Metzen imagined Arthas as, in some ways, Thrall's opposite. "I needed someone who embodied all the nobility and high-minded ideals of the Alliance, and I wanted to challenge all of that. In the same way that Thrall came out the gate as a character who immediately challenged your expectations of a Horde character, with his humanity and openness and honesty, I wanted Arthas to be the counter to that."

If Thrall came to represent some of what we consider "humanity's" qualities, Arthas would come to symbolize the depths humanity could sink to.

"I wanted Arthas to epitomize everything that was great about the Alliance . . . and then I wanted to shatter it," explains Metzen.

TOP LEFT: Samwise Didier
TOP RIGHT: Blizzard Animation
UPPER & LOWER MIDDLE: Bernie Kang
BOTTOM: Chris Robinson

Visually, Arthas's in-game avatar began as a beacon of light and hope, an exemplar of Alliance righteousness: the paladin.

"Arthas was created after we already had our paladin design," says senior art director Samwise Didier. "Basically, asymmetrical shoulder pads, a cool little scarf wrap, and a giant hammer. So we made an Arthas version of that model. He was a prince, so he had been pampered all his life. Not so much to where he didn't know how to fight, but he was definitely in a position of leisure and royalty. We made him look finer, with long blond hair."

Arthas's aesthetic would change, however, based on coming face-to-face with a seemingly unsolvable problem and being forced to answer the question of how far he would go to save his people.

"That's where he got interesting," says Metzen. "The nefarious Lich King offers this Faustian deal: 'I'll give you might, power, the means to crush your enemies, along with the sword Frostmourne that steals souls.' My whole plan was, Arthas's soul would be the first one it ate. And it was never coming back."

Artists then revised Arthas's design to match the character's dramatic turn. "If he's going to embrace Frostmourne," explains Samwise, "he needs to have darker armor, with more skulls and an undead feel."

Complicating matters slightly was the helm that Arthas would ultimately don, completing his fall from grace by assuming the mantle of the Lich King. "We had to figure out how to have him still look like Arthas," says Samwise. "We thought, if we can have that hair coming out, people will still get it."

Arthas would also be represented in far more detail in some of *Warcraft III*'s key cinematics, a process overseen by former vice president of art and cinematic development Nick Carpenter.

"Nick oversaw the creation of Arthas in 3D," says Metzen. "Which is much starker. But the frost armor was definitely informed by Sammy's lines and Sammy's big, thick, mighty aesthetic, refined through Nick's art direction to be very distilled and very striking. With the frozen eyes burning out of the iron helm and this long hair blowing in the breeze, you had the sense that the former prince was still in there. I love the way that Arthas transformed visually from this fair-haired paladin to this monstrous, cold, inhuman warrior."

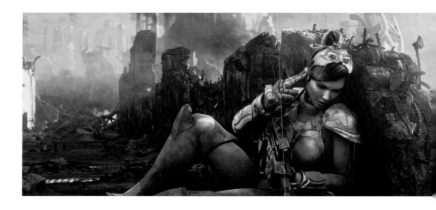

KERRIGAN: QUEEN RISING

SARAH Kerrigan was a cocreation of Metzen and a former lead product designer, who introduced the character early on as a potential foil for *StarCraft*'s other main character, James Raynor.

"We had the rough idea that Raynor would meet this kind of tough female character, and they would strike up some vibe," Metzen explains. "She was cool, and she had these psychic powers, so the first time they meet, Kerrigan can already read Raynor's thoughts. She calls him a pig. So we were able to have fun with the telepathy end of things and show right away that she was a no-nonsense character."

She was also a fairly complex character right from the start. Metzen continues, "She had been trained as this assassin, but she didn't have full memories of the things she had done. She was someone who really carried the weight of the past and who, like Raynor, was seeking redemption."

The dynamic between Kerrigan and Raynor quickly became central to the game's narrative, providing a human element amidst the sprawling mythology and conflicts of *StarCraft*'s science-fiction setting.

"*StarCraft* was about the revolutions of these mighty alien species clashing over humanity's heads," says Metzen. "We felt that the Raynor-Kerrigan dynamic really drew you into it all emotionally. They started to feel like the beating heart of the story. These two against the universe."

Kerrigan would also come to provide a human lens through which to view the entirely inhuman zerg, a story line that would challenge the relationship between Raynor and Kerrigan in new and interesting ways and set Kerrigan on the path to her ultimate fate.

"Kerrigan was taken by the zerg," Metzen says, "and turned into this monstrously powerful alien hybrid. Raynor wanted to rescue her and make good on their relationship, but we decided to frame it as her being on her own path, with the power that the zerg awakened within her serving who she wanted to be."

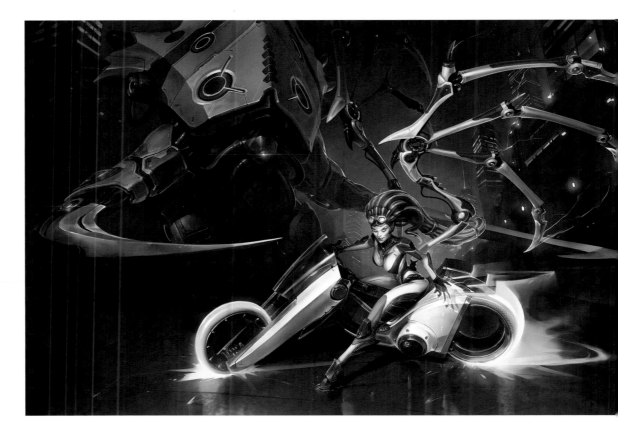

Kerrigan's redesign included another feature that would come to be an iconic representation of her hybrid form. "I had this name in my head," Metzen reveals. "The Queen of Blades. It suggested to me these bone wings; the interest there was not in suggesting she could fly but instead using these razor-taloned angel wings to suggest that she has both ascended and descended at the same time."

A kind of carapace-like skin completed Kerrigan's "zergified" appearance and, along with her newfound power and complex character progression, cemented her place as one of the most memorable antiheroes in video game history.

"She suddenly had power enough to shake the heavens," Metzen reflects, "and go toe-to-toe with the terrans and the protoss on her own terms. She finally made decisions for herself. And while that horrified Raynor, who missed the woman he was in love with, suddenly Kerrigan became an individual who shook things up at a galactic level, defining her own fate and her own path and violently resisting the idea of being controlled by anyone."

Unlike Arthas, whose journey led him beyond a point of no return, Metzen envisioned a different end for Kerrigan. "We felt at the time that Arthas, for all the things he had done, didn't deserve sweeping redemption. Where Kerrigan, by contrast, for all the potentially duplicitous things she had done and the lives she had sacrificed, just by way of contrast it felt like she had found a very specific kind of redemption in the end. They stand as stark contrasts, as two of our most notable franchise villains whose paths led to very different destinations."

As with Arthas, Kerrigan underwent a stark physical and visual transformation that produced unique challenges for artists. "We had her going from the highest pinnacle of technology," observes Samwise, "at least on the terran side, being a Ghost—she had the Ghost suit, rifle, she could cloak, she could call down nukes—and then she gets zerged-out and changed to something completely biological."

Kerrigan's rebirth would require a complete design overhaul, making her appear alien while retaining some semblance of her human identity. "We still wanted her to look like Kerrigan," Samwise says. "Instead of her ponytail, we gave her the equivalent of zerg hair that almost looked like segmented serpent tails."

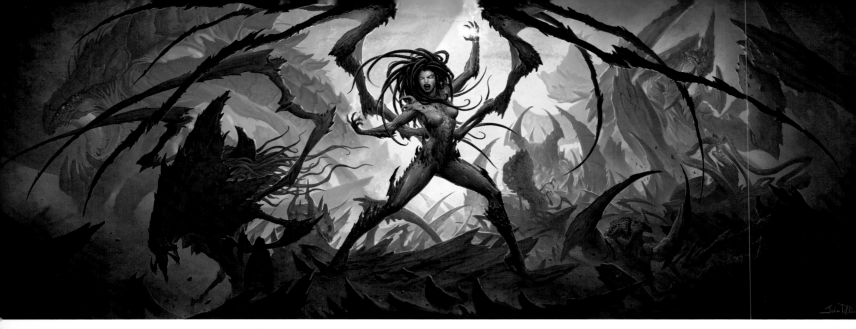

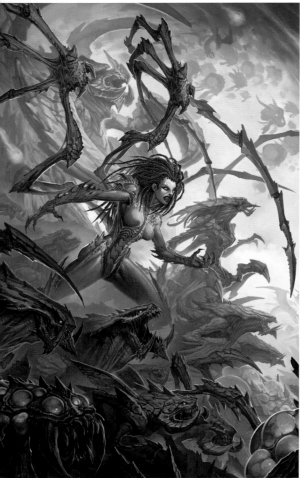

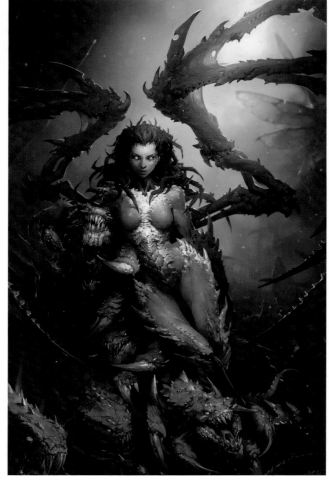

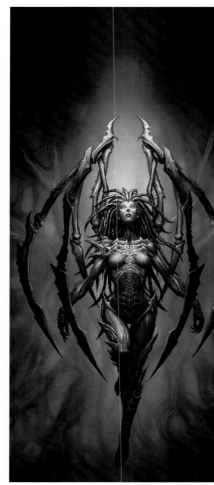

TOP, MIDDLE LEFT, BOTTOM RIGHT: John Polidora
MIDDLE CENTER: Laurel Austin
MIDDLE RIGHT & OPPOSITE: Glenn Rane
BOTTOM LEFT: Blizzard Animation

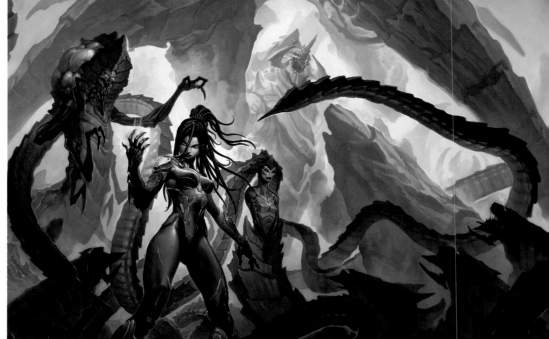

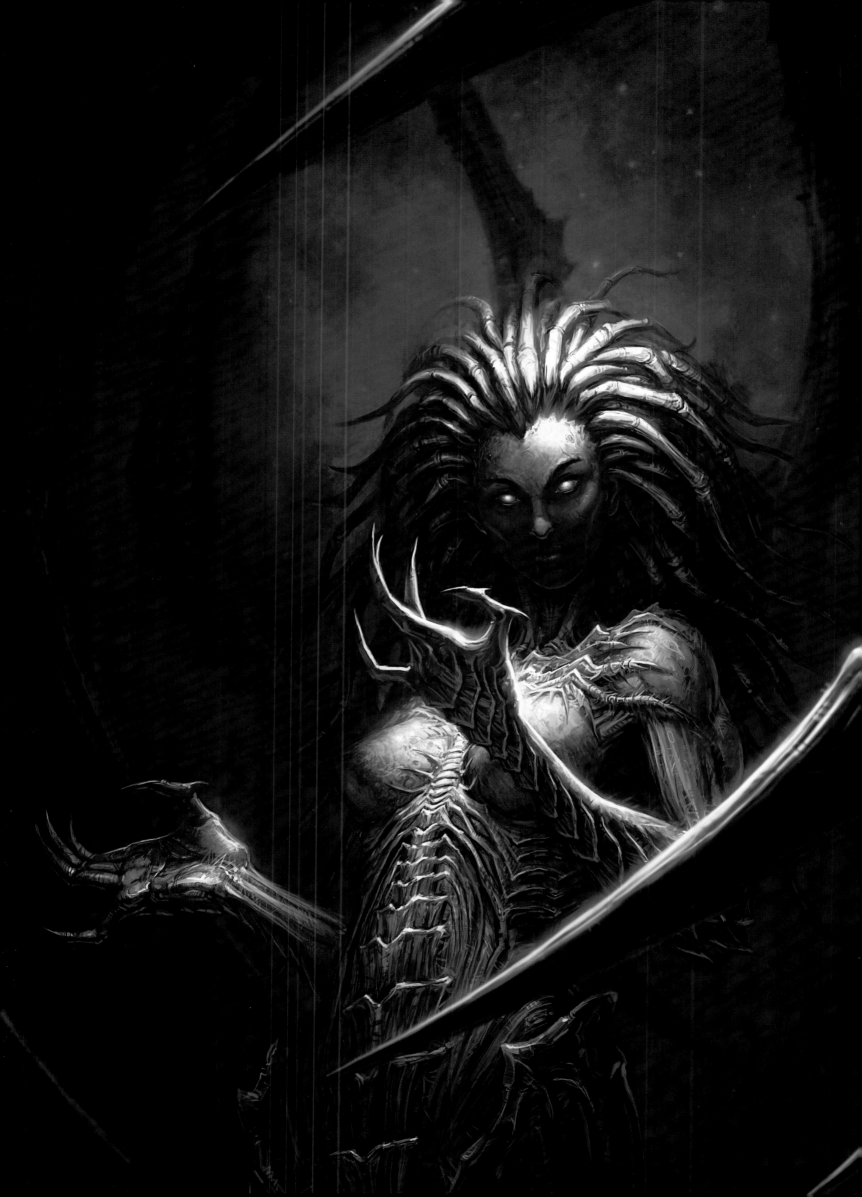

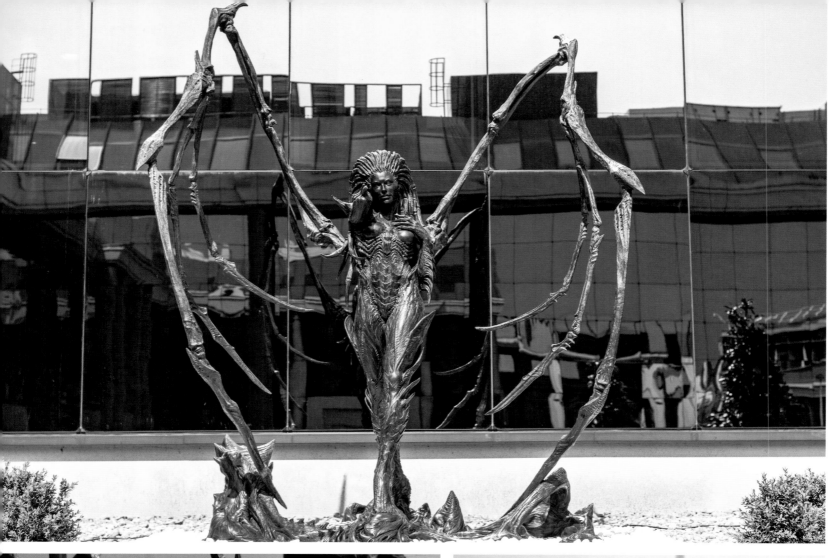

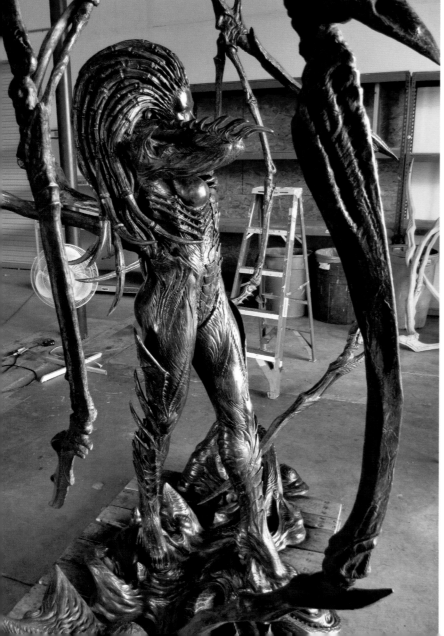

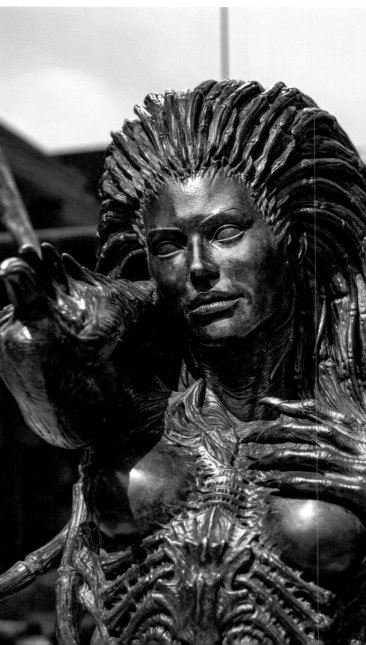

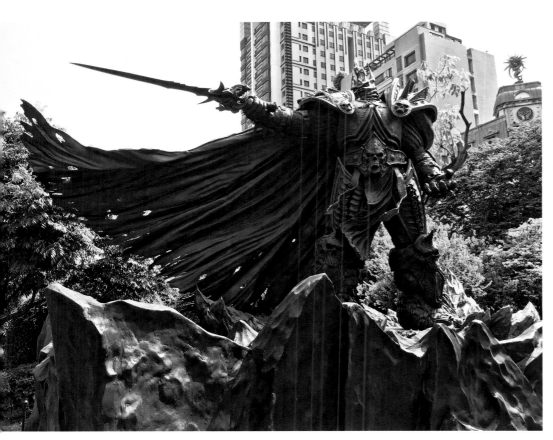

CASTING CALLS

AFTER the bronze orc wolf rider statue at the Blizzard main campus in Irvine, California, had been completed (see chapter 4) the Versailles office campaigned for a statue of their own.

Carpenter, who had spearheaded the Irvine project, took on the task, beginning with mitigating cost. "I thought there might be an opportunity to repurpose a Kerrigan sculpt we did for BlizzCon," Carpenter says. He contacted iconic sculptor Steve Wang. "I asked if it was possible to repurpose the Kerrigan molds for a bronze. He said, 'Totally.'"

The project was not without its hurdles. "They had to resculpt the head," Carpenter says, "and put every part in a place where it would hold its own weight because those things are thousands of pounds, but we were able to use those molds."

Even when the statue was finished, there was a final obstacle to overcome. "The patina turned out pink," Carpenter says. "You want the nice bronzes and greens and browns and umbers, but it was pink. I thought, 'Isn't that baked into the metal? We're screwed, right?'"

Wang proposed what seemed like a risky solution: burn the pink away.

"I watched him burn this thing up," Carpenter recalls. "It changed the metal to almost that rainbow color that you see on exhaust pipes. It made this zerg-like patina that neither of us had ever seen before and probably couldn't reproduce if we tried. It all turned into kind of purples and this subtle green that is, in my opinion, one of the greatest patinas of all time."

Not to be outdone, the Taiwan office requested a statue of their own. Specifically, Arthas. And . . . they wanted him displayed in a park.

"I said, 'Like a *park* park?" Carpenter recalls. "How does that work? You're going to put a big death knight in the middle of a park?' They said, 'Yeah, we want to do it.'"

Carpenter and Wang tackled the challenge head-on, using the Lich King figure completed by Blizzard senior sculptor II Brian Fay as a maquette. "We made a big base to get it off the ground because every part of Arthas can kill you," Carpenter laughs.

The sheer size of the statue—fourteen feet tall—necessitated a whole new level of detail.

"We wanted to understand how the armor material was formed from a story and lore perspective," Carpenter explains. "It's almost like he's haunted from these decisions he's made, like the pain inside him is pushing out through these forms, and we really locked in on that. I didn't want it to look like it was built by mortal hands, with armor hammered on a forge, so we really talked about these skulls pushing through the armor and revealing themselves."

After nine months of hard work, the project was unveiled to much fanfare. And Carpenter couldn't have been happier with the result.

"That thing is monolithic," he says. "And terrifying. It's such an incredible piece. My personal favorite. The only unfortunate thing is the base is so high you can't get near it."

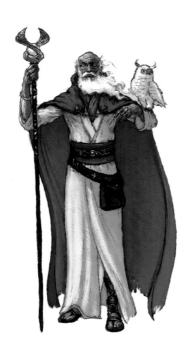

DECKARD CAIN:
STAY AWHILE . . . AND READ

NAMED from the winning entry in a fan contest, Deckard Cain is fondly remembered by legions of *Diablo* players. With his signature voice and voluminous scrolls of lore, the old scholar was one of the most valuable NPCs in the game. And yet, Cain possessed no extraordinary abilities beyond a keen perception and encyclopedic knowledge.

"He's not the big barbarian with the axe or the dark, stealthy rogue who ambushes or poisons the enemy," observes

Samwise. "He's not the one who's going to win the day with the sword in his hand or the magic at his fingertips. He's the most unassuming of all heroes, who uses his knowledge and learning to help guide us to save the world from destruction."

Chris Metzen built out a history for the character, based on an ancient order called the Horadrim, of which Cain was seemingly the last surviving member.

"His ancestors had trunks of scrolls and books that he had really internalized," says Metzen. "He loved all of this lore. He saw himself as the custodian of this legacy of devils and the fight against the darkness, the secret war between heaven and hell."

BOTTOM: Bernie Kang
TOP LEFT: Victor Lee
TOP RIGHT: Chris Metzen
OPPOSITE, TOP: Blizzard Animation
OPPOSITE, BOTTOM: Chris Thunig

The attribute that has truly stood the test of time, however, is Cain's voice.

"It was this gritty, low-end gravel," Metzen says. "This guy who sounded like he was at the end of his years, who was still energetic about telling these stories. It wound up being this magical voice. The actor brought Cain off in a way that was captivating and charming, like this funny old uncle. You'd want to sit by the fireside and just listen to him tell those tales."

The performance was so memorable, in fact, that Deckard Cain became the automated voice that provides instruction when outside parties call in to Blizzard.

And though Cain was not playable in the *Diablo* games, he's found another life in an alternate universe, one in which he *is* playable:

"In *Heroes of the Storm*, you can have him on the battlefield," says Samwise. "He's not going to run into the battle and hold the front line; he drops healing potions for characters. He aids the battle without actually being the big tough guy warrior or badass magic user."

CHAPTER **TWENTY-SIX**
A NEW COSMOLOGY

OPPOSITE: Brom

Diablo reimagined angels and demons, using visual development to push the envelope of character design. Take Tyrael, for instance, the archangel who began as the faceless judge and jury of humankind but ultimately evolved into its fierce flesh-and-blood protector. In this chapter, we'll follow key character evolutions, from the soaring spires of the High Heavens to the darkest depths of the Burning Hells.

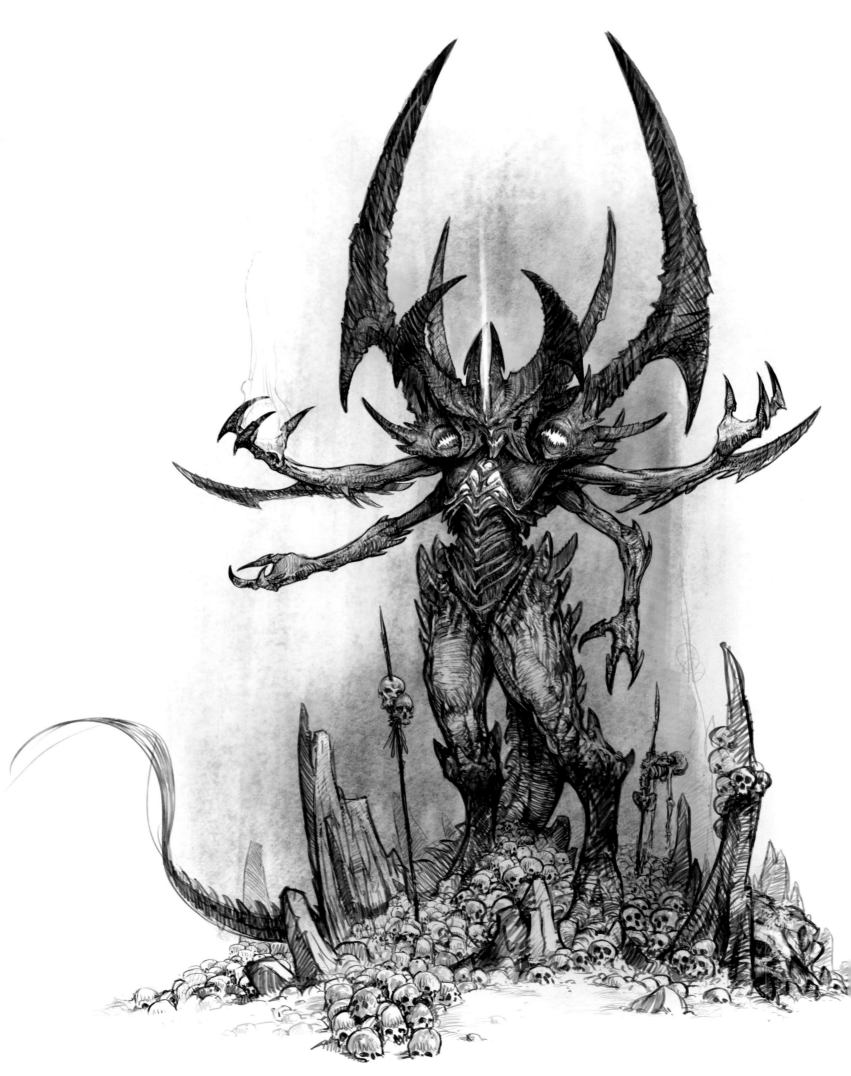

THIS PAGE: Jean-Baptiste Monge, Chris Metzen
OPPOSITE, TOP: Anthony Rivero
OPPOSITE, BOTTOM LEFT: Bernie Kang
OPPOSITE, BOTTOM RIGHT: Victor Lee

THE DEVIL YOU KNOW

WHEN "Big Red," Diablo himself, was being developed for *Diablo III*, the iconic Prime Evil underwent a significant change. Lead concept artist Victor Lee started off with the familiar depiction: hulking, red, horns everywhere. "Then there was some talk," Lee says, "that maybe Diablo should be female."

Lee and other artists continued exploring. "We thought, 'Should she be grotesque but somehow beautiful? And what about wings? Can we have snapping jaws on the wings?' We drew out all these crazy ideas."

In the end, the cinematics team created the version seen in the game, incorporating ideas from the *Diablo* artists. "I think it was a successful design," Lee says. "It was fresh, and people liked it."

In *Diablo IV*, other demon designs have undergone significant revision. Andariel, the Maiden of Anguish, was one character that developers felt needed an overhaul.

"Sometimes we take a design and we evolve it," says *Diablo* art director John Mueller. "And sometimes we take a design and we totally flip it. Andariel was a flip."

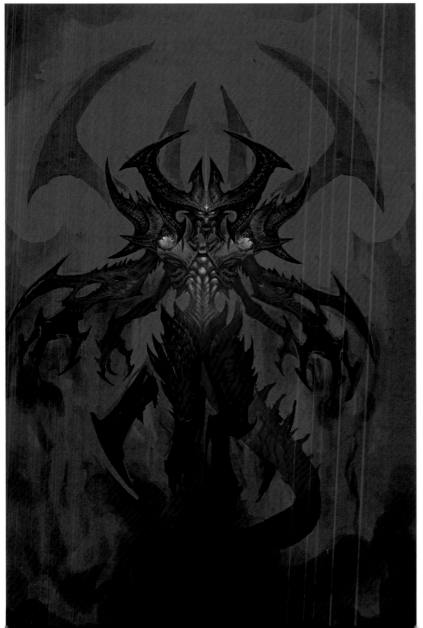

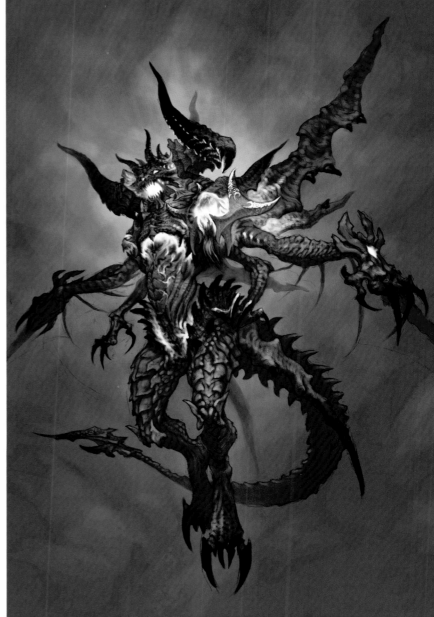

The consensus on the *Diablo* team was that Andariel felt dated and out of place. The challenge came in how to bring forward a new look and feel for the demoness while retaining aspects that made the original design exciting.

"The original had this crazy hair," Mueller notes. "So we couldn't lose that. But in the new version, anguish is present in every part of her design. She's very tortured looking, strapped to a giant yoke, in chains. She's such a dangerous demon that other demons have put her in this device because she cannot be trusted."

The demon Duriel, the Lord of Pain, required only minor revision. "We made him even grosser," Mueller says. "But if you squint, he still looks like the same character."

Diablo developers try to look at older characters with fresh eyes every time. But how do they decide which demons to bring back?

"Our artists and designers will get together," Mueller says. "We'll do some concepting, iteration, and we'll see where it goes. That's how it is at Blizzard—the core value of 'every voice matters' is really true when we're reimagining or ideating on an important boss. We bring a lot of people in to give a lot of feedback."

TOP LEFT: Samwise Didier
TOP RIGHT: Michael Dashhow
BOTTOM: Victor Lee

TYRAEL: ABOUT FACE

DIABLO features incredibly unique angel designs: rather than feathered wings, they possess glowing tendrils of light. Many of them are hooded, and where a face should be, only a mysterious, unsettling void exists.

But where did this design originate?

The first angels depicted in *Diablo I* manual art, such as Izual in an illustration by former senior vice president, story and franchise development Chris Metzen, portrayed feathered, birdlike wings. Angels elsewhere in the manual wore hoods, but there were clearly faces within them.

The design changed much later, when artist Paul Limon developed a version of Tyrael intended for use in a cinematic. Limon chose not to give the angel a face for a few reasons. One, to add mystery. But there was another, more pragmatic reason as well . . .

"I was running out of time to model the face," admits Limon.

Nevertheless, when Metzen saw the design, it stuck. "It fascinated me for the angel to not have physicality," Metzen says. "It conjured this idea of, 'There's not a person in there, is there?'"

Limon also discarded the feathered wings in favor of ethereal energy ribbon wings, although he added feathers to the armor as a nod to traditional wings.

"The energy wings were genius, in my opinion," Metzen says. "What I ended up running with was, 'What if angels are made of sound and energy?' There's not a person in there, it's a soul, and the wings became the neon expression of that person. They are the angel, and they had a sound."

The idea of angels as sound, or music, factored into Metzen's take on the armor as well. "Ultimately, a game where you're getting instruction from and/or fighting swirls of color does not feel epic. The armor drew the eye and created physicality."

While the design was widely well received and applied to other angels in the franchise, the lack of a face proved to be difficult for some. "*Diablo* angels have always been challenging to me," admits Lee. "Because one of the tools we use to give characters *character* is the face. And for *Diablo* angels, we took out the face—everyone wears a hood—so we lose a significant tool to build character."

The unusual design took artists like Lee out of their comfort zones and forced them to invest more heavily in silhouettes, weapon types, color palettes, and armor as ways to differentiate the angels and give them more personality.

LEFT: Chris Metzen
RIGHT: Blizzard Animation

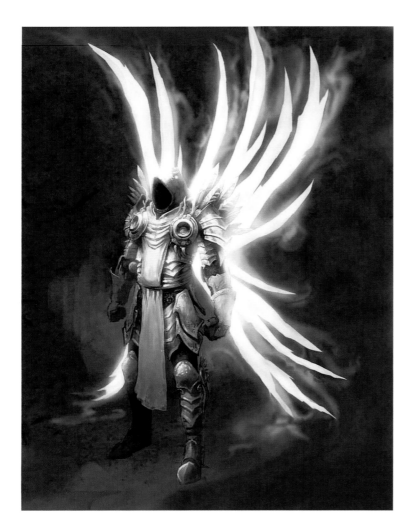

ADDING SUBSTANCE

"ULTIMATELY, Tyrael was meant to be the Archangel of Justice," Metzen says. "Justice is what's coming. It is harsh retribution, consequence, so justice is rarely a feel-good theme. It's the hammer coming down if you mess up."

And though Tyrael was expected to be merciless by his angelic peers, the archangel developed a soft spot for humans.

"I love the idea that Tyrael, of all of these angels, was the one who saw the potential in humanity," Metzen reflects. "Justice, of all things, becomes the lens through which we see the humanity of the franchise, of the meta story of *Diablo*."

In *Diablo III*, a fellow archangel named Imperius served as a main adversary of Tyrael. Designers used the angels' armor design to tell their very different stories.

"Imperius is Valor, and he's all about himself," Metzen reveals. "His armor is golden and fiery and full of filigree. By contrast, we wanted Tyrael's armor to reflect his character. He's a very pragmatic, utilitarian guy, so his armor is relatively unadorned, almost the baseline that would inform all other designs."

Ultimately, Tyrael chose not just to fight *for* but *alongside* humanity, by stripping away his wings, taking on a mortal form, and plummeting from the High Heavens to the world of Sanctuary.

"It was Tyrael's job to burn out humans as a failed creation," Metzen explains. "But instead of becoming the hammer, he becomes the champion of humanity. And they in turn become the vehicle of justice. Humanity will become heroic and stand up and fight the darkness and fight corruption on its own."

And the image of Tyrael as the faceless enforcer with the glowing ribbon wings has endured. "The faceless hood, the armor, the design of the wings—that design for Tyrael has become a standard," Mueller observes. "It feels foundational to what makes a *Diablo* angel look like a *Diablo* angel."

So much so, in fact, that Blizzard commissioned a soaring version to display at BlizzCon and on the company campus, a statue that would be unlike any that had come before it . . .

TOP LEFT & TOP RIGHT: Joe Peterson
BOTTOM RIGHT: Victor Lee
OPPOSITE: Bernie Kang

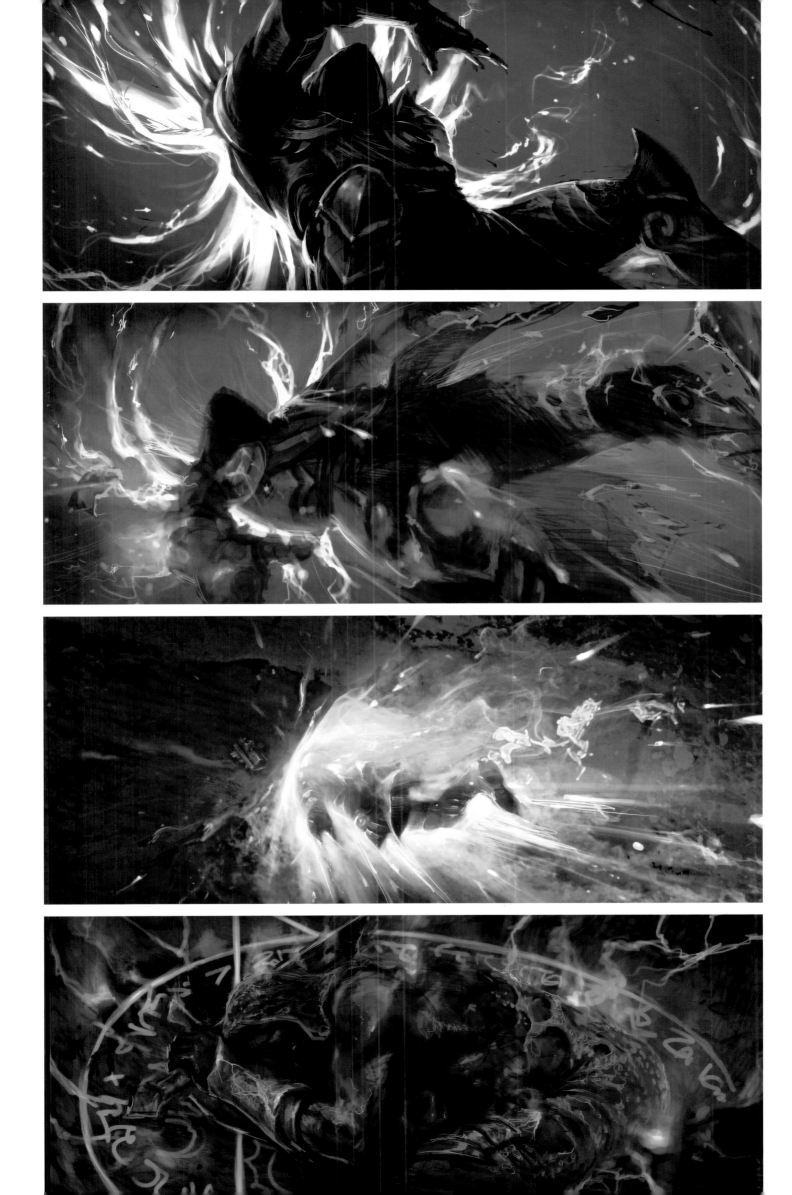

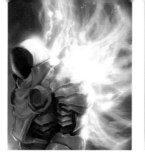

TYRAEL ASCENDANT

BLIZZARD had worked with Hollywood effects genius Steve Wang to make statues before. Tyrael, however, would present all-new challenges for the master craftsman—challenges largely concocted by former vice president of art and cinematic development Nick Carpenter.

"Everything had to be better than what we had done last time," Carpenter relays. "I started thinking maybe there's an opportunity to have Tyrael be suspended by his own wings. I didn't want to see this angel just standing on a platform. I wanted something that felt majestic."

Carpenter sat with the 3D model, experimenting with different variations to achieve the floating effect. "I started folding the wings down so he'd basically be suspended. I thought there might be a way to cast in fiberglass so the wings would be translucent yet would be able to hold him."

While sound in theory, the idea would prove difficult to execute: "Steve said, 'That's impossible,'" Carpenter laughs. "He said it would buckle under its own weight, even if we made the armor as light as possible."

The 3D model, however, proved to be a saving grace, as the detailed model allowed Wang to 3D-print the armor pieces. Wang then went back to his shop and brainstormed ideas for constructing the wings.

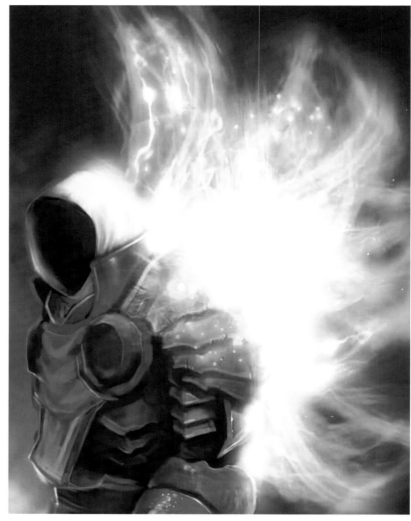

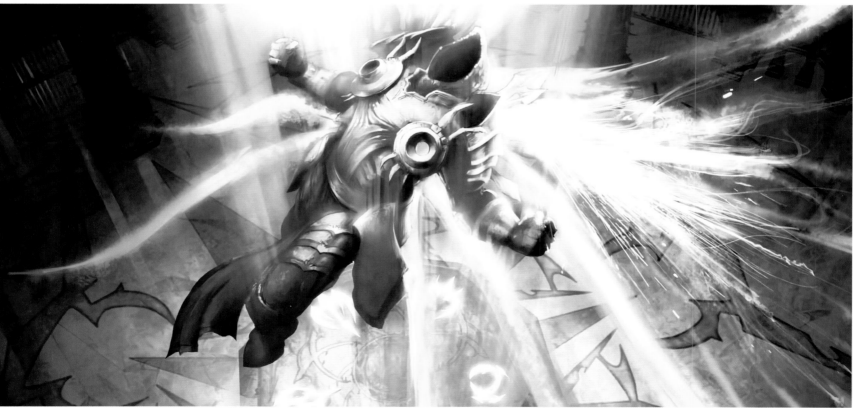

THIS PAGE: Blizzard Animation
OPPOSITE: sculpt by Onyx Forge Studios; photo credit Dana Bishop

"The one that stuck out," Carpenter says, "was 'What if we weld this steel-gauge, super-thick armature that will hold him up, encase that armature with clear plastic, and then put lights inside of it with cotton to give it this glowing effect.'"

Wang's team then put together a mock-up with wire and straws, and the course was set. "I thought, 'It's crazy, but let's go for it,'" Carpenter says. "And they started creating this thing. This was the first time I had seen 3D printing at this scale, and the fidelity we were getting, it looked like aliens made them. The inside looked like honeycombs. It looked like there was no hand that could possibly make that."

The wings proved challenging, right up to the very end. "We spent a long time trying to make sure the wings didn't look like tentacles," Carpenter remembers. "They still do, a little, because they're just tubes with metal piping inside of it that's all welded, and then you've got like skin over the top of this painted facade."

Despite the hurdles, Tyrael soared. "They pulled it off," Carpenter confirms. "He hangs over, a little bit off his platform, to make him feel like he's ascending. I've never seen anything like it. And I don't think anyone else would be crazy enough to even try to pull off something like that again."

The statue's story, however, doesn't end there. For every BlizzCon where Tyrael makes an appearance, a team of highly trained personnel are responsible for getting the figure to the venue and back again safely.

"Tyrael is the most harrowing to move," says Blizzard curator Dana Bishop. "Because he's floating, they have to have multiple people brace him and then undo his hook and slowly lower him down into his cradle. And then he has eight energy ribbons that have twelve individual strands of LEDs inside every single one that have to be carefully threaded out and removed. So Tyrael is the one I gasp at the most when I'm watching him come down."

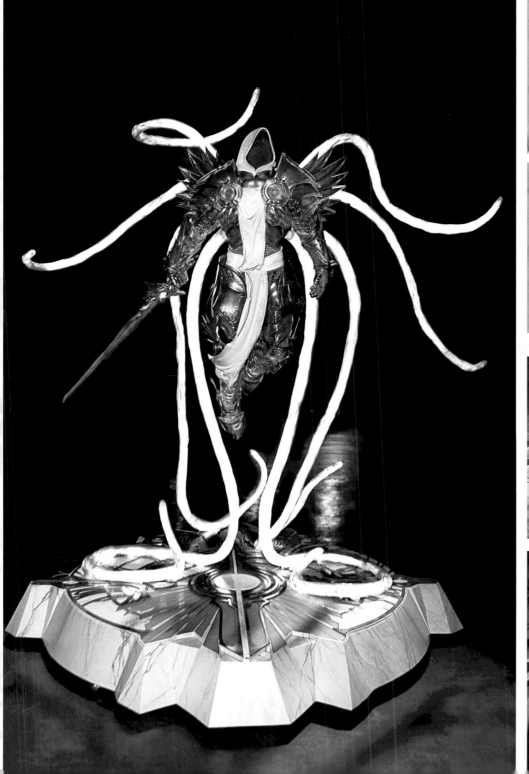

CHAPTER **TWENTY-SEVEN**
ALTERED REALITIES

OPPOSITE: Luke Mancini

Heroes of the Storm is a game where franchises collide. It introduces players to a world of endless possibilities, alternate story lines, and jaw-dropping role reversals. In the following pages, we'll examine how **Heroes** takes the most legendary characters from Blizzard's universes and unites them in a battle for the ages.

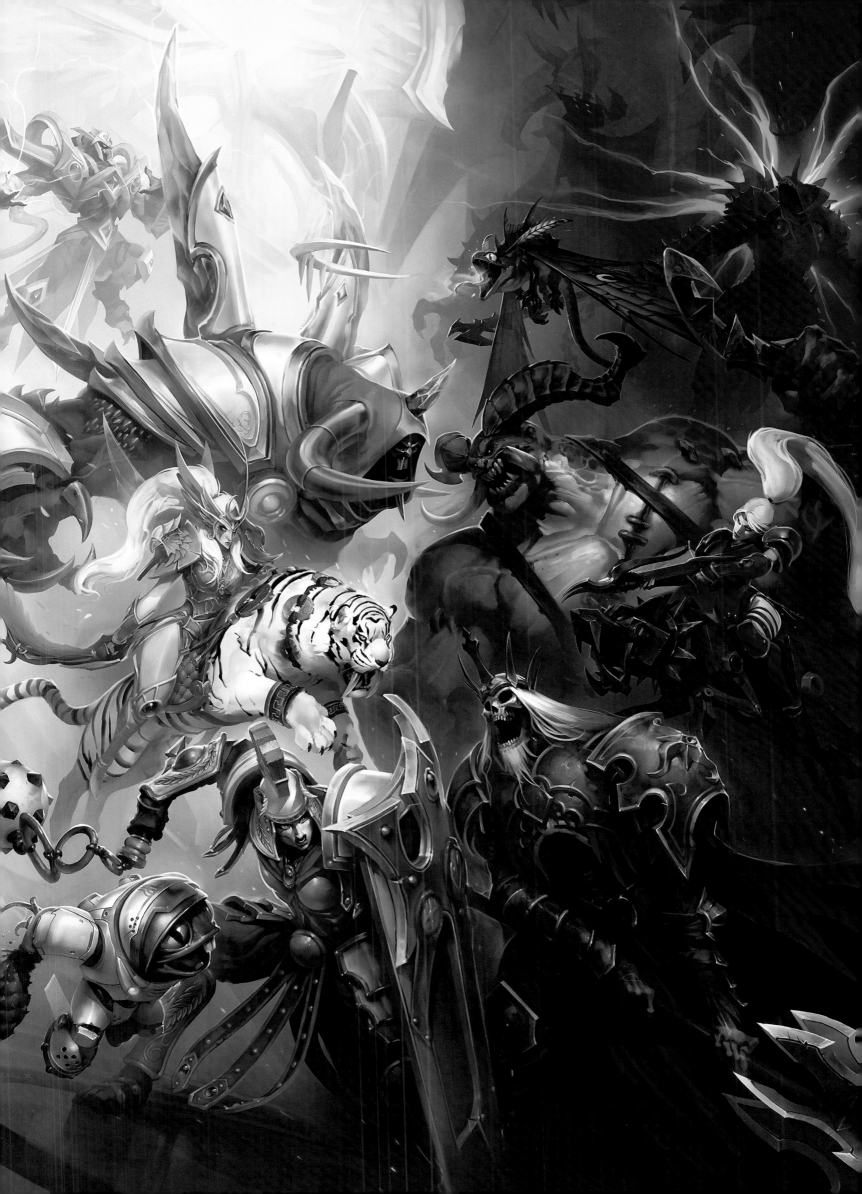

ALL THE TOYS

THE project that would evolve into *Heroes of the Storm* began life as a mod—or altered version—of *StarCraft II*. "There were super-popular games that were built out of the *Warcraft III* engine," explains senior art director Samwise Didier. "They became such a huge game in the industry that it spawned a whole new genre of MOBA-style (multiplayer online battle arena) gameplay. A brawler."

The team chose to make a MOBA-style game to show at BlizzCon, using the *StarCraft II* engine. The game featured a *StarCraft*-like sci-fi setting with some fantasy elements. "We didn't want to do just straight *StarCraft*," Samwise reveals. "We wanted to make it a fun and interesting game, but we didn't have a lot of time to build on it."

The demo was well received at BlizzCon, enough so that the company knew it had a potential hit on its hands. "We said,

'Okay, what are we going to do?'" Samwise remembers. "*StarCraft? Warcraft? Diablo? Overwatch* wasn't around at the time."

Samwise was still considering when one day, in a break room, he looked at a Blizzard-branded, stand-up arcade game. "I stared at the side of it," Samwise says. "And I ran and got our main designer, and I said, 'This is what our game needs to be.'"

The side of the game featured a collage of characters from Blizzard's main IPs, including Illidan, Arthas, Zeratul, Diablo, and Thrall. Samwise recalls, "I said, 'That's what it should be right there. It should be all the toys in our toybox. This'll be a game where we can play every single character, villain, monster, and hero in one game.'"

OPPOSITE, TOP RIGHT: Glenn Rane
OPPOSITE, TOP LEFT & BOTTOM: Luke Mancini

THE team was excited to move forward with their new game idea. Some artists continued working on it, splitting their time between the MOBA—which was being called *Blizzard All Stars* at the time—and the remaining installments of the *StarCraft II* trilogy, *Heart of the Swarm* and *Legacy of the Void*.

"The workload became too heavy," Samwise says. "So we started staffing up. We got some of our senior people jamming on ideas for design and for the maps and the heroes themselves."

Questions abounded. Who would be the first hero? What kind of skins would the team do?

"That was a whole new thing," Samwise recalls. "We hadn't really done that before, making skins for existing units. Would people still know who a character is? Some people said, 'Arthas is so iconic. We can't make a skin of him—that will mess up gameplay.' I thought, 'Well, other games are doing it, and Blizzard has shown that if other games are doing something, we can do it. And if we like playing a game and we make our own version of it, it usually comes out really fun.'"

One of the biggest questions that remained revolved around story. What kind of world would bring together heroes and villains from completely separate universes? And more importantly, how would such a world impact those franchises?

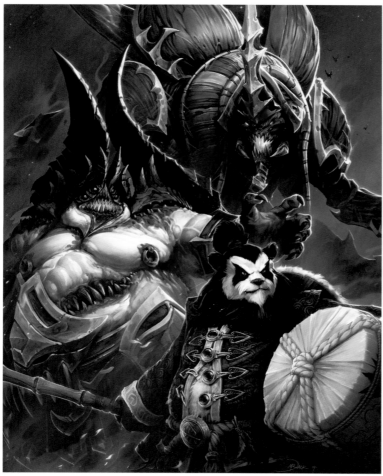

MIXING RESPONSIBLY

"WE knew from the very beginning that we didn't want *Heroes of the Storm* to affect any of the other worlds," Samwise explains. "We didn't want to mess up anyone else's games or stories they had planned out for the future."

The team set the game in an alternate reality called the Nexus, where characters and events exist in complete isolation.

"What happens in the Nexus does not apply to the franchises themselves," Samwise says. "We put together a light story line for people who were really interested in the hows and whys, but it was definitely something that was not meant to hamper anything our other dev teams were working on, so right out of the gate we were saying, 'This is not canon.'"

This arrangement benefited the *Heroes* team as well. "It was helpful on the creative and design end," Samwise reveals. "Because we didn't want to be held back by what the other games were either going to do or had already done."

The removal of story constraints allowed the developers to focus on the Blizzard core value of "gameplay first."

"*Heroes* is really about the art and the gameplay," Samwise says. "Not about adding to other stories. Working without

TOP & BOTTOM: Luke Mancini
OPPOSITE: Dmitry Prozorov

restrictions was liberating. We were just making a game. Every other IP has hours and years of history and people playing them; they have these worlds, these books full of story, that you have to go by. For us, it was a mindset of, 'What is cool art? Let's make that. What is good gameplay? Let's make that.'"

For many people on the team, it was reminiscent of processes used in the past.

"There was a spot in *Warcraft III* when the expansion hit and we were waiting for direction to come in, and we just started concepting," says art director Trevor Jacobs. "We would say, 'What about this? What about that?' And no one was telling us no. The expansion was loose and fun, and that was probably the best content we've generated. *Heroes of the Storm* development is one hundred percent that."

Samwise agrees. "When we were working on the original *Warcraft* or *StarCraft*, we came up with the gameplay and art first, and the story followed. In my opinion, that's the best way to create games. It may not be the best way to write a story, but it's the best way to create games because all you worry about is the actual gameplay. Imagine the rules of basketball or baseball if you had to have a story to go with it: 'We really can't have the shortstop go between second base and third base due to story concerns.'"

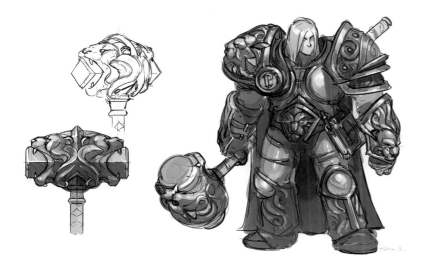

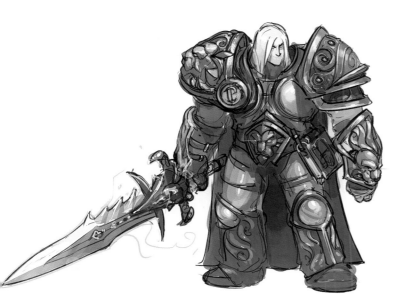

ROLE PLAY

WHILE the team enjoyed freedom in exploring Blizzard's marquee characters, there were still important points to keep in mind. "We worked with other teams to make sure we kept the essence of what the characters were," Samwise explains. "We wanted to doctor them up so they felt new, while still keeping them recognizable. We wouldn't get rid of Tyrael's wings, for example. We needed to keep the classic, iconic elements of them."

This approach was helpful on the gameplay side also, as it was important for players to know what character they were playing and how they stacked up against others.

"You need to know if Tyrael's coming after you," Samwise says. "You need to know if that's Diablo or that's the Butcher or if it's some zerg creature. That was difficult at times. The Butcher has a meat cleaver and a hook. Stitches also has a meat cleaver and a hook. So we needed to make sure they were still distinct."

For some iconic characters, the team added their own spin. In Samwise's words, "We made Kerrigan 'Queen of Ghosts,' which was basically the Queen of Blades but with a high-tech Ghost suit and wings and neon blades. One of my favorites was for a *StarCraft* siege tank. We didn't want to just put in a 'siege tank'—we wanted to build a character. So we made Sergeant Hammer, a badass tank driver who blows you away from afar and knocks you out up close."

While other Blizzard game teams are not obligated to include *Heroes of the Storm* characters in their franchises, they may choose to do so, as was the case with Sergeant Hammer and others.

"There's really zero risk with some of the character and skin ideas," Samwise observes. "There's a potential benefit to the other teams because if something we do really strikes a chord with fans, they have that option to include it. Characters like Lunara, who is a night elf dryad who was made for *Heroes of the Storm*, she's now in *World of Warcraft*."

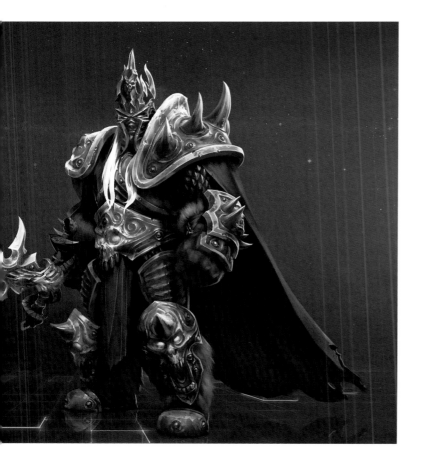

ONE STYLE FITS ALL

FOR many new games, one early objective is to create a strong and unique art style. *Heroes of the Storm* was in a much different position, however.

"Our goal wasn't to define a new art style," Samwise reveals. "It was to take existing art styles that everyone knows and loves and recognizes and make them all work in one game."

Heroes of the Storm's art style continued to undergo refinement, beginning with a character type that many Blizzard artists were intimately familiar with. "We started with an orc," Samwise confirms. "They're a little bit bigger than humans, around six and a half, seven feet tall. We knew that our human would be a little bit smaller, and we went from there. *Heroes of the Storm* is basically the ultimate definition of what real-time strategy orcs should look like."

According to Samwise, elements such as shape language, proportion, and color palette were all adjusted on a per-franchise basis.

"With *Diablo*, whose characters are a little more realistic with smaller proportions, we gave them a ten to fifteen percent increase in their bulk so when you see a barbarian from *Diablo* standing next to an orc from *Warcraft*, the styles don't look radically different. We took *Warcraft* characters and nudged them to be slightly more realistic, more compact and toned-down, but we wanted to make sure there wasn't such a wide difference between a hyper-cartoony, colorful, *Warcraft* hero and the darker, more brooding *Diablo* hero."

StarCraft characters occupied a middle ground, being less colorful and exaggerated in proportions than *Warcraft* but with more realism in texturing. This left *Overwatch*.

"We worked with the *Overwatch* team," Samwise relays. "Characters like Tracer are a little bit thicker; they have to be so you can see them from the game view. We were able to make it so they didn't look radically different from what people in *Overwatch* are used to, but they also didn't look like little stick figures next to mighty orcs."

Level of detail was a special case scenario for two reasons: One, characters needed to look good from the game's top-down perspective and be clearly defined—players had to be able to tell the difference between Thrall, Samuro, and Rehgar, for example. The second reason had to do with something that was new for Blizzard at the time: players' ability to purchase skins and heroes in the virtual store.

"There was a back-and-forth," Samwise reveals. "Where a character might be too detailed for the game but look gorgeous in the gallery or be just right for the game but look a little too flat in the gallery."

Having two different models or textures, one for the game and one for the gallery, was not an option.

"It was the exact same model," Samwise confirms. "That was super important for the team because we want you to be able to see exactly what you're buying. We don't want you to have this ultra-detailed character in the store and then get it in the game and it's different."

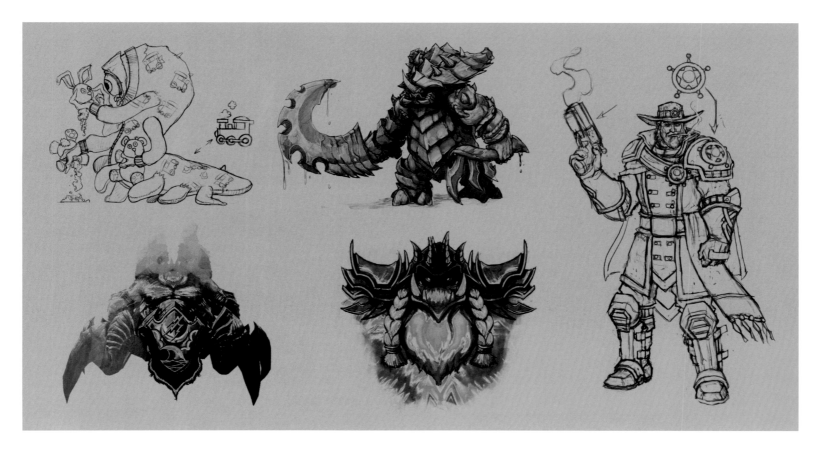

THIS PAGE & OPPOSITE, TOP: Samwise Didier
OPPOSITE, MIDDLE & BOTTOM: Luke Mancini

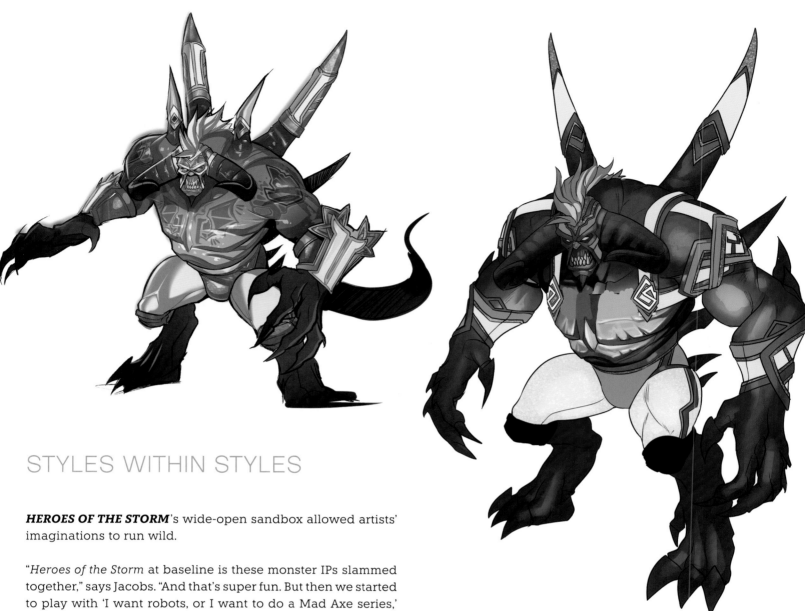

STYLES WITHIN STYLES

HEROES OF THE STORM's wide-open sandbox allowed artists' imaginations to run wild.

"*Heroes of the Storm* at baseline is these monster IPs slammed together," says Jacobs. "And that's super fun. But then we started to play with 'I want robots, or I want to do a Mad Axe series,' and that's when it started to become even more fun because we were juggling a dozen things that I've always wanted to do but that didn't take a full game cycle to create. We could do something within six weeks that might have taken seven years if we had to make a full game."

The immensely popular Mecha Storm set of characters and skins began with the artists' love of anime and a desire to celebrate styles from different cultures. "We decided, 'Hey, we want these fun shapes from these animes. Let's pick the best heroes,'" Jacobs recalls. "So we came up with Rehgar because he needed a cool skin and he transformed (from orc to wolf), which was a plus; Tyrael was such a badass angel, and he was so iconic, we thought, 'If we give him a thruster move along with the sword, there might be a cool mech moment there.' And Abathur, he was low on skins, and could use a super sci-fi one, so with those three, we had our path."

Company leadership was impressed enough with the idea that more money was allocated for the Mecha Storm cinematic than the team would normally receive. The work was outsourced and art directed by one of the team's lead animators. The final result was an instant fan favorite.

"It was one of those projects where we enjoyed it as much as the fans," Jacobs beams.

Another culturally themed idea started small, with a *Heroes* animation lead's desire to do a Luchador Diablo. It was a notion that quickly gained momentum.

"A handful of people were doubting," Jacobs says. "But we had some room to breathe, and we said, 'Let's let the idea develop.' We weren't expecting something rad with it, but ideas kept sparking other ideas. An animator would come back and say, 'I'm going to do this.' We asked for three concepts, and we ended up with ten."

The team then began building a realm around the luchador theme, complete with its own backstory. To top it off, artists created a mount, a large chihuahua with a luchador mask—a luchihuahua.

"There was a concern that we might take the concept too far," Jacob reveals. "So we worked with our Latin American localization group, and they loved it. In fact, they helped us cast a real luchador announcer for the game. It was so over-the-top fun, this thing that was supposed to be a smaller event that became a passion project that got everybody on the team on board and loving it."

TOP: Oscar Vega
OPPOSITE: Andrew Kinabrew

CHAPTER **TWENTY-EIGHT**
GETTING IN

THIS SPREAD: Wei Wang

For video game lovers around the world, landing a job at their favorite studio can seem like an impossible dream. Now, with modern technology connecting talent to art directors like never before, dreams are becoming reality. But it's not just the talent of tomorrow that's finding a home on Blizzard's campus. Across all of Blizzard's IPs, fans have made the transition from admirers to full-time employees. They've come from all over the world—Russia, China, Australia—to build a career doing the work that they love.

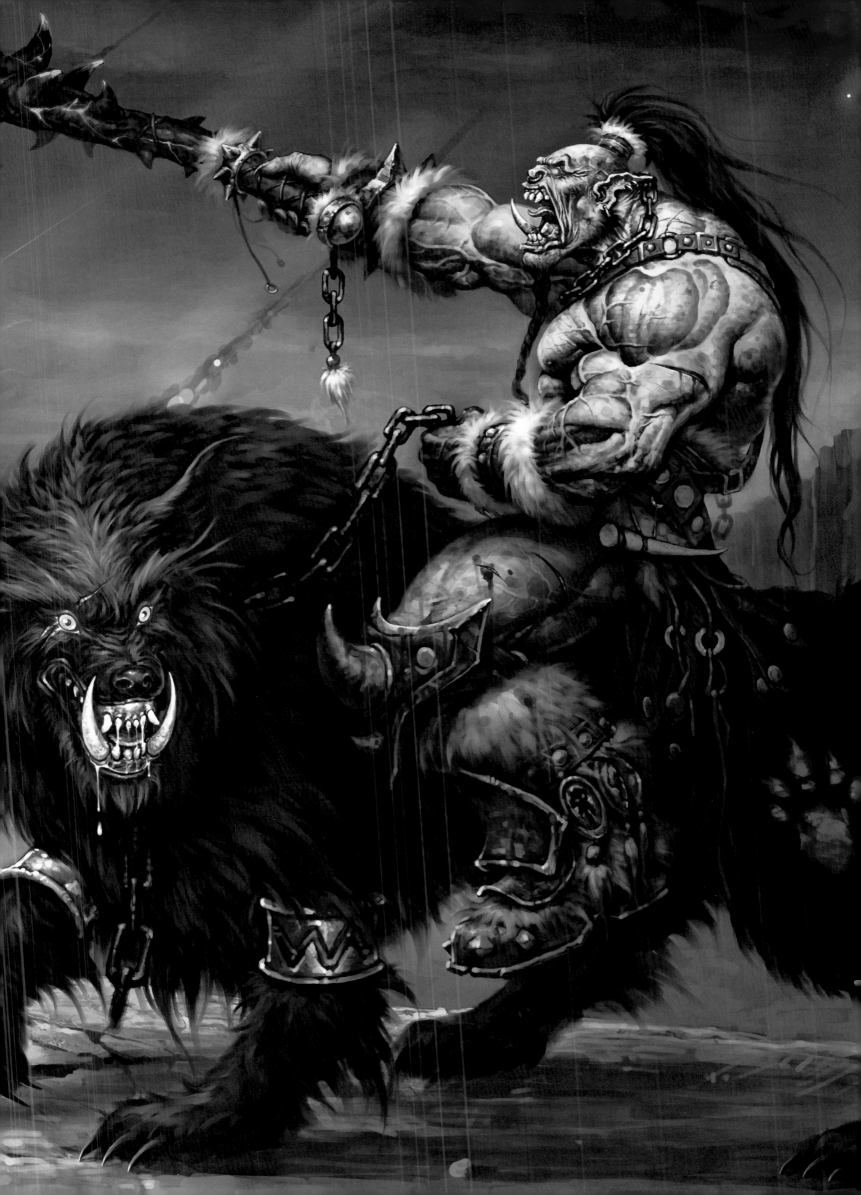

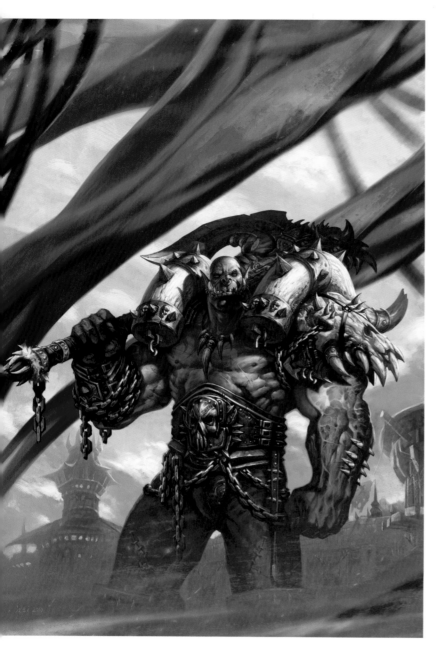

LUKE MANCINI—"MR JACK"

SENIOR concept artist II Luke Mancini grew up in rural Australia, far from any local video game shops where he might go to pick up the newest titles. His fondness for *StarCraft* began when he received a demo disc that came with a computer magazine he subscribed to.

"It included a map editor and three missions that were not in the actual game," Mancini remembers. "I spent a year playing those missions over and over again. I remember being super excited about the manual with all the tiny 3D renders of the units and Metzen and Sammy's drawings. It imprinted in my head."

Mancini loved the game so much that he convinced his teacher to let the students install *StarCraft* on the science lab's eight computers. "We would go in a couple days a week during lunch and play. We had LAN parties throughout high school."

After graduation, Mancini went to college to study graphic design, figuring he might follow in his father's footsteps as a freelance illustrator. "It didn't cross my mind that I could actually work at Blizzard one day," Mancini says.

Later, following the announcement of *StarCraft II*, Mancini began drawing all the alien zerg, including old Brood War units and new units as they were being announced. "Even though what we were seeing was higher res and more detailed than the old Brood War stuff, when you saw a video or a gif on the website, it was pretty low-res, so there was still a lot of room for interpretation."

Mancini's take drew the eyes of senior art director Samwise Didier. Following a phone interview in 2009, Blizzard flew Mancini out to California to meet him in person. By the time Mancini arrived back home in Australia, the studio had made an offer.

"It's a great story of someone outside the industry doing the art that he loves for the game that he loves," Samwise says. "We saw it and said, 'Hey, instead of this guy doing killer fan art, let's have him do killer official art for us.'"

Mancini jumped right in, creating promotional art for *Heroes of the Storm* and *Hearthstone*. He's also been instrumental in creating character concepts and *Heroes* skins.

WEI WANG

WEI Wang was among the first to transition from fan to full-time artist. While living in China, he illustrated an image of an orc on a wolf that he presented in person to former Blizzard president Mike Morhaime.

Senior art director Samwise Didier recalls, "It was amazing—as good or better than the stuff we were doing at Blizzard already. We wanted him to become a part of the team, and since he was in China, we were able to have him work at our China office."

Wang eventually relocated from China to America and continued to craft incredible art, including promotional illustrations and game box covers. "Back when you bought games in stores, box covers were the first thing you saw," Samwise says. "They drew you in and made you want to pick that box up."

Examples of Wei's fantastic work may be found throughout this book. As Samwise notes, "His art is a huge piece of Blizzard history."

KIM-SEANG HONG—"NESSKAIN"

VISUAL development artist Kim-Seang Hong, aka "Nesskain," was a comic book illustrator working for a French publisher when Blizzard noticed his art and hired him to illustrate the digital *Warcraft* comic book *Anduin: Son of the Wolf*.

When *Overwatch* was announced, Nesskain crafted a series of character illustrations. *Overwatch* character art director Arnold Tsang was impressed. "A lot of the drawings felt like frames from highlight intros, except there was a lot of VFX. He captured the action of the game, the vibrant colors of *Overwatch*, but also the attitudes of the characters. To this day, it's some of the best *Overwatch* art I've seen."

Since Nesskain was already doing comic book work, the team started off by having him illustrate *Overwatch* comics for characters like Reinhardt and Pharah.

From there, the team wanted to try Nesskain on 2.5D hero origin shorts. "The *Overwatch* team used to do them," Tsang says. "But we got busy and wanted to outsource the work. Nesskain composes awesome vignettes of characters, sometimes in action poses, sometimes doing ordinary things. He can do it all, so he seemed like the perfect choice."

Nesskain eagerly accepted: "2.5D is more like telling a story with the illustration. They like to break down the character into seven shots. It's more challenging because it's not focusing only on the character. I have to do backgrounds, and there's way more to draw, but I come from comics, so I prefer to tell a story rather than just draw pictures."

The team was ready to hire Nesskain but worried that the origin shorts might not be enough to fill his schedule. The agreement was made to have him do *Overwatch* cinematic concepts as well, and he was hired on to Blizzard's Creative Development department.

"Last year, a bunch of concept artists from Creative Development did a tour of duty on the *Overwatch* concept team," Tsang says. "Nesskain was one of them, and he ended up sticking with the team for an additional six months."

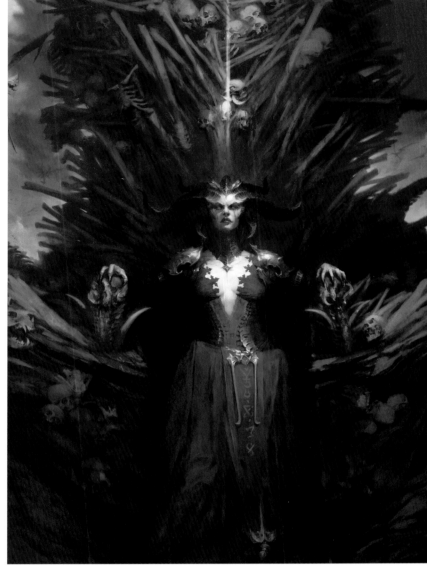

IGOR SIDORENKO—"SID"

DIABLO art director John Mueller took notice of Sid's work online. His style was reminiscent of the old masters, an aesthetic that was perfect for what Mueller wanted to see in *Diablo IV*.

For Sid, it was an opportunity that sparked memories dating back to childhood, watching his friends play *Diablo I*. "*Diablo I* was surreal," Sid says. "High adrenaline. One of the first gaming experiences I had. I played *Diablo II* and still play *Diablo III*, so I'm a lifelong fan of the franchise."

After doing contract work for three years from his home in Russia, Sid got the call and relocated. Now he brings life to the worlds that awed him in his youth, creating concept art for game characters, heroes, nonplayer characters, and illustrating mood pieces to maintain the vision of *Diablo*.

Sid's piece *Creation of the Nephalem* is a stunning example of that vision, and it's the artist's favorite creation to date. "Initially, it was a different composition," Sidorenko says. "It was a vertical canvas but small, just Inarius, Lilith, and a figure of the first Nephalem. But John Mueller wanted to add to it, so it turned into a giant canvas that took more than a month."

BACK TO SCHOOL

WHEN the *World of Warcraft* team noticed that art schools had begun to pivot away from hand-painted training in favor of the photorealistic and next-gen styles of the time, they brainstormed ways to reach out to students.

Senior art director Chris Robinson envisioned a program that would reinvigorate the talent pool coming out of schools, give back to the art and studio communities, and provide financial assistance for students.

The initial broad strokes of this plan took form in the *World of Warcraft* Student Art Contest. "We identified the schools that wanted to participate," Robinson says. "Then we sent out representatives to give a talk. The first round laid the ground rules—'Here's what we want you to create, here are the tools we use internally, and here are some brief demonstrations of how we go about creating this stuff.'"

A time limit was provided, art was reviewed, and the winners were given several opportunities, all the way from a Blizzard visit to sit with artists and receive critiques to working an internship on the team for a limited time.

The contest focused on juniors and seniors so as not to entice students to work at the company rather than finishing school. The messaging for freshmen and sophomores was to continue working toward their goals. "We saw that kids would do this," Robinson says. "Come back year after year, start a rapport with people on the team, eventually end up winning and then coming in as interns."

Some of those interns would return to their schools and spread the message. As word of mouth spread, some students chose schools specifically because they featured the contest. "Now, there's a whole network of past winners and kids currently in school," Robinson says. "People who are working at other studios who are all part of it, this family of people who were involved in the contest."

The most important question, of course, is, "Did any of the winners land a full-time job at Blizzard?" The answer: of course. Nearly a quarter of the artists on the *World of Warcraft* art team came from the Student Art Contest.

"Mole Master"
Tris 4,500
1024x1024

"Old Crow"
Tris 5,918
1024 x 1024

TOP LEFT: Michael Chae
TOP RIGHT: Clayton Chod
MIDDLE: Wan Gee
BOTTOM: Ariel Fain OPPOSITE: Chris Thunig

IS BLIZZARD FOR YOU?

WHAT does Blizzard look for in an artist?

For Robinson and the *World of Warcraft* team, the needs are specific. "We're looking for knowledge of environmental design, architectural design, and character design. We want artists who can concept their own work, model it, texture it, and get it into the game. We're looking for someone who can hit the *Warcraft* style yet create something unique that goes beyond what we've already seen."

For Samwise, the answer is slightly different. "I don't care about degrees or anything like that. It's about the art. If the art is cool, that's the first thing. Next is if they're going to be a good game developer. As a game development artist, you have to be able to work on everything from cool characters to dumb rocks. Can you do concepts of toasters? Filing cabinets? The artist I'm looking for is one who rises to every challenge, who says, 'I'll make the best toaster you've ever seen.'"

CHAPTER **TWENTY-NINE**
PARAGONS

For Blizzard artists, one incredible by-product of the studio's success has been the opportunity to work with icons in the art industry. Superstar illustrators have participated in Blizzard's Fine Arts Program and generously donated their time and expertise by working on-site. The experience has been a source of pride and fulfillment for many employees and a reminder of how lucky they are to do the work that they do.

WORLD-CLASS COLLABORATION

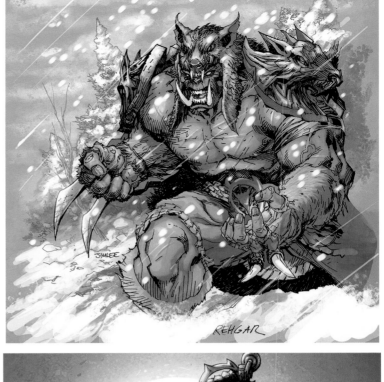

IT began with one of Blizzard's first games, *Blackthorne*. The company hired Jim Lee, a favorite comic book artist of the employees to illustrate the game cover. The experience was a positive one, and the company worked with Lee later on a line of Warcraft comic books. Lee created covers for the comics, and senior art director Samwise Didier illustrated alternate covers. "That was really cool for me," Samwise recalls. "I was a big fan."

Many more opportunities would arise for Blizzard artists to work alongside their heroes, putting some of them in the intimidating position of providing critiques or even touch-ups of their favorite artist's work.

BOTTOM: Mike Azevedo, MAR Studios
MIDDLE, TOP, & OPPOSITE: Jim Lee

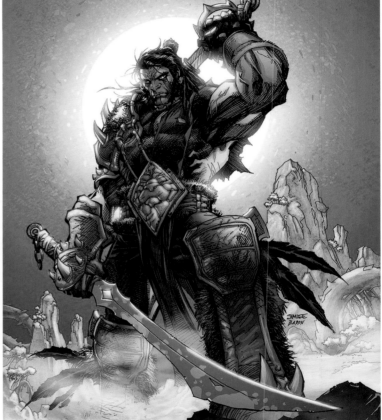

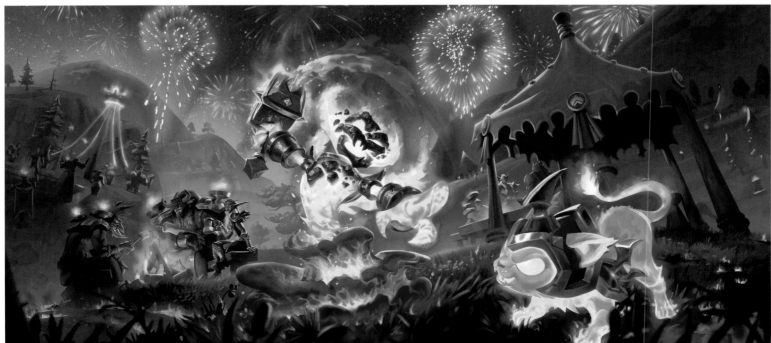

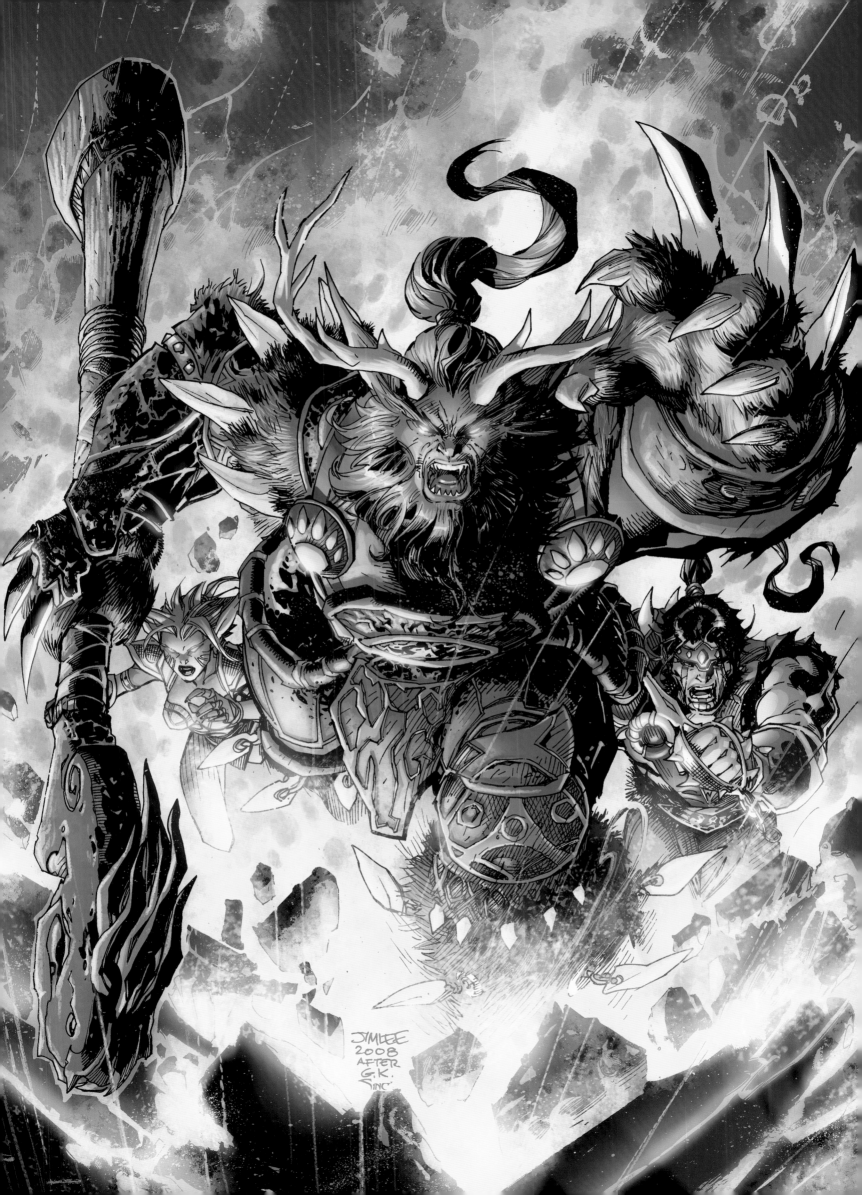

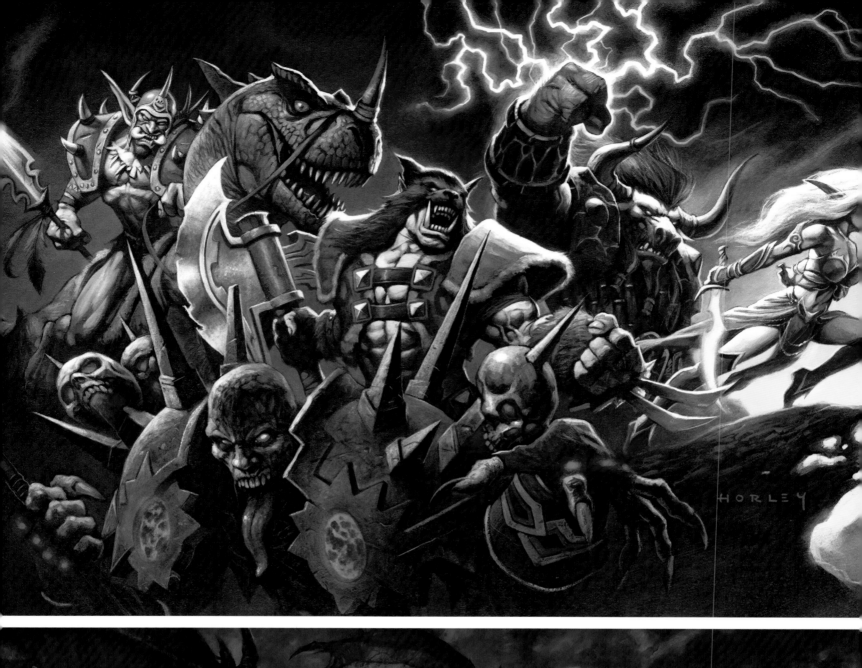
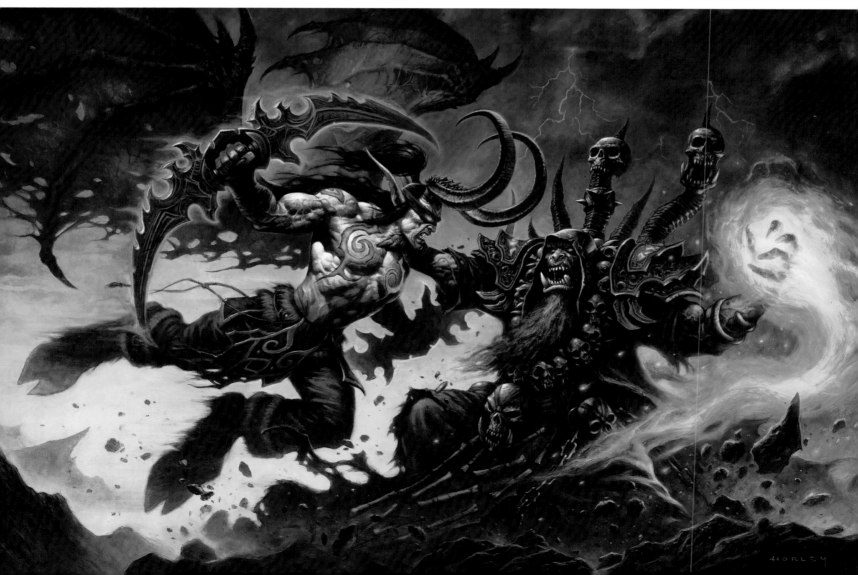

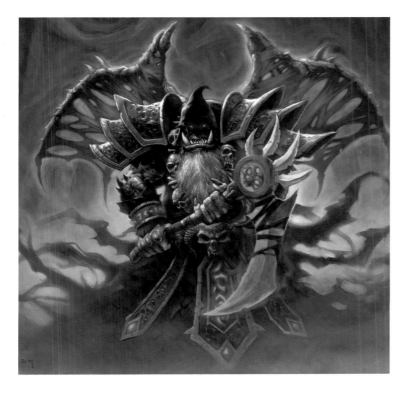

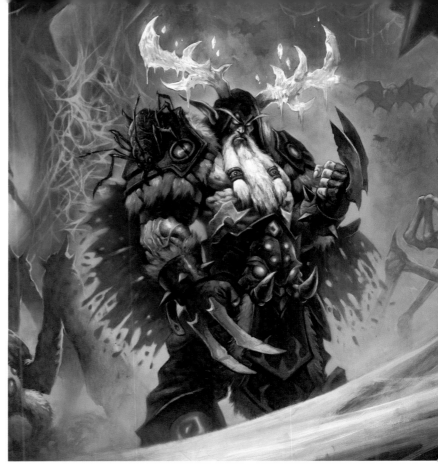

ALEX HORLEY

LEGENDARY artist Alex Horley first came to Blizzard's attention during the company's time producing the *World of Warcraft Trading Card Game.*

Blizzard had begun working with several external artists to meet the game's schedule, but *Warcraft*'s over-the-top fantasy style of saturated colors and comic book proportions wasn't widely practiced or understood. "It took us forever to train artists in the Blizzard style," Samwise recalls. "A lot of them just didn't get it, but the first card I saw from Horley, I thought, 'Yeah. This guy gets it.'"

Horley's grasp of *Warcraft* was as unique and insightful as it was accurate. "*Warcraft* is a fantasy adventure on steroids," Horley observes. "It pushes the boundaries of the genre with bold color palettes, over-the-top designs, and the epic scope of the lore."

Horley and Samwise met in person during a San Diego Comic Con signing and shared an instant bond. "We loved so many of the same things growing up that still inspire us today," Horley says. "He is one of the most creative people I know and one of my closest friends."

As the *World of Warcraft* team began developing *Warlords of Draenor*, they planned an illustration that would showcase all the Warchiefs featured in the game. "We knew it was going to be a big selling point," senior art director Chris Robinson explains. "Seeing the orc clan leaders standing shoulder to shoulder in all their glory."

In the discussion of what artist to hire for the job, Horley was the first name Robinson brought up. "He has such a clear understanding of what *Warcraft* is. But on top of that, you couldn't work with a more humble, awesome person."

Horley brought another element that appealed to Robinson as well—an expertise in traditional oil painting. "We thought, how cool would it be to have an actual oil painting that we could put on the wall? While we all love digital art and that's what we do for a living, we're always going to have that tie to our roots."

"It felt a bit strange at first," Horley recalls. "Arriving each day with my easel and painting supplies while everyone else had a screen in front of them. But I feel that learning how to work traditionally provides a greater understanding of how to create the best digital art."

By the time Horley returned home to Italy, he had made quite an impression. "I can't tell you how many artists would stop by my area, just fired up," Robinson says. "They'd say, 'This was so cool. I got to sit and watch and ask questions.' Even nonartists—designers, engineers—came by."

Over the many years that Horley has continued to work with Blizzard, he established a powerful legacy: a multitude of eye-popping illustrations, all done in traditional style, as well as contributions to the Fine Art Collection.

"Working with Blizzard has been the most rewarding experience of my career," Horley shares. "The respect and appreciation I received from the start always pushed me to try to improve. Best of all, and most importantly, I've developed strong friendships on a professional and personal level with some of the most amazing artists and art directors in the field. I look forward to continuing to create new art for Blizzard for a long time to come."

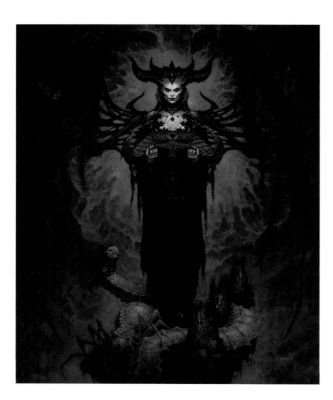

BROM

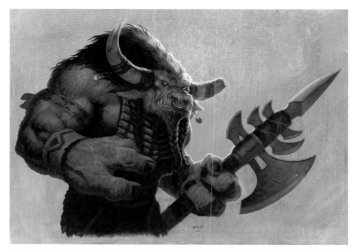

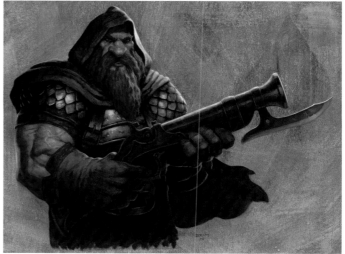

BROM was already a heavyweight in dark fantasy painting when Blizzard first contacted him to illustrate a game cover for *Diablo II*. The company was thrilled when Brom said yes, but for Brom the offer was a pleasant surprise as well. "One of the first games I ever played was *Diablo I*," Brom says. "I do a lot of covers for products and books that most of the time I either don't play or haven't read—it's just part of my job. But I was a huge *Diablo* fan, so to get that call was a thrill."

For inspiration, Brom relied on the game's main character, as well as his own imagination. "My job back then was to take pixelated images and bring them to life, flesh them out in a way that players would say, 'Oh, that's what that character looks like.' As opposed to now, where I feel I'm taking photorealistic material and trying to bring an analog warmth or stylization to it."

The final cover depicted *Diablo*'s Dark Wanderer as a hooded skull with a hole in the center of the forehead. Brom did such a good job of bringing the horrific character to life that changes had to be made. "That image was so striking and so scary for people that we had to tone it down," Samwise remembers. "We put some filters on it, and he made it so the hole was more faded under the hood."

The professional relationship continued, all the way up to *Diablo III* and another pivotal conversation, during which Brom was asked to work on-site. For Brom, the timing was fortuitous. "I was at a point in my life artistically where I had been working at home, freelance, for probably fifteen years on my own. I was hungry to work with other people and be in a studio again."

Arrangements were made for Brom to work three months of the year at Blizzard and three months at home on his own personal projects. "It was a wonderful balance," Brom says, "in the fact that I got to be in an environment with other creative people on the Blizzard campus, which I loved—so many artists, so many creative people. I loved the whole energy of that."

At first, Samwise felt trepidatious about art-directing one of his role models on a regular basis. "That was something I never thought I would be doing . . . art-directing someone like Brom. But he's a pro. When he does work for someone and they ask for changes, he does it."

In fact, Brom found the process invigorating. "It might sound like, 'Oh, somebody's telling me what to do,' but that's actually what I was craving. The back-and-forth—to do a drawing and have the director run it through the team, to have people draw on top of my drawing—I was starving for collaboration. And whenever I think of all my work at Blizzard, that's what I think of—the collaborative side of it."

Ultimately, time away from family called Brom home. Nevertheless, he continues actively contributing, now on *Diablo IV*. Even more incredibly, the *Diablo* connection has been passed from father to son. "As a family, we've played these games our whole lives," Brom says. "My younger son, Devin, spent about a year trying to break into the industry doing game design. His ultimate goal since he was little was to do dungeon design for Blizzard, especially *Diablo*. About a year and a half ago, I found out Blizzard was looking for game designers, and he sent his stuff in, and lo and behold he got hired. It's amazing that my son and I are both working together on *Diablo*—a career and lifetime highlight."

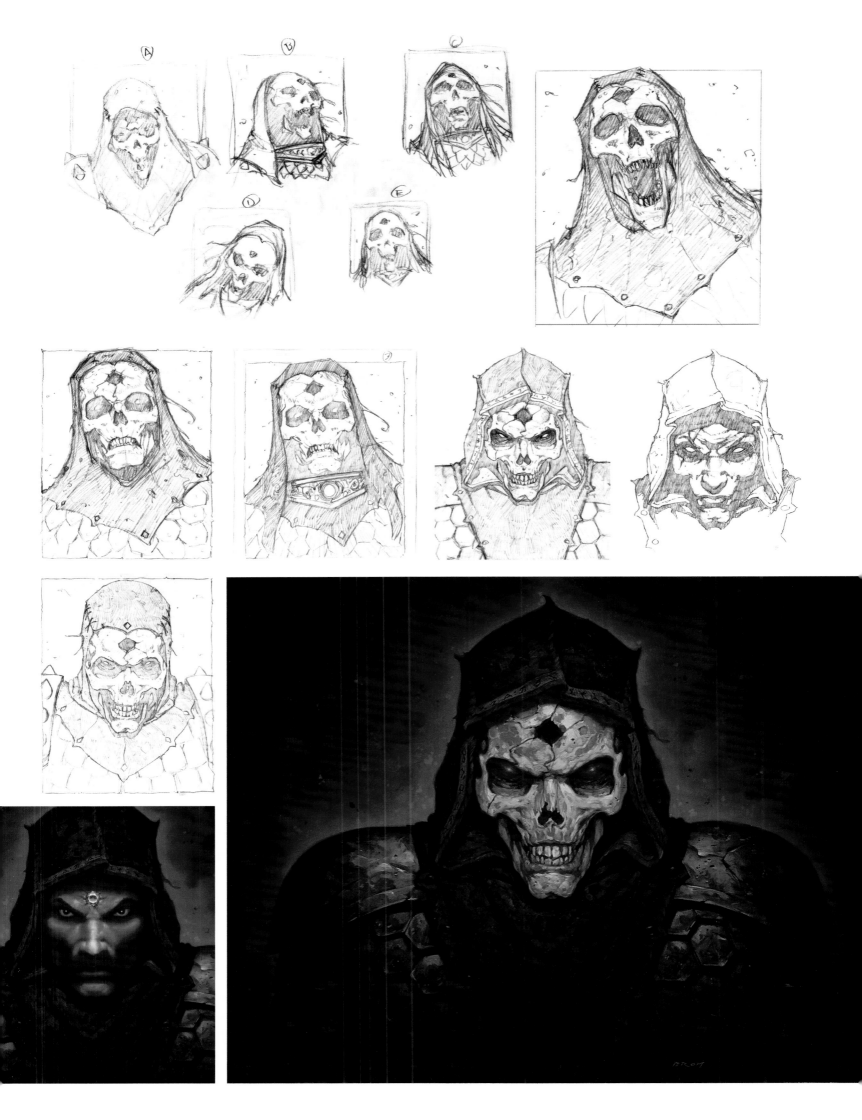

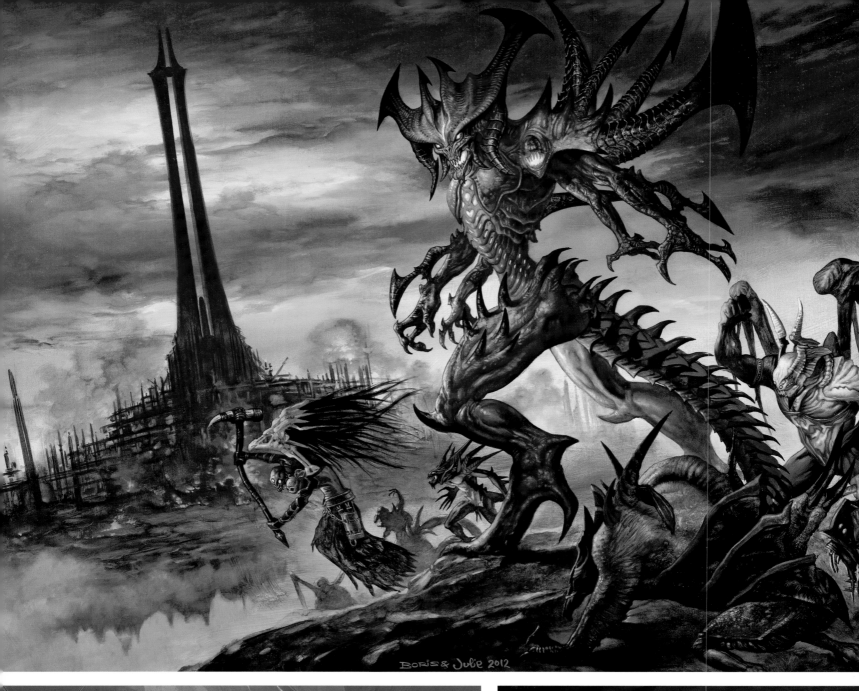

TOP: Boris Vallejo, Julie Bell
BOTTOM RIGHT: Alex Horley
BOTTOM LEFT: Syd Mead
OPPOSITE, TOP: Craig Mullins
OPPOSITE, BOTTOM: Paul Bonner

318

THE BLIZZARD FINE ARTS PROGRAM—
MASTERFUL INTERPRETATIONS

SOME of the biggest names in the world of art have contributed to Blizzard's Fine Arts Program.

The goal was simple: reach out to artists whom Blizzard looked up to and ask them to interpret the company's intellectual properties in their own style. "We wanted their take on our IP, our characters, our world. With very little direction," Robinson elaborates. "It was, 'Here's some shots of what our characters look like; here are some renders of them. Send us any questions about armor sets or environment.'"

For employees, seeing the worlds they created through the eyes of artists they loved affirmed hours and months and years of hard work. But in the words of Robinson, it also did something else: "That outside perspective and influence was a nice breath of fresh air, to remind me how lucky I am to do what I do."

And for former senior vice president, story and franchise development Chris Metzen, the Fine Arts Program—and one piece in particular—will forever hold a special place in his heart . . . and home.

"My favorite artist is Alex Ross," Metzen says. "I grew up loving superhero comics, and I love what he does for superheroes—his quasi–Norman Rockwell visuals that take you into these universes and evoke the highest themes and ideals that these characters were meant to evoke. Superheroism. An old-fashioned feel that, in his hands, becomes very relevant to the now."

Through the Fine Arts Program, Metzen was able to connect with his favorite artist. Looking at the company's various IPs, Metzen felt Ross and *StarCraft*—and specifically Jim Raynor—would be the best fit.

"The cool thing about Raynor," Metzen says, "is he was always meant to be the everyman in a universe where these space gods are coming to life and going to war. Raynor was meant to remind us of *us*. All this was right up Ross's alley, so the idea of him painting Raynor made me stupidly giddy."

Ross did a few concept passes, including Raynor sitting on his bike, but the idea that won out was a scene that Metzen and former vice president of art and cinematic development Nick Carpenter had intended to include in a *StarCraft II* cinematic. "The idea was that Raynor had one last bullet in his revolver," Metzen explains. "And on it he had etched the word *justice*. That bullet was saved exclusively for Arcturus Mengsk. We never found a way to make it work in a cinematic, but suddenly here was this moment, and that was what Ross chose to paint."

Ross finished the piece, and Metzen, as expected, loved it. And though he later left the company, Metzen never forgot the Alex Ross painting of Raynor.

And on Christmas Day, Metzen awoke to a wonderful surprise. "Unbeknownst to me, my wife had reached out to Blizzard and said, 'It means a lot to him . . . can we buy it?' Turns out we didn't *have* to buy it—come Christmas morning, it was gifted to us. I literally cried. My chest heaved. I didn't realize just how in love I was with this image and how it captured that character, that story, that time in my life, and my love for this painter that I idolized. It all just hit me. That painting hangs with distinction in my home and will for my descendants . . . if they know what's good for them."

TOP: Michael Whelan
OPPOSITE: Alex Ross

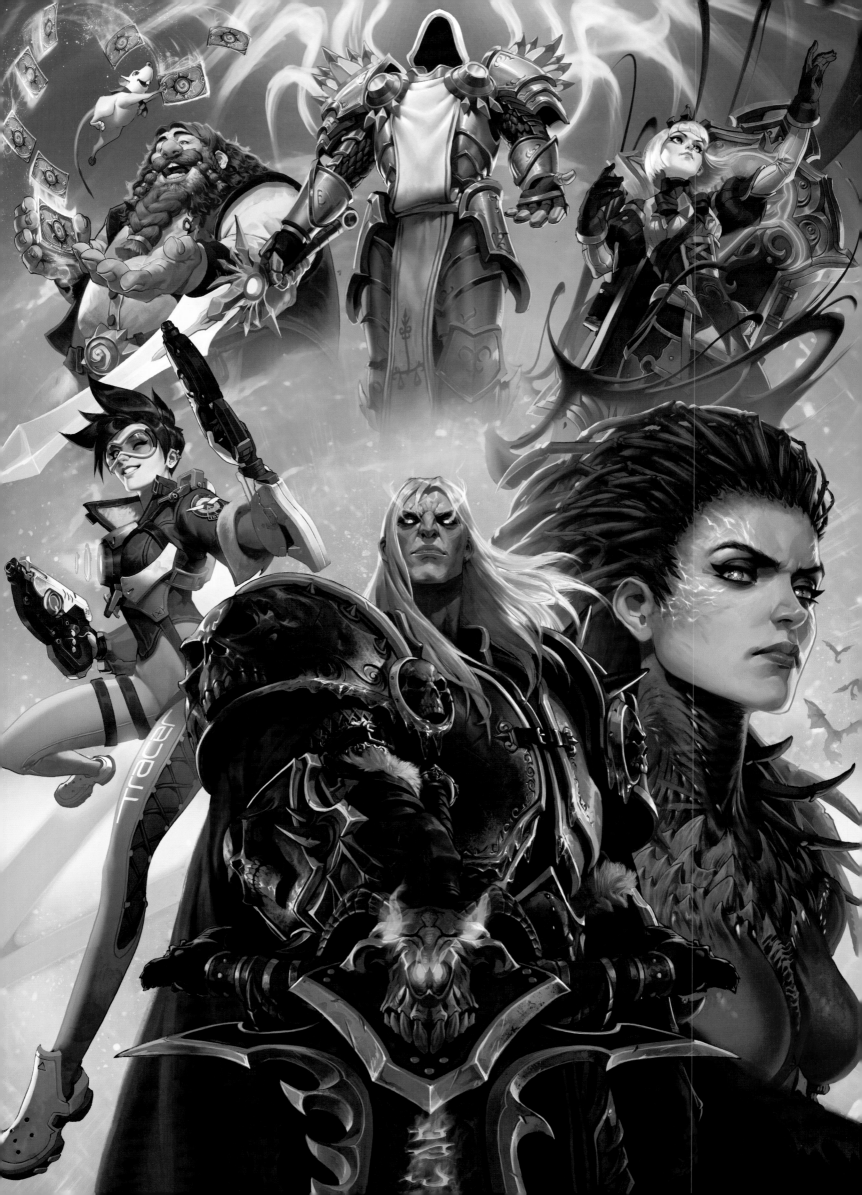

CHAPTER **THIRTY**
LEGACY

In 2021, Blizzard Entertainment celebrated thirty years of making the most epic entertainment experiences ever. In this chapter, through the eyes of company veterans, we'll look back on the incredible accomplishments of the past and look ahead to what the future may bring.

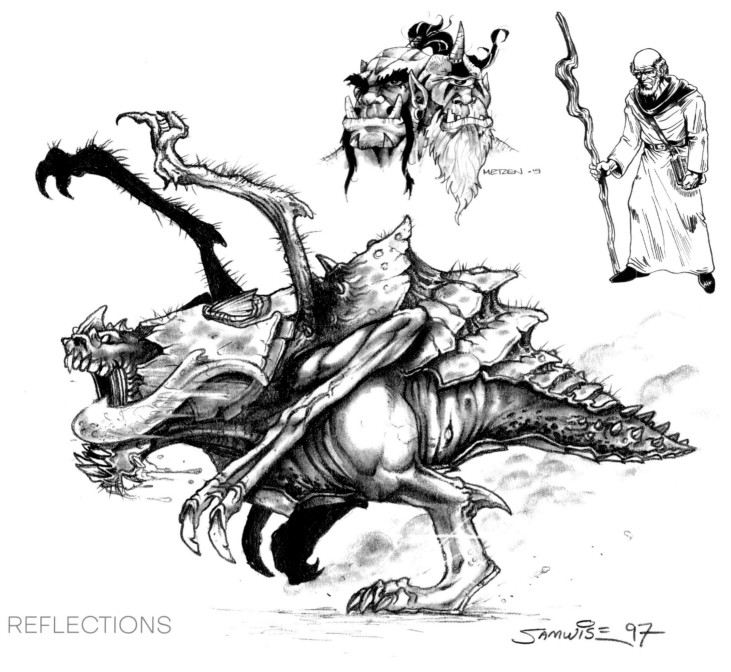

REFLECTIONS

FANS and competitors alike have wondered how Blizzard managed to capture lightning in a bottle time and time again for the last thirty years. Senior art director Chris Robinson weighs in. "'Gameplay first' is one of our core values, but there's a lot of discussion around what that means. You can take that to mean that we're a design-centric company—and to a certain extent we are. Our games stand on the strength of their design, and no matter how pretty you make something or how well it runs or how far it pushes technology . . . if it's not fun, nobody's going to play it."

But what does that mean for art?

"What it means to me is that, while these gameplay experiences are hopefully the most memorable that people have in games or interactive entertainment, you really need a strong window into that world in order to appreciate the design," Robinson explains. "Art is what initially draws people in. If you see someone playing a game from across the room that draws your attention, you can't help but go check it out because you see the colors, the art, the world, the characters, the movement, the effects. You have to look into it—you want to know more about it. No great design will ever see the light of day unless it has that window to attract people to it. That's what art does for Blizzard and for our games."

That same excitement is felt not just by fans but by the employees as they develop the games and watch other Blizzard games take shape over time.

"We have these internal sites where all the artists on a team can post their work in progress or finished artwork," Robinson explains. "Art directors can go in and take footage of their game and post, 'Here's what this part of the game looks like.' It's so cool from an inspirational perspective as an artist, seeing what all these other artists are up to. I genuinely feel that we have some of the greatest developers in the industry. If you turn a corner and run into somebody at Blizzard, you're probably running into somebody who's at the top of their game. It keeps you on your toes. You look at the new people coming in and the awesome artwork that's happening on any given day, and it drives you to not just walk but to run."

Senior art director Samwise Didier, who has been with the company almost from the beginning, recalls the company's earliest days: "We had a bunch of people who grew up around the same time, watched the same movies, read the same comics and books. A lot of us were the best artists at our high school or at our previous jobs, and when we all got together, something clicked, and it was not about money or prestige

TOP LEFT: Chris Metzen
BOTTOM LEFT: Samwise Didier
TOP RIGHT: Michio Okamura

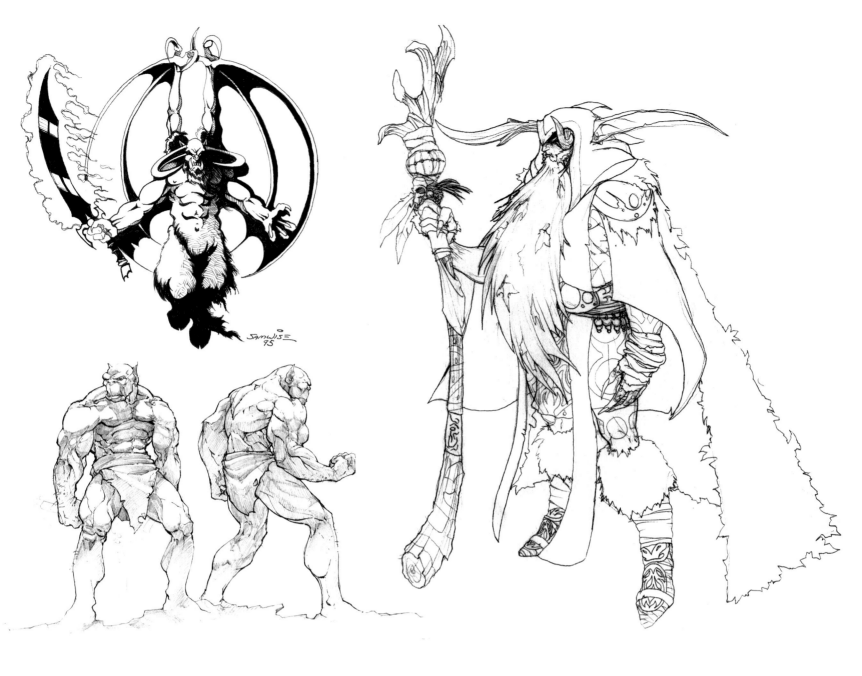

because we were super young. The company didn't have a ton of money because we didn't have any of the franchises yet. We built them together."

And while Blizzard's games didn't always boast the highest levels of technology, in Samwise's view, they didn't have to.

"What we did bring to the world were some of the coolest video game franchises ever made. Something everyone could relate to that wasn't based on history or the real world, just a bunch of stuff we came up with, and now we've had a lot of people join Blizzard and add their ideas to these worlds. I think one of the best things we did was to show you don't have to be the greatest or most perfect artist—you just have to have a lot of passion and a lot of drive, and you can learn along the way and make some really amazing games."

In the eyes of former senior vice president, story and franchise development Chris Metzen, fate may have played a hand in Blizzard's formation as well. "It's a miracle that we all got together at all. We were kids who didn't know any better, who could draw and imagine, but we didn't know what we didn't know. We were not epic product developers. We had no idea how to build a game from start to finish. We had no concept of

what we were doing. But we grew together, and we challenged one another. Over the years at Blizzard as an artist and as a craftsman, it was about doing it together, imagining together, drawing together. There's a magic there that I will chase the rest of my life, that has very little to do with these big games we happened to stumble into over the years. That's a miracle. But the far greater one was finding each other."

For this early fellowship, art became a visual shorthand. "Our artwork was always, at base, a means of communication, and building upon those things almost like stones in a wall," Metzen continues. "Sammy would draw a certain kind of creature, and I'd say, 'That's awesome. I want to take it in this direction,' and stone by stone we were building something that we couldn't really see the final shape of. I believe that process is still happening at Blizzard today. As much as you can say that you can codify the art of Warcraft and the art directors that are developing the most modern *WoW* expansions, I think they're still in the process of building something in which the end result is not entirely seen; those stones are still going in the wall."

325

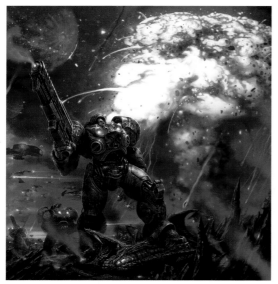

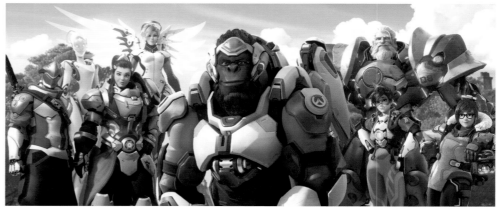

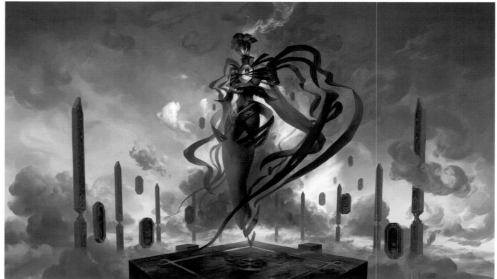

PROJECTIONS

FOR a studio with such a storied past, what does the future, especially the future of art at Blizzard, look like? One certainty is change.

"I'm excited about the opportunity to explore new art styles," says *Overwatch* senior art director Bill Petras. "I think we're going to evolve our house style and constantly evolve into different creative visions. I'm looking forward to Blizzard building more large and immersive worlds. But there are certain things about Blizzard that I hope won't change. I hope we continue to empower artists and developers to make stylized game worlds with great visuals."

One factor that's certain to play a role in future change is the advancement of technology. In the eyes of Chris Robinson, one key will be to apply lessons from the past while forging ahead.

"To use the animation industry as a broad example, it had that era where, as soon as we figured out what 3D animation looked like, everybody said, 'That's the future—forget 2D animation. I want to make a 3D movie. The whole industry's moving toward 3D. Let's fire all our 2D animators and forget about the past and double down on 3D animation.' It took a while, but I think now the world is seeing that it was a huge mistake to abandon one media for another. Developing visual styles in tandem and not just jumping ship is important."

Also important, from Robinson's point of view, will be for Blizzard to continue combining art and storytelling. "We've never set out to create the most graphically advanced game in the world. We're not trying to re-create reality one-to-one and finally trick somebody into thinking they're watching a real person act. That's not the game we're in. The game we're in is using storytelling, design, art, and engineering as a vehicle to tell a story and pull people into these worlds. We're not going to advance a whole lot if we chase making our graphics a little bit more believable, but we will advance if we focus on how we can be more immersive storytellers and how we can use art as a window into storytelling."

One critical ingredient has been, and always will be, the fans.

"One of the things that drives me, one of the things I hold near and dear, is really remembering that the art of this game and the worlds we create are not just ours as the developers—they really do belong to our players and our community," says *World of Warcraft* art director Ely Cannon. "In a way, we're creating it together. It's our solemn responsibility to do the right thing and continue creating art that captures the hearts and minds of our players and really speaks to them."

When considering what lies ahead, Chris Metzen points to the latest *World of Warcraft* expansion, *Shadowlands*, as evidence that the franchise is in good hands. "It is no different from the

TOP LEFT: Wei Wang
TOP RIGHT: Blizzard Animation
BOTTOM LEFT: Rafael Zanchetin
BOTTOM RIGHT: Peter Mohrbacher

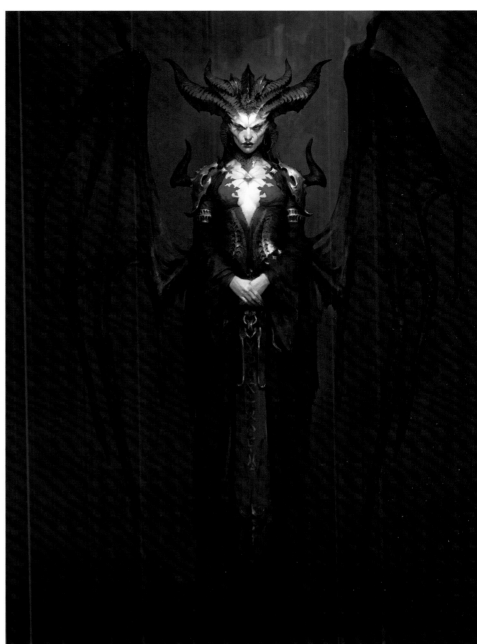

impetus when we started—it's simply far more gorgeous, far more informed. The kids today sure do it better than we did. Now, as a fan and not as a craftsman, I fall into it as much or more than I did when we began. To me, it's a testament to the fact that it was never about any one of our unique expression points or about us specifically. It was about realizing this thing that was bigger than any of us."

And while the games and their future success may not be reliant on Blizzard's pioneers, those pioneers absolutely laid the foundations that future Blizzard developers will build upon.

"Even though we may not have been aware of it," Metzen says, "we started a tradition that has multiple facets, that ultimately underpins this idea that art and the creativity and ideas were about the greater whole and putting your whole self into it. Any given design, any given illustration or sketch in the corner of a manual page, all of it mattered. All of it is worldbuilding. All of it is done to please and be seen by your friends down the hall. You're creating together, and that was always where Blizzard was strongest. It wasn't trying to anticipate this vast

audience out there. There's no way to do that other than to remember that you are also that audience."

Ultimately, as Samwise and others have observed, it will all come back to art.

"Who knows where the technology is going in the future," Samwise says. "I think our tradition at Blizzard has been strong from the beginning, and it's always going to be strong. One of the reasons Blizzard games are so popular is because we've developed an art style that resonates with millions of people all over the world."

In the end, maybe it all comes down to one simple rule, the rule that big shoulder pads and oversize weapons and space cowboys were made from: the Rule of Cool.

"You look at *World of Warcraft*," Samwise concludes, "and it's an old game now by most standards, but it's still a beautiful game, and people are still playing it. So it doesn't matter how fancy or high-tech your art is . . . it just has to be cool."

RIGHT & TOP LEFT: Igor Sidorenko
MIDDLE LEFT: Luke Mancini
BOTTOM LEFT: Blizzard Animation

BLIZZARD
ENTERTAINMENT

FORGING WORLDS

Vice President, Consumer Products: Matthew Beecher
Director, Consumer Products, Publishing: Byron Parnell
Associate Publishing Manager: Derek Rosenberg
Director, Manufacturing: Anna Wan
Senior Director, Story and Franchise Development: David Seeholzer
Senior Producer: Brianne Messina
Lead Editor: Chloe Fraboni
Editor: Allison Avalon Irons
Book Art & Design Manager: Betsy Peterschmidt
Historian Supervisor: Sean Copeland
Senior Historian: Justin Parker
Associate Historian: Madi Buckingham

Published by Blizzard Entertainment.

Blizzard Entertainment does not have any control over and does not assume any responsibility for authors or third-party websites or their content.

Library of Congress Cataloging-in-Publication Data available.

Case / Jacket

ISBN barcode: 978-1-950366-56-9

Manufactured in China

Print run 10 9 8 7 6 5 4 3 2 1

Written by Micky Neilson
Introduction by Samwise Didier
Edited by Chloe Fraboni
Produced by Brianne Messina, Derek Rosenberg
Lore Consultation by Madi Buckingham
Cover Designed by Betsy Peterschmidt
Endpapers by Tae Young Choi, Even Amundsen

Interior Designed by Cameron + Company
a division of ABRAMS. All rights reserved.

Publisher: Chris Gruener
Creative Director: Iain R. Morris
Designer: Rob Dolgaard

*Page 93 and 97 feature concept art (modified from the original) of Prospector Logann, a character from the StarCraft universe who served as the inspiration for Overwatch's Jesse McCree. In the original pieces, the emblem on Logann's shoulder resembled the flag of the Terran Confederacy, the fictional government faction introduced in the original 1998 StarCraft real-time strategy game. For this book, the art has been modified to reflect evolving perspectives on the original game's iconography and the development team's vision for the Overwatch universe.

SPECIAL THANKS to Laurel Austin, Dave Berggren, Dana Bishop, Dennis Bredow, Brom, Eric Browning, Nick Carpenter, Ely Canon, Michael Carrillo, Sarah Carmody, Jeff Chamberlain, Lan-Fang Chang, Nat Cooper, Jeremy Cranford, Anh Dang, Ryan Denniston, Samwise Didier, Allen Dilling, Steven Dowling Jr., Randal Dumoret, Brian Fay, Judy Fernando, Ed Fox, Erin Fusco, Renaud Galand, Lily Gardner, Christie Golden, Alex Horley, Jeff Kaplan, Trevor Jacobs, Jessica Dru Johnson, Roman Kenney, Careena Kingdom, Joseph Lacroix, Bree Lawlor, Jim Lee, Jungah Lee, Peter Lee, Victor Lee, Paul Limon, Jimmy Lo, Luke Mancini, Richie Marella, Chris Metzen, Miki Montlló, John Mueller, Will Murai, Nesskain, Daniel Orive, Ted Park, Justin Parker, Bill Petras, Gary Platner, Glenn Rane, Korey Regan, Chris Robinson, Dion Rogers, Alex Ross, Igor Sidorenko, Henry Szkeley, Justin Thavirat, Ben Thompson, Arnold Tsang, Chris Thunig, Steve Wang, Tina Wang, Wei Wang, Melissa Ward, Ben Zhang

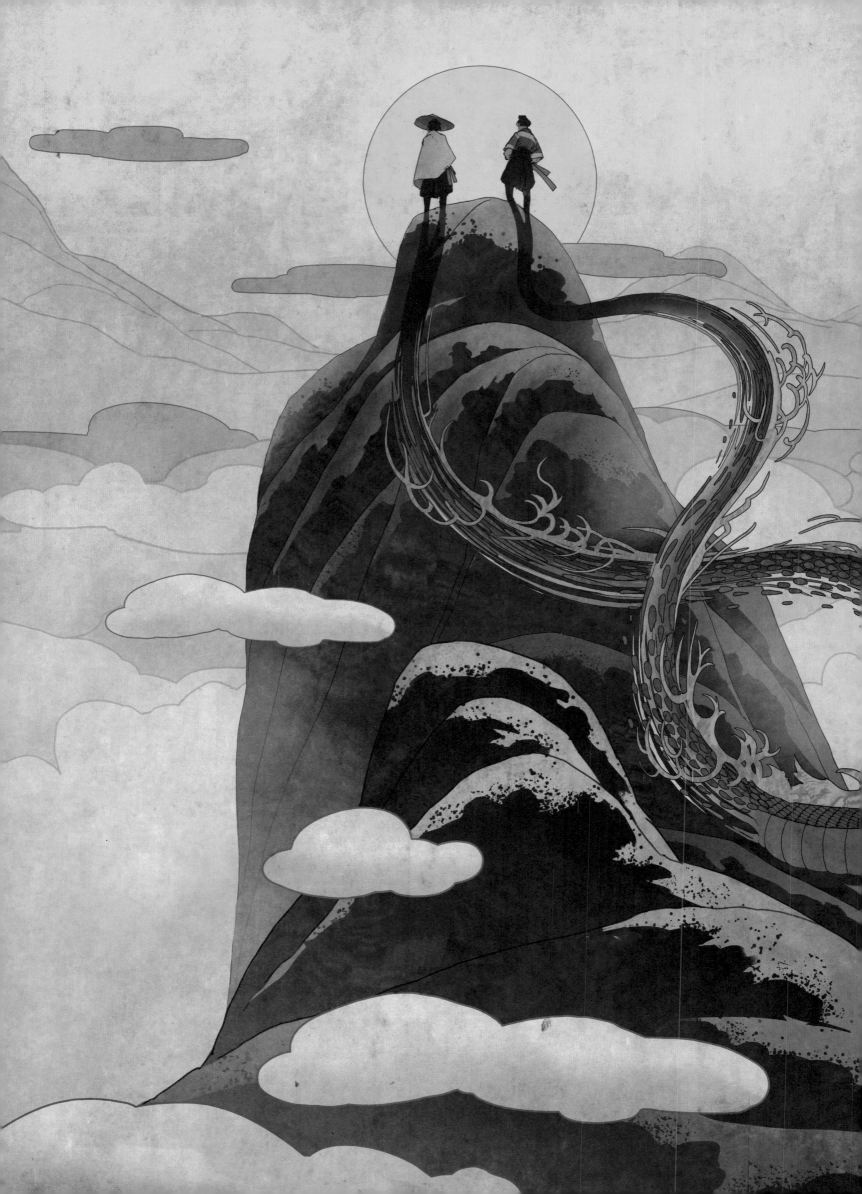